Praise for Louis Zamperini and *Devil at My Heels*

"Harrowing."
—*New York Times*

"Louis Zamperini is a modern miracle. His life reads like something out of a storybook."
—Billy Graham

"Zamperini's nickname may have been 'Lucky Louie,' but after spinning through the pages of *Devil at My Heels,* I consider myself the fortunate one. It's a thrilling read."
—John Naber, president of the U.S. Olympic Alumni Association and author of *Awaken the Olympian Within*

"Inspirational."
—*Library Journal*

"In World War II, Olympian Louis Zamperini faced incredible challenges as he survived forty-seven days at sea and more than two years as a Japanese POW. And once he came home, he had to face a greater challenge—overcoming his rage and bringing himself to forgive. *Devil at My Heels* is an extraordinary story of war and a touching tale of the triumph of love."
—James Bradley, author of *Flags of Our Fathers*

"Exemplary. . . . Rewarding."
—*Kirkus Reviews*

"Amazing. . . . A stark telling of the trauma POWs faced during the war, and of learning to forgive."
—*Post and Courier*

"A harrowing odyssey of survival. . . . Zamperini was defying all odds. . . . A tribute to the human spirit."
—Associated Press

"Remarkable. . . . Anyone wanting to see a real account of life as a prisoner of war will benefit. . . . Despite the horrors they depict, the human spirit shines through."
—*Stuart News/Port St. Lucie News*

"Resurrects Zamperini's heroism. . . . A harrowing life constantly redirected toward good works."
—*Publishers Weekly*

"We too often use phrases like 'life-and-death' to describe sports events, too cheaply use 'hero' to describe athletes. Then along comes someone like Louis Zamperini . . . for whom no other word will suffice."
—*New York Post*

---
*About the Authors*
---

LOUIS ZAMPERINI appears regularly before students from primary schools to colleges, veterans' groups, troubled youth, sports clubs, senior citizens, and religious organizations. Zamperini, eighty-seven, lives in Hollywood, California, and only recently gave up skateboarding.

DAVID RENSIN's most recent book is *The Mailroom: Hollywood History from the Bottom Up*. He is also the coauthor of show business legend Bernie Brillstein's widely lauded memoir, *Where Did I Go Right?*, as well as bestsellers with Tim Allen, Jeff Foxworthy, Chris Rock, and Garry Shandling, and a groundbreaking humorous sociology of men named Bob called *The Bob Book*. Rensin lives in Los Angeles, California, with his wife and son.

# Devil at My Heels

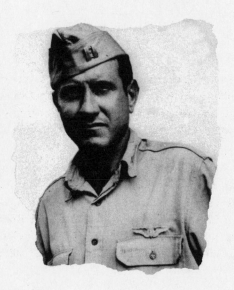

### A HEROIC OLYMPIAN'S ASTONISHING STORY
### OF SURVIVAL AS A JAPANESE POW
### IN WORLD WAR II

## LOUIS ZAMPERINI

*with* DAVID RENSIN

Perennial
*An Imprint of HarperCollinsPublishers*

*For Cynthia, my children Cissy and Luke,
and my grandson, Clayton*

First Perennial edition published 2004.

*Designed by J and F Metsch*

*Map by David Lindroth*

The Library of Congress has catalogued the hardcover edition as follows:

Zamperini, Louis.
    Devil at my heels / by Louis Zamperini with David Rensin.— 1st ed.
    p. cm.
    ISBN 0-06-018860-X
    1. Bomber pilots—United States—Biography. 2. Zamperini, Louis. 3. World War,
1939–1945—Personal narratives, American. 4. Survival after airplane accidents, ship-
wrecks, etc. 5. Track and field athletes—United States—Biography. 6. World War,
1939–1945—Prisoners and prisons, Japanese. I. Rensin, David. II. Title.

D811 .Z266 2003
940.54'7252'092—dc21
[B]

                                                                    2002029350

ISBN 0-06-093421-2 (pbk.)

06  07  08  ❖/RRD  10  9  8  7  6  5  4

The 1929 Geneva Convention Relative to the
Treatment of Prisoners of War

Article 2:
Prisoners of war are in the power of the hostile Power,
but not of the individuals or corps who have captured them.
They must at all times be humanely treated and protected,
particularly against acts of violence, insults and public curiosity.
Measures of reprisal against them are prohibited.

A smooth sea never made a good sailor.
—*Anonymous*

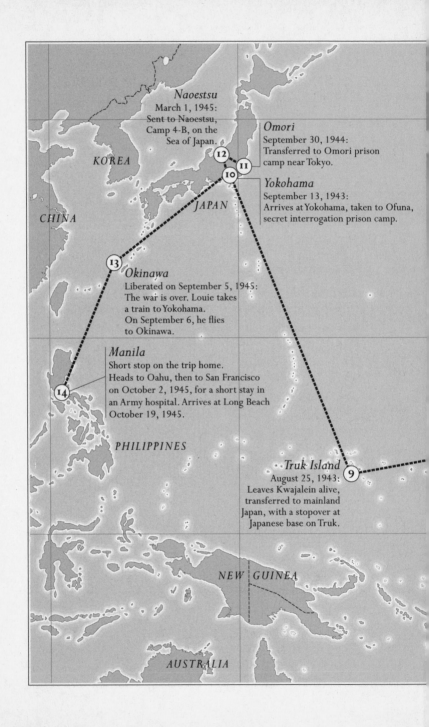

*Naoestsu*
March 1, 1945:
Sent to Naoestsu,
Camp 4-B, on the
Sea of Japan.

*Omori*
September 30, 1944:
Transferred to Omori prison
camp near Tokyo.

*Yokohama*
September 13, 1943:
Arrives at Yokohama, taken to Ofuna,
secret interrogation prison camp.

KOREA

CHINA

JAPAN

*Okinawa*
Liberated on September 5, 1945:
The war is over. Louie takes
a train to Yokohama.
On September 6, he flies
to Okinawa.

*Manila*
Short stop on the trip home.
Heads to Oahu, then to San Francisco
on October 2, 1945, for a short stay in
an Army hospital. Arrives at Long Beach
October 19, 1945.

PHILIPPINES

*Truk Island*
August 25, 1943:
Leaves Kwajalein alive,
transferred to mainland
Japan, with a stopover at
Japanese base on Truk.

NEW GUINEA

AUSTRALIA

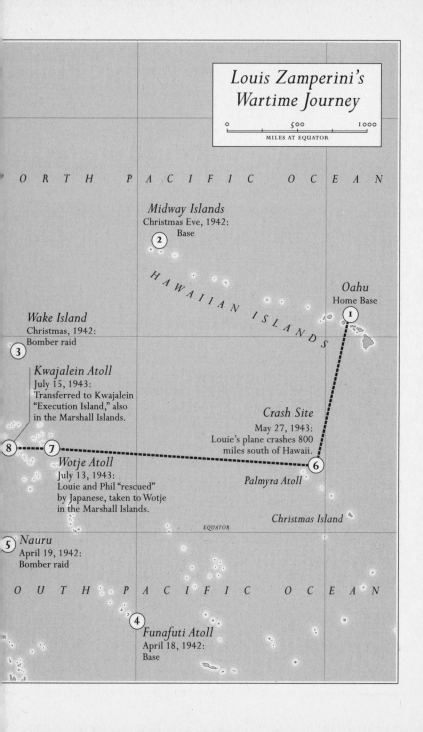

# CONTENTS

# FOREWORD

## SENATOR JOHN McCAIN

Louis Zamperini's life is a story that befits the greatness of the country he served: how a commonly flawed but uncommonly talented man was redeemed by service to a cause greater than himself and stretched by faith in something bigger to look beyond the short horizons of the everyday. What he found, beyond the horror of the prison camps and the ghosts he carried home with him, is inspiring.

The remarkable life story of "Lucky Louie" takes him from the track as an Olympic runner in Berlin in 1936, where he met Hitler, to a raft in the Pacific fending off man-eating sharks and Japanese gunners to prisoner of war camps where rare goodness coexisted with profound evil to a hero's return to America, where he would first plumb the depths of despair and self-destruction before soaring to heights he could not have foreseen or imagined.

This book contains the wisdom of a life well lived, by a man who sacrificed more for it than many people would dare to imagine. It is brutally honest and touchingly human, comfortably pedestrian and spiritually expansive. It should invoke patriotic pride in readers who will marvel at what Louis and his fellow prisoners gave for America, and what we gained by their service. It holds lessons for all of us, who live in comfort and with plenty in a time of relative peace, about what we live for.

More than a story of war, its lessons grow out of Louis's wartime experience. Its moral force is derived from the very immorality of American prisoners' savage treatment by their wartime captors, and the way Louis would ultimately drive away their demons. Rather than destroying Louis's moral code, war and recovery from war's deprivations revealed the mystery of Louis's faith in causes far greater than the requirements of survival in a temple of horrors.

Whether in religion, country, family, or the quality of human goodness, faith sustains the struggle of men at war. Before I went off to war, the truth of war, of honor and courage, was obscure to me, hidden in the peculiar language of men who had gone to war and been changed forever by the experience. I had thought glory was the object of war, and all glory was self-glory.

Like Louis Zamperini, I learned the truth in war: There are greater pursuits than self-seeking. Glory is not a conceit or a decoration for valor. It is not a prize for being the most clever, the strongest, or the boldest. Glory belongs to the act of being constant to something greater than yourself, to a cause, to your principles, to the people on whom you rely, and who rely on you in return. No misfortune, no injury, no humiliation can destroy it.

Like Louis, I discovered in war that faith in myself proved to be the least formidable strength I possessed when confronting alone organized inhumanity on a greater scale than I had conceived possible. In prison, I learned that faith in myself alone, separate from other, more important allegiances, was ultimately no match for the cruelty that human beings could devise when they were entirely unencumbered by respect for the God-given dignity of man. This is the lesson many Americans, including Louis, learned in prison. It is, perhaps, the most important lesson we have ever learned.

Through war, and in peace, Louis Zamperini found his faith.

—October 2002

# 1

## THAT TOUGH KID DOWN THE STREET

I'VE ALWAYS BEEN called Lucky Louie.

It's no mystery why. As a kid I made more than my share of trouble for my parents and the neighborhood, and mostly got away with it. At fifteen I turned my life around and became a championship runner; a few years later I went to the 1936 Olympics and at college was twice NCAA mile champion record holder that stood for years. In World War II my bomber crashed into the Pacific Ocean on, ironically, a rescue mission. I went missing and everyone thought I was dead. Instead, I drifted two thousand miles for forty-seven days on a raft, and after the Japanese rescued/captured me I endured more than two years of torture and humiliation, facing death more times than I care to remember. Somehow I made it home, and people called me a hero. I don't know why. To me, heroes are guys with missing arms or legs— or lives—and the families they've left behind. All I did in the war was survive. My trouble reconciling the reality with the perception is partly why I slid into anger and alcoholism and almost lost my wife, family, and friends before I hit bottom, looked up—literally and figuratively—and found faith instead. A year later I returned to Japan, confronted my prison guards, now in a prison of their own, and forgave even the most sadistic. Back at home, I started an outreach camp program for boys as wayward as I had once been, or worse, and I

began to tell my story to anyone who would listen. I have never ceased to be amazed at the response. My mission then was the same as it is now: to inspire and help people by leading a life of good example, quiet strength, and perpetual influence.

I've always been called Lucky Louie. It's no mystery why.

I WAS BORN in Olean, New York, on January 26, 1917, the second of four children. My father, Anthony Zamperini, came from Verona, Italy. He grew up on beautiful Lake Garda, where as a youngster he did some landscaping for Admiral Dewey. My dad looked a little bit like Burt Lancaster, not as tall but built like a boxer. His parents died when he was thirteen, and soon after that he came to America and got a job working in the coal mines. At first he used a pick and shovel and breathed the black dust. Then he drove the big electric flatcars that towed coal out of the mines. He worked hard all his life, always had a job, always made money. But he wanted more, so he bought a set of books and educated himself in electrical engineering.

Anthony Zamperini wasn't what you'd call a big intellect, but he was wise, and that's more important. His wisdom sustained us.

My mother, Louise, was half-Austrian, half-Italian, and born in Pennsylvania. A handsome woman, of medium height and build, Mom was full of life, and a good storyteller. She liked to reminisce about the old days when my big brother, Pete, my little sisters, Virginia and Sylvia, and I were young. Of course, most mothers do. Her favorite stories—or maybe they were just so numerous—were about all the times I escaped serious injury or worse.

She'd begin with how, when I was two and Pete was four, we both came down with double pneumonia. The doctor in Olean (in upper-central New York State) told my parents, "You have to get your kids out of this cold climate to where the weather is warmer. Go to California so they don't die." We didn't have much money, but my parents did not deliberate. My uncle Nick already lived in San Pedro, south of Los Angeles, and my parents decided to travel west.

At Grand Central Station my mother walked Pete and me along the platform and onto the train. But five minutes after rolling out, she

couldn't find me anywhere. She searched all the cars and then did it again. Frantic, she demanded the conductor back up to New York, and she wouldn't take no for an answer. That's where they found me: waiting on the platform, saying in Italian, "I knew you'd come back. I knew you'd come back."

MORE STORIES SHE loved:

When we first moved to California we lived in Long Beach, but our house caught fire in the middle of the night. My dad grabbed me and Pete and whisked us out to the front lawn, where my mother waited. "There's Pete," she said, as my dad tried to catch his breath. "But where's Louie?"

My dad pointed. "There's Louie."

"No! That's a pillow."

My dad rushed back into the burning house. His eyes and lungs filled with smoke, and he had to crawl on his knees to see and breathe. But he couldn't find me—until he heard me choking. He crept into my room and spotted a hand sticking out from under the bed. Clutching me to his chest, he ran for the front door. While he was crossing the porch, the wood collapsed in flames and burned his legs, but he kept going and we were safe.

That wouldn't be the last of my narrow escapes.

When I was three, my mother took me to the world's largest saltwater pool, in Redondo Beach. She sat in the water, on the steps in the shallow end, chatting with a couple of lady friends while holding my hand so I couldn't wander off. As she talked, I managed to sink. She turned and saw only bubbles on the surface. It took a while to work the water out of me.

A few months later a slightly older kid in the neighborhood challenged me to a race. I lived on a street with a T-shaped intersection, and the idea was to run to the corner, cross the street, and be first to touch a palm tree on the far side. He led all the way and was almost across the street by the time I got to the corner. That's when the car hit him. I ran back home scared to death, pulled off a vent grate, and hid under the house. I could see the mangled boy lying on the con-

crete, and the ambulance that soon took him away. I didn't know his name; I don't know if he died. I know it wasn't my fault, but I've always felt guilty for taking up his challenge—and relieved that I lost my first race.

My mother would often remind me of those times, saying, "We move to California for your health, and here you are almost dying every day!"

MY DAD GOT work as a bench machinist for the Pacific Electric Railroad, the company that ran the Big Red Cars, and we bought a house on Gramercy Street in Torrance, a neat little industrial town on what was then the outskirts of Los Angeles. There were still more fields than houses, and the barley rose three feet tall. At first, thinking we were renting, our German and English neighbors got up a petition against us. They didn't want dagos or wops living on the street. But they had no choice. I still have a copy of the deed; it restricts the house from being sold to anyone other than "white Caucasians." Although we qualified, the rule was still wrongheaded. My parents were hardworking, honest, and caring people forced into defending their rights and themselves. In the end they simply returned good for evil and just by being themselves won over the entire street. Twelve years later my brother and I were selected by the Torrance *Herald* as the "Favorite Sons of Torrance." After World War II, when my parents were planning to move, the same neighbors who'd originally wanted to keep us out got up a petition to keep them from moving away.

My mother ran the household. She was strict but fair. Every morning before school we had chores. You've never seen a house as clean as an Italian home. She also cooked fabulous meals—lasagne, gnocchi, risotto—and we had a great family life. For as long as I can remember there was laughter in our home and the doors were always open to friends. After dinner we'd walk around the block and chat, then come back and play music. My mother played the violin, my dad the guitar and the mandolin. My uncle Louis, my mother's brother, played every instrument there was. Dad would survey the gathering quietly and

break out with his gentle million-dollar smile. Everyone should have that kind of happiness.

When the Depression came my parents sacrificed all their comforts for the family. Dad made sure he paid our bills first and used whatever was left over for food and clothing. If we ran out of food, I'd shoot swamp ducks, mud hens, or wild rabbits for dinner. Or my mother would send us down to the beach at low tide to bring home abalone—the poor man's meal in those days. Even though we didn't have a lot of money, shopkeepers were extremely courteous because we were all in the same boat and everyone cooperated and helped one another. I don't want another Depression, but we need some way today to help us all pull together again. A positive way.

I NEVER CONSIDERED myself that different from my friends until I started grade school, where I began to feel painfully self-conscious. Everyone spoke English well but me. Now I can't speak Italian, but then I got held back a year because I couldn't understand the teacher. She called my parents and said, "You've got to start speaking English at home."

We did, but only when someone insisted on it. Dad still considered Italian easier because he mispronounced a lot of English words or mixed up their meanings. Like, "Take the sweep and broom the side-walk." We knew what he meant, and he knew we knew, so there was no giving him a hard time.

My mother spoke better, and eventually I caught up with my English lessons and forgot most of my Italian, except for a few swear words. But I still had enough of an accent for the kids to pick on me. Though I was born in America, I was made to feel like an outsider. Every recess I was surrounded by jeering, kicking, punching, and rock-throwing kids. The idea was to make me crazy so I'd curse in Italian. *"Brutta bestia!"* The longer it went on the more my resentment grew.

It didn't help that I thought I was a homely child with skinny legs, big ears, and a wild mass of black, wiry, hair. I could never get it to comb back and stay. I tried pomade, even olive oil. I'd wet down my

hair at night and stuff my head into a nylon or silk stocking with the foot cut off and the end tied. Because I spent so much time trying to get my hair to look like the other guys', anybody at school who touched it was in trouble. Sometimes I didn't wait to see who'd done it; I'd just turn and swing. Once I shoved a teacher. Another time I hit a girl with a glancing blow and the warning "You don't mess up my hair!"

As a result I got beaten up a lot, and I wanted to kill those responsible. I spoke to my dad, and he made me a set of lead weights, got me a punching bag, and taught me to box. After about six months I got even by beating the hell out of those who bullied me. Once I followed a kid who taunted me into the bathroom; after landing a few punches I stuffed paper towels down his throat and left. Fortunately, another kid found him in time. When the principal heard, he sent me home and my dad punished me.

The whole time I was busy getting revenge I desperately wanted to fit in. For instance, I remember a mound of dirt on the school grounds and a big guy who'd get up there and say, "I'm king of the mountain!" I wanted in on that game; I wanted to be king of the hill, but he'd shove me down. One day my mother made an apple pie and gave me some for lunch at school. I gave it to the big guy. Finally he let me up on the hill.

Otherwise, my wish went unanswered. The group never really accepted me, and I had to follow my own path. More and more that became getting into trouble, and the self-esteem I developed from my successes there was the kind that comes from feeling good about getting away with being bad.

The wrong kind.

Take smoking. I had started when I was about five years old. At first it was curiosity; I got a little bit in my lungs and felt dizzy. But soon, walking to school each morning, I'd keep my eyes open for passing cars. If someone tossed a cigarette out the window, I'd run up, grab it, and save the butt until I had some matches.

Eventually the local motorcycle cop caught me. Afterward, whenever he could, he'd be at my house before school to give me a ride so I wouldn't smoke.

When I was older, I'd wander in and out of stores and hotel lobbies with my head down, searching for butts. The long ones I saved for myself; the rest I dumped into a paper sack. Then I'd go to my favorite hiding place on Tree Row—a long, deep ditch by the railroad tracks, lined with eucalyptus—where I'd snip off the charred black ends, unravel the paper, and pour the loose tobacco into Prince Albert tins. This I sold to unsuspecting pipe smokers as "slightly used" tobacco for a nickel, half the retail price.

I tried chewing tobacco—in class. The teacher thought it was gum. "Louis, you spit that out immediately!" I swallowed instead and got sick as a dog.

Most Saturday nights my folks would bundle us kids into the backseat of their old car and drive to San Pedro, to shop at an Italian store. Then we'd visit relatives. I'd sniff the hard, black cigars left lying in the ashtrays and bide my time until I could empty a few wineglasses instead of drink the ginger ale set out for kids.

When I was in the third grade, the principal finally had enough. He put me over his knee and whacked me with the big strap that hung in his office. That afternoon, at home, my parents saw my purple, bruised behind when I changed clothes. "What happened to you, Toots!?" my mom asked, using her affectionate nickname.

"The principal beat me," I said, like he was a stinker.

"What for?" asked my father.

"He caught me smoking."

My dad very casually laid me over *his* knee, pulled down my pants, and spanked me on the same purple spot. I deserved it. I didn't cry, though. I never cried. I didn't stop smoking, either.

Soon, I had a reputation as "that tough little kid down the street." I may have tried to look like an angel, but other parents warned me to stay on my own block and away from their children. I guess I played too rough. I cursed freely. I destroyed property. I ordered kids around. I never used my head, never thought about consequences.

In school, girls were informers who often told on me for my mischief. I had no use for them. But when I *wanted* their attention, I couldn't get it. As revenge, I'd take whole cloves of garlic to the classroom and chew on them, then breathe in their direction just to offend

them. Some girls got so mad they struck or kicked me. In turn, I'd chase them and pull their hair.

I mostly hurt only myself. Once I fell and landed on a pipe. It punctured my thigh and took a big chunk out of my leg. Another time I jumped on a big piece of bamboo. It cracked and nearly cut off my toe, leaving it to dangle by a piece of skin. My mother held it in place while Mrs. Coburn, a nurse who lived next door, cleaned the wound and stitched it back on with a needle and thread. Then my mother taped it real tight, and miraculously it healed.

When I was still in elementary school I climbed an oil rig just for fun. The wood rungs nailed to the side often cracked in the sun. One came loose, and I fell twelve feet, landing on the corrugated pump-house roof, then bounced into a sump hole ten feet deep and filled with oil. You can't swim in oil. I sank like a rock until my feet touched a drilling pipe that had long ago disappeared into the black waste. I straddled it, then grabbed it. Fortunately, it was well rusted; my hands held, and I inched my way up until I broke the surface, heaving for air.

After I got out I walked home, covered in gunk. My eyes burned so much I could hardly see. People on my street didn't recognize me; maybe they thought I was the Creature from the Black Lagoon. Even my mother wasn't sure it was me. "Toots," she called. "Is that you?" My dad had just come home from work and had to clean me with a gallon of turpentine and a paintbrush. He started at the top of my head. Boy, that stuff stung. Then he put me in a tub of hot water. I thought my skin would parboil off.

My parents tried hard to change me, but in those days there was no widespread psychology for kids, particularly poor kids, so I was just off and running. All they could do was put up with me. By the time I turned twelve, I was out of control, full of ill will and clever ideas.

I still remember a few.

My friends and I would take long pieces of wire and shove toilet paper into pay-phone coin-return slots. Later we'd come back with a hooked wire and remove the paper—and have enough money backed up behind it to last a week.

Once, because a Red Car conductor wouldn't stop for us and we had to wait for the next train, we put thick axle grease on the tracks just where he had to brake for the station, then waited. Every morning three women took that train to work in Gardena. They stood on the platform as usual, and as the train neared the station the conductor applied the brakes—and kept on going. The women screamed bloody murder; they thought he'd ignored *them* on purpose, making them late for work. The conductor had no idea what happened. He finally stopped the train, got out, stepped on the track, slipped and fell. Now he knew. He had to collect dirt and sprinkle it on the grease. Then he backed up and let the women onboard and had to listen as they gave him a piece of their minds.

I knew who around town made their own beer and wine. These were small-time bootleggers—and neighbors—who did whatever they could to make a dollar during the Depression. They probably sold half of what they made and drank the other half. On Saturday nights, when everyone went to the movies, we'd break into their houses and steal the booze. Then we'd stash it in a cave we'd dug in the wilderness part of Tree Row. Our victims were helpless because even though we'd later walk around brazenly tipsy, they couldn't report us without risking their own hides.

After I got nabbed drinking beer at Hermosa Beach, I had a great idea to get around getting caught. I worked at the dairy, probably to pay for some trouble I'd caused. I took a milk bottle, poured in white paint, and rolled it around, coating the inside. I turned it upside down and set it on a newspaper overnight, then put it in the sun and let it dry for three days. When I filled it with wine or beer and went to the beach, the lifeguards thought I was a good, clean-cut kid drinking milk.

Another classic prank was ringing the church bell to wake up the town. I figured out how to get up in the tower, tied piano wire around the bell, and dropped the other end down the side of the building. I walked the wire across the street and climbed into a pepper tree. When the town rolled up the sidewalks—usually at nine-thirty, ten o'clock—and the streets were mostly dark, my buddy and I pulled the wire. *Ding-dong! Ding-dong!* I could see lights blink on all over, and

people rush out of their houses. One woman stood under the pepper tree and said, "Oh, *Mama mia,* it's a miracle!" The only miracle is that she didn't see me above her.

By the time the fire truck and police arrived, I had disappeared.

My favorite caper was stealing pies from Meinzner's Pie Shop after a guy who worked there humiliated me by slamming the screen door in my face when my friends and I asked if there were any broken pies he would give away, like the restaurants regularly did with leftover cobblers on Saturday nights. A few weeks later another gang copied our crime, got caught, and bragged they'd been responsible for *all* the thefts. I wanted the police to know the real culprits were still at large, so my gang took more pies. The next day the headline in the Torrance paper read: MEINZNER'S ROBBED AGAIN.

Some incidents I'm still ashamed of:

I worked on a dairy farm when I was eight. A bull became enraged and charged me, and I had to dive through the fence to safety, scraping and bruising myself in the process. Later I used my Daisy BB gun to pepper the bull's long, hanging scrotum. Let's just say he was furious.

When a dog on my paper route bit me I used my BB gun once more, and the dog never bothered me again.

I was famous for shooting spit wads at girls but invariably ended up in a classroom corner facing the wall for my trouble. However, when a teacher put me there for a wad I hadn't spit, I let the air out of her car tires after school.

Roger, a classmate with whom I had a disagreement, punched me in the back. I lay in wait for him after school and pummeled him bloody. Later, he and his father came to our house and accused me of breaking poor Roger's nose. The dad was so pushy and insistent that my uncle Bert threw him off the porch and broke *his* nose.

MY TRANSFORMATION INTO a rebel with a chip on his shoulder was soon complete. But even though we were poor and I'd had it tough in some ways, I couldn't claim "I never had a chance." No one had beaten me into sullen defiance or ignored me entirely. My father

didn't use his paycheck for liquor instead of food. My mother wasn't a shrew or a slattern or an ineffectual drudge. I had no dissolute background; I just acted like I wanted to even though I loved my family, even though when my dad beat me I knew I deserved it and respected him for disciplining me. I was just a social misfit, the proverbial square peg who couldn't fit into the round hole like the rest, or appreciate what he had. Over the years I've seen it happen to other kids; they're raised immaculately, and then at a certain age, boom, here comes trouble.

I USED TO go to the Catholic church, often barefooted. The church was about eight blocks from home, and one time I came in late because I'd been goofing off on the way. The place was jammed. I found an end seat and sat down. To my surprise, the priest stopped, walked off the altar and right to me, grabbed me by the ear, and twisted it. He said, "You go home and get a note from your mother about why you're late." I got so mad, I wanted to strike him. Instead, I stalked out in a huff.

At home I told my mother, "I'm never going back. I'd rather die." Afterward, I always avoided the priest. It was a small town. When I'd see him coming down the street, I'd go down another street. I didn't want him to bawl me out again, to domineer me. Instead I went to the Baptist church with a buddy. My mother and dad thought that as long as it was a church, it was good, so they'd give me a dime. I was supposed to put it in the offering plate, but I'd keep it and ride the roller coaster at the Redondo Beach pier.

My parents didn't go to church. They weren't really devoted. Plus, we were too strapped to give anything when the priest came to the door, so they'd just act like no one was home until he gave up and left.

EVENTUALLY I GOT mixed up with older troublemakers, and that pushed me over the edge. They knew my reputation and wanted to get me involved in all sorts of mischief. I let them lead me by the nose until I was well groomed in the art of disorder and started my own gang. John, Billy, myself, and even a girl were social castoffs with one desire:

to get even with anyone who looked at us cross-eyed. And if it involved protecting my family, my thirst for revenge was all the more keen.

We were an unruly bunch, but everyone agreed on one point: they took their orders from me. My nickname was "the Brain." I came up with the ideas. Stealing was our sport; nothing else was as exciting. I loved outwitting others, destroying property, and the thrill of being chased—as long as we escaped. We swiped everything from chocolate bars to auto parts, and when we ran out of trouble to cause we roamed town egging other gangs into BB-gun wars or brawls. If we got caught, indignation consumed us until we could gather our wits and avenge ourselves.

Because I trained constantly with my weights and punching bag, I no longer hesitated to defend myself in a fight, much less to attack. I never hit a man when he was down, but I had no problem bludgeoning someone who stood up to me.

I didn't care how long it took, I'd wait until I could get my revenge for wrongs real or imagined. For weeks I lay in wait for a boy from the neighboring town of Lomita. I'd stolen some pies from his bakery truck, and he'd squealed to the police, who made me pay for the goods. Every day I boiled over with resentment and visions of retribution. One night I spotted him walking out of the Torrance theater with a friend. I followed them to a dark street and challenged him.

Both were older and heavier, but when they laughed at me I went wild. I knocked down the friend, who ran off, and then I went for the stoolie. I punched and pummeled him and didn't stop until he rolled limp into a ditch. I left him there.

Back home, I went to my room, peeled off my clothes, and slid into bed, trembling. I must have had a nightmare because I woke up with a start, paralyzed with fright. My blanket was on the floor and the room was bright with light. For some reason, my mother stood there, sobbing.

"You're hurt. You're hurt."

I held up my hands. They were smeared with blood. My sheet and my clothes, too. For a second my heart almost stopped, then I realized it wasn't my blood. "It's okay, Mom," I said. "I just got into a fight." My mother went back to bed, and I washed up. Yet all night I shook,

wondering how badly I'd beaten the bakery-truck boy. When I fought I never thought about anyone actually dying.

The next morning I forced myself to return to the scene. My victim was gone. For two days I worried. Then I saw him driving the truck, his face swollen and wrapped in bandages. I wanted to whoop and holler—not because he was alive, of course, but because I had really fixed him.

WITH EACH DAY I grew more erratic—touchy, irritable, defiant one moment, happy-go-lucky the next. One night at dinner, my parents, long mystified by my behavior, finally said, "Why can't you be a good boy like your brother?"

I felt like I'd been stabbed in the heart. But my response was sullen instead of emotional: "You love Pete more than you love me." My parents were shocked speechless for a moment, then choking back tears, my mother said, "Louie, let me tell you this: if the Lord asked me to give up one of my children, He'd have to take whichever one He wanted. I couldn't say take this one or that one. I wouldn't."

"Well," I grumbled, "how come you always pick on *me?*"

"How can I help it?" she shot back. "*You're* the one who, if I say, 'Empty the garbage,' says 'Just a minute' and then disappears!" I knew she could have rattled off plenty of other examples, but instead she jumped up from the table and ran to the bedroom crying. It killed me to see my mother hurt, but all I did was scowl, shove back my chair, and leave in disgust.

I wasn't jealous of Pete. It wasn't his fault that I thought my mother liked him better. I respected him. He was my hero. When he'd go somewhere with a buddy and he wouldn't let me come along, I'd follow anyway. Sometimes he'd have to insist I go back, and I'd resent it, but I wasn't mad. When you're a kid, a brother two years younger seems like ten years younger. Otherwise, we were close and eventually inseparable. We shared the same room. We played games together. We slept outside on the grass a lot, especially on hot nights.

I even stuck my fists into situations when other kids gave him a hard time. When I was thirteen, a local bully who was about a foot taller

than Pete had him cornered about half a block from our house. He threatened and shoved him, trying to get Pete to fight. Pete refused. On my way home from school I heard the commotion, and when I saw Pete get shoved I just walked right up and punched the bully right in the teeth, then ran like hell. He chased me all the way home, but I made it into the house.

But none of that mattered now. I hated being compared with Pete. As a result I withdrew even more. I kept to myself at home and moved my bedding into the backyard. If anyone came to the front door, I retreated to the garage until the visitor left. I even refused to eat with the family. To my mind, I lived alone, and although I was often miserable, I liked it that way.

WHAT I *DIDN'T* like was getting caught and risking being sent to Juvenile Hall, way up in Los Angeles. One day, after I was nabbed for some prank, Chief Collier of the Torrance Police took me to the local jail to meet the inmates. He idled purposefully in front of two guys sharing a cell, then asked me, "Where do you go on Saturdays?"

"I go to the beach," I said.

"When you're in *there*," he countered, shrugging toward the cell, "you *can't* go to the beach." Then he said, "Louie, if we didn't respect your folks so much, you'd be in reform school right now. But we're warning you: this is where you'll end up if you don't wise up."

I knew he wanted to scare me, and it sank in. I cherished my freedom. I suddenly realized I'd just have to be that much smarter and not get caught again. To further demonstrate my scorn for authority, a few days later I stepped out from behind a tree and tossed a handful of rotten tomatoes in a policeman's face, only to disappear by the time his vision cleared. That became my style: hit and run, leaving victims to spot me only by my rapidly receding shadow.

MY DAD ALWAYS had work he needed me to do, and I always wanted to disappear when he did. One day with my buddy Johnny— a blond, square-headed fellow—I hopped a freight train and ended up

in San Diego. We slept in a wash under a bridge. In the morning I saw a steer wandering in the ankle-deep water. You know how kids are; we thought we'd have our own rodeo. Johnny jumped on and got dumped off. I jumped on and the steer bucked and ran, then tossed me onto a tree stump. When a tree doesn't get cut clear across, it leaves a fringe; that fringe nearly cut off my kneecap. I wrapped two handkerchiefs around it tight, to hold it all together.

We tried to hitchhike home, but nobody would stop. Fortunately, we were right near a gas station, so Johnny cornered a guy and said, "I've got a real problem. My buddy's kneecap is cut bad. He lives in Torrance and we're trying to get home." The guy took us to Long Beach. I called home from there, and my dad picked us up. My mother—ever forgiving—and our neighbor the nurse put hydrogen peroxide, iodine, and oils of salt on my wound and bandaged me.

But as soon as I healed, I took off again. On one trip Johnny and I slept in a boxcar going north. Two hoboes slept at the other end. Just before daylight they tried to roll us. Because the wheels clicked so loudly on the tracks, I didn't notice the bums until they literally had their hands on our wallets. I jumped up and hollered: "John!" He scrambled up and we lit into them. They were older and went all out, but we knew how to fight and beat them badly. Then we tossed them off the train, going maybe thirty miles an hour. I'm sure they had bruises to remember, but I couldn't have cared less.

Another time Johnny and I hopped a train heading south and crouched between two cars. When night came we watched a tramp lie down in a boxcar, his arm dangling over the rails. I did the same, but as I maneuvered into position, the train lurched sharply around a bend. I managed to cling to the brake arm; the snoring bum had no warning. The motion dislodged him, and I watched him drop to the tracks, where the wheels cut him in two. I got no sleep that night.

MY BROTHER, PETE, was our high school track team's star miler, and he always tried to interest me in running. My attitude was that school activities were for children. I only showed up for basketball games because I'd discovered—I couldn't believe it!—that our

Gramercy Street house key fit the gym-door lock. Instead of paying the small fee to see a game, my gang and I got in for free until someone snitched and changed the locks.

That pretty much did it for my troublemaking. The principal, my parents, and the chief of police had had their fill. According to the school disciplinary system, each student started the year with a hundred merits. If he lost twenty, they called him into the office. I'd lost them all and was probably in the hole another fifteen. My punishment: the deficit would carry over to ninth grade, making me ineligible for sports or any other school activity I wanted to pursue. When they told me I almost laughed in their faces. What did I care?

My only serious concern was that I didn't want to be labeled a mental case. It's hard to believe, especially now, but in those days kids with mental problems could be sterilized because people thought the problem was hereditary. Fortunately, everyone knew I was just a pain in the butt, not crazy.

What I didn't know was that my brother, who'd grown tired of the police coming to our house and was always worried about my direction in life, had come up with a plan to get me out of trouble. He and my mother met with the principal, asking him to reconsider the demerits. "We're trying to get Louie interested in sports," he said. "It might keep him off the street, give him something to do."

"That's true," said the principal.

"But," said Pete, "if I got him to run, and the demerits made him ineligible . . ."

The principal frowned, but Pete pressed his advantage. "If he gets a break, if he gets a chance to find that he has some other way to draw attention and get recognition, it might help."

The principal relented, and in February 1932, when I was fifteen— because I was a January baby I was in the smaller class that the California school system started each winter, so kids born midyear didn't fall behind an entire year—I entered the ninth grade with a clean slate.

Of course, I had no intention of running unless someone forced me to.

.    .    .

A FEW WEEKS into the semester the school held an interclass track meet. My class wanted to compete. I was one of four boys in a roomful of girls. The other boys were either fat or sickly. That left me. The girls talked fast and overrode my objections. On Friday, feeling green and foolish and just to get the girls off my back, I showed up for the meet, half ready to run.

I hid behind the bleachers until my event, the 660-yard race, was announced. Then I lined up with the others and waited. When the gun sounded, I took off, barefoot, arms flapping.

On the sidelines the head coach exploded with laughter. When he caught his breath he told Bob Lewellen, the local printer and Boy Scout leader as well as part-time assistant coach, who stood beside him, "That kid will *never* make a runner, that's for sure." He turned to Pete and asked, "Who is that?"

"That's my kid brother."

"Well," said Lewellen, "he may not have any qualifications—no chest, no legs, no form—but he's got guts, and that's what counts. Has he signed up for track?"

"No," said Pete. "They had to beg him to show up today. I bet wild horses couldn't make him run again. But it would be swell if he would."

I came in last. The pain was almost intolerable, and I don't mean mental pain. I'd rather have had someone cut me with a knife than bear the misery I felt from being out of shape because of drinking, smoking, and dissipating myself. I stumbled off the track, hid behind the bleachers, and thought, Never again. Never.

A week later our team met rival Narbonne High for the season's first interscholastic track meet. My brother said, "This is a big meet for us. Torrance against Narbonne. You've got to run."

"I'd rather be dead," I told Pete.

"You've *got* to," he insisted.

We argued, but in a way Pete was right. Torrance didn't have anyone to run the 660. Narbonne had three boys. I signed up, lined up,

and took off. A hundred yards from the tape, two Narbonne runners led. Their third guy was back a ways, and I lagged behind *him*. I didn't care whether I beat him or not; I was just doing my brother a favor. Then I heard the kids from my school hollering, "Come on, Louie!"

I hadn't realized anybody at Torrance other than my buddies and the principal knew my name. Suddenly I felt a surge of adrenaline and beat Narbonne's last guy by about a foot.

That night Pete said, "You could be a runner." He knew I had drive, and the beginnings of a final kick.

"Yeah, but the pain," I whined.

"That will go away when you train. You'll get in shape."

"I don't know. . . ."

Pete locked his eyes on mine. "Do you want to be a bum all your life? Or do you want to amount to something? You can become a runner."

I knew in my heart that I was already a bum. A teenaged bum. I pictured myself standing in a soup line. I thought of what I'd seen on a sidewalk by the Columbia Steel mill in Torrance: the cleanup guys on a real hot day hauling heavy steel, sweating, dirty, filthy. I thought, Boy, I hope I never end up like that. But the truth hit me: I figured the best job I could get would be the worst job over there.

That night I had to make a decision: Give up suffering on the track and continue with my delinquent life, or decide that, if nothing else, the recognition from running—forget winning—might be worth it. I had to admit that even the small bit of attention I got by coming in third tasted pretty sweet.

I continued to smoke and drink but reluctantly stuck with running. Pete made me train after school. Much to my disgust he ran behind me with a switch and whacked my butt to keep me moving. I protested but it worked. My running improved. In subsequent races I came in second, third again, and finally won. I couldn't believe it! Then I won another and another and made the all-city finals. I came in fifth but was number one in my school. I got a little bronze button to pin on my sweater. I felt like the button was made of gold.

.    .    .

WHEN SCHOOL LET out, my parents wanted me to do work around the house, and it just bugged me no end. I got itchy feet again.

Johnny and I jumped a freight train for Northern California. I still remember the balmy summer night, lying on top of a catwalk, looking up at the stars while we rolled through the San Joaquin Valley.

We didn't have more than a few dollars, so we stole food from orchards. By the time we got to San Francisco we were hungry and miserable, and the weather had turned bad. Summer rain can be cold up north. I snatched a can of beans from a nearby hobo camp and ran for it. We ate them cold, our bodies drenched.

During "dinner" I spotted a passenger train pulling out, heading south. I could see the people inside, warm and cheerful. When the dining car rolled slowly by I noticed everyone dressed for the meal, sitting at tables covered with white cloths. They drank from crystal glasses, ate from covered platters, and looked so satisfied. I'd never *been* in a dining car, let alone on a passenger train. I turned to Johnny and said, "Boy, are we dopes."

He tapped at the bottom of the can to get the last few beans.

"Look at those people, riding in style," I said. "That's the life. Someday I'm going to be in one of those cars. Someday I'm going to have the works."

Johnny said he wished he had more beans.

I shut up then because I didn't want Johnny to think I'd gone soft. But inside I knew: whatever it took, I would improve myself. I wanted to never again be cold, hungry, dirty, and on the outside looking in.

"Let's go home," I said.

WE FINALLY FOUND a southbound train, climbed into an open boxcar, and hid in the corner from the railroad dicks. One came by, did a quick inspection, but didn't see us. He slammed, locked, and sealed the door.

We woke up the next morning to find the interior hotter than blazes. And we weren't moving. I tried the door, but it was still locked. I noticed a trapdoor in the ceiling, but I had no idea how to get

it open until I spotted a broken steel-ladder rung, the kind that goes up the side of a boxcar, in the corner. Johnny held me on his shoulders while I worked at prying the trapdoor open with the edge of the rung. It took hours, and even then it wasn't cracked all the way. I had to force my head out, which cut my big ears and scraped my chest. But I made it, dropped over the side, and opened the door to let Johnny out.

Turned out we were sidetracked near Tulare and had to walk two miles to the little town just to get some water. We also found a small restaurant. In those days you could get a T-bone steak for about thirty-five cents. We pooled our resources and dug in, then walked back to the freight yard and hopped another southbound train.

Too late, we realized a railroad dick was aboard. We found a load of corrugated culverts, about twenty inches wide and thirty feet long, stacked up pyramid-style, and squeezed inside the uppermost one. I lay silent and still, listening as the guy poked around. I thought we were high enough that he wouldn't bother to look, but he was thorough. He ran the butt of his .38 revolver along the corrugated metal, and the sound inside the pipe was deafening. Then he stuck his gun in our faces and demanded we immediately leap from the train. Even though we were moving about thirty miles an hour, we jumped without hesitation and rolled into a landing.

After hiking along the track for about three miles, we came to a small switching yard. I saw a flatbed with mining cars stacked on it three high. Three hoboes reclined in the lower car. What morons, I thought; they could easily be detected. Johnny and I climbed into the top car. An hour later we both had to take a leak, and we let it go on the perforated metal floor. Almost immediately we heard yelling and cussing from below.

The dampened hoboes were still grumbling when we entered a tunnel. The ceiling was only about two feet above our heads. We ducked low and were suddenly engulfed by a huge cloud of steam that washed back from the engine. Johnny and I pulled our jackets over our heads to protect ourselves from the scalding heat. Now I knew why the hoboes stayed in the lower "accommodation." Afterward Johnny and I looked each other over and agreed that we'd been done medium

rare. Before we could move out, the train entered another tunnel. After another steam bath we scrambled down to the second car.

At the Los Angeles freight yard we hiked to the Pacific Electric depot and hopped a Big Red Car to Torrance. By then Johnny, too, had come to the conclusion that running away from home and responsibility was pretty dumb. The world, we'd discovered, doesn't love you like your family loves you.

My parents welcomed me home with open arms and big smiles— more than I deserved—and I didn't complain. I let my dad know I was ready to do any kind of work he wanted me to do. I started by painting the house.

That night in bed I turned to Pete and told him, "You win. I'm going all out to be a runner."

It was the first wise decision of my life.

# 2

## THE TORRANCE TORNADO

THAT SUMMER I cut out my bad habits and trained fanatically. Instead of hitchhiking to the beach, I ran the four miles from Torrance to Redondo. Then I ran two miles along the beach and four miles back to Torrance. I even ran to the store for my mother. On weekends I'd head for the mountains and run around lakes, chase deer, jump over rattlesnakes and fallen trees and streams. I've always been a loner, so the solitude never bothered me. I just ran like crazy. I felt really free and piled up mile upon mile.

When school started I knew I was in good shape, but I had no idea how good, or how fast I could run in competition. In September I entered a two-mile cross-country race at UCLA with over a hundred runners from all over the state. As a sophomore, I was in class C, the youngest runners. I hoped I wouldn't come in last, but during the race I felt like my feet never touched the ground. I won by a quarter mile and broke the course records for all *three* classes: A, B, and C. My time was 9:57, equivalent to collegiate standards.

Afterward I asked the officials if maybe I'd unintentionally cut some corners, but they assured me that I'd completed the full course. Though few people today remember, that is still the most thrilling

race I've ever run, and I realized my promise to Pete—and to myself—could actually come true.

I could be a runner. A real runner.

I APPLIED MYSELF with similar diligence at school. Serious studying was a new experience for me, and my progress was shaky. At times, faced with a difficult arithmetic problem or English composition, I longed to slam my books shut and head for the hills to run it off. But I held on, if only because I had to make good grades to stay on the track team. I didn't want to cause any problem that might get in the way of the recognition that running and winning had brought.

Most days I felt as if I'd transferred to a new school. Classmates nodded when they passed in the halls, or stopped to talk. At times I even thought I caught a whiff of respect: Louis Zamperini, the wop hoodlum from nowhere, had made a success of himself.

While I clung furiously to my change of heart, my character remained pretty much the same. I still kept mostly to myself. I still had a temper. I still wanted to do almost everything my way. But I had begun to accept the physical pain of training; Pete kept pushing but no longer needed to encourage me with the switch. He was a strict coach and lectured me when he thought I needed it.

"You've got to develop self-discipline, Toots," he would say. "I can't always be around. You need to take care of yourself on weekends."

I'd rather have had an ice cream sundae, but I did what he told me. I didn't want to let Pete down. I also knew, however much I struggled against it, that running was the right course to follow.

To stay on the straight and narrow I made a secret pact with myself to train every day for a year, no matter what the weather. If I missed working out at school, or the track was muddy, I'd put on my running shoes at night and trot around my block five or six times, about a mile and a half. That winter we had two sandstorms and I had to tie a wet handkerchief across my face and mouth just to go out. I also kept box-

ing, to develop my chest muscles. In the end I was probably even more disciplined than Pete wanted me to be.

By February 1933, I was ready. The Torrance High track uniforms were wool, weighed too much, and itched terribly. I told my mother I wanted to run as if I had no clothes on. She bought me a silk shirt and made my shorts from an old pleated black satin dress. Inside, she sewed what she claimed was a teeny piece of felt from the cloth of the cloak of Saint Teresa. They probably made millions of those, but I didn't object. I wore leather shoes by Riddell. They had a steel plate inside, for screwing in cleats, and each was as heavy as three of today's running shoes.

As a sophomore, I entered the class B 1,320-yard competition, three quarters of a mile. My spindly legs still embarrassed me, so I warmed up behind the bleachers where the crowd couldn't spot me. But once the race started, I forgot my worries and ran as hard as I could. I kept winning.

I really wanted to run the mile and set my sights on the class A race. I won in 4:58, breaking the school record held by my brother. He was probably more excited about my win than I was. Later that spring, at my first race in the Los Angeles Coliseum, I broke the state record for the class B 1,320, with a time of 3:17. It was an easy race; I wasn't pushed. Afterward the Torrance paper boasted about me, and it felt very different from my other exploits that, although anonymous, had once made the local headlines.

Pete continued to coach me and even got permission to run alongside me in races when no competition existed, forcing me to extend myself. He was wise. When I complained about the pain and exhaustion of the final lap in a mile race—which took about a minute—Pete gave me some advice that's stuck with me to this day: "Isn't one minute of pain worth a lifetime of glory?"

Pete knew. He was the seventh-best college miler in the country and could have done even better. There is no doubt his dedication to me cost him personally. I knew that with Pete's help I had a good chance to become a world-class athlete.

I researched how other runners trained, and I doubled their efforts. When I started to beat them, I knew the simple secret: hard work.

I had only one problem. I didn't want anyone in my family to watch

me run except Pete. That may seem strange, I know, but I was still making the transition from juvenile delinquency to decent behavior. I wanted to wait until I had my foot firmly in the door before I let my parents, their hearts already all aglow, come to the meets. I was embarrassed by what I'd put them through and if there was even the slightest chance of failure, I didn't want to have it happen right before their eyes. At the mere suggestion that my parents might come to a meet, I'd freeze and warn them to stay away. One afternoon, my mother came anyway. I didn't notice until I'd already run two laps. I stopped dead in my tracks, trotted to the fence, and told her to leave.

"Hurry," she said. "They'll catch up."

I wouldn't budge until she relented. Then I won the race.

The more I ran, the better I got. I entered half-miles, 1,320s, and miles. My name began to crop up in local sportswriters' columns. They called me "Leather Lung" and "Iron Man." I relished the attention and my first encounters with fame. I became well known on campus. Party invitations rolled in; dates were available for school dances. Even so, I couldn't resolve an inner conflict: because I'd always been such a rotten kid, I felt I didn't deserve any of it. I got caught between wanting and needing the attention—not the fame, but for doing something besides getting in trouble—and hating the attention.

NOW THAT GIRLS knew my name and admired my exploits they'd always say hello at school. The one girl I thought was really nice also talked to me, so I took typing class with her even though I wasn't too keen on typing. When she took tennis, so did I. Soon we began dating.

One day a new girl, Rita, came to school. I'd never run into anyone like her. Rumors about her reputation flew. "She's a hot pepper." "She's a firecracker."

Rita acted very interested in me, always smiling and saying hi. I ignored her, certain she fooled around with everybody. Frankly, she really scared me. I'd kissed girls before, but only normal girls: sweet, unintrusive, reserved. I wanted to make the advances to someone I liked, to declare my interest. To me, Rita was too hot to handle.

And she couldn't take a hint. At a school dance she forced me onto

the floor with her by threatening to embarrass me in front of everyone. Then she wanted us to go outside and get a drink of water. Reluctantly, I walked with her to the fountain, where she threw herself at me. I was too stunned to move. I'd never had a French kiss before. I couldn't believe it! And frankly, it was repulsive. Then she pushed her body hard into mine. That did it. I made her stop and ushered her back inside.

I should have learned my lesson, but I didn't. A few weeks later, to make my girlfriend jealous, I asked Rita on a date. In the middle of the dance we went to her car, where she tried to have sex with me. I pushed her away and got out.

Not only couldn't I handle her unbridled aggressiveness, but I was in training. The coach had already warned us to use restraint during the track season. "You've got to be pure and give your all to your sport," he explained. He wasn't moralizing about abstinence as much as worrying that the emotional involvement that's supposed to go hand in hand with the sex would make a mess of us and our training. He believed entanglements could quickly ruin any athlete.

He was right. When my first steady and I broke up for three weeks, I felt miserable and couldn't perform well on the track. Training is tough enough, but when someone you love is mad at you, it's almost impossible.

MY NEW STATURE brought more than dates and recognition; I was elected junior-class president. I'd run but never believed I could win. I didn't tell my parents about the election, though, preferring to have them find out by accident. A week later, when they questioned me proudly, I replied with an elaborately casual shrug. I'm pretty much the same today. Sure, I get excited inside, but I don't want people to think my ego's all swelled up. I just accept life. Maybe that's why, years later, a friend of mine said, "Fame has never bothered Louie. He's nothing if not down-to-earth."

To be perfectly honest, one reason I did my best not to brag is that as a mischief-making kid I had trained myself never to crow about my exploits. Almost every victory was a secret. I guess I've just stayed that way.

.    .    .

MILE RACES BECAME easier and easier. As a high school junior I ran 4:28 and 4:29 without being pushed. Because Torrance High's oval was sandy, my times would have been better on a professional track. I needed a real test, and soon enough I got it.

On May 19, 1934, the best milers in Southern California assembled at the Los Angeles Coliseum for a big meet. Among the runners was Virgil Hooper. He held the state record of 4:49.2 and had already run a 4:24. They expected him to win, with close competition from Bob Jordan, of Whittier High, and two Indians from the Sherman Institute: Elmo Lomachutzkeoma and Abbot Lewis. They'd all run 4:30 or better.

For days Pete and I talked only about the race. We visualized it over and over again, trying to dope out the action in advance. Pete was by then student-body president at Compton College and had broken the state college mile record in his first meet against UCLA, thereby almost assuring himself a scholarship to the University of Southern California. We both worried about Hooper and strategized about when I should start my final kick for the finish line.

The morning of the meet I felt awful. My head ached, my stomach churned. I wasn't really sick, just nervous, like usual. Whenever Pete tried to reassure me—"Aw, Toots, it'll be a cinch"—I'd snap back, "No race is a cinch." He didn't like it, but he had to agree.

Before a race I always liked to be alone, but that morning I was too anxious to go off by myself and focus. Instead, I made excuses for my imminent failure, saying I was from a "little ol' town" and here were these big competitors—high school seniors, whereas I was just a junior—running in the Coliseum.

Pete finally had enough of my complaining.

"What's the matter?" he teased. "You scared?"

I blew up. "I'm not scared. I just don't feel good. You don't understand."

"You're just chicken."

I wanted to throw the kitchen table at him. Instead, I turned to my mother and said, "I'll go out there and run. And if I drop dead, my legs will still keep running."

I caught Pete grinning.

But at the Coliseum I balked again. So many runners had entered that we had to start in two lines, the second about three yards behind the first. I drew the third lane of the second row, a handicap of maybe two seconds and a few extra yards. That made me mad. What chance would I have against Hooper now?

The heck with it, I decided, and walked off the track.

Pete rushed over. "What's the matter?"

"I'm not running. Look where they put—"

Pete let me have it before I could finish. "Now I *know* you're chicken. I was kidding before, but now you're proving it."

"I am not."

"Then get back on the track."

I stood my ground. Then a coach came over and said, "You can make that up. Easily." I spun around and got back in line.

The gun sounded and I took off. I had a plan: to run the first three laps in 3:17, the same time as my 1,320 state record, and then take off. But because I'd started in the second row, right away I got caught in the pack and couldn't break through. Runners crowded in front and stretched out to the sides. All I could do was stick to my pace and look for an opening.

Meanwhile, Elmo and Abbot, the two Indian boys, blistered the track with an amazing 58-second first lap and a 2:01 half mile. I had moved up, but I didn't try to catch them. I just ran my race. If they were that good, I figured, then they deserved to win, but as they rounded the first turn of the third lap both boys wilted and I passed them.

My brother had called out my time at the quarter mile and the half mile. When I heard him yell, "Three-seventeen!" after the third lap, I moved out and passed everyone. Hooper had a boil on his neck, which hampered his style, and had dropped out. I was all alone—or so I thought. With two hundred yards to go I felt someone touch my heel. Gaylord Mercer, a dark horse from Glendale High, had closed the gap. His lead leg hit my trailing leg and startled me so much that I shot out like a rabbit and made for the finish line, beating him by about twenty yards. They timed my last lap at 64 seconds.

Pete couldn't find the words as he pinned the medal on my shirt. Apparently I had broken what they then called the World's Interscholastic Mile record that had stood for eighteen years. My time of 4:21.2 would stand for another twenty. Even more amazing, the radio announcer who interviewed me one minute after the finish was stunned to see me breathing gently through my nose.

TWO WEEKS LATER I lined up again in the Coliseum, this time against college men, in the 1,500-meter, which is 119 yards short of a mile. The favorite was the Pacific Coast collegiate champion from USC. The winner would receive a gold wristwatch donated by movie star Adolphe Menjou.

At the starting line I heard other racers mutter sarcastically, "Hey, kid, you're in the big leagues now; just keep out of our way," and "Now you'll find out what real competition is." I kept my mouth shut and won the race, beating the Pacific Coast champion by twenty yards. My time was 4:00 flat, the equivalent of a 4:15 mile. And I didn't even feel like I'd pushed myself.

I knew I was good, but I didn't realize how good until I beat the college runners. Yet when I left the stadium with Pete, I felt down. The parents and friends of boys who had placed no better than third consoled and encouraged them. The backslapping and hugging only made me, the winner, feel lonely.

From then on I made sure I invited my parents to every meet. To have them with me made me proud. Winning, I had realized, wasn't much fun unless I shared it with others.

MY SENIOR YEAR I got elected student-body president and took it easier running, working on my style rather than trying to break records. Pete continued to coach me, and after I graduated in January 1936 I told him my heart was set on making the Olympic team in the 1,500-meter. It wouldn't be a piece of cake. We both knew there were five great milers in the country, all college graduates, one being Glenn Cunningham, my hero. I'd read about how his legs were badly

burned as a child. (One day I'd see the scars for myself, in the showers.) That he ran at all inspired me and made me realize I also had a chance to be a champion.

But Pete said I'd probably have to be patient. "You'll just have to wait for the 1940 Tokyo games. You'll be in your prime by then."

He was right. Cunningham had already run an indoor mile at 4:06:04 and had outdoor times of 4:09 and 4:10. I was still, on average, 8 seconds behind. Eight seconds might not seem like much in most situations, but in a race it's a lot longer than anyone realizes—about seventy-five yards.

A week later Pete called to tell me that one of the country's premiere distance runners, Norman Bright, would compete in the Compton Invitational in two weeks. His race was the 5,000 meter, which is just over three miles. "I'm going to enter you," he said, "just to see how close you can come to Bright, who will most certainly make the Olympic team. But switching from fifteen hundred to five thousand meters is a big step, and you have only twelve days to condition yourself to that distance."

To build up my strength and endurance, I ran five miles a day and had a fresh miler pace me for each mile. I pushed so hard that I wore out the tip of my toe and blood saturated my socks and shoes. Then I tapered down to shorter distances and finally speed work.

I had no idea what I could do against Bright. Pete had already watched him at a meet in San Diego and realized he ran to conserve energy, saving his strength for a final kick. Pete said he'd let me know when the last lap came so I could move out the entire quarter and, he hoped, take the sprint out of Bright.

During the race Pete miscounted and signaled me with *two laps* to go. I sped up, as did Bright. We passed each other five or six times in the stretches, and I found it hard to believe I could keep up. Eventually Bright lost his steam and I pulled away for the final two hundred yards. I could see him over my shoulder. The crowd was going crazy.

Then the officials made a big mistake. Instead of telling a runner we'd lapped to get off the track to the left (the inside), they motioned him to the right as I tried to pass him on the right. Maybe I should have cut to the left, but my momentum was already established and I was

forced out to the eighth lane, where we collided by the grandstand. I hitch-stepped, went down with one hand on the ground. By then Bright was well ahead of me. I recovered and ran at an angle for the inside lane. The officials got so excited that they goofed again, dropping the tape, then picked it up quickly as I caught Bright at the finish line. It looked like a dead heat, but he won by an inch or two.

I had lost my first race in three and a half years.

When I was a winner my friends would slap my back, my girlfriend would hug me, my parents would cheer, I'd be on the radio. Then I'd look at the other guys, friends and family patting them on the back in a different way. That always made me feel bad, especially because I knew someday it would be me. I promised myself to be upbeat when the time came, and now it had. Would I gripe? Be ashamed? Be resentful? No. I put my arm around Bright and congratulated him honestly. "That was a brilliant race, and you deserved to win," I said, smiling. When I walked away I had more self-esteem than I'd gotten from all my winning. I knew I could always handle defeat gracefully.

ON THE STRENGTH of my performance I got invited to the Olympic tryouts at Randalls Island, New York. Torrance raised some spending money for me and the city merchants gave me a suitcase with TORRANCE TORNADO stenciled on the side. (I covered it with masking tape because I didn't want the other athletes to give me a hard time.) They also contributed shaving gear, clothing. Since my dad worked for the railway, I got a year's pass good for one round trip anywhere in America on the Southern Pacific.

Still, the thought of going to New York worried me. I kept saying, "Pete, it's not fair that you can't go with me. I might get lost."

"It's time you went out on your own anyway," he said.

We left after dark. At dinner I sat in the dining car, eating off of fine china on a white tablecloth, and I remembered myself a few years earlier in the San Francisco train yard, freezing cold and miserable, looking through the windows of a departing train at the happy people, dreaming it was me.

Now my dream had come true.

.  .  .

I ARRIVED IN New York during the city's hottest week in many years. We stayed in Manhattan, in prerented rooms. The whole adventure excited me, except for the reaction of the local papers. I'd grown used to seeing my name in print back home, and I was annoyed that the East Coast press had never heard of me. I wrote a letter to Pete that read: "In the papers here they've have picked the place winners for Sunday's 5000 meter. (1) Lash, (2) Bright, (3) Lochner, (4) Ottey, (5) Deckard. They don't even know I'm running. But if I can cope with the heat, I'll beat Bright and give Lash the scare of his life—and then I'll make the print." I signed it, "Brother headed for Berlin."

I TOOK A boat to Randalls Island, warmed up, and then lay in the shade—not that it mattered, it was hot there, too. Ten minutes before the event, I stretched, loosened up, and mentally reviewed my plan. I didn't think I could beat Lash—he was the world-record holder in the two-mile—but I just had to get second or third place to make the Olympic team.

When the race started I did just what Pete had taught me: slip in behind the leaders as close as I could, stay on their inside, and relax. Being out in front can make a runner tense. You're alone and can't see anybody. I liked to run just behind the leader and look at his feet. If he ran a foot from the curb, I'd place myself three inches from the curb so that psychologically I'd run a shorter mile. Strategy was my game. I stayed constantly alert to who ran besides me, to who might box me in. If I competed against a guy everyone thought would beat me, I wanted to be clever, so when I trained I'd speed up for fifty yards on every lap and then slow down to the regular pace. When I did it in the real race, I forced my competition to catch up every time I pulled ahead. Eventually it bushed him, and by the final lap I'd have it going away.

At first we stayed packed together. I was maybe tenth of sixteen runners. Bright was in front of me. We had plenty of distance to cover, so I took it easy. After about a mile and a half some guy col-

lapsed from the heat and we all jumped over him. Eventually, that happened to Bright; the intense sun was not kind to fair-skinned, freckle-faced, sandy-haired fellows. I pulled alongside and urged him to stick it out, but Bright had developed blisters from running a 10,000-meter race a week earlier, and his pain was unbearable. I admired him for trying. I desperately wanted to beat him, but not this way.

Just before the last lap Lash was out front, Deckard moved up on his tail, and I closed in on Deckard. We were all well ahead of the field. On the far straightaway, when I should have made my play and gunned for Lash, I mentally spaced out for a few seconds. My mind said, How can you pass a world's champion, a guy who took the record away from the Finns? Instead of kicking, I stared at his back with admiration. Before hitting the final curve, Deckard moved out into the second lane, which forced me into the third. I woke up, passed him, and moved into the second lane, just behind Lash. Then we battled down the stretch as I closed in on him—me against the champion. But champions don't give up. We hit the tape together.

Because I'd been gaining on Lash I thought I'd won, but the announcer called his name instead. I left the track without congratulating him. But I didn't care. Nobody knew me, the West Coast runner; the announcer had even called me the "dark horse" because of my black tracksuit. I went to the locker room, but someone rushed in and brought me out again, and an official handed me a certificate that read "First Place." The race film had confirmed a dead heat. That was great. But even better, most of the New York press finally learned to spell my name correctly.

CONGRATULATORY WIRES POURED in from family and friends. Not only had I proven a point for Pete and myself, I'd made the Olympic team.

Those who didn't qualify were gentlemen, congratulating us and bidding us a good time in Berlin. No emotion, just Godspeed. Today it's different. Someone who doesn't make the team might weep and

collapse. In my day no one fell on the track and cried like a baby. We lost gracefully. And when someone *won,* he didn't act like he'd just become king of the world, either. Athletes in my day were simply humble in our victory.

I believe we were more mature then. Today's athletes have more muscle and better physical-fitness programs, lighter shoes and faster tracks—but some still can't win or lose cheerfully. Maybe it's because the media puts so much pressure on athletes; maybe it's also the money. In my day we competed for the love of the sport. Performance-enhancing drugs could be had, but no one wanted to win unfairly or damage his health. In my day we patted the guy who beat us on the back, wished him well, and that was that.

That's not to say I had no emotions. I just kept them to myself as usual. But inside, the punk kid from California, the high school boy, was overjoyed at having prevailed.

THE NEXT DAY I checked in with Olympic headquarters, where they measured and fit me for my official team dress wear: white slacks, navy blue jacket with an Olympic shield on each button. A straw hat, too. After I got my team tracksuit—satinlike pants, light wool shirt—I boxed up my lucky shorts and sent them home. I was allowed to keep my shoes.

Afterward we attended an orientation about how to comport ourselves on the SS *Manhattan*—our ship to Berlin—and at the Games. They talked to us as if we were children.

The ship left port on Wednesday, July 15, on its way to the Eleventh Olympiad. Everyone assembled on deck for a group picture that made many a front page. Overhead, airplanes and blimps soared and dipped. Well-wishers chanted, " 'Ray,' ray for the USA! A-m-e-r-i-c-a!" With its two massive funnels colored red, white, and blue, the ship carried 1,064 passengers. Of those, 334 were athletes, and 354 were officials, coaches, trainers, newspapermen, chaperones, and relatives.

The athletes traveled second-class. I shared a stateroom with Billy

Brown, who did the hop, skip, and jump and like me was the youngest competitor in his event. The accommodations were impressive. I especially liked the big ballroom. Although no Fred Astaire, I was light on my feet, and the older girls—thankfully—gave me a break. I also liked to waltz, slow and smooth. But one night a storm hit and the boat pitched and rolled so much that everyone slid all over the floor. One of our shyest athletes careened headfirst into a female athlete, an embarrassing get-together. The rest of us held on to the superstructure and cracked up. As the ship rolled back he was released from the entanglement and ran blushing from the ballroom.

The food wowed me the most. I couldn't believe the layout. The first time I ever went out to eat I'd had a sandwich with a toothpick and an olive at the drugstore—big stuff. The selection onboard was beyond words—plus it was free. At mealtime each table was laden with not just a basket of sweet rolls but with *six* kinds of sweet rolls. Here's a partial list of the fixings, as reported in the *Los Angeles Times:* "Lunch: roast beef, baked potatoes, stewed celery, milk, tea, baked apple. We ate seven hundred pounds of beef. Supper: chicken soup, roast chicken, cranberry sauce, mashed potatoes, peas, ice cream, hard candy."

I couldn't control myself. I must have gained ten pounds before I got to Germany.

When I wasn't gorging myself I went to first-class to work out with the other athletes. The deck went all the way around the ship, unbroken. On the port and starboard sides were cabinets stocked with beer. After a hard run we'd all stop for a glass from the tap and head back to second-class.

I spent some free time collecting souvenirs: ashtrays, towels, whatever. My training as a former juvenile delinquent and petty thief made it easy—and I noticed that almost everyone shared my collecting bug. I also tried to meet all my sports heroes and enjoy the camaraderie. The older athletes took me under their wing.

All the movie people—like Helen Hayes and Joe E. Brown, who became a close friend after the Games—traveled in first-class, as did the Olympic officials. The Committee was mostly wealthy guys; you

might say they were to the manner born and we were the serfs. Today our Committee is different. They respect the athletes and the athletes respect them.

At night we stayed on our own deck, unless invited topside, as was Eleanor Holm, a 1932 Olympic swimming champion and the world's greatest backstroker. She'd met William Randolph Hearst, Jr., in first-class while working out, and they became friends. When the Olympic bigwigs saw her dancing with Hearst, they didn't like it that she'd left the athletic group. Then they watched her drink champagne, and that did it. She might have been warned first; I don't know. I think they just tied it all together and the next day Avery Brundage called her on the carpet and dismissed her from the team.

Brundage was famously strict on amateurism, yet he was a hypocrite. He'd condemn athletes for taking money here and there, but we all got a bit more than the amateur rules called for. Every dollar helped, especially during the Depression, but it still broke the rules. Let me put it this way: I've never met a world-class *amateur* athlete in the true sense of the word.

Look what happened to the great Jim Thorpe. He was a starving Indian who made twenty dollars playing professional baseball, so they stripped him of his medals as punishment and broke his heart. It was pathetic to see him treated like a condemned criminal. In fact, it was so ridiculous that about ten years ago they gave all the medals back to his family. I'd just broken the high school world's record when he and I took a speaking trip together, sponsored by the Torrance Kiwanis, who were just trying to help Jim. I'd give a short talk on "High School Athletics Today." He'd put on headdress feathers, perform, say a few words, and get ten dollars.

Almost everyone thought Eleanor Holm's punishment far exceeded the crime. The older, more mature athletes protested and asked Brundage to let everyone vote on the matter. I thought that if Holm lost her place, then they should have thrown off 95 percent of the team for drinking beer. Brundage said no, he was the authority. Like a dictator with an iron fist he issued edicts and everybody had to listen. I don't even think he let the other officials vote. Of course, Hearst

immediately hired Holm as a correspondent, so she went to the Olympics anyway. But she didn't swim. Our loss.

I didn't like any of it, but what was done was done. Besides, by the time we docked in Hamburg and took the train to Berlin, I had my own event to worry about.

# 3

## WORLD-CLASS

THE OLYMPIC VILLAGE dazzled me. It was completely fenced in, and wild animals roamed the enclosure loose. The Finns had a special bathhouse where I could sit in the sauna and beat myself with eucalyptus leaves, then dive off the end of a pier into a lake covered with swans. The Germans built the quarters like hotel rooms, only without bathtubs because, as I'd read in the newspaper, Hitler was germ-phobic. He didn't like the idea of sitting in his dirt and not being able to rinse off well, and he believed we should all follow his example. As a result the Olympians had to make do with showers and bottles of Odol disinfectant.

Hitler also wanted the grounds immaculate. When a couple of American athletes tossed banana peels and apple cores on the ground, the Germans ran right over and scooped them up. The city of Berlin was so clean it was almost antiseptic. No spittle on the curbs. No papers in the gutter. They even had men in white coats on every corner to sweep up after the horses, so there were no flies. Germany seemed like the most spotless place on earth. Of course, I know Hitler had to put on a big show. He had ulterior motives, and I make no excuses for him.

In the Olympic Village dining room, built as a giant semicircle two

or three stories high, every door led to a different country's food. I tried them all, which was stupid, because I put on even more weight.

Though storm troopers—the tallest, most handsome blonds—always stood watch, the atmosphere was light, even jovial. When someone said, "Heil, Hitler!" we'd give him back the same, except we'd say "Heil, Adolf!" They'd laugh. Nobody got mad.

In 1936 we still thought of Hitler only as a dangerous clown.

I SETTLED IN and prepared for the opening ceremony. On Saturday, August 1, 1936, athletes from every country lined up on the field. Our team dressed in white pants, navy blue coats, and straw hats; the girls wore little tams. The big event was thousands of carrier pigeons released into the sky—they shot up and circled the stadium—immediately followed by cannon fire, which scared the pigeons, and seconds later their droppings hit our straw hats and shoulders with a distinctive pitter-patter. I remained at stiff attention, grinning, thinking not about myself but about the poor girls who got it all through their hair.

TO QUALIFY FOR the 5,000-meter event I ran one heat. I stayed in the pack until the end, when my sprint put me near the front, and I managed to make the cut. It wasn't easy because I was seriously overweight.

In the finals we ran in bunches according to pace. I wanted to get to the inside curb as quickly as possible, and I got a good start, but the leaders—the great Finn runners—moved out quickly. After the first lap I realized the pace was a bit fast for me, considering my extra pounds. The Finns pulled away and I stayed with the second group, about fifty yards behind. A third tailed us by thirty yards.

By the last lap I was the only one in my group with any energy left. Pooped, breathing hard, and sweating, I still remembered my brother's instructions: when I felt the most done-in was the time to exert myself. *Isn't one minute of pain worth a lifetime of glory?* I opened

up and ran as fast as I could. My time for the final quarter mile: an unbelievable 56 seconds. I had no idea I could go that fast, especially at the end of such a long race. I finished with the lead group and placed eighth—the first American to hit the tape.

I wasn't crazy about my overall performance, but I consoled myself by thinking it had been only a warm-up, a prelude to the 1940 Tokyo Olympics. There, in *my* event—the mile—I would show everyone what I could really do.

I showered and joined some teammates in the stands. We sat near Hitler's cement box. Between us lay a buffer zone of officers such as Göring and Goebbels. They did not allow anyone to approach the führer, but if you could get your camera to one of the officers, he'd take a picture of Hitler for you. I gave my camera to Goebbels. He asked my event.

"The five thousand meters."

"And what is your name?" he inquired.

"I didn't win anything," I said, "so it's not that important."

"No, Hitler wants to know the name of every athlete."

"Okay. My name is Zamperini." I gave him the camera and he took a picture.

When Goebbels came back he said, "Hitler wants to see you." My mouth dropped open.

I walked over and shook his hand. He seemed friendly enough and said, through an interpreter, "Ah, you're the boy with the fast finish." Then I went back to my seat. Frankly, it wasn't that big a deal. Even if Hitler had given me his wristwatch, it still wouldn't have meant much. He was just another dictator. So what? Sure, he was an anti-Semite, and I certainly wasn't, but I'm embarrassed to say that at the time I didn't understand what that was all about. I'd just graduated from high school and was more concerned about myself than about governments and how the world worked, or didn't.

LATER I HIT the streets of Berlin with a friend from the team. We hiked everywhere, saw the sights. We wanted to find an *Automat,* where they served liters of beer. You could drink one and walk around

with a little boost. Maybe try something you normally wouldn't. We also wanted souvenirs. I grabbed an ashtray from a *Tanz* bar—a dance hall and bar. I also copped a fan.

At the Reich Chancellery we stopped and stood across the street to take in the magnificent building. In front, two guards marched from the doorway in the middle to the corners, where each would do an about-face and goose-step back to the center. While we stared, a limousine pulled up and Hitler got out and went inside, accompanied by some officers.

Of all the possible souvenirs, I wanted a Nazi flag the most. I couldn't get the beautiful ones, the long silk streamers that hung from the building tops, so I set my sights lower and spotted a banner maybe ten, fifteen feet up, on a pole stuck in the Chancellery's perimeter wall. My mind went to work; thinking maybe I could get it when the guards weren't looking, I watched them walk their circuit and timed how long it took. I figured I could be across the street and up and down the pole while they walked toward their respective corners, then gone before they swung again in my direction.

As soon as the guards turned I made my move, but when I got under the flag it was higher than I figured and I had some trouble getting up the pole. When the guards did their about-face, they saw me, and began to yell. I stretched, grabbed the flag, then dropped to the ground and ran. I heard a loud crack that sounded a lot like a rifle shot, and the words *"Halten sie! Halten sie!"* I didn't need to understand German to figure it out.

I made the smart move: I stopped. The guards seized me and cuffed me a bit for good measure before they took a good look at my Olympic clothing and realized I was an American athlete. One guard spoke very halting English. He wanted to know why I'd torn down the flag. I told him my name and the truth: I wanted a souvenir to take home to America—and here I embellished a bit—"to always remind me of the wonderful time I had in Germany."

He left me with the other guard, went into the building, and returned with an older, high-ranking officer, introduced as Fritz. I later learned it was General Werner von Fritsch, commander-in-chief of the German Army (whom they eventually executed for going

against Hitler's policies). Von Fritsch said, "Why did you tear down the swastika?"

I repeated my explanation. It must have been the right answer. He presented me with the flag, "as a souvenir of your trip to Germany."

I still have the flag today.

The story of my little adventure hit the press and quickly died. But a few years later, during World War II, our side resurrected it as part of the propaganda effort, and twisted it around into an event that never happened. I didn't know they'd done it, but when I found out I understood: our government had to paint the enemy as black as possible.

Walter Winchell and Burgess Meredith told the story on radio. Instead of tearing the flag off the Chancellery wall . . . well, here it is, straight from a transcript of the show:

> The scene is Berlin, 1936. The American delegation is facing the reviewing stand where Chancellor Hitler and his official staff are giving the Nazi salute. Some of the boys are responding with the salute. Others are just standing there awkwardly. But . . . wait! One boy from the ranks has burst out to one of the poles and has snared the swastika flag, which he's trampling on the ground! There's a mild uproar! Oh, the führer will be very mad!
>
> It was Lou Zamperini, Southern California distance runner, who was the first of the millions of American boys to show his contempt for Nazism.

Another version had me ripping down the flag and running a lap with it.

Nice sentiments, but neither happened.

I'D HAVE LOVED to win an Olympic medal but I was just as happy to have won a place on our team. The whole trip was high adventure. Who can put the euphoria into words? It's the total experience: the competition, the parties, the other athletes who became friends, and later the inevitable nostalgia.

After the Games ended in mid-August we attended one celebration

after another. The Germans picked their most beautiful girls to wait on us; young, comely Fraüleins all. They treated us like kings. The night before the train ride to Hamburg our hosts threw a banquet at a luxurious country club. In the great dining room were long tables covered with delicacies. Again, the girls conscripted by Hitler to wait on our team were absolutely gorgeous, and apparently thrilled to serve us.

My friend from the flag-stealing incident and I told the two cutest gals that we wanted to see them after the banquet. Soon we were outside, hidden under the orange trees, necking. That's all we did—honest. When it was time to go, our bus driver kept honking the horn but we couldn't leave our beautiful companions. Then our teammates hollered and we had to break the clinch. The girls ran after us, crying, "Please take us to America!" I got a lot of good-natured grief from the team about that incident.

Next we had an exhibition track meet in Hamburg. To welcome the team they set up another huge dining room full of food. The bar had a big groove down the middle so they could slide glasses of beer right to you. Naturally, I gorged myself, until they announced it was time to get ready for the meet. The team thought the meet was the next day. What a dirty trick. Our distance runners refused to compete because they knew racing on a full stomach would kill them. Only the field-event guys went.

That was our farewell to Germany. The next day everyone boarded the SS *Roosevelt* for home, with a stop in England to compete in the British Empire Games.

THE ACCOMMODATIONS IN London were atrocious. While the Olympic Committee stayed at the Grosvenor Hotel, we were bused out of town and billeted at some dreary-looking slum in the boondocks, with no opportunity to see London or have a social life. The stairs of these tall tenements were so narrow I had to carry my bag in front of me, up six flights. My room made me want to sleep on the street. I guess the others felt the same because when I went down again, everyone was outside and unhappy.

We took a quick vote and decided not to work out that day and to

boycott the Empire Games altogether. We'd simply sit on the curb and wait until the Olympic Committee came out to hear our grievances.

When Brundage arrived he stormed into the group and demanded we accept the accommodations we had. "We want to stay at the same hotel you're at, the Grosvenor," countered the older Olympians, speaking for the group. They argued, Brundage left, came back. We didn't waver. Finally he agreed. He had to.

Later, just to spite the Committee, we ordered the most expensive French Champagne for breakfast, lunch, and dinner, and charged it to our rooms.

MY TRAIN TRIP from New York back to Torrance took about five days. I arrived in the evening. The new Torrance police chief, John Strohe, met me at the Los Angeles depot and drove me through the city, sirens screaming and red lights flashing. When we reached the outskirts of town I noticed a crowd in the street. I jumped out, thinking there'd been an accident.

The people lifted me onto a ton-and-a-half truck and put me on a sparkling white throne surrounded by several athletes in tracksuits. I sat there embarrassed, my face burning. I'd planned a quiet homecoming and had not even wired my parents until I'd reached Chicago.

Torrance Square was full when we arrived. The town's fire engine drove around trailing streamers that read, ZAMPERINI COMING HOME TONIGHT. Loudspeakers blared, "Welcome home, Louie." It was simply overwhelming.

I had always shied away from public displays of affection, but the townspeople had me cornered. I said a few words and sat down, waiting for my chance to sneak away. Then I spotted a crippled woman in her wheelchair, the stepmother of my best friend. She liked argyle socks and I'd remembered to buy her a pair in New York. I jumped off of the platform and gave her the gift and a big hug.

That began the celebration. The reception was amazing. I even managed a laugh when Chief Strohe said, "After I chased Louie up and down every back alley in Torrance, he had to be in shape for *something*." He was right. If Torrance's only police car went south, I'd

head north. I wondered how many of Torrance's citizens knew how close I'd once come to being little more than a no-account delinquent.

THAT SUMMER, EVEN before the Olympics, a number of colleges had tried to recruit me. I spent a week at Stanford with Clyde Jeffrey, a sprinter. They gave me a convertible to drive and we stuck around for a few days, checking out the campus. Notre Dame offered me a scholarship and when I turned it down I told Coach Nicholson to give it to a mediocre runner named Greg Rice. I'd beat him by fifty yards in the mile. Afterward, I'd told Greg, "You're not a miler—you're a two-miler." He got my scholarship, switched to the longer race, and broke the world's record.

Coach Dean Cromwell of USC wanted me, too. He was a legend. His USC team had won more national championships than any other university in America. When you went to USC you could ask any athlete on the field, "In what event did you hold the world's record in high school?" However, whenever anyone introduced Cromwell as "the world's greatest track coach," he wouldn't stick out his chest. He'd simply say, "Well, I get the greatest athletes in the world. Why shouldn't I be the world's greatest track coach?"

Cromwell had been on the 1936 Olympic track-team coaching staff and had come to many, if not all, my high school track meets. He was known for his broad grin and the way he encouraged his and other athletes. His famous greeting was "Hi, champ." Even though part of his job was to solicit and proselytize for his team, his praise made me feel important.

My brother, already one of the nation's top milers, attended Compton College. Cromwell was smart and offered a scholarship to *both* of us.

I entered the University of Southern California in September 1936 and did well on the field. As a freshman I was invited to the big Princeton Invitational, where I won my first national title in the two-mile. Pete still coached me now and then but I listened less often, shrugging off his advice with a cocky and arrogant "Yeah, yeah. I know." After all, I was the one who'd been in the Olympics.

Clearly, my personality still needed help. Although on the oval, I ran to win and to support the team, off the oval I didn't win any popularity contests. I was still mostly a loner, stubborn, with a low boiling point.

That winter, against Coach Cromwell's advice, I decided to take up skiing. I figured it would develop my legs and lungs and could only help my running. But when I took off down a slope at Big Pines, I ran into ice on the slide, lost control, and landed in a heap. I tried to stand, but the pain in my leg and knee made me topple over again. The verdict: bad knee, torn ankle ligaments, crutches, no running for two months.

Pete gave me a hard time. "You've got a responsibility to the team and to the people who admire you. The kids. You've got to sacrifice to uphold the traditions of athletes."

That made me angry. "If I can't live a normal life and do what other people do then I don't want to run," I threatened sharply. Those words set the pattern of my life for the next few years. I wanted it all: the fame, new achievements—and all the distractions and fun college offered.

I'D NEVER REALLY set my heart on breaking any world record save for one: the National Collegiate Mile. Bill Bonthron of Princeton had aced my hero, Glenn Cunningham, by inches, and broken the record in 4:08:08. I planned to get the title back someday for Glenn— and for me.

I trained hard but not in the way Coach Cromwell approved of. In those days the coaches didn't allow us to train by running uphill, something I'd done ever since the summer I decided to run everywhere I went. This meant no running up and down the stairways in the stands at the Coliseum. The doctors said it would damage the heart; in reality it did the heart good. And the legs. I didn't listen. Every evening I'd climb the Coliseum fence and do the "agony run." At the top my legs seared with fire, then I'd walk across a row, go down again, and up another staircase. I did that after each normal workout. Here's why. People say all anyone needs is a positive attitude. It's nice to have, but a positive attitude has nothing to do with

winning. I often had a defeatist attitude before a race. What matters is what you do to your body. Self-esteem can't win you a race if you're not in shape.

IN JUNE 1938, healthy again and a sophomore, I traveled to Minneapolis for the NCAA meet. The USC team had won three years straight, but the competition this time was far more rugged. The morning of the meet Cromwell walked his thirty-four athletes half a mile from our hotel to a cafeteria for lunch, then across the street. He pointed at a large plate-glass window. "There's the trophy," he said, as we stared at the four-and-a-half-foot symbol of victory.

I thought we could win again, especially if I beat Chuck Fenske of Wisconsin, who'd won the mile race two years in a row. Everyone expected him to repeat. In fact, no one rated my chances better than fifth. Maybe the experts were right; no Pacific Coast runner had ever won that NCAA title. In fact, the West had never produced any great distance runners; the East controlled everything. I wanted the record badly, but despite Coach Cromwell's motivational exercise, I could only taste the bitter pill of my own pessimism.

THE NIGHT BEFORE the race, as I lay in bed reading, I heard a knock at the hotel room door. Coach Nicholson of Notre Dame stood there. "Louie," he said, "I've got something to tell you." He motioned me outside. "I'm ashamed to say this, but I just came from an eastern coaches' meeting and they're going to tell their milers tomorrow to do anything they can to get you out of the race. Be aware of what's going to happen, and try to protect yourself."

The eastern coaches all disliked Dean Cromwell because the press kept calling him the world's greatest track coach even though he'd never had a great distance runner. To them, the mile was the glamour race, not the 100 or 220 yards. The mile was magical. They didn't want Cromwell to have a winner.

"Thanks, but don't worry about me," I told Coach Nicholson. "I can take care of myself." Or at least act like I could.

I went back to bed and didn't give it a second thought. I'd never seen anyone do *anything* evil on the track. My competitors had always been gentlemen. Of course, they'd all been from the West.

THE NEXT MORNING my roommates and I went to see *The Count of Monte Cristo*, with Robert Donat. Being Italian, I loved it; the count got revenge on everybody. My adrenaline pumped and flowed. After the movie we took a taxi to the hotel, had a light lunch, and went to the track. Over the loudspeaker I heard the announcer call the names of the three or four fellows they thought would win the race. One at a time they jogged back and forth in front of the stands.

No one mentioned me.

THE GUN SOUNDED and we took off. As usual, I didn't try to take the lead, but I felt great, like I would never get tired. I thought about what Coach Nicholson had said about the East Coast runners. I figured he meant they'd try to box me in and keep me from making my move.

Soon I *was* boxed in, but I quickly realized they had other tactics in mind when I suddenly felt a searing pain in my leg. The runner ahead of me had reached back with his foot and caught me in the shin with razor-sharp spikes, making three gashes a quarter inch deep and an inch and a half long. I'd been nicked before; that happens when you run in crowds. In fact, every runner gets chased by dogs when he trains. If you want the dog to leave you alone, you extend your back leg six inches and nick his snout.

This felt different.

"Hey, what are you doing?" I yelled. "Cut that out!"

He did it again. My socks began to fill with blood.

I had to get out of the box. I pulled my elbows close to my body, in good racing form, and tried to slide between two runners. But they set their elbows at a ninety-degree angle and caught me in the ribs—a favorite trick of predominantly indoor runners. I later discovered a hairline fracture, but at the time it just knocked the wind out of me.

The race seemed to drag by slowly, and I fought frustration for three laps. Then the leader made his move. The other runners, thinking he'd win easily, relaxed and the box opened a bit and I squeezed through. Apparently they'd forgotten my finishing sprint. I caught the leader and passed him easily. Safely out in front, I glided a bit for last ten yards because I was so mad that they'd run such a slow race.

When it was all over, Coach Cromwell asked how fast I thought I ran. Famous for being able to time my laps within a second, I said, "I'm lucky if I broke four-twenty."

"Then you're lucky," he said, "You ran 4:08.3 and broke the National Collegiate record. What's more, you're not even breathing hard. You could have run anything. Even four flat."

A four-minute mile? The impossible dream? But suddenly it didn't feel so impossible.

If I have any regrets about that race it's that had I been able to follow through on my plan to really open up the last half mile, I might have broken four flat *that day*. I'd felt that good.

When the doctor patched me up I had three gashes on my shins, a spike hole through my foot, and both my socks had turned red. The newsreels show me afterward, wrapped in big bandages. People wrote letters, asking, "We don't understand it—why were your legs taped?" Even my future wife, who was probably twelve at the time, told me years later that she and her mother had gone to a theater to see Errol Flynn in *The Adventures of Robin Hood* and had also watched me in a newsreel with both legs bandaged.

In the end I was just glad to win. I got the record back for Glenn Cunningham and me.

THAT NIGHT I should have rested for next race and let my legs heal, but a big local politician lent seven of us his Cadillac, and his son as driver. We bought the kid a movie ticket and took off on our own with the car. We picked up three girls at our hotel, had a few beers, and didn't get to bed until 3 A.M. A week later in the Big Ten meet at Evanston, I lost to Fenske by five yards.

After that, although I won some races and lost others—and defended my NCAA mile title in 1939 with an easy victory in 4:13.6—my attitude was never the same.

AFTER YEARS OF strict training, I just wanted to relax and play a bit. I spent a lot of time with Harry Read, a college friend and fraternity brother. An unexcitable fellow who had no particular objectives, Harry impressed me because he was always so calm and even-keeled. He had all the money he wanted, as well as a new car and a twenty-four-foot yawl named *Romancia*. Harry could trace his American ancestry back several generations, which just stoked my deeply rooted sense of inferiority and insecurity. But Harry never pressed his advantage.

Harry considered track a waste of time. In turn, I couldn't understand his addiction to sailing. He did get me down to the marina one day, and after drinking beer, scraping, and sandpapering, he took me out on the bay. The trip was pleasant enough but no big deal.

We did have one big interest in common: neither of us was a scholar, and we agreed that our immediate mission in life was to do whatever promised to be adventurous and fun. On a Christmas vacation trip east with Harry I bought a new tan Plymouth convertible in Detroit. At home, we'd tool around the state, go to festivals and beer busts.

Another friend, James Sasaki, was a mild-mannered, brilliant Japanese citizen. He was about thirty, slender, with a narrow, squarish face and slicked-down hair parted in the middle. During his nine years in America, Sasaki had attended Harvard, Princeton, and Yale, and he was now at USC. Because he was well versed in American history and slang we occasionally talked about athletics after our political science class. His educational zeal impressed me. We had two things in common: a love of sports and many Japanese friends in the South Bay area.

DEAN CROMWELL GREW unhappy with my attitude. He didn't say much, but I could tell what he thought from the way he looked at me. In the fall of 1939 I'd received many calls from indoor track-meet

promoters, begging me to run. At first I said no, but they hounded me until I was ready to give in. Cromwell forbade it. "You can't do it, Louie," he said. "You're on a scholarship here. And you'll wear yourself out before track season. Running indoors is not the same, and the cold weather back east will knock you flat. You're not used to it."

When someone stood in the way of what I wanted, I stopped listening. "Well, I'm working at the studios making thirty-five bucks a week," I countered, "so I have money." (When studios needed extras, athletes at USC and UCLA often got first crack. I got to work on *Juarez* and *The Hunchback of Notre Dame* with Charles Laughton.)

The only way I could compete indoors was to quit school and my scholarship on a Friday, race on the weekend, and reregister on Monday. That would cost $170, but the promoters promised to cover me. I finally gave in and defied Coach Cromwell by accepting an invitation to run at Madison Square Garden. I ran under the auspices of the Los Angeles Athletic Club.

Every Friday afternoon I caught a plane for New York, ran my race, then hopped a return flight to Los Angeles. Sometimes, if I won, I wouldn't even wait for the grandstand review; I'd just pick up my medal and dash to my hotel across the street, still in my tracksuit. That was foolish. Because of the miserable winter weather I frequently got sick. But I still ran well: ten races in a row under 4:10. In one, the Wanamaker Mile, I ran 4:07.6 with a fever and strep throat, and came in second to Fenske, followed by Glenn Cunningham and Gene Venzke, all of us in record time. Those races kept people saying I had a good shot at being first to break the four-minute barrier.

No matter what Coach Cromwell said, I loved running indoors. There was no wind or weather to contend with. The crowd sat closer; I could see their faces and even smell the women's perfume. But Cromwell was right: it was different. In their drive to win, the runners did not hesitate to trip, shove, push, and elbow.

The competition finally did me in. We ran on a smaller track, built on boards. At the Garden, the straightaway rose an inch and a half over a terrazzo floor. During one race I got knocked off the track, into a pileup. There's a picture in *Life* magazine of everyone in a heap. My

shoe slipped into the space beneath the track and floor. Trying to get free, I tore the ligament in the second toe of my left foot.

With time off to recover, I took inventory of my life. When my foot healed I would set my sights on the Tokyo Olympics. I also resolved to work hard and be more disciplined. I felt great that I was once again reaching for excellence in my athletic career.

Unfortunately, I developed a severe chronic pain under my right collarbone. At first I dismissed it as a pinched nerve and kept running, but guys I usually beat by forty or fifty yards suddenly followed closely on my heels or passed me. In desperation I ate baby foods and cereals and tried to regain my strength. Winning meant more to me than anything, but nothing worked. At the 1940 NCAA mile, I lost.

Los Angeles sportswriter Braven Dyer had called me "the greatest distance runner the Far West has ever produced." Now I feared he'd been wrong and there would never be a four-minute mile for Louis Zamperini.

UNWILLING TO GIVE up, I kept training for the 1940 Olympics coming that September. But one day, while my dad timed me, I collapsed on the track. Then I fell in a race. Cromwell tried to help, but no one really knew what to do. He sent me to a dentist—why?—who diagnosed the problem as an infected wisdom tooth. He pulled it, but my chest still hurt. I saw another doctor, who took out a tonsil. No improvement. A third doctor punctured my sinuses and flushed them out. That didn't work, either. My times just kept getting worse.

After graduating from USC, several of us went to Lockheed to find work. Even with college degrees we couldn't get decent jobs. I wanted to work in an office, but they said, "You'll do manual labor first, *then* apply for an office job." They hired me as a spot welder, pending a physical. After the exam the doctor surprised me with the straight dope. "Do you realize your whole right lung is full of pus?" he said.

"What?"

"You have pleurisy. You've had it for months. You're the runner, right? I don't know how you finished a race with a lung full of pus. You only used one lung."

The mystery of my pain solved, I got a shot, took antibiotics, and started working out again. Soon I felt like a tiger, but it was all for nothing. In the meantime, Japan had invaded Manchuria and taken island after island in the Pacific. The 1940 Olympic Games were canceled, and my dreams came crashing down.

# 4

## ON A WING AND A PRAYER

I T DIDN'T TAKE long for me to move into to the Expediting Department at Lockheed. I got to dress in nice clothes, too. But it was just temporary. With the world at war, I knew America could be drawn in anytime. During lunch, I'd watch one P-38 after another fly in and out of the company airfield. I figured it would be exciting to be up there myself, so I applied to the army air corps.

MY PRIMARY TRAINING started on March 19, 1941, at the Hancock College of Aeronautics in Santa Maria, just south of San Luis Obispo, in California. They'd named the field after Captain G. Allan Hancock, a big oilman who built the Hancock Library of Biology and Oceanography at USC. He also created Hancock Park in Los Angeles, a famous mid-Wilshire neighborhood, on part of the land left to him by his father, Major Henry Hancock.

I drove north with a couple of buddies. The army took pictures of me in my tracksuit, posing in a racer's starting-line crouch, on an airplane wing. Because of my track career, I was always good for some free publicity, and I was happy to help. After a few weeks of ground studies they finally put me *in* a training plane. What a shock. I'd flown to New York on commercial planes, but it's different in a small craft.

Some guys loved it. I didn't. At first I got a little disoriented, twisting and turning, but when they put me through the "spins," that was it.

I had a better time on the ground. We got weekends off, and most of us went into town to drink. That was fine as long as you didn't come back drunk. If you did, the MPs would haul you to the infirmary and forcefully inject a 15 percent Argyrol solution straight up your penis. It burned and you'd scream your head off and not sleep well that night. They said it was for our own good, though. The air corps didn't want anyone to catch VD from the girls in town. I heard more than one recruit protest, "No, I didn't have any sex with *any* woman." But who trusts a drunk?

I didn't fool around, but one night I came back not walking a straight line, and I knew they wanted to give me the Argyrol. Instead, I jumped the fence and got away with it. The next time, though, I got caught climbing over the fence and was confined to the base for two weekends.

The first weekend Captain Hancock flew his Lockheed Lodestar to our field. Hancock and I had become friends at USC because of my interest in his cello performances, and he was scheduled to play at the base. All military personnel were required to attend, but it was optional for the cadets. I was the only cadet who showed up, and that made us even closer friends.

Later Hancock said, "Louie, I'm flying to Long Beach. You can come and visit your parents in Torrance and I'll have you back to school by Sunday." I told him I appreciated the offer but I was confined. "The restriction board at the gate reads, THESE CADETS ARE NOT TO PASS THROUGH THIS GATE. And my name's on it."

"We're not going to pass through the gate," he said with a laugh. "We're going to fly over it." I spent my two restricted weekends at my parents' house, and no one was the wiser.

I WASHED OUT of flying school, came home, and rented an apartment in Hollywood with two buddies who'd also been let go. We were officially still cadets, waiting for termination papers, but we had nothing to do except go to the beach, the movies, and athletic events.

When the discharge orders arrived, I moved back to Torrance, a civilian again—but eligible for the draft.

My letter to report for a physical came while I was working as a movie extra. I made seven dollars a day, and any extra who stayed through the whole shoot got a twenty-five-dollar bonus. I didn't want to avoid my duty to my country, but I wanted that additional money. I'd heard that during World War I, men who wanted to postpone or get out of their service would put a chunk of tobacco under their armpits to raise their temperature. Or they'd put a cigar up their anus. When they got to the front of the line, they'd be dizzy and sick. I didn't want to go that far, so I ate lots of candy to induce a high sugar level. I wasn't sure it would work, but when they tested my urine and told me I'd have to come back, I was happy. I finished the movie and got my bonus, then went back and took my physical again, and passed.

I joined the army on September 29, 1941, and went to Camp Roberts, near Paso Robles, California, for basic training. The army thought I had certain useful qualities, so they made me an acting corporal in charge of fitness. I also went to the NCO school on the base and came out with top grades.

I was at Camp Roberts—actually, out on a weekend pass—when the Japanese bombed Pearl Harbor. A buddy and I were at a movie in town when they stopped the film and the theater manager made the announcement: "All military personnel are to report to their bases immediately. The Japanese have attacked Pearl Harbor."

On my way out of the theater I ran into a friend from the local air base. I wasn't in any hurry to get back to Camp Roberts, and he said, "We could use you at our base." I had military rifle training, and they had a whole barracksful of guns that nobody knew how to use because their air corps guys never had rifle drills. My commander cleared it, and I spent the day there with the air corps pilots and mechanics and so on. I put them through drills and taught gun nomenclature and how to take a firearm apart and put it together again. When I got through they drove me to Camp Roberts.

·        ·        ·

I DID WELL in basic training, and the army selected me to go to Officers Candidate School at Fort Benning, Georgia. Then a second set of orders came, the result of my having unthinkingly signed a piece of paper after washing out of Hancock College. The orders directed me instead to bombardier school at Ellington Field in Houston. I met with the Camp Roberts CO, a general, and told him I wanted to stay in the infantry. He said he'd try to help, but there was nothing he could do.

At Ellington Field I found another guy who didn't want to be there, either. We both put in for transfers. Meanwhile, I went about my studies and did some more publicity for the air corps: pictures in the paper of me racing a bomber down the runway, talking about the Nazi flag incident in radio interviews. Apparently, the air corps didn't want to lose the extra visibility that having me around brought, so my request for a transfer never went through. I kept asking, "What happened to my transfer? They transferred so-and-so last week . . ."

Frankly, I hated the air corps until one day when two other cadets and I walked down the street in Houston and a big white convertible Cadillac with two beautiful young women pulled up. We were only cadets, but we still wore wings—and they were looking for men with wings.

"You want to go to a plantation party?" they offered. We hopped in. At the party, food and drink were plentiful and free and dancing with the beautiful Texas girls was a bonus. After a few more get-togethers just like it I decided that maybe being in the air corps wasn't that bad after all. Then I got elected captain of the cadets and was put in charge of a large drum-and-bugle corps. We performed at the stadium, in front of top brass and Washington officials, to honor those who died at Pearl Harbor.

Next I went to Officers Candidate and bombardier school in Midland, Texas. The curriculum was tough and included math and physics; we had to make sure the bombs went straight after we dropped them. The washout rate was high. By keeping my nose buried in my books, I survived.

However, fun was not out of the question. Before a practice night-bombing mission, my pilot, a sergeant, asked if I could drop my bombs quickly so he could keep a rendezvous with his girlfriend. "Where are you going to pick her up?" I asked.

"I'm not meeting her on the ground," he said. "I promised to fly over the local theater when the movie lets out at nine, and she promised to wave at us."

We took off with several other AT-11 crews. The sergeant arrived first on the target, and I unloaded my bombs in such a hurry that later my scores were not up to par.

Then he did a wingover and hurried back to Midland. The sergeant buzzed Main Street, barely clearing the power lines. I looked down at the theater and saw people begin to pour out—and look up, puzzled, at our extremely low altitude. By the fourth pass, the sergeant yelled, "Do you see a girl waving a scarf?"

"Yes," I hollered back. "She's in the middle of the street with everybody else, wondering what the heck we're doing!"

He made two more low passes, rocked the wings, revved the motors, and switched the landing lights on and off. His girlfriend continued to wave the scarf. Satisfied, the sergeant headed back to the Midland airfield. Before we arrived, frantic citizens and the police had already flooded the base with calls, all reporting an unidentified aircraft over the city.

Some were certain the enemy had invaded Midland.

They weren't completely crazy. Only months before, at about 7 P.M. on February 23, 1942, while most people listened to President Roosevelt's Fireside Chat, a Japanese submarine surfaced twelve miles west of Santa Barbara, California, near the rich oil field on Ellwood Beach. According to one newspaper, "They lobbed sixteen shells into the tidewater field and [the residents] heard strange explosions . . . but [the Japs'] marksmanship was poor." Tokyo claimed the raid was a "great military success," though in reality the damage was no more than five hundred dollars. Nonetheless, this was the first attack on our mainland since the War of 1812—and the last before the September 11, 2001, terrorist attacks in New York and Washington, D.C.

Back at the Midland airfield the commanding officer ordered all crews to report immediately to headquarters. "Okay," he barked. "Who was the damn fool who scared the hell out of the good people of Midland?"

Knowing the other crews weren't aware of his revised flight plan, the sergeant kept his mouth shut. So did I. The CO was furious, but since no one else took credit for our asinine adventure, he assumed a crew from another base had caused the mischief.

Mission accomplished, we celebrated.

ON AUGUST 13, 1942, I graduated in the top fifteen of my class. On October 25 the air corps sent me to Hickam Field, on Oahu—which had also been struck in the Pearl Harbor raid—as a second lieutenant with the B-24 bombing unit of the Forty-second Squadron, of the Eleventh Bombardment Group, of the Seventh Air Force. The Eleventh eventually ran more than six thousand sorties to avenge the Pearl Harbor massacre.

My assignment also included working out of Kahuku Air Base on Oahu's north shore. There I continued my training, learned to speak a little Hawaiian, and ran practice bombing missions at eight thousand feet until my margin of error was about fifty feet. In other words, a virtual bull's-eye. My reward was a master bombardier classification and the knowledge that, in the words of Major General Eugene Eubanks, "The greatest bombing planes in the world take him [the bombardier] into battle through every opposition, and in thirty seconds over the target he must vindicate the greatest responsibility ever placed on an individual soldier in the line of duty."

I FLEW IN a B-24 Liberator. Here are its stats:

| | |
|---|---|
| Type: | Heavy bomber |
| Crew: | 8 to 10 |
| Armament: | Ten .50-caliber machine guns and |
| | up to 12,800 pounds of bombs |
| Length: | 66 feet 4 inches (20.22 meters) |
| Height: | 17 feet 11 inches (5.46 meters) |
| Wingspan: | 110 feet (33.53 meters) |

| Gross weight: | 56,000 pounds |
| Number of engines: | 4 |
| Power plant: | Pratt & Whitney R-1830 |
| Horsepower: | 1,200 each |
| Range: | 3,200 miles (5152 kph) |
| Cruise Speed: | 175 mph (281 kph) |
| Max Speed: | 303 mph (487 kph) |
| Ceiling: | 28,000 feet (8,534 meters) |

My baptismal raid took place just past midnight on Christmas Eve, 1942. Two days earlier we'd fitted our B-24 with bomb-bay fuel tanks, which meant a long hop, but no one knew to where. They just told us to take enough clothes for three days. I got a simple one-dollar bombsight for low altitude work, instead of the expensive model made by Norden. At 10 A.M., twenty-six ships took off from Kahuku. Five minutes later we opened our secret orders. Our mission was first to fly to Midway Island, 1,300 miles northwest of Honolulu. It took eight hours to get there. Each ship received a case of cold Budweiser when we landed. The marines there seemed to know exactly where we were headed next. One guy said he'd expected us for a few weeks. All I expected was a shower, quickly, even if all they had was hot and cold running salt water. I got one.

Afterward there wasn't much time to see the sights, which was no big disappointment, since Midway's only natural attraction was the albatross, also known as a gooney bird. Thick-billed with white chest feathers fading into chestnut, they take off into the wind, gathering speed like a plane. If they come in for a landing too high or low, they crack up in the bushes. Sometimes they fly into poles and wires, not seeing them in time to change course. Again, just like a plane. In fact, that's what they nicknamed the C-47 Skytrain, the military version of the DC-3 cargo ship: Gooney Birds.

At a briefing we learned about the rest of our mission: be the first to bomb Wake Island since the Japanese had occupied it a year earlier.

I was pleased even though I realized the mission would be like running a marathon. All Pacific runs were. In Europe, in most cases, pilots flew only several hundred miles to drop their bombs; some planes

could make two or three sorties in one day, loading up in between. Our journey to Wake was five thousand miles, one way. Fully loaded, we could fly almost three thousand miles without refueling; to make it to Wake required modifications, hence the bomb-bay fuel tanks and only six 500-pound bombs—half a load. That day workmen also coated the underside of our wings with lamp black—early stealth technology—so we couldn't be seen at night.

After a briefing the next day at 14:00, we studied our maps and targets thoroughly. Two hours later we took off, the ships stripped of all excess weight, heading for Wake, another eight hours away. Traveling these unheard-of distances was worth the risk to gain the element of surprise. With little to worry about but passing navy vessels that occasionally shelled Wake, the Japanese there felt secure and complacent. They never expected bombers.

Even though B-24s had the necessary speed and could handle the range, to some the ship will never be as popular as the earlier B-17, a good plane and, with its streamlined side profile, a glamorous bird. However, a plane doesn't fly sideways, and the B-24 was the real workhorse that won the war. Consolidated Aircraft and other companies manufactured 19,600 of them, a record. Until the B-29 came along, no bomber beat the B-24 for speed, range, or bomb capacity.

Each crew named its own plane and confirmed it with nose art. We christened our B-24 *Superman* and painted the Man of Steel on the fuselage.

Our pilot, Second Lieutenant Russell Phillips, was a short, easygoing Hoosier, a man who didn't waste words. We called him Phil. He flew us from Midway to Wake at ten thousand feet with lights on until we were within 150 miles of the target. The lead planes were scheduled to drop their payloads just after midnight.

At 00:05 hours I saw bombs from Colonel Matheny's plane hit the island. I opened our bomb-bay doors. Intermittent clouds covered Wake, so we dove from eight thousand feet to four thousand feet and pulled up. Because we used dive-bomb tactics, I only had a handheld sight and a few seconds to synchronize and calibrate my instruments as antiaircraft fire and 7.7-millimeter incendiary shells flew like firebirds over our right wing.

No one expects a heavy four-engine bomber to do a dive-bombing act, but we had a Davis wing that allowed the plane to cruise with pursuit-plane performance. B-24s were almost fighter-bombers. In fact, General Hap Arnold had set up my group as an experimental unit. At Kahuku we practiced skid bombing with torpedoes: dropping our explosives right above the water. Unfortunately, we encountered complications with them bouncing on the water and popping back up to strike the plane. Thank goodness accidents only happened on simulated runs with practice torpedoes. Eventually, General Arnold decided that skid bombing wasn't *that* good an idea for such a heavy ship.

We leveled out to drop our payload. I saw a red light on the tail of a Zero taking off at the south end of the island. I synchronized on the light through a thin layer of clouds and dropped one bomb on the north-south runway just as that craft left the ground. I missed but left a large crater. After waiting two seconds I dropped my five remaining bombs on the bunkers and planes parked near the east-west runway. Then we hung a sharp left turn in a barrage of bullets and watched the fireworks while Mitchell, the navigator, shouted out our heading and we made for home. Despite all the stuff the Japanese threw at us, not a plane was hit. I looked back to see bombs bursting everywhere—the rockets' red glare, indeed—and the island on fire.

We had smashed Wake and left the Japanese confused. Our dive-bombing made them think the attack was carrier-based. We made only one mistake: using the gasoline in our wing tanks first. When we pulled out of the initial dive the bomb-bay tanks were still full, and the centrifugal force caused them to slip an inch or two, wedging the doors slightly open. That created drag and used up more precious fuel, not to mention caused a draft.

The weather turned stormy and visibility failed, but all twenty-six planes returned safely to Midway. We landed around 8 A.M. This time the marines greeted each crew with a quart of whisky. At 14:00 hours we gathered and heard a radiogram from Admiral Nimitz: "Congratulations on a job well done." He knew what he was talking about; the navy had hidden two submarines off Wake to get a visual account of the attack. That night they threw a big party, and the next morning we

took off for Hawaii. When we arrived at Kahuku, no one was there to cheer us because our raid had not yet been announced publicly. It didn't matter. I was interested only in a freshwater shower and the Christmas party at the North Shore officers club that night.

ON NEW YEAR'S DAY 1943, my group received the Air Medal, presented by Admiral Nimitz, for our raid on Wake. Afterward, I went to a party with First Lieutenant Nichols, a pilot, and Second Lieutenant Carringer, a bombardier. The only problem we had was returning the forty miles to Kahuku from Honolulu. By the time we arrived at 4:30 A.M., the base was well underwater from a steady rain, and frankly, we were a bit underwater, too.

AFTER WAKE A newspaper reporter asked me if I'd been afraid. I think my answer must have surprised him—it certainly surprised me. "No," I said. "I've been more scared before races against Cunningham and Fenske." Yet it made sense. The Japanese didn't hit or challenge us. I also said, "But I never had a greater thrill than when I saw my bombs hit the objective." My comment still managed to ruffle some feathers among the brass, so from then on I kept my bravado to myself and prayed my luck would hold out as I flew countless reconnaissance and search missions and bombing runs over the Marshall and Gilbert Islands, in weather both violent and sublime.

I'd been called Lucky Louie stateside for years, and now my army buddies said it, too. Standing silently at one funeral after another, I thought maybe I did lead a charmed life, not that I could think of any reason why. To keep up the front, I maintained my devil-may-care composure on the outside, but on the inside I never stopped wondering how long my good fortune would last, how many more times I'd get back in one piece.

Lots of men didn't, and not always because their plane went down in combat. The B-24 had a few built-in problems, like leaks in the fuel-transfer pump, which shifts gas from one tank to the other in order to keep the plane balanced. For some reason, that pump was

lousy. Also, although the fuel cells were self-sealing, the wings often filled with fumes that permeated the plane. I always smelled gasoline while guys around me lit cigarettes.

An electric-motor spark could also set off an explosion. It happened to one bombardier I knew. His plane blew up at five thousand feet. Lucky for him he stood right at the end of the bomb-bay catwalk; the doors were still open and the blast pushed him out. He parachuted to earth and was the only survivor.

It's no wonder they sometimes called B-24s "Flying Coffins."

Afterward the bombardier refused to fly any more combat missions. He complained often of a bad back. The doctors couldn't find any evidence of a soft-tissue injury, but who can argue with a guy with a bad back? When we talked I realized he'd just used that as an excuse to get out of the service. They finally had to send him home because he kept complaining.

Another time a bombardier from a different squadron got sick and they called me to take his place. I had some kind of flu and said, "I can't do it. I'm in bed." The third guy they called took the mission, and the plane flew into a mountain.

I recorded those and other unfortunate incidents in my war diary:

*January 8, 1943*
*Reported to Operations for briefing at 8:05 A.M. Received report that Mozonett's ship went down just after takeoff from Barking Sands on the island of Kauai. We'd gone out together on a rescue mission only a few weeks ago—his first as first pilot. This time, Major Coxwell was at the controls. Lt. Franklin, copilot. Lt. Seymore, navigator. Lt. Carringer, bombardier. Captain Hoyt, S-2 man (intelligence). The plane went into the drink just after takeoff. The rumors were that its fuel was a mixture of kerosene and the usual 100 octane gas. The plane was found submerged 20 yards offshore while we practice-bombed same area from 15,000 feet. All members of the crew dead. They took off for a mock raid on Pearl Harbor, at 25,000 feet. It was dark at the time and the other two ships in the formation—Lt. Nichols's ship and Lt. Scholar's ship, carrying Captain Lund—didn't know about the fatality. Casualties: six officers and five enlisted men.*

*January 9, 1943*
*Up at 5:00 A.M. Briefing at 6:30. Took off on search mission at 7:00.*
*Filthy weather out 700 miles and back. Saw nothing. Major Coxwell's*
*crack up brought the total ships lost to nine since arriving. Personnel*
*lost: 53; 27 officers and 26 enlisted men.*

| Ship | Cause | Dead |
|------|-------|------|
| 1 | 4 motors stopped; forced landing | Navigator, bombardier |
| 2 | went down crossing Frisco to Oahu | 10 |
| 3 | motor afire, forced down Kahuku 424th | 4 |
| 4 | hit mountain in soup, take off wheeler 372nd | 9 |
| 5 | Blew up midair, 371st. Steel escaped | 7 |
| 6 | Mokoleia, in ditch, fell apart | 0 |
| 7 | Camera ship over Wake Island, hit by AA fire in wing and bomb bay tanks. Ran out gas 2hr short of Midway, went down | 10 |
| 8 | In drink on takeoff —Kerosene; Coxwell, Hoyt, Mozonett, Carringer, Seymore | 11 |
| 9 | nose wheel out | 2 |

Later the full report came in. Unable to contact the tower, Major Coxwell had taken off downwind, only to crash two or three hundred yards after completing his turn. Several crew members got free of the plane, but while trying to swim to safety sharks and barracudas caught and literally ripped them to pieces. Two other ships, also unable to

contact the tower, made it back by the skin of their teeth. We found a waterlogged paycheck for 400 dollars, belonging to Mozonett, on shore.

I KNEW THAT one day my crew might also end up in the ocean. Our squadron had already lost so many planes that not considering the possibility was just plain foolish. I had more than once nearly been among the dead.

When the bombardiers scheduled for two missions were unavailable, I volunteered. It wasn't exactly bravery; after every three missions we'd get a day off, and I always wanted more free time. In each case the bombardier returned at the last minute and I stayed home, sorely disappointed until both planes met with disaster. The first, full of bombs, flew into Oahu's central mountain ridge and exploded. The second crashed at sea.

I'd see planes crack up on landing and takeoff. Men would be at mess one day and not the next, and we'd never find their remains. Sometimes, when mixed crews—men from different crews put together into a new one after casualties—went on search missions, their unfamiliarity working with one another led to disaster.

Thirty minutes into one mission on *Superman,* Phil yelled, "Hey, Zamp, come up here! A motor quit. We can't restart it and Douglass can't find the problem. The gremlins are at it again. What do you think we should do?"

Gremlins were the imaginary elflike beings that supposedly trouble the crews of warplanes. They were usually associated with mechanical trouble, or failure, much like computer "bugs" are today.

Phil had asked for my help because I always seemed to have a fix. Primarily he was thinking of Lund, the operations officer, who took special delight in raking pilots over the coals for what he considered an improper decision. To put Phil at ease I said, "Go back to Kahuku." We knew other guys who'd had a motor quit, but they were already at the point of no return so they finished their mission. We'd just started.

Phil said, "Lund will eat our asses out." Lund was a mean son of a gun, but I could deal with him. "Go back," I said. "I'll handle Lund."

Sure enough, Lund saw us from his office as we landed. He climbed into his jeep and raced out onto the tarmac. "What the hell are you guys doing back here?" he yelled.

I said, "We had a motor quit."

"Other guys finish missions on one motor," he insisted.

"Okay, Lund," I said. "We'll take off on three motors and finish the mission on three motors—if you'll go with us."

That brought him up short. "Well, let's see now," he said. "There's, uh . . . uh . . . Okay, you can take ship number nine."

I'd been bold because, hey, what could he do? It was war. They needed us. Would they lock me up? Send me home? Great—send me home! Bombers blew up, crews got lost at sea. War's not glamorous. Send me home.

WHEN WE WEREN'T in the air I attended briefings and studied. I recall one lecture on emergency first aid for gunshot wounds, and bleeding control in general. Another covered offensive and defensive attacks against Zeroes. I took a class in meteorology and worked to perfect my instrument and compass skills. We practiced air-raid procedures and tear-gas alarms. I took skeet shooting at least once a week to learn to lead the target. The more I shot, the better chance I had of machine-gunning down a Zero. I also learned how to fly because Phil was promoted to first lieutenant and then let me log time at *Superman*'s controls to qualify as the third pilot.

Otherwise, I spent my spare time working out, playing tennis, seeing movies at the base theater and in Honolulu, hanging out at the officers' club, reading every Ellery Queen mystery I could get my hands on, shopping whenever I picked up my paycheck, listening to music or the radio, fooling around with my buddies, going to parties, checking out the nurses, making friends around the islands, and writing home. I missed my family terribly. Fortunately, I hadn't left a wife or girlfriend behind, so with no emotional strings I figured I should live it up while I could.

I also stayed in top shape and ran along Kahuku Beach. With the pleurisy gone I felt better than ever. On the airfield and at an exhibi-

tion meet in Honolulu I ran a 4:12 with ease. If I'd lost ten pounds I could have run even faster. In fact, I ran so well in Hawaii that I got invitations from New York promoters to run against Gunder Haag, the top European miler. However, General Hap Arnold refused to grant me permission. The way he explained it, I was in a special bomb unit. Due to our sometimes secret and experimental missions, I couldn't leave the island.

IN MID-APRIL 1943, at Kahuku Air Base, we learned we were about to make a big raid Down Under; during the war this referred not to Australia and environs but to southern Pacific islands. On the morning of April 18 I got up early and ran a mile on the beach, then did five 50-yard sprints. I reported with my flight crew to the alert room for a briefing and learned that our next assignment would be one of the longest ever.

Our orders were to fly from Oahu southwest to Canton Island, just below the Equator, refuel, then head southwest again to Funafuti, in the Ellice Islands group (now known as Tuvalu) in the south-central Pacific. Takeoff was at 13:00 hours. We checked the ship from A to Z but never got off the ground. Phil taxied too far on the runway and buried our left wheel in the mud. For two hours we struggled to get free, then had to change ships. Our new plane, number 143, had no radar, no belly turret, and no nose turret.

We bounced through two storms on the way but arrived safely at Canton Island, gassed up, ate, and left for Funafuti, an island maybe eight hundred yards wide surrounded by a series of small islets and completely covered with coconut and other tropical trees. Funafuti is where rescuers brought World War I ace Eddie Rickenbacker after his plane went down on an important mission from the States to General MacArthur in the Pacific, and he spent twenty-seven days adrift, fighting the elements. That was a long drift and I'd always been amazed that he'd survived.

Funafuti's natives were primitive Micronesians who lived as they had for almost five hundred years. They spoke no English but managed to say hello in the usual way: "Halowa." Girls and boys no older

than five smoked cigarettes, reminding me of my youth. Funafuti had a great swimming beach, if you didn't mind the occasional shark. I was curious to see more and toured the village. My big discovery: girls wore a cloth (a *lawa lawa*) around their bodies—and that's all. That night the base theater featured *Wives Under Suspicion* with Warren William and Gail Patrick. Then a big storm blew in. We filled our canteens with ice water at the Reef and bunked down for the night in tents with dirt floors.

I ate a fair breakfast, then waited for a briefing at 13:00 hours. Meanwhile our own plane arrived, liberated from the mud, and we traded crews. I supervised loading bombs: three 500-pound demolitions and five fragmentation cluster bombs with six 30-pound frags on each.

At the briefing General Hale announced our target: Nauru Island, home to the world's greatest concentration of phosphate. The Japanese sorely needed phosphate for fertilizer and explosives. Our orders were to fly west toward Guadalcanal, hang a sharp right, and come in on that heading to confuse the Japanese about our base location. Over Nauru the entire flight of twenty-six bombers would drop their payloads from eight thousand feet, at noon. We'd also maintain radio silence.

Some of us questioned the plan, since Nauru was heavily fortified with antiaircraft guns. We believed the flights should vary in altitude. I turned to Phil and said, "That's a pretty low bomb run. All the Japs have to do is synchronize on the lead flight and we'll all get hit."

"Those are the general's orders," he said with a casual smile and a shrug. Phil didn't fight unnecessary battles, but he had convinced me repeatedly on previous flights that he was one of the best pilots in our group. If Phil seemed relaxed, I wanted to relax, too.

The next morning we were up at 03:00 hours, ready and anxious. At 05:00 we took off, but just barely. Between Funafuti's limited, 3,500-foot airstrip and our plane's heavy load, bombs and fuel and a crew of ten, it was tough to get off the ground. We flew low, flicked the lagoon with our landing gear, but managed to climb.

*Superman* was the lead ship of E flight, of the 372nd squadron. Our navigator, Lieutenant Mitchell, gave us an ETA and finally announced the island was twenty minutes away, dead ahead. Then he squeezed

into the nose turret, with its twin .50 caliber machine guns, his job now the same as the other gunners': to ward off enemy fighters and provide the bombardier—me—with an uninterrupted run on the target. With my Norden bombsight wired to the automatic pilot, I assumed control of the plane with each aiming correction. I did my calculations, fed them into the bombsight, and focused on the drop.

Suddenly we entered a cloud of flak and antiaircraft fire. General Hale had, as I'd anticipated, made a mistake by having us all fly in at the same altitude. Puffs of black smoke dotted the sky around us—a dangerous situation. With bombs armed and ready, one hit in a vital spot would blow us to smithereens.

An explosion rocked the plane as antiaircraft fire shattered our right vertical stabilizer. Then below us the fragments of another antiaircraft burst hit the fuselage like hailstones on a tin roof and penetrated the underside. The ship yawed but I got my crosshairs back on target. I managed to drop my payload on the planes, structures, and antiaircraft batteries along the runway. I also had a free-choice target. Spotting a small building at the end of the runway that looked like a radio shack, I dropped my bomb, and much to my surprise and delight I hit the island's fuel-supply depot. A cloud of smoke and fire billowed skyward. A photo of this was in *Life* magazine.

I looked out the greenhouse nose window and counted nine Zeroes in the air. Seven were nearby at ten o'clock. Three peeled off and headed our way. The first came dead ahead at one o'clock. He opened fire and Mitchell returned it, simultaneously. I heard a loud crack as a cannon shell from the Zero severed our turret power cables and whizzed past me, missing my face by inches. It continued through the Plexiglas window and lodged into the port wing between the number-one and number-two motors. Fortunately it failed to explode, saving the ship and crew from disintegrating into flaming fragments drifting lazily down into the sea.

But there was no time to speculate about miracles. Mitchell had scored a deadly hit just before the turret power went dead. Luckily, the Japanese pilot slumped forward against the stick and the plane dived beneath us and spun crazily to earth, sprouting a fiery crimson

tail. Meanwhile, with no power to the turret, I had to physically extricate Mitchell.

I felt another explosion as *Superman* shook again. Over the intercom someone called for help. I crawled back to the flight deck and found our radioman, Sergeant Brooks, hanging from the narrow catwalk, over the open bomb-bay doors, with eight thousand feet between him and the ocean. The catwalk is seventeen feet long and only ten inches wide; traversing it in a moving airplane in good conditions is itself a high-wire act. It wasn't meant to be a trapeze.

I will never forget Brooks's pleading and bewildered eyes as he stared up at me. I grabbed him by the wrists, and thanks to my weight training and a burst of adrenaline, I soon had him on the flight deck just below the upper turret.

The bomb bay was covered with thick reddish purple oil, meaning that cannon fire had penetrated the area on the starboard side and knocked out our hydraulic system. That's why the doors wouldn't shut. I realized then that we wouldn't be able to raise or lower our flaps or landing gear, either, except by hand. And our brakes wouldn't work.

I manually shut the bomb-bay doors and attended to Brooks, who babbled incoherently. When I looked at his back I knew why. Shrapnel had penetrated his sheepskin jacket and his head, leaving him bloody to the waist. I gave him a shot of morphine, put an oxygen mask on his face, set it for ten thousand feet, and did what I could to stop the bleeding.

Another crash above me sounded like cannon fire hitting the radio compartment. Then I felt something wet and warm trickle down my neck. I looked up at Sergeant Pillsbury in the upper turret; the shells had crushed his foot and peppered his leg with shrapnel. Twelve inches lower, and the metal fragments would have caught me in the head, had I not been kneeling over Brooks. What was left of Pillsbury's toes dangled through his shoe. Blood spurted and dripped down on me. But Pillsbury didn't cry out in pain. Instead, he screamed angrily and swung his gun toward the Zero as it made another pass, then madly triggered his twin .50s. Flames spurted from the Nip's cowling, and he slumped back. I followed his plunge until he hit the drink.

The Zero pilots were almost like kamikazes, coming in so close. They couldn't miss us and we couldn't miss them.

I grabbed a medical kit, gave Pillsbury a shot of morphine in the leg, put a sulfa drug on his foot, and bandaged him. Then another round of fire shook us severely and Phil almost lost control. It took all the strength and expertise he and his and copilot, Lieutenant C. H. Cupernell, had to keep us airborne as shells ripped into the B-24's waist.

More cries for help arose after the burst that had hit Pillsbury also shot-locked the flight-deck door. I gave it a couple of mule kicks, and it gave way. I hurried down the catwalk, then stepped into the waist section again. I thought I'd seen the worst of our situation, but no. The carnage was stunning. Four airmen—Douglas, Lambert, Glassman, and third pilot Nelsen, were all torn flesh and exposed innards, a blood-spattered scene. Douglas and Glassman, though critically wounded, still manned their guns as a resolute Zero pilot made a very close return pass over the starboard side. Glassman caught him coming in, and Douglas nailed his aft end as he passed over. The Zero went into a long spiral and then straight down as he entered Davy Jones's locker. Thank God this was the last Zero. One more hit and we'd have joined them.

It seemed to me then that our battle with the three Zeroes had taken an hour, but in reality it probably took less than ten minutes. It was a fast-running game of staying focused on staying alive.

Staying alive . . . I had too many wounded men to take care of myself. I called Phil on the intercom and said, "This is more than I can handle. I need help."

"I need Cup here to keep the plane from stalling," he replied.

"This is important," I shouted, and described the situation. Phil said he'd use his knees as well as his hands on the yoke to stabilize the plane, and Cupernell came aft. His eyes widened with disbelief as he took in the blood and guts, but he immediately tended to a lieutenant lying on the deck with his stomach ripped open. He was our extra passenger who had asked to come along to "see the fun."

"Is he dead?" I asked.

"Not yet," said Cupernell. He worked on Douglas's leg while I treated Nelsen's ripped stomach. We stripped clothes off the other

wounded and gave morphine and sulfanilamide. Seeing my buddies like that was a shock, but I was well trained. I buried my feelings.

AT THE BRIEFING prior to takeoff, the S-2 officer said that if it looked like we might not make it back, to remember the submarine *Drum* would be twenty miles from Nauru on our return heading in case we had to ditch. But we were already well beyond the 20-mile mark, with 730 to go. Phil and Cup finally had the plane under control, erratically, but with the Pratt & Whitney motors still humming we decided to make straight for home.

I assessed the damage. The right vertical fin was shattered. The hydraulic system, radio, and nose turret were out. My immediate concern was a hit that severed all but one strand of rudder and elevator control wires on the right side of the plane. Thanks to my limited sailing experience, with the arming wire from the bomb rack I was able to splice the strands together. It was crude, but it did the job.

Mitchell focused solely on getting us back to Funafuti and was oblivious to our situation until he confirmed our ETA. Later, he felt bad about not being able to contribute during our medical emergency.

Witnessing the men who suffered the worst of it, I have never seen such courage. I can't remember the wounded screaming with pain— and not because the noise of battle was so fierce. They stuck to their guns and simply accepted their bloody wounds. It was as if they were saying, "You can hit me, but you can't make me cry." I liked that sentiment; it had always been my own. I believe they took comfort in knowing that our counteroffensive had cost the Zeroes dearly. Looking at each of their sober faces, I said, "You guys got all three Japs, and I confirmed the kills." They managed satisfied grins.

EVEN IF WE made it back to Funafuti, I didn't know how we could land. The flaps, wheels, and brakes depended on the now destroyed hydraulic system. As a backup, we were able to hand-crank the flaps

and put the wheels down. But the brakes were another matter. It seemed obvious to me that given such a short and narrow runway— less than a mile long—we'd plunge off the strip and into the ocean. This was a serious situation, the six critically injured men aboard notwithstanding.

I pumped the wheels down by hand, hoping they locked, and left the flaps for last because if I cranked them down first, I couldn't see whether the wheels were locked in place. I also opened the bomb-bay door, hoping the drag might slow us a bit more.

Next I turned my attention to the problem of stopping. For brakes, I rigged up two parachutes, one at each waist window. As we touched down I planned to pull both rip cords together and pray that my jury-rigged air brakes would do the job. I also worked it out so that I could stand in the middle and turn the plane by controlling the left and right chutes. It was makeshift and crazy.

Mitchell gave us twenty minutes to Funafuti. Phil worried aloud about the ship porpoising on a normal descent to touchdown and crashing, so he decided to come in low and flat. Even with extra speed I was sure my parachute brakes would work.

I also tied parachute cords around each airman and a secure part of the plane. Rather than make a knot that would tighten on impact and be next to impossible to untie, I simply looped the cord and gave each man an end. They'd be secure yet could free themselves easily.

Finally, the moment of truth arrived. Our wheels hit the blacktop and the plane grumbled and creaked. Suddenly it ground-looped, spinning us off the runway to the left and right at another B-24 coming our way. After all we'd gone through, would it end with two 4-engine bombers smashing into each other on the tarmac?

Cupernell instinctively hit the right pedal, even though he knew we didn't have any brakes. There was just enough fluid in the well to cause the wheel to momentarily lock, swinging us ninety degrees to the right. Seems the cannon fire that had narrowly missed my face had also entered the left tire and flattened it, which had caused the ground loop and cleared us of the runway.

We stopped.

.    .    .

HOW EERIE THE sudden silence. I jumped out and gave the cross signal, and the marines raced out to help us. One marine was way out in front of the others, and when we came face to face I shouted, "Art!" and he shouted, "Louie!" It was Art Redding, a USC champion half-miler and pilot. "What the hell are *you* doing here?" he asked. (Later, poor Art crashed off Funafuti and was eaten by a shark.) We hurried to evacuate the injured, but the marines, graciously, would not allow me to help. I went ahead to meet the doctor. He introduced himself as Dr. Roberts, which was an odd coincidence since I'd taken my first advanced first-aid course at USC from another Dr. Roberts.

Wanting to be with my crew, I asked Roberts if I could help. He said, "From what I'm looking at I can use all the help I can get."

Ambulances hauled seven men to the hospital for emergency operations. Afterward the doctor said, "If it wasn't for the proper medical care you gave the injured, three would have died. You saved two, and the copilot saved another."

Later, Phil and Cup attended the briefing where Brigadier General Landon and Major General Hale evaluated the mission's success. They discussed the tragedies that struck our first flight over the target. They knew we'd encountered fierce opposition. We were in the lead flight because, as in the marines, the best go first. We spearheaded the raid to knock out enemy antiaircraft nests and Zero fighters, thus paving the way for the trailing flights and providing them with uninterrupted bomb runs on the phosphate factories. It was months before they'd be able to resume production. What's more, the Japanese had been duped into sending out their available fighters against our flight, leaving the coast clear for the rest to shuttle in and out of the target area at will. We heard that there was scant antiaircraft fire to bother the later flights, and only two Zeroes, which, seeing their heavy losses, decided not to mix it up.

Both generals credited Phillips and Cupernell with a miraculous performance in bringing the badly damaged *Superman* back without a crash, and on April 21 they said so to Charles Arnot, the war correspondent for the *Honolulu Advertiser*. General Hale then came to the hospital to pin the Palm Leaf on our wounded crew members.

Our B-24 was put on display, the center of attention. The marines and airmen swarmed around counting cannon and bullet holes. General Hale said we had the worst-shot-up B-24 that ever limped back to the base: 4 cannon holes, 2 heavy antiaircraft hits, 500 shrapnel holes, and 150 7.7-millimeter bullet holes. The nose and upper turrets were useless. The right tail was gone. We had truly made it on a wing and prayer.

I went to General Hale to give him a breakdown of our mission. I told him of Phillips's and Cupernell's skill and courage. I told him of the gunners who had delayed medical attention to keep on shooting. I recommended a commendation for these men, but the general didn't seem to be listening, so I stopped talking and went back to the hospital.

Arnot had just returned from checking out the damage to *Superman* and found me there. He asked how it felt when I was faced with the task of patching up the wounded. I said, "It was the toughest race of my life."

In the interview I gave Arnot and a marine major, who was also a pilot, a blow-by-blow description of our engagement with the enemy. The major said, "After examining your bomber and from what I saw in the hospital, I would say that besides a batch of Purple Hearts, your crew most certainly earned the Distinguished Flying Cross."

Like all flyers, I knew the Cross stood for "heroism and extraordinary achievement in aerial flight," but I said, "Just being able to help is reward enough for me."

Just then Dr. Roberts came in and said, "Lieutenant Zamperini, your radioman, Brooks, just died." Sad. Mentally, physically, and now emotionally worn out, I went to my tent and fell asleep.

I SLIPPED INTO my bunk that night not knowing that one of our pilots had panicked during the mission and broken radio silence. He'd called Command to ask, "Should we take the heading back to Guadalcanal?"—which we were supposed to do before cutting over to our real destination—"Or shall we go directly back to Funafuti?"

About one in the morning I awoke to the sound of aircraft overhead. I thought, Well, somebody's coming in from the States. Wrong.

The Japanese had intercepted the pilot's radio transmission and learned our location. We had no warning because the marines, evidently, had not been fully alert and had not picked up the planes on their radar. Or maybe, like me, they thought they were friendly.

Explosions started at the far end of the island as Sally or Betty bombers, or both, pattern-bombed our installation. The attack continued for ninety minutes and did considerable damage. Every airman in my tent immediately and spontaneously dashed for cover, no matter that it was raining and we were clad only in our briefs. We tumbled into an air-raid shelter dug under a native hut and jammed in like sardines, our hearts pounding. Someone landed on top of me. Just then—*boom*—a mortar hit and blew my tent and the war correspondents' tent to kingdom come. Later I found a reporter huddled over his mangled typewriter mourning it as if it were a close friend.

More damage. During the first pass, a frag bomb ripped an army truck to pieces and mangled three men from the 371st to ribbons. On the second pass the church took a direct hit. Fortunately we had evacuated two minutes earlier and also told the natives to hide in foxholes. Three died when they didn't get inside far enough. On the third pass they killed more soldiers. On the fourth pass we took direct hits on two B-24s, each fully gassed and stocked with bombs. Later we found landing gear and motors four hundred yards away.

The Japanese laid tiny Funafuti to waste and got us good, ruining several planes, demolishing the personnel area, and filling our makeshift hospital with dead and dying. I went to the field hospital again to help Dr. Roberts.

The next day we remained on alert, waiting for the Japanese to return. They didn't. Eventually the commander ordered incomplete crews and those without ships but fit for combat to fly back to Canton. Those still in good shape flew to Tarawa to retaliate.

The day after that we left Canton for Palmyra, a beautiful island of palm trees and coral eight hundred miles south of Hawaii that served as a navy and marine base. It was gorgeous and almost like another world after what we'd been through. (Years later, former Los Angeles district attorney Vincent Bugliosi would write about a murder that happened there in *And the Sea Shall Tell*.) I ran into a few fellows from

USC, and spent some time at the officers' club. They also had a swell theater. I saw *They Died with Their Boots On*, starring Errol Flynn, had a few beers, took a hot shower, and went to sleep glad I was alive and that my boots were under the bed.

FOR SOME REASON, when General Hale submitted his report of our mission to headquarters in Hawaii he wrote that the destruction had been very light. It wasn't true and it made me mad. Half our planes were hit, ours the worst. And though everyone made it back to Funafuti, we lost ships there on the ground when the Japanese retaliated. I still have pictures that show the total devastation. Few of our B-24s could be salvaged. Caught in their bunkers, they exploded and left holes thirty feet deep and eighty feet across.

Of course, Hale never recommended Distinguished Flying Crosses for *Superman*'s crew. I credit this omission to a lack of communication between General Hale and myself. I believe the trouble started shortly after I arrived in Hawaii. After any raid, the press would interview the commanding officer; if I was on the mission they'd also talk to me, the famous Olympian. Sometimes our stories didn't exactly jibe; more often my picture appeared instead of General Hale's. I'm convinced he resented that, but the press was right. You had to talk to the soldier on the front line to get the story. As General Colin Powell has said, "In battle, to get the real dirt, head for the trenches." Of course, it's not the whole story; no one plane or infantryman can see the whole picture. You're so focused on your job and staying alive that you are usually unaware of what anyone else is doing. That's why we had debriefings. Every man would tell his story, and the commanding officer and his staff would put the pieces together.

When General Hale put the pieces of the Nauru raid together, he didn't present all the facts, as far as I'm concerned, and our crew, which to my mind and others' had more than earned a Distinguished Flying Cross, was passed over. As far as the history of World War II is concerned, I am sure that there were as many discrepancies as with history in general. As Will and Ariel Durant have written, "Most history is guessing, the rest is prejudice." Still, I got mad and sick to my

stomach when I read what General Hale said: "One plane got hit." My crew just said, "Tell him to shove it. We don't want any medals. Not when they give them away indiscriminately to some people and then, when people really earn it, they aren't recognized. It's a farce. Think of all the guys who should have had medals and didn't get them. They're dead."

I had to agree. In the end a medal doesn't mean a hill of beans. We all know what we did.

BECAUSE DANGER AND death were all around, I did what I could to distract myself. A time-honored way was to needle crewmates, or get back at them for needling you.

At Kahuku we lived in a barracks with a room on each end. A crew that didn't return left one unoccupied, so I took it. It came with an icebox that had three shelves. I gave a shelf to Phil and one to Cupernell. Whenever I'd get a ration of beer I'd put it on my shelf. But too often I'd find my beer gone. All of it. At first it was kind of funny, but we only got a small ration of beer and the joke quickly wore off. I decided to get even.

One morning we were supposed to report to our ship to swing the compass. That meant taking off and following various headings to check their accuracy with the navigator. They did not require me on the run, but I showed up before Phil and Cupernell got there. While the ground crew prepped the plane, I walked around the ship, chewing a big mouthful of gum, like I was in the midst of a preflight inspection. Working my way to the nose, I found the two small holes I wanted: drain openings for hoses in the cockpit that connected to the pilot relief tubes; in other words, funnels into which the pilot and copilot peed while flying. The urine ran down the hoses, and the wind sucked it out.

I plugged both holes with gum.

When the crew reported for duty, I got on the ship with everybody else. I went to my post in the bomb bay, and we taxied to the end of the runway for takeoff.

Procedure calls for closing the bomb-bay doors just prior to hitting the gas. Before the doors shut I dropped onto the tarmac and dashed

off the runway. It's a big ship inside and nobody missed me. Phil took off assuming I was onboard. Instead, I headed for Honolulu.

Later the engineer gave me a blow-by-blow description of all the fun I'd missed. When Phil had to urinate he used his funnel. Instead of emptying, it filled to the brim. Phil needed one hand to balance the funnel so it didn't spill. He couldn't figure out the problem, so he called the engineer, who decided to pour the excess into the copilot's funnel. Cupernell didn't mind, but first he wanted to take *his* leak. When his funnel filled as well, no one could believe it. Two malfunctions simultaneously?

There they were, balancing their funnels and trying to fly.

The first bit of air turbulence was the coup de grâce.

Phil and Cupernell landed, soaked. The engineer went under the ship, found the gum, and scooped it out. Then they came looking for me, but I was already gone. Phil, who called me Zamp unless he was mad, kept hollering, "Where's Zamperini?" He figured I had to be nearby, but I stayed in Honolulu for a couple of days.

When I got back they were still uptight. I treated their complaints casually. "Hey, no use getting sore about it," I said. "After all, I gave you a lesson, a hands-on experiment, in the laws of physics: liquid seeks its own level. Just like my beer."

They looked at me, puzzled, then half grinned. My punishment was to pay for a few beers, after which they felt much better, and my rations never disappeared again.

I STILL WANTED my revenge for the carpet bombing on Funafuti, and I found it during a raid on Tarawa. Operating out of Canton Island in the South Pacific, we were on a secret two-plane photoreconnaissance and bombing mission covering the Marshall Islands. The squadron commander had two specific targets in mind: Tarawa on the first mission, Makin on the second. Tarawa was covered with broken clouds, which prevented photographs and bombing. We flew in circles, hoping to find an opening, until our engineer reported the fuel supply dangerously low. We had also lost sight of our lead plane. Cupernell said, "I'll bet that damn colonel headed back without telling

us." Just then a stern voice came over the radio. "I heard that, Cuper-nell," the colonel said. "Salvo your bombs and head for home."

I prepared to dump all six of my 500-pound bombs when I spotted a "necessary" military installation at one end of Tarawa. Just offshore six thatched-roof outhouses on stilts graced the lagoon. The entire crew was behind me: these structures must be laid to waste. As a master bombardier, I coolly commanded the skills of my trade. I peered through my Norden bombsight, lined up the crosshairs, and let go. The result was a direct hit of memorable and messy proportions.

Flush with victory, we made a beeline for Canton. But the engineer had some bad news: we might not make it back. Howland Island, the destination that Amelia Earhart had failed to reach, was nearby, so we had two choices. Plan A: try for a night water landing just off Howland. Plan B: jettison some heavy gear, move the crew forward, throttle back, and take our chances. B-24s were totally vulnerable and not at all graceful during water landings, even on a smooth sea. If we put down and anyone was injured or died, the blood in the water would attract the sharks.

We opted for plan B and trusted our navigator to find Canton, a mere speck in the sea. When we spotted it through the clouds and landed, sputtering, the last of our fuel spent, everyone had smiles and congratulations for Mitchell, who'd gotten us home.

That evening the P-39 marine pilots based on Canton treated us to beer at the "officers' club"—a Quonset hut covered with coral. Scrawled on the front door—and in all the toilet stalls—was the signature of a character legendary throughout the Pacific theater: KILROY WAS HERE.

Luckily, even in the face of incredible and persistent danger, we were, too.

# 5

## PREPARE TO CRASH

*May 27, 1943*

*Been fixing up our new living quarters, a house only 80 feet from the beach. Stove, icebox, even a private bathroom. Moving in not a moment too soon: a quart was stolen from under my pillow last night.*

*Got a call from operations that a B-25 has gone down in the ocean 200 miles north of Palmyra. We're the only crew left on the base, but Superman is in for repair. Phil went ahead and volunteered us for the rescue mission anyway.*

The only available ship was a "musher" called the *Green Hornet*. A musher flies with her tail down and can't get off the ground with a bomb load. Our engineers had checked it from nose to stern more than once and promised it was exactly like all our other B-24s: it *should* fly right; it just didn't. No matter. We'd stripped many of its parts to use on other planes, so we mostly flew the *Green Hornet* on the cabbage run, meaning we'd take it to the main island of Hawaii to pick up lettuce, fresh vegetables, steaks, and stuff like that. Very occasionally it went on search missions.

Our crew of ten, after the Nauru raid injuries, was Russell A. Phillips, Otto Anderson, Leslie Deane, Frank Glassman, Jay Hansen, Francis McNamara, Michael Walsh, C. H. Cupernell, Robert Mitchell, and me. We were joined by an officer who just wanted to go

to Palmyra, where we'd land and refuel after the search. At 18:30 we and another B-24 also on the mission took off.

I figured we'd be back for dinner. Rescue missions were nothing new. We'd recently saved a B-25 crew after they'd sputtered out of gas and ditched in the ocean a couple hundred miles from Oahu. I spotted them with the Zeiss binoculars I'd bought at the 1936 Olympics in Berlin. From the sky, bobbing rafts look like mounds of water to the naked eye. I saw not only the rafts but smoke from a flare. We flew closer, radioed in, and circled for an hour until the PBY—a navy flying boat—picked up the crew.

For some reason during the flight out, our copilot, Cupernell, wanted to change seats with Phil, who I'm sure didn't give it a second thought because sometimes he'd also let me fly the plane so I could log hours and be used as a third pilot in case of emergency, or to cover for him and Cupernell after they'd had a hard night in Honolulu and no sleep. I didn't party much because I wanted to stay in top shape. A beer or two, that was my style. On the other hand, they'd stagger in after hours and, once aloft, take turns curling up on the radio deck for a nap.

WE ARRIVED IN the downed plane's vicinity to find cloud cover at one thousand feet. Phil dipped to eight hundred to get a better look and called me to the cockpit while we circled so I could scan the sea for wreckage or a life raft.

Suddenly the RPMs on our number one (left outboard) motor dropped radically. It shook violently, sputtered, and died. Phil called the engineer forward to feather the props. Blades normally face nearly flat to the wind so they can cut into the air and pull the plane forward. However, when a motor stops, those surfaces are like a wall and everything slows. Feathering means to turn the blades edge-on to the wind. Think of it this way: you're in a car doing seventy miles per hour. Put your hand out the window, palm forward, and the wind will blow it back. Turn the edge of your hand to the wind, and it slices right through. Feathering is possible because we had variable-pitch propellers, allowing a different blade angle for takeoff, cruising, or when the motor stopped.

After the Nauru raid a new engineer had joined our crew, a green kid just over from the States. He was so eager to help that he rushed into the cockpit and feathered the *left inboard* (or number-two) motor by mistake—and it died. That old musher could barely fly with four motors and no bombs; suddenly we had two motors out, *both on the same side*.

At first we seemed to glide, then the plane shuddered and we dropped like a rock. Remember that we were at eight hundred feet, flying beneath the clouds. Even at one thousand feet you don't have much chance to do anything in an emergency, particularly restart a motor. Before you know it you hit the ground—or in our case the water—and all that's left is an oil-slick fire and debris. Still, I would gladly have taken the extra two hundred feet and a few more seconds to try and save ourselves.

We had neither.

When props go out, most pilots immediately compensate by increasing the power to the engines that still work. All our power was on the right wing, and to boost thrust would force the plane sharply to the left and push it in a circle, causing the dead side to drop while the live side climbed. Flyers in similar situations had been killing themselves like that for years until a test pilot named Tony Lavier figured out that if you lose power completely on one side, you had to *decrease* power to the good engines. Then you level out. It seems unnatural, but it works.

Phil could throttle back to keep the plane from yawing to the left, but the *Green Hornet* itself was in such miserable shape that the maneuver would simply make us drop faster because we had no lift.

Caught between two bad options, Phil had no right choice.

He increased power hoping that if we stayed aloft even a little longer he might regain control, restart the motor, or attempt a water landing. It was no use. The *Green Hornet* angled to the left and keeled over.

THE MOST FRIGHTENING experience in life is going down in a plane. Those moments when you fall through the air, waiting for the inevitable impact, are like riding a roller coaster—with one important

difference. On a roller coaster you close your eyes, hold on despite the sheer horror, and come through. In a plummeting plane there's only sheer horror, and the idea of your very imminent death is incomprehensible. Of course, only if you've lived through a crash can you tell anyone about the abject terror. You think, This is it. It's over. I'm going to die. You know with 100 percent of your being that the end is unavoidable. Yet a part of you still believes you can fight and survive no matter what your mind knows. It's not so strange. Where there's still life, there's still hope.

What happens is up to God.

Phil looked at me. I knew without his uttering a sound that we were probably dead. Still, his lips moved. Maybe he shouted, maybe he whispered, but I heard him loud and clear. I'll never forget his words: "Get to your stations and prepare to crash."

I RUSHED TO my position in the waist section, at the right window, next to the machine-gun tripod. I already wore my life jacket; I knew the drill because we'd practiced it again and again on the ground.

In every water emergency a lot depends on how you land—if you land. A B-17 can make a smooth touchdown; if you dump the fuel beforehand, it will float for about thirty minutes, enough time to get all the life rafts and supplies off the plane. B-25s can also handle the water, but B-24s usually fell apart no matter how good the landing. The retractable bomb-bay doors were about a quarter inch from being flush with the fuselage. Hit the drink at two hundred miles an hour, catch the edge, and water rushes in, tearing the plane to bits—and that's if you come in easy.

In our case, none of that mattered.

All B-24s pack two life rafts in fuselage compartments above the wings, mounted against spring-loaded plates. The outside covers latch with a pin, with a weight on the end. When the plane hits water, the impact dislodges the pin, the doors burst open, and the spring plate throws the rafts out about a hundred feet, over each wing, into the ocean. That pulls a trigger mechanism and the rafts inflate while still

attached to the plane by parachute cord. When the plane sinks below
a certain depth, the cords pull free of the plane.

A third life raft was packed in the bomb bay next to my position. My
job was to get it out of the plane after a water landing. A big, water-
proofed metal box of rations sat nearby, with enough fortified choco-
late, cans of water, and other food supplies to last ten guys for two
weeks. The engineer or tail gunner's job was to grab the survival box.

My stomach tightened and lurched as we tumbled and turned. I
crouched low and braced myself against the soft round raft. In fact,
I'm sure I hugged it.

The nose and the left wing hit the water simultaneously. We did
half a cartwheel.

I expected my life to flash before my eyes. It didn't.

Then the plane blew apart.

FROM PHIL'S WARNING to impact took less than two minutes,
then the world was on fire. Had I been in a boat nearby, watching the
*Green Hornet* explode into a ball of flame, it might have sounded like
melting, twisting metal and fireworks trying to harmonize. Sur-
rounded by chaos, I heard nothing but my fear.

The crewman to my left died instantly. The ration box flew by my
head and disappeared. The crash tossed me forward and down, forc-
ing me under the tripod, which was bolted to the deck plates. The raft
jammed beneath my body and wedged me in. The double tail snapped
off, and the wires connecting the elevators and trim tabs to the cock-
pit controls sheared and whipped around the tripod like tightly coiled
springs, further caging me. It took only seconds, enough time to real-
ize that I was still alive, trapped, and the plane was sinking.

No matter how I struggled, I just couldn't get loose from the tri-
pod and the sharp, springy wires that wound around me like metal
spaghetti. I looked out the waist window and saw two mangled bodies
drift by. I sucked in a huge lungful of air and kept my eyes open as we
went under. No way I'd give up. I'd done free diving in Hawaii, and
because I ran I could hold my breath longer than most people—over
three minutes. I used to practice by sitting on the bottom of a public

pool, hanging on to the drain grate, until my friends thought I'd drowned and dove in to save me.

When my ears popped I knew I was about twenty feet beneath the surface. As I sank deeper I felt a pain in my forehead like I'd never experienced, much less ever imagined, as if someone had hit me with a huge sledgehammer. My sinuses seemed about to burst; the headache was unbearable. This is hopeless, I thought. What can I do? Nothing. I can't budge the wires. I'm sinking. My air is about gone. I have to accept it.

I'm going to die.

I lost consciousness and everything faded to black.

AND THEN FOR some unexplained reason my eyes opened.

Was I dreaming? Maybe I'm dead, I thought. Maybe this is the afterlife.

I figured out pretty quickly that the afterlife—at least the one I'd counted on—was probably not a wet, cold, and gloomy place in which my lungs screamed for air. I was still underwater, some seventy feet down, but I found myself completely free of my death trap and floating upward. My arms reached out blindly, hands searching, and then I felt a tug. My USC ring had snagged on the right waist window. I immediately grabbed the frame with my left hand, and although I thought my lungs would burst, I arched my back and squeezed through the opening, scraping the skin off my back.

I knew I had to inflate my Mae West—my life jacket. I could do it either of two ways. In the plane we blew them up by mouth. I couldn't do that underwater with no air. The other way was the $CO_2$ cartridge packed into each vest. Sounds easy enough except that most vests didn't have cartridges because the men always swiped them— sometimes even from other airplanes—so they could make soda water to go with their Scotch.

Luckily I still had a functioning cartridge and the jacket inflated. Then I rose toward the light for what seemed like forever, swallowing seawater mixed with gasoline, oil, hydraulic fluid, blood. When I broke the surface I gasped for air and threw up. The whole thing had taken maybe fifteen seconds; I had operated on pure instinct.

All I could see was fire on the water. As I caught my breath it hit me that I was alone, floating in the vast Pacific, hundreds of miles from land, the ocean floor far below and my despair perhaps even deeper.

SUDDENLY I HEARD a cry for help. Through a break in the smoke to my left I saw an auxiliary gas tank float by, twenty feet away, with Phil and Francis P. McNamara, the tail gunner, clinging to the side. Their eyes were wild and strange. Blood gushed from a deep triangular gash on Phil's head.

I looked around for any of the remaining eight crewmen but saw no one. We three were alone with the bobbing debris and our knowledge that with blood in the water the sharks would soon arrive en masse. That scared the heck out of me, especially when I saw two life rafts that had been automatically ejected from the plane drifting away from the wreckage on the current.

I wanted to help Phil and Mac, but to lose our only means of survival would be crazy. The guys could wait. I made for the nearest raft, but with clothes and shoes on I couldn't keep up. It was a pointless chase; the rafts were moving farther away. I'd just about given up when I spotted the last three feet of the hundred-foot nylon parachute cord attached to the raft. I managed to grab the rope and reel in our new home.

I climbed in, unhooked the oars, and rowed back to the bomb-bay tank hoping Phil hadn't passed out or bled to death. I helped him and Mac into the raft and immediately put pressure on Phil's carotid artery. From my survival training I knew about the little dip in our jawbones and how to find the artery there. The bleeding slowed.

"Mac, take off your T-shirt and soak it in the water," I ordered. "Now hold it on Phil's head and press." I took my hand off the artery, removed my T-shirt, tore it into a long strip, and wrapped it around Mac's now bloody T-shirt and Phil's head, to hold the compress tightly in place.

"Boy, Zamp, I'm glad it was you," Phil said softly. That sent an immediate and affirming message. Phil still believed I had most of the answers.

The whole time I'd kept my eye on the second raft. We needed it not only for the emergency supplies and tools but as a place Phil could lie quietly. I shoved the oars into the ocean and gave chase. Rowing was painful, an absurd struggle with three men aboard. Fortunately we were going with the current and I finally got close enough to grab the parachute cord.

Those cords saved our hides, plain and simple.

Parachute cord is nylon and very tough. I used one length to lash the two rafts together, through the topside grommets. Then I retightened the saltwater compress on Phil's head, and Mac—who, miraculously, was uninjured—and I transferred Phil to the second raft and told him not to move.

"Zamp," he said, as we made him comfortable. "You're the captain now."

"Sure," I said, trying to reassure him. "Don't worry. Take it easy. We'll be picked up soon."

THE LIFE RAFTS were standard issue: sturdy inner tubes inside canvas covered with yellow rubber. Each one had two sections, meaning a separate inner tube and valve on each side. That was smart for safety reasons. If one side went flat, you'd still float. Each raft was about as big as a desktop inside, maybe three feet wide and six feet long. Two seats cut across the width, both molded in and filled with air. Underneath each seat was enough room to shove your legs in case you had to lie on the bottom during a storm to maintain a low center of gravity and keep the raft from turning over.

A supply kit came with each raft. After checking Phil again I started an inventory but was interrupted when Mac suddenly screamed: "We're gonna die. We're all gonna die!"

I couldn't believe my ears. "Are you kidding? We're *not* gonna die."

"Yes, we're all gonna die! You know we are."

Though we never had time to radio a distress call, I absolutely believed we'd be saved. Our failure to land at Palmyra was itself a signal. The other B-24 on the search mission—it had split off to cover another area—was probably already on the ground in Palmyra, wait-

ing for us. "*Hey*, we're gonna get picked up today or tomorrow," I said with certainty, looking at Phil instead of Mac. "Don't worry. We're not gonna die. We've rescued plenty of guys and now they're out searching for us. We'll be eating dinner with the marines tonight—or tomorrow night."

But Mac kept screaming. I tried reverse psychology. I threatened to report him when we got picked up. Neither worked, so I did what I had to do: I cracked him across the face. Mac flew backward, surprised yet somehow content. He regained control and, for the moment, kept his fears to himself.

Look, no one wants to crash, but we had. I knew the way to handle it was to take a deep breath, relax, and keep a cool head. Survival was a challenge, and the way to meet it was to be prepared. I'd trained myself to make it. I was in top physical condition. Except for his head gash, Phil was in good shape, too. We played three or four sets of tennis almost every day at the officers' club. Mac was also young and healthy, but his mind didn't seem ready to take the kind of great punishment that might await us. I worried about him.

I noted the time and location of the crash, the ocean currents and the trade winds. Then I returned to the inventory. I found the patch kits—the same stuff you'd use to fix a bicycle tire: sandpaper, patches, rubber dope. We had air pumps that came in their own little cases. We had a flare gun, and dye to mark the water so planes could find us. Also a mirror made of chromed brass, and a pair of pliers with a screwdriver handle. That's all. Not even a net to catch fish.

And I couldn't find the most important item.

Where was the knife?

Frustration began to eat at me. "Where's the knife?" I grumbled. I almost swore, but I knew that was a sign of a person losing his cool. Yet, what a blunder. I swear I almost started to search for the raft's trademark to see if it was made in Germany or Japan. Some dummkopf had put in pliers when everyone knows that no matter where you are, on land or sea or in the air, *you need a knife*.

We had no knife, and I couldn't make one appear out of thin, warm salt air.

As for provisions, between the two rafts, we had six bars of chocolate and eight half-pint tins of water. Designed as survival food, the chocolate bars were big, divided into six sections, and meant to last about a week. The instructions were to eat only one section a day, and to take thirty minutes to do it. The chocolate was fortified—it said so in big letters on the package—with all the vitamins, minerals, and protein anyone in an emergency would need.

I took the water and chocolate from Phil's raft and placed it in mine. It didn't seem like a lot, but that didn't bother me. We were only two hundred miles—or ninety minutes—north of Palmyra, and eight hundred miles south of Hawaii. I was sure that the search-and-rescue planes would find us soon.

WHEN LIFE INSTANTLY and drastically takes you completely by surprise, the first reaction is confusion. If one minute you're following a normal routine in an airplane, motors roaring, and a couple of minutes later the plane crashes and you're on a raft, lost and adrift in a vast, loud silence, the disorientation is, at best, intense. Then a new world unfolds. You need time to understand and figure out what's happening. Fate had thrown us into 65 million square miles of salt water and stillness. I couldn't hear the wind; I couldn't hear birds; I couldn't hear waves. I felt like one minute I'd been watching television and the next I'd suddenly found myself on the moon.

With Phil patched up and Mac subdued, I finally had a moment to settle back and think, but I found no peace of mind. I thought of the eight other crewmen and the sharks that never slept, but that was too horrible to contemplate. Instead I tried to figure out how we three had survived. That was easy: we'd all been on the right side of the plane. Phil, because he'd switched seats with Cupernell. I'd been at the right waist window, and Mac had been behind me. The impact threw Mac free when the tail snapped off, but I could hardly imagine how Phil had made it. Anyone familiar with a B-24 cockpit knows how tough it is to get in or out on a *good* day. Phil should have been dead. The cockpit must have split apart when the nose hit the water.

Because he was on the right side and up higher than Cupernell, who probably died instantly, the force pushed Phil through the opening, tearing his scalp on the way.

That left me. More than Phil or Mac, I should be dead. I began to focus on my miraculous escape from an impossible situation, and I had one simple question: "How did I get loose?" I relived every moment trying to find a logical answer. I went through it repeatedly. My ears had popped, I felt the unbearable pressure on my forehead, I lost consciousness . . . then my eyes opened and I was free. But how? Again: my ears popped, I felt the pressure . . . I was free. It made no sense. If the water pressure had knocked me out at a certain depth and at that point I was still sinking, why didn't the increasing water pressure keep me out? Not to mention that the tripod was bolted to the deck and wrapped in metal wire.

I had no choice but to believe that something strange and wonderful had happened, and I was at a loss to understand it.

Memories surfaced of all the times since childhood I'd narrowly escaped death or horrible injury. Then I thought of a letter I'd sent just that morning to Payton Jordan, a friend in navy preflight school who'd been a USC sprinter and would later become an Olympic coach. I'd stuffed it in my pocket, intending to mail it, when we got the call to report for the rescue mission. I discovered it just before takeoff and tossed it out the window to one of the ground crew. "Mail this for me, would you, please?" The letter began with the words "I am still alive and kicking around, why I don't know."

As undesirable as my situation was now, I was still alive, and although I still didn't know why, it was better than the alternative.

I soon tired of reviewing the movie of my life, but with no other pressing engagements, I relaxed, tried to focus on the sea's soothing motion, and just let sleep come.

I AWOKE WITH the words *Lucky Louie* stuck in my head. From high school on I'd always accepted the nickname with a certain smugness. Now I desperately needed it to remain so. Neither Phil, Mac, nor I were regular churchgoing guys; we never prayed before heading into

combat. But because we'd survived the crash I had to at least consider the possibility of some kind of divine intervention. Just to be on the safe side, I thanked God for saving our lives. My buddies prayed with me. Of course, on life rafts that's what you mostly do: you pray.

FOR THREE GUYS used to looking down at the ocean, we now found ourselves always looking up. Hours passed, the sun slid toward the horizon, the air grew damp, our stomachs growled. No rescue plane had appeared, so I portioned out some chocolate and resigned myself to a night at sea.

In the dark it quickly grew cold, and the chill penetrated our bones, making it almost impossible to sleep. Using the sea anchor, a hollow, collapsible piece of canvas a lot like the feed bag you put over a horse's mouth, we scooped six inches of water into each raft and let our bodies warm it like a blanket. It worked. We finally drifted off into an exhausted, deathlike slumber.

The next morning we dried out in the sun and scanned the sky hopefully for planes. No one wanted to spend another night on the ocean.

For breakfast I figured we'd each have a little more water and some chocolate. We had enough for a week if we took it easy, but when I went for our rations the chocolate was gone.

I didn't understand. I'd secured our supplies the night before, and the ocean had been calm; the chocolate couldn't have washed overboard. I knew I hadn't eaten it, and Phil, in the other raft, was too weak to move.

The obvious hit me: Mac.

"What did you do?" I hissed. *"What did you do?"* Phil stared at me. Mac said nothing, but his eyes opened wide and his expression turned pathetic. Almost funny.

"Why?" I asked.

Again, no response. But what could he say? Mac had no excuse for his actions. "I don't know *anyone* who would do something like *that*," I said. "We're three *together*; we must cooperate and pull *together*, work *together*." I wanted to crack him in the face again, but I didn't. I turned away, disgusted. Mac was a weakling, a kid who'd broken something

and didn't want to take responsibility. What could I do with someone like that, kick him in the head? Sure his problem was psychological, induced by stress, but we were all under stress. Mac seemed helpless. He was numb and he knew he'd done wrong, no question. But why get angry? Besides, I truly believed we'd be picked up in a day or two. For a moment I even worried about him: Who knew what eating six bars of fortified chocolate would do to your insides?

I partly blamed myself for not anticipating his panic and his impulses. Mac never took proper care of himself. On the base he skipped our physical-fitness program. He chain-smoked. Drank. Spent his nights in Honolulu doing who knew what. He also missed meals. We had pretty good food in the dining room, but he'd come in, eat whatever was sweet, and leave. You couldn't make him listen. Several cups of coffee and three pieces of pie? No problem. Mac had developed a sweet tooth long before he met our chocolate. I should have known I couldn't trust him. Instead, I was like the guy who puts his hand in front of a rattlesnake expecting not to get bitten. Only a fool does that.

Everybody in the service gets the same combat training. We go to the front line with the same equipment. When the chips are down, some will panic and run and get court-martialed. Why? Because we're not all brought up the same. I was raised to face any challenge. If a guy's raised with short pants and pampering, sure, he goes through the same training, but in combat he can't face it. He hasn't been hardened to life.

It's important to be hardened to life.

Today kids cut their teeth on video games. I'd rather play real games. This generation may be ready to handle robotic equipment and fly planes with computers, but are they ready to withstand the inevitable counterattack? Are they emotionally stable? Are they callous enough to accept hardship? Can they face defeat without falling apart?

Mac was good at his job because he had lots of practice, but I shouldn't have expected any more from him on a human level. I still can't imagine what he was thinking as he gobbled the chocolate,

knowing that the next morning we would wake up and find it gone. I
only knew that I couldn't let it throw me.

THE SECOND MORNING the skies were overcast, making us harder
to find. We waited, not saying much. Phil, at least, didn't seem any
worse off than the day before. I wondered how far we'd drifted. At
about noon I heard the familiar yet faraway thunder of Pratt & Whit-
ney motors overhead. I grabbed the flare gun just as I saw a B-24's
nose break through the clouds. She was so low I could recognize her as
one of our own squadron. I wanted to place a flare by the pilot but
didn't because I was afraid I might hit the plane. Instead, I aimed
where the waist gunners and tail gunner would see it and fired. The
bomber made a ninety-degree turn and I shouted, "She sees us!"

Even Phil managed a smile.

But she hadn't seen us. At first I thought, "Those stinkers; they're
not at their positions!" Yet, even to someone looking from as low as
one thousand feet, our raft was a speck that blended in with the white-
caps. Then the clouds closed and the plane disappeared in the dis-
tance. I figured they'd try again the next day. For now, we were
alone.

Well, not exactly alone. A couple of sharks had arrived. Occasion-
ally they nosed the raft to test its strength, hoping—as only sharks
can—for material flimsy enough to soon surrender us to their relent-
less hunger and waiting jaws. We were hungry, too, but we had to
ignore it. Better just to sleep. Mac and I scooped a few inches of water
into the rafts, and once again we all huddled down for the night.

YEARS LATER I learned from a crewman on our sister B-24 that
we'd been officially reported missing at 04:30 the next morning. By
dawn, the plane was out searching for us and did so for a whole week,
until it had to return to Oahu for maintenance. By then we were pre-
sumed dead.

On the third day we heard another plane. I spotted a B-25 flying

north, just a dot in the sky at about ten thousand feet. We fired flares, tossed dye into the sea, and said a prayer. The B-25 never swerved from her path.

Being stranded was bad enough, but now we had another worry. From the B-25's position and course I could tell that we had drifted west, beyond the usual air lanes between islands. It meant that unless another miracle occurred, we had run out not only of chocolate but of chances for a quick rescue, and perhaps for a rescue at all.

With Phil incapacitated and Mac a mental wreck, both now depended on me. I had to muster all my resources and training because without food and with only a little fresh water remaining, I had no idea how long we could last. Imprisoned by the ocean, our only choice was to accept and adapt to the situation. I knew the trade winds came in from the east and were pushing us toward the Marshall or Gilbert Islands. But those were still a couple of thousand miles and many, many days away.

For a moment anxiety clutched me; the sea could swallow us all. But rather than give in, I made myself a promise: no matter what lay ahead, I'd never think about dying, only about living. Despite our situation, I felt so fortunate to be alive that I was actually happy. Maybe it seems odd now, but it didn't then.

# 6

## ADRIFT

AFTER A WEEK, I started thinking about the chocolate, especially when Mac panicked and I had to crack him again. He'd fallen apart; all he talked about was death. I tried to reason with him and reassure him, but he had lost his vision of the future and it usually took another hard slap to shut him up. Then he'd sleep.

There was good news, too: Phil had rallied.

Drifting west, beyond the air lanes, I adapted myself to my fate instead of resisting it. Rescue would be nice, but survival was most important.

TO LIVE, A man needs food, water, and a sharp mind.

We'd begun with eight half-pint tins of water in the survival kit, but we soon ran out. We were, of course, surrounded by water that never stopped moving, waves turning into new waves, rising and falling. If you've seen movies of men in our situation, one character, scruffy and burned by the sun, always says, "All this water and not a drop to drink!" as if facing down a great temptation. We never thought of it that way. You can't. Drinking salt water is deadly, and we knew it. At best, I could wet my tongue occasionally. Otherwise, I pictured us adrift on a desert. No one in his right mind would drink sand.

Soon, what water we had came only from afternoon squalls and single, low-hanging clouds that drifted across the sky. Sometimes the showers missed us, but when we got lucky we caught the rainwater in the canvas pump cover. It was about six inches wide and two feet long, and I'd ripped it open along one seam so it became a funnel-shaped container. Other times the cover doubled as a hood to shade us from the sun.

When it rained we'd drink first to quench our thirst. When our bellies were full we'd suck up any extra water from the hood and spit it into the empty cans. Sounds distasteful, but transferring water by mouth was the only way because who can pour water in a moving raft, on a rough sea, in a rainstorm? Even more important, this method protected the fresh water from being spoiled by the salty whitecaps that broke over the sides of the raft.

It didn't always work. Sometimes we rode out a squall and never got more water than fell into our upturned and open mouths. At one point we went seven days without a drink. The clouds just seemed to know we were there and avoid us. Several times each day they would hover on the horizon, move toward the raft and then away and beyond us, leaving our lips to blister and swell and our throats to burn. Sometimes we'd chase clouds, rowing like mad, only to exhaust ourselves and still miss their life-giving bounty. As desperation set in, just to stay hydrated, two of us would keep the sharks away with the oars while the third hung in the water for a few minutes.

In the end, we resorted to prayer.

When I prayed, I meant it. I didn't understand it, but I meant it. I knew from church that there was a God and that he'd made the heavens and the earth, but beyond that I wasn't familiar with the Bible because in those days we Catholics, unlike the Protestants, weren't encouraged to read it carefully—at least in my church we weren't. Yet on the raft, I was like anybody else, from the native who lived thousands of years ago on a remote island to the atheist in a foxhole: when I got to the end of my rope, I looked up.

I said, "Fellows, we've been praying about everything else, so let's just pray for water, and sit back and relax. Otherwise we're going to kill ourselves." I meditated and started speaking. My prayer sounded as

if I wanted to strike a bargain with God: "Answer my prayers now, and I promise if I get home through all this and whatever is to come, I'll serve You for the rest of my life." What else could I say? What would anyone say? Given our miserable situation, devotion was all we had left to offer.

Before an hour had passed, I saw a squall heading our way. This time it did not veer, but slowly moved overhead. Based on our recent luck I didn't expect a drop, but suddenly the cloud burst and it poured. I held up the hood to catch the water, drinking as it collected, sharing this gift with Phil and Mac. With the first taste I knew I was the wealthiest man in the world. I could have swallowed five gallons, but of course my shrunken stomach couldn't hold more than a pint.

Maybe God had answered our prayers; maybe the sudden rain was a coincidence. In either case, our daily conversations with the Almighty took on a new sincerity, and we recited the Lord's Prayer more often. Clearly, it couldn't hurt.

EVEN AFTER WEEKS adrift on the ocean, my stomach never growled. My whole body did. Hunger is constant. Next to water, food is crucial because the alternative is deadly and inevitable: the body would eat itself.

Occasionally the waves threw tiny fish into the raft. Even though they were edible and Mac's eyes opened as wide as his mouth, I said we weren't going to eat them. "We're going to invest them for bigger returns." Using the tiny fish as bait, we caught a ten-inch pilot fish, a good reward for our risk.

Our survival gear included a can of different-size hooks and some fishing line. But almost every time we tried to fish, the sharks easily stole the hook and the bait. As a last resort, I tied hooks to my thumb, index, and little finger and hung my hand in the water. Sometimes I would leave it there for up to thirty minutes—always watching carefully for sharks—until I had to unwrap my fingers to let the blood circulate. Sharks hunt side by side with their pilot fish, and when a curious fish got close enough I'd grab it. As the pilot fish tried to escape, the hooks dug in, and soon we feasted.

.    .    .

I DON'T KNOW on what day, but once we slept through a calm night and rose with the sun to find the ocean glassy smooth. I knew we had entered the doldrums, which often happens near the Equator. The seamless stillness was alien and yet exotic, and so quiet that we could hear small fish break the surface 150 feet away. I took advantage of the increased visibility to scan the horizon for a ship or submarine. Nothing.

The calm did not prevent sharks from tailgating us as usual. The smooth surface simply allowed us a better look at their graceful movements as they swam around the raft. As one glided by I reached in behind its head and allowed my hand to move down its back and up over the dorsal fin. The shark didn't flinch. I was at one with nature, as they say.

I repeated this several times while Phil slept and Mac lay back, unconcerned. As the shark made another orbit, I got on my knees for a better perspective. Suddenly, the shark shot up, shattering the surface, with its mouth agape. It looked like a demon out of hell and tried to snatch me out of the raft. I reacted instinctively and thrust both my palms against its nose, which stuck out about a foot past the mouth, and was able to shove the ravenous creature back into the sea. Then, as its companion tried the same stunt, I grabbed an aluminum oar and jabbed it in the nose. Mac, much to my surprise, hoisted the other oar, and we worked together warding off the predators until they'd had enough.

I congratulated Mac and thanked him for his help. The incident had scared us both, but because of his response to the hairy situation, Mac's attitude took a turn for the positive. As weak as he was, he performed excellently and had for the first time done something commendable. Now I considered him a credit, not a liability. I was proud of him and told him so.

I also told him I'd never heard of sharks jumping into rafts or even boats. It seemed unbelievable, but later I learned it wasn't uncommon.

.    .    .

ANY ANIMAL IS dangerous when hungry. That goes double for man because he's got the brains and the ingenuity to get what he wants. After days without food, our utter lack of sustenance took a menacing turn. I don't mean cannibalism. That's sick. I could never have lived with eating another human being.

I'd been thinking about those two miserable sharks who tried to jump into the raft. They still hung around and had become a thorn in our side, trying to eat us when we weren't even part of their food chain. But when you're famished, you take what you can get, and they had tried to take us. I had an idea.

"Turnabout is fair play," I said to Phil. "The sharks wanted to take us; let's take them. From now on they're part of *our* food chain."

I had it all figured out. Phil would hold the bait, dipping it in and out of the water to get a shark's attention. Then I'd grab the shark's tail, haul it into the raft, and kill it.

When the bait tempted a small one, I leaned over the raft and grabbed the tail. Big mistake. Sharks are gritty like sandpaper, and I couldn't hold on because a five-foot shark is stronger than a six-foot man. It quickly pulled me out of the raft. I forget how I got back in, but I shot out of that water like a Polaris missile. I thought it would turn around and attack me, but I guess it was just as scared as I was.

After that I said let's forget the five-foot sharks.

A couple of days later we saw some three-and four-footers, and no larger ones. We hung the bait again. This time I decided to get lower in the raft. I grabbed a passing tail and, as quickly as I could, pulled the shark out of the water. Its mouth opened, but Phil was ready, holding an empty flare cartridge. He shoved it in. The shark instinctively closed its mouth and wouldn't let go of the cartridge. I took the screwdriver end of the pliers, rammed it through the shark's eye, into its brain, and killed it.

Ripping a shark open without a knife is a very tough job. I'd used the pliers to fashion sawlike teeth on one corner of our chromed-brass mirror. Though sharp enough to open a man's arm like butter, the shark skin put up a fight. It took almost ten minutes to cut through the belly.

Because of my survival course, I knew that eating raw shark meat

would make us sick. The smell, a bit like ammonia, was bad enough. The only edible part was the liver, a great source of vitamins. On two different occasions we had a luscious, gooey, bloody meal.

Meanwhile, the larger sharks remained our constant companions, often thrusting their heads up out of the water, trying to avenge their brothers by eating us.

OUR ONLY OTHER source of food came from the sky. Gooney birds—albatrosses—are beautiful and graceful creatures in flight, with six- to eight-foot wingspans. We admired the way they took advantage of the warm tropical breezes to maneuver in all directions, foraging for small fish. Their colors, going from a pure, dominant white to a gorgeous chestnut or black, made them works of art.

Now and then we'd see an albatross fly by, but we never expected to catch one. The sailors' superstition about killing an albatross was written of in Coleridge's "Rime of the Ancient Mariner," and it seemed a shame to think about eating one, but when the time came we knew it had to be done, superstition or not. I remembered the scene in *Mutiny on the Bounty* when Captain Bligh spots a bird on top of the mast and hits it with an oar. That made sense. Ocean birds will land on whatever's available. Too bad we didn't have a mast.

One afternoon, while Phil and Mac slept and I dozed lightly under the sun hood, I saw a shadow and felt something land on my head. I knew that gooney birds usually settle in just after they've fed, so if I could catch one, its stomach might still contain small fish. Some we could eat, some we could use for bait.

I lay very still and made my plan. I had to be careful. Any quick movement and the bird would take off. I must have taken two minutes to move my hand into position, though it seemed longer. Then I shot out and grabbed a leg. The gooney sliced at me repeatedly with its razor-sharp beak in an attempt to break free. An albatross beak is ser- rated, like a knife, and the end is comparable to an eagle's claw. I still have the scars on my knuckles, and remember the sharp pain. To make it stop I wrung the bird's neck.

By then, Phil and Mac were awake. We were so hungry that I

immediately tore the gooney apart. I ripped off the feathers and used the mirror teeth to cut the flesh open, dismember it like a chicken, and distribute the parts.

We had only one problem: we couldn't eat it. The smell was unbearable, gamey, like a dead horse, and the warm blood—gah!—threw our stomachs. An unexpected effect of drifting in a raft on the ocean is that we'd lost our sense of smell. We had no fresh donuts, hot coffee, sizzling steaks, potatoes, or onions to keep that sense stimulated. But it doesn't really go away, as I discovered when I smelled the raw bird. Nauseated by the pungency, I tossed it overboard.

To remind us of more familiar smells we developed the weird habit of sticking our little fingers in our ears and sniffing the earwax. Very satisfying.

Hunger, of course, prevailed. When we caught the second albatross I said, "Hey, we're going to have to try and eat at least the breast."

I didn't even let it sit in the sun to warm up, perhaps cook a bit. I just tore into the raw meat, and boy, was it hard to swallow. I was also concerned about Mac again. He didn't look good, and I feared he had begun to fade. By the time I caught the third gooney bird, we weren't so finicky. I tore off its head and put the bleeding neck into Mac's mouth and allowed the blood to flow. I squeezed that gooney's carcass until the last drop went down his throat. We were now so starved that we ate the entire bird with gusto. This time it tasted like a hot fudge sundae with nuts and whipped cream on top. I ate the eyeballs and all the rest, dipping the legs into the salty ocean to give it flavor. It was so delicious we made a humorous vow to eat raw meat the rest of our lives.

ONE MORNING I caught a dark gray tern and was so famished that while I was killing it I was simultaneously tearing off its feathers with my teeth. Later, my beard itched. At first I couldn't figure it out, but there was only one explanation: a bird way out in the middle of the clean, beautiful ocean—with lice! I went crazy. I had to get Phil to keep the sharks away while I stuck my head in the water five or six times and tried to wash the bugs out of my beard.

. . .

TO COMPENSATE FOR not having enough real food, I cooked us make-believe meals. This required exhaustive and extensive planning. First I'd create the whole menu. We'd have salad, soup, gnocchi, chicken cacciatore, omelets, steaks, desserts—whatever I'd watched my mother make when I was young and learned to do myself. I'd include bread, wine, olive oil; if I eliminated any step or detail of the preparation, the guys would pounce. "You forgot to grease the skillet," Phil once chided me. Or "What about the butter? Don't you need butter in gravy?" I had to say how much salt, how much baking powder— "Just a teaspoon"—how long to bake at what temperature, how much to knead the dough, how to make the crust crispier, how to make spaghetti sauce, or turkey stuffing, how long to bake the turkey. I cooked breakfast every morning, lunch every afternoon, and dinner every evening. I drew the line when they got selfish and wanted brunch—except on Sundays. I did it by the seat of my pants, and it was great because it killed time, it acknowledged but deflected our hunger, and it exercised everyone's mind, especially mine.

BESIDES FOOD AND water, the mind is a crucial line of defense against adversity. I knew this from college. Dr. Roberts, the physiology professor at USC, had told us, "Your mind is everything. It's like a muscle. You must exercise it or it will atrophy—just like a muscle."

I immersed myself in routine, glad to do mental exercises like making meals for my crewmates. I also added columns of figures in my head. Then double columns. I solved equations. I hated math and may not have gotten the answers right, but I didn't care. I also took a mental inventory every day.

In movies, the longer someone stays isolated the more they lose their minds. It's not necessarily true in real life. In the movie *Cast Away*, instead of going nuts, that guy had it made! Sometimes the greatest thing in the world is to be alone; there's no reason to go stir-crazy or buggy. It's a beautiful life. Everything you do to survive is positive and an accomplishment. You figure out how to catch the fish,

get water, build a hut. Even if a castaway isn't the happiest guy in the world, there's no reason for him to go insane.

Proof of that is Robinson Crusoe. When the longboat came ashore for him after four years, naturally he was a ragged mess—beard, tattered clothes. But he was perfectly competent. He was afraid they were going to miss him, so he shouted, and when his rescuers saw him, they thought, He has a demon! Turn about! and headed back toward the ship. But Crusoe was smart. He yelled, "I believe in God the Father and the Lord Jesus Christ!" They stopped rowing and said, "Demons can't say that." They rowed back, rushed up, and immediately embraced him. Did four years of isolation damage his mind? More likely his mind was better than when he first got lost.

The more I did to keep my brain active, the sharper it became, despite the horrible conditions. I had no distractions or interference from the outside world. No job to go to. No girlfriends who needed attention. Instead, I tried to remember my life as far back as I could, and I asked my crewmates to do the same. To my surprise it brought up events I didn't even realize I'd forgotten.

I also planned for the future. Every day I pushed to hear more of what we dreamed of doing when we got home. My big idea was to turn the P.E. depot in Torrance into a nice restaurant with a bar. Someone eventually did it, too.

"Well, I want to be a schoolteacher," Phil said. "I want to live in La Porte, Indiana." He'd tell me about the Indianapolis 500. He used to take the family, bring a lunch, spend the whole day. I'd tell him about our lifestyle in California.

Phil's dad was a preacher, and Phil knew the words to lots of church songs. He'd lead and we'd sing with him.

Mac, on the other hand, was much weaker and quieter than usual. I tried to encourage him. "When we land in the Marshalls or Gilberts"—I didn't say *if*, I said *when*—"we're going to find a deserted island and live for as long as we can." I'd flown over them often on bombing runs, and I knew from my training that we could survive there.

People always ask, "How did you keep track of the time and the days?" A lot better than with pencil and paper, where one might make

a mistake writing it down. Every day was so precious we had no trouble remembering; in fact, we had all day long to think about anything we wished to—even if it was only our names. Again, it's not like in the movies. Hollywood tries to make it more dramatic and create all kinds of emotional moments with guys moping and groaning and crying. In reality, there's no pressure other than whatever it takes to eat, drink, and stay alive. I could lie back and meditate peacefully for hours if I desired. I could talk about the past and the future. I didn't have to lose my mind unless I wanted to.

What moments of despair I did experience came mainly from the weather. We were adrift in the middle of the world's biggest ocean. It could get brutal during a storm, with waves twenty-five to thirty-five feet high. Then the next day it would be perfectly calm. One day we were fighting for our lives, the next we were enjoying the clouds, the sunset, the soaring albatross, the dolphins and porpoises. Through it all I never lost my sense that life could be beautiful. I kept my zest for living, morning and night. I'd made it this far and refused to give up because all my life I had always finished the race.

WE STILL WORE the tropical khakis—long pants, short-sleeve shirt, T-shirt—we'd dressed in the day we left on the rescue mission. But soon our clothes turned yellow, the color of the raft's rubber coating.

We also broke out with water sores—open, pussy messes the size of a quarter or half-dollar—from being wet all the time. Otherwise, we never got sick, no sniffles or colds. Why? There were no diseases to catch in the middle of nowhere.

MOSTLY, I HAD happy dreams. I slept in a muddy quagmire, a foot deep, or on a rocky hillside, or on a hard woodpile. Never water.

ON THE TWENTIETH day I removed Phil's bandage. He'd healed nicely. He could now move easily between rafts and join the living.

.    .    .

AFTER THREE WEEKS I realized we'd been adrift longer than Rick-enbacker, and had set a record about which, despite my relentless optimism, no one might ever know. People have survived longer, on a raft as big as a room with a shelter and a stove. That's different. I pitied flyers who had crashed in the Aleutians. How long could they live? Hypothermia killed them overnight, if not sooner. It just depends on the luck of location and facilities. On a sturdy raft, with lines and fishhooks and nets and knives, anyone could live indefinitely. Men have survived 130 days or more on a big navy raft, and when rescued they were just as fat as the day they crashed. Not us. We were slowly wasting away.

The drastic change in diet caused a line to appear across our finger-nails and toenails, darker in front, lighter behind, marking the moment like a personal calendar. After a few days we even stopped going to the bathroom. At first we weren't sure why, but eventually we just accepted it—and occasionally made a joke or two.

"Hey, Phil," I said one afternoon. "Do you remember the time I pulled that laxative trick on you for stealing my gum?"

"I sure do," he laughed. "Let me hear it again."

We both knew the story, but it helped to pass the time.

"Yeah. Well, I always chew gum when I fly because it makes my ears pop. I like Wrigley's Juicy Fruit; it has kind of a mellow flavor. But every time we'd get ready to take off you guys would go, 'Oh, hi, Zamp,' and, flashing big smiles, pull the gum out of my pocket for yourselves. After a while I thought you ought to buy your own. But you and Cup wouldn't do it. Next thing I knew you were taking two sticks each, leaving me with one. I switched to P-K gum, figuring you wouldn't like it, but you did.

"Finally I thought, Those son of a guns. I'm not only going to get even and stop this nonsense, but teach them a lesson in morals.

"In college we used to chew Feenamint gum as a laxative. On the package it gave the potency—three pieces was listed as harsh. Of course, I couldn't just put a pack of that in my shirt pocket or you'd

get suspicious. So I got some Feenamint and put it in the P-K wrappers. Feenamint was a little larger than P-K, so it wouldn't go in flat; I had to put each piece in at an angle. Then I put it in my pocket and waited. When you helped yourself to my gum I just acted angry and walked away."

"I thought you *were*," said Phil.

"About four hours later, we were on a mission that took us eight hundred miles out. Usually, when we had to relieve ourselves on the plane we used a little portable toilet contraption into which we inserted a waterproof bag. Then we tied the top and tossed it out the window. I remember you went back and did your business. Then Cup . . ."

"And Mitchell said, 'What did you guys eat for lunch?' " Phil added.

"Right. And then the gum hit and you rushed back again."

"And I used the last bag," said Phil.

"Then it hit Cupernell again."

"And there were no bags."

We both laughed so hard we could hardly talk. When I caught my breath I said, "It hit Cup so hard he had no time to waste. He got the four gunners and screamed, 'Hold me! Hold me!' Then he hung his butt through the waist window and let go, creating an abstract mural along the fuselage!"

"When we got back we still didn't know what had happened," said Phil.

"The ground crew chief said, 'What the hell is that?' I said it was an emergency camouflage job. Later, I admitted my prank but said I had no regrets except that we weren't flying over enemy territory when it happened."

"But then Cup said, 'After all those juicy steaks at P.Y. Chong's, I *needed* a good cleaning out!' " said Phil.

"And I said, 'In that case you owe me twenty cents for the Feenamint.' "

I AWOKE TO find the sun in my eyes. Phil was already up, Mac stirring.

"What time is it?" I asked.

"There's the sun," said Phil, pointing to it hovering not far above the horizon.

"Looks like eight o'clock."

"What's for breakfast?" Phil asked.

"How about bacon and eggs?" I replied. "Or ham? Toast, jam. Orange juice."

"Didn't we just have that?" Mac mumbled.

"Probably," I said. I tried to vary the menu, but it was hard to keep track. "We could have pancakes instead. My mother had a great recipe. Biscuits and fresh fruit, too."

"Not for me," said Phil. "I'm still full from dinner. The risotto and gnocchi really filled me up. I don't think my stomach can take it."

"That's the wine," said Mac. "You drank a bottle by yourself."

"Who can say no to Chianti?" I said.

"Or dessert," said Mac.

"Biscotti, gelati, . . ." said Phil.

"Tiramisu," we all added at the same time.

ON THE TWENTY-SEVENTH day I heard a noise overhead.

I looked up and saw a plane almost too distant to do us any good. Desperate, we took a quick vote and decided to use two parachute flares plus one packet of dye in the ocean to attract the plane's attention. I also used the mirror to flicker at them, but the plane disappeared.

Then suddenly it reappeared, descending. They had seen us.

That was probably the most emotional moment of our lives, three grown men, tears running down our faces because we knew we'd be rescued. Man, it was great. The plane—it looked like a B-25—circled. We waved our shirts and screamed.

In return we got machine gun fire.

"Those idiots!" I yelled. They thought we were Japanese. Then I saw the red circles, the rising sun, on their wing tips. The plane was a Japanese Sally bomber, which looks similar to our B-25. *They* were Japanese!

I slid into the water and hung below the rafts to avoid the bullets.

Phil and Mac did the same. My Boy Scout leader had told me that water would stop bullets after about three feet. He was right. The bomber's aim was true, and I could see the bullets pierce the raft only to slow and sink harmlessly. We weren't hit.

When it was safe, Phil and Mac tried to get back in the raft. They were so weak I had to boost them both, then climb in myself. When the bomber came around again Phil and Mac couldn't get back in the ocean. They'd have drowned. However, I slipped overboard, preferring to socialize with two seven-foot sharks than be an easy target for the enemy. My survival instructor had told me to show a shark my teeth and the whites of my eyes, to scare it. That didn't seem to work, but a good straight-arm to the snout did.

Each time the bomber strafed the raft, I pushed myself deeper, holding on to the parachute cord so the current wouldn't whisk me away. Yet the current was so strong that it was tough to remain vertical, which made it easier to scare sharks and avoid bullets. How I got through those twin terrors, I hardly remember because I worried more about what was happening to my friends in the raft. I could see the bullets pierce the canvas and rubber raft and plunge into the water. I was afraid Phil and Mac had been hit. But were they dead? When the plane circled for another pass I pulled myself into the raft to discover a miracle: they'd missed Phil and Mac by a couple inches.

The strafing continued for nearly thirty minutes. Each time I told them to lay out, dangle their arms, attract no attention, pretend they were dead. Otherwise they had no chance.

Then the Japanese made a pass without firing, and I assumed they thought Phil and Mac were gone. Or they'd had their fun shooting at what they thought were dead men, anyway. Maybe it was over.

But moments later the plane returned, this time directly on course. I went over the side, my head between the two rafts, and looked up to see the bomb-bay doors open. I thought, Oh, no! Sure enough, a black object emerged: a depth charge. It was the ultimate in barbarism, a little extra target practice. I stopped breathing, waiting for the terrible blow to shatter the sea. It landed thirty to fifty feet away—but didn't explode. Evidently, the bombardier didn't arm the charge properly, and it sank to the bottom. Had it exploded, it would have finished us.

Then the Japanese disappeared, leaving two wrinkled rafts, riddled with bullets, rapidly deflating, and three desperate men not certain if they'd survive another day.

PUT AN INNER tube in a swimming pool and shoot it full of holes with a .22. It won't sink. Some air remains, plus rubber floats. One of the rafts—Phil's former hospital bed—had the bottom shot out and was beyond repair. The other, us on top of it, lay nearly flat in the water and in some spots, inches below the surface.

Now we really had to fight for our lives. I grabbed a pump, screwed it to a valve, and started pushing like mad. The bullets were 7.7s, larger than a .22 shell but not as big as a .25. I could count a total of forty-eight holes. Fortunately, a hole in rubber semiseals automatically, and when the air pressure outside and inside is virtually the same, no air escapes. Bubbles emerged as I pumped, and we floated slightly higher, but this was a long, long way from okay. The holes needed patching, and thus began the eight most miserable days of our lives. We had to pump around the clock; it nearly killed us.

To get to the rubber itself, I had to cut a cross in the canvas cover with the mirror edge. (No knife, remember?) I'd peel back the canvas to reveal the hole, then rough up the rubber around the puncture. The sandpaper didn't work; water in the kit had long ago melted off the grit. Emery cloth, waterproof, is a better choice. The idiot who made the raft should have thought of that. I had to use the mirror teeth to scrape the rubber before I applied glue and a patch. Sometimes a whitecap spoiled the glue and I'd have to start over, but when it worked the patch held, even though the rubber bulged through the canvas.

If patching was all we needed, it might have been easy, but everyone had to pump to keep the raft afloat. During my turn I grew so tired that I put the handle on my chest and pulled the pump toward me. We'd take five-minute shifts, going around in a circle; for the first few days we pumped around the clock. It was brutal. Mac could only do it maybe five times; Phil a bit more. I had to do fifty or a hundred pumps to make up for them.

I repaired holes on the top first, and we pumped a little less. Then

I patched the bottom. The dilemma was figuring out how to do it with three men still in the raft. I decided to let the air out of one raft tube while we sat precariously on the other half. Then I'd pull the bottom of the flat half face-up to patch it. Phil would hold up that section, and Mac's job was to ward off the sharks with the oars to keep them from biting us on the butt.

I also cannibalized the second raft. With pliers, I tore the canvas from the galvanized rubber and used it for protection against the sun during the day and and as a blanket at night.

My kingdom for a knife.

THE SALLY BOMBER attack had one good result. For twenty-seven days I'd hoped we'd be saved. Hope is incomplete and ongoing. Faith is the substance of things hoped for and is complete. Now I had evidence of land nearby. My hope turned to faith that, if we lived, we'd see this through.

Their bomber, a copy of our B-25, was our reference. It probably had the same airspeed and the same range. The Japanese probably took off for their missions the same time in the morning as we did. Using that knowledge, and the time they'd spent shooting at us, Phil and I did some calculations to figure out how far we were from the Marshall or Gilbert Islands. I knew that unlike some currents that will drive rafts around in a circle, ours was steady and headed west. I could tell by the position of the sun and stars. Allowing that we might drift between the scattered islands at night—a heartbreaking thought—we bet a full-course meal on who could correctly predict landfall.

"We'll probably land on the forty-sixth day," said Phil.

I picked the forty-seventh.

A COUPLE OF mornings later I awoke to dead calm. The water looked like a sheet of glass, slightly iridescent, mesmerizing. Nothing moved. We'd hit the doldrums again. At times it's probably the most still water in the world. I imagined stepping out of the raft and walking on it.

In the distance, I saw a black line on the horizon. Unlike the water, it moved, growing, undulating, rolling toward us. I thought, My God, it's a gigantic wave, the roaming hundred-foot wave I'd heard stories about. I couldn't tear my eyes away.

Suddenly I knew it was not a wave but hundreds of porpoises, swimming together, diving in and out of the water, coming right at us. Would we be capsized and torn apart? We lay low and waited. But instead of disaster, the porpoises swam gracefully under us and came up on the other side. When I looked in the water I discovered their purpose: millions of minnows. Food. I wished for a net. I used my hands. No luck.

ONE NIGHT THE moon was bright and full and huge, and its light sparkled and made the calm sea glow. The sharks, our daily companions, departed, leaving us with a quiet evening "at home." We bailed in the usual water—our blanket—to warm our bodies as we huddled tightly together.

A few hours later our tranquillity was rudely shattered by a thump on the bottom of the raft so powerful that our bodies winced with pain and we were lifted a few inches off the ocean surface. Stunned and frightened, I looked over the side and followed a huge fin as it circled the raft. When it came alongside again, the monster's tail flipped sideways, sending a wave of cold water over us. Then I got a good look at our visitor: a huge bluish gray shark maybe twenty feet long. A great white.

I put my hands on Mac and Phil and whispered, "Lay low and don't move or make a sound." Again, we were hit from below. Again, his tail inundated us with water. Hardly an accident, the shark's purpose was to stir whatever he suspected might be alive in the raft and find out if it was edible.

We were petrified but managed to stay quiet and still as the great white repeated his routine for maybe an hour, though it seemed like half the night. Then, as mysteriously as he had appeared, the shark gave up, dove underneath us, and disappeared, never to be seen again. Mac, Phil, and I took deep breaths, and the air in our lungs never felt

better. But the next morning Mac acted strangely different. Quieter. No, resigned. The great white had scared him good, and I think that was the turning point for him. Mac began to fade.

I REMEMBER SPEAKING to a men's club in San Diego after the war and telling the story of the great white. A marine biologist criticized me. He said great whites were cold-water sharks and would not leave their natural northern feeding waters full of seals and sea lions for the warm southern Pacific. I couldn't argue with him and from then on referred to the shark simply as a "huge denizen of the deep." But as of February 2002, almost sixty years later, new research confirmed that great whites are, in fact, world travelers. Tagged, they have been tracked to the ocean off Baja California, Hawaii, and other tropical waters. They spend as much as five months a year in the open ocean and dive as deep as two thousand feet. Warm-blooded, like humans, they enjoy basking in the temperate waters of the Pacific, and I know I was right when I say one visited us on the raft that night long ago.

ON THE THIRTY-SECOND day I was still patching the raft, stopping to pump only about once every fifteen minutes, when Mac quit moving and sank into a daze. Was he just despondent? Or starved? Or both? He'd had as much food as Phil or I, sometimes more; but now his will to live and perhaps his body's ability to use nourishment had failed. Each of us probably weighed no more than seventy-five pounds—too light even to make a satisfying snack for the sharks that had relentlessly stalked our raft. Our flesh was almost transparent, our bones plainly visible. But unlike Phil or me, Mac had finally all but shut down.

He asked Phil, "Can I have a drink of your water?"

Phil said no, which is what he should have said. We had about a mouthful apiece. The guy was almost dead, why give him water? Then he asked me, and like an idiot, I gave him a drink. It was a dying man's request and I did not deny it.

The next afternoon Mac stirred a bit and asked questions about

death, questions for which I had no good answers. Then he asked the only one that really mattered: "Am I going to die?" That was it: ' "Am I going to die?"

"Yeah," I said, thinking it would be unkind to promise him further agony. "I believe you'll die tonight."

"Yes, sir," he agreed. "I think you're right."

Finally, a few hours after midnight on the thirty-third day, Mac groaned, stiffened, sighed, and died. After a quiet moment I said, "Phil, Mac is gone." Honestly, I'd expected it sooner. We lay there all tangled up and didn't move until morning, when I said a brief eulogy.

Francis McNamara had once been an average-looking guy, five-feet-ten, light hair. Now he looked like a overstretched rubber band dried in the sun, a skeleton with skin. We slipped him overboard, a burial at sea, just like in the movies, and as he sank out of sight Phil and I were all the more determined to survive our ordeal.

THE DAYS DRAGGED by, but I'd wake up each morning almost energetic, thinking, "Oh boy, another day closer to the islands!" I knew we'd get there. I knew my charts. I knew the trade winds and the currents.

But our trials were not over.

We'd braved hunger, thirst, sharks, bullets, and death. Now came a storm. We'd been through others, but none with waves that seemed to tower almost forty-five feet high. One moment the raft rested on a "mountaintop," the next it was at the bottom of a "canyon." The ride was more frightening than the sharks or the machine guns. It took all we had just to stay alive. Again.

This much I knew: we had to stay low, our feet tucked securely under the seats. Under no circumstances could we lash ourselves in with the parachute cord. I remembered a rescue mission in Hawaii, after a storm. We found a colonel and two men in their raft, upside down, blue bottom up, tied in. Dead.

I scooped about four inches of water into the raft for extra stability. Then I tied the cord under the seats and looped it around each of us only once, without a knot. If a raft turns over, you can't untie a knot

in the water. A wet rope is brutal. We held the rope, hands aching. The night passed, filled with terror and rain.

The next morning, the forty-sixth day, the rain was intermittent but the waves still fierce. As one roller lifted us high, I spotted land. At first I wasn't sure, but when we rose again, I saw more green.

"Phil," I said. "I've just seen an island."

He popped up and said, "I see it, too."

The date was July 12, 1943, and I assumed that as we'd hoped and prayed, we had finally reached the Marshall or Gilbert Islands. We were still too far away to be sure, and another stormy night would pass before we could accurately assess the situation. We covered ourselves with the canvas to ward off the cold and tried to get some sleep. Our only fear was drifting between and past the islands in the dark.

The next morning the big blow was gone and we found ourselves in an atoll lagoon. I counted sixteen tiny islands, all apparently deserted. I could see old huts, bananas, breadfruit, and coconuts—but no people. I couldn't wait to get ashore. One island was as big as a bedroom, with a single tree on it like you see in a comic strip. We broke out the oars and rowed. It seemed almost too good to be true.

It was. I heard airplane engines and looked up to see two Zeroes, probably at ten thousand feet, in combat practice. I knew they couldn't see us.

I kept rowing, pitifully weak after forty-seven days adrift, trying to make land before anyone discovered us. Then I saw a new island. I said, "Hey, there was no island there."

"Whaddaya mean?" said Phil.

"There's an island right over there, with one tree on it."

Phil looked and said, "Yeah, I see it—but there're two trees."

"You're crazy. There's only one tree." I looked again, and this time there were two trees. "What's happening here?"

It wasn't an island at all but a boat with two masts, and it was heading straight for us.

My brother, Pete, 4, and me, 2.
Olean, New York.
*(Courtesy of Louis Zamperini)*

The whole family on Gramercy
Street, in Torrance, California.
Left to right: Sylvia, my dad, me,
baby Virginia, my mom, Pete.
*(Courtesy of Louis Zamperini)*

Torrance High graduation
shot, 1936.
*(Photograph by H. Haas; courtesy of
Louis Zamperini)*

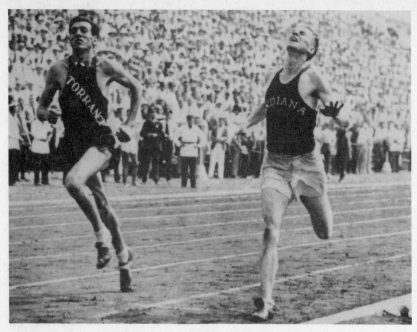

The race of a lifetime. Don Lash and I in a dead heat at the 5,000-meter Olympic qualifying trials, July 1936. I always finished the race.

*(Courtesy of Louis Zamperini)*

Working out at the Olympic
Village in Berlin, 1936.

*(Courtesy of Louis Zamperini)*

1942, Euphrata, Washington. Now I'm a bombardier waiting to be assigned a plane. We wanted a B-17 but got a B-24. My pilot, Russell Phillips, is to my left.
*(Courtesy of Louis Zamperini)*

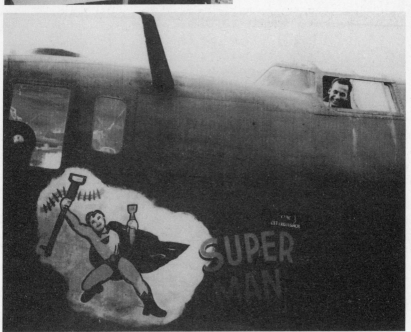

Our B-24. We named it Superman. That's Russell Phillips, our pilot, smiling in the window.
*(Courtesy of Louis Zamperini)*

View from our B-24, after I dropped my bomb on-target on Nauru.
Moments later the Zeroes came after us.

*(Courtesy of Louis Zamperini)*

Inspecting a shell hole after barely making it back from
the Nauru raid.

*(Courtesy of Louis Zamperini)*

The *Green Hornet*. She couldn't fly straight. We took her out on
a rescue mission and never came back.

*(Courtesy of Louis Zamperini)*

Francis McNamara. This was on
May 26, 1943. The next day we
crashed at sea. He survived 33
days. We said a prayer and gave
his body to the sea.

*(Courtesy of Louis Zamperini)*

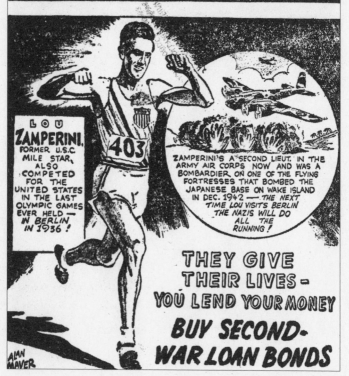

I kept this newspaper clipping in my wallet. When the Japanese found it, they broke my nose.

I<small>N</small> GRATEFUL MEMORY OF

First Lieutenant Louis S. Zamperini, A.S.No. O-663341,

WHO DIED IN THE SERVICE OF HIS COUNTRY A̶T̶

in the Central Pacific Area, May 28, 1944.

HE STANDS IN THE UNBROKEN LINE OF PATRIOTS WHO HAVE DARED TO DIE

THAT FREEDOM MIGHT LIVE, AND GROW, AND INCREASE ITS BLESSINGS.

FREEDOM LIVES, AND THROUGH IT, HE LIVES—

IN A WAY THAT HUMBLES THE UNDERTAKINGS OF MOST MEN

*Franklin D. Roosevelt*

PRESIDENT OF THE UNITED STATES OF AMERICA

My parents got this from the president, but they never gave up hope.

Ofuna Prison camp.
*(Courtesy of Louis Zamperini)*

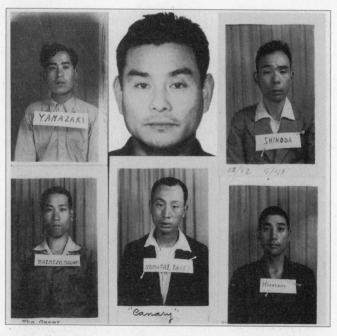

A rogues' gallery of my prison guards. Kitamura (top row, middle), "the Quack,"
was a sadist who beat POW Bill Harris twice and almost killed him.

*(Courtesy of Louis Zamperini)*

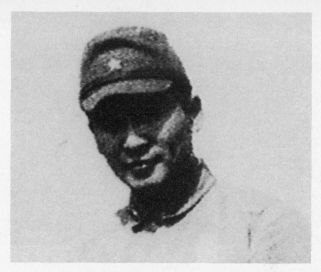

Matsuhiro Watanabe, "The Bird." Top, circa 1944 *(courtesy of Yuichi Hatto)* and in Japan, 1998.

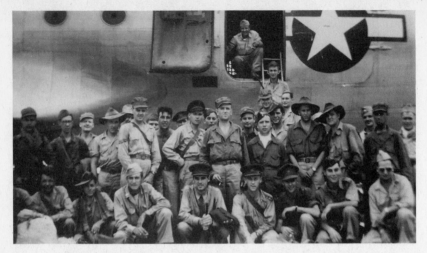

On Okinawa, September 6, 1945, the day after our liberation from Naoestsu, in front of the plane that flew us in from Yokohama. I'm the only American (sixth from right, front row); everyone else is British or Australian. My friend Tom Wade is in the front row, second from the right.

*(Courtesy of Louis Zamperini)*

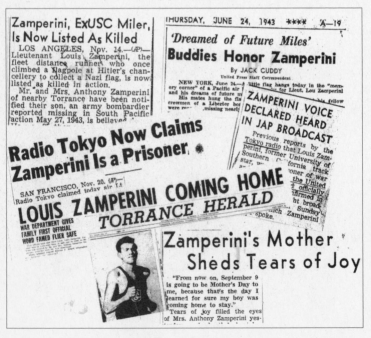

A collage of headlines about my death and my return.

*(Courtesy of Louis Zamperini)*

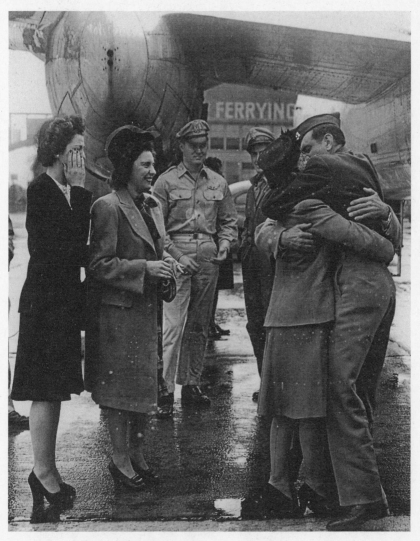

Welcome home in Long Beach. I'm hugging my mother while
my sisters, Sylvia and Virginia, look on.

*(Courtesy of Louis Zamperini)*

My brother, Pete (left), and me. He was my mentor and
always believed I'd come home.

*(Courtesy of Louis Zamperini)*

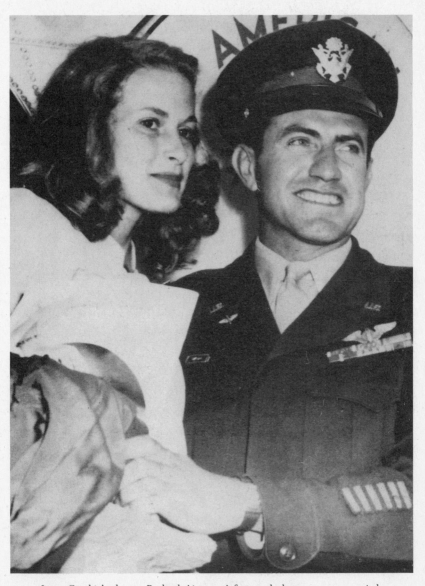

I met Cynthia's plane at Burbank Airport. A few weeks later we were married.

*(Courtesy of Louis Zamperini)*

Japan, 1950. He saved my life on Kwajalein, but I didn't find out until after the war. If only I could remember his name.

*(Courtesy of Louis Zamperini)*

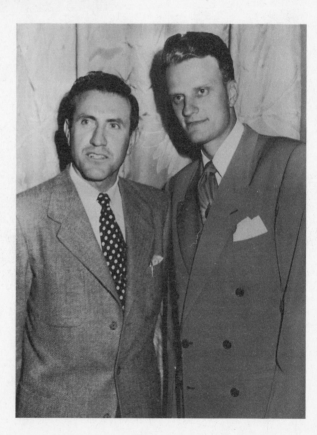

Me and Billy Graham.

*(Courtesy of Louis Zamperini)*

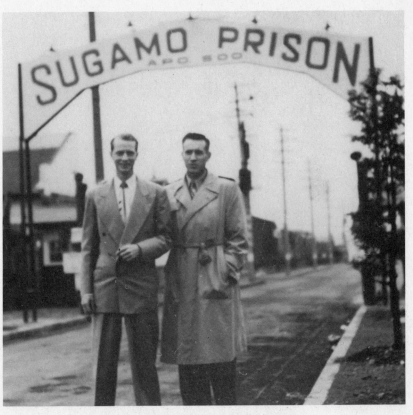

I confronted my captors and forgave them all.
At the time, only the Bird was missing. I'm on the right.

*(Courtesy of Louis Zamperini)*

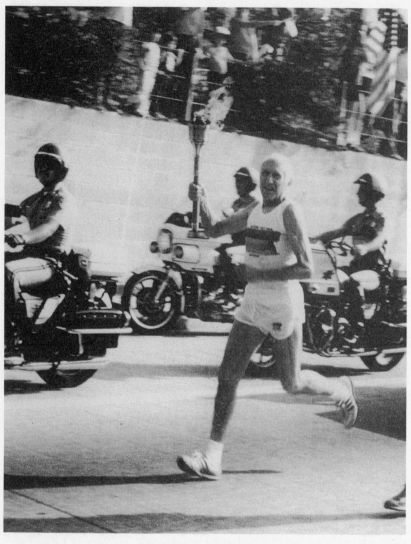

Running with the torch and a police escort at the
1984 Olympics in Los Angeles.

*(Photograph by Bruce Jones; used by permission)*

# 7

## EXECUTION ISLAND

THE TWO-MASTED BOAT was a Japanese patrol ship. At first we lay low in the raft, but then I realized we had to get ashore quickly and hide. I rowed like mad for the nearest patch of green, but I was in no shape to make much headway. Before long they spotted us.

That was it.

The ship made a slow pass, about thirty feet distant. I could see the crew on deck, holding swords and rifles. One man trained a machine gun in our direction. Phil and I raised our hands weakly above our heads, and suddenly the thought of being alone on the ocean seemed more inviting than ever. Someone shouted in Japanese, but we didn't understand. A crewman threw a rope at us but missed. Rifles were raised and a couple of men opened their shirts and motioned for us to do the same. Oh, God, I thought, they want to shoot us in the chest. I undid my shirt, closed my eyes, and waited. Nothing. I opened my eyes to see the same men waving. We waved back. Turned out they just wanted to see if we had hidden guns and now realized they had nothing to worry about from two hopeless and helpless skeletons. It was almost humorous and perhaps frustrating to soldiers who would have liked to capture bigger game.

On the second pass the boat got close enough to land the rope and haul us in. Then they reached down, grabbed us, and lifted us aboard.

I tried to push myself up from the first hard surface I'd felt in almost two months, but I couldn't stand. I could barely crawl.

A crewman salvaged our raft from the sea and threw it on the deck. What a mess. The yellow rubber had turned to gum and was ready to pop. Phil and I might have lasted another two weeks; the raft maybe two days.

Although the Japanese clearly had nothing to fear from us, they tied us to the mast, and a big fellow who wanted to prove his authority or vent his anger hit Phil across the face with a pistol. I knew I was next, but my mind was sharp and I had a trick up my sleeve: I kept my head forward. When he swung the pistol, I threw my head back. The gun missed me, but I nearly knocked myself almost unconscious when I smashed the mast with the back of my head. That seemed enough to satisfy our captors, and they acted more civilized. Someone gave us water and a few hard biscuits. Despite intense hunger, I ate slowly and maintained my self-control in front of the enemy.

TWO HOURS LATER the boat dropped anchor at Wotje, an island in—just as I'd predicted—the Marshall group. The idea that we'd actually drifted about two thousand miles and survived was mind-boggling.

We were taken ashore, blindfolded, in a barge. I knew we'd landed when I felt coral scrape the metal bottom. A soldier threw me over his shoulder. Another carried Phil. They dumped us in a truck and drove to their outpost. There they put us on a scale. Thirty kilos didn't mean much to me, but I later learned it meant that I weighed about sixty-seven pounds—and that I'd lost a third more than that, nearly one hundred pounds.

On Wotje Phil and I were treated well by a kindly Japanese doctor, and got food and water, which we managed to keep down by eating carefully. A few of the Japanese officers spoke English. They quizzed us about what had happened.

"We were on a rescue mission in friendly waters," I said. "We had motor trouble and crashed at sea." Soon the conversation turned to other topics, including where I'd gone to college and my running

career. Our rescuers/captors were most intrigued that we were still alive. They listened to our tale, clearly sorry for us, not at all like enemies. Our sharpness also astounded the Japanese; perhaps they'd expected two delirious, mushy-headed dummies who'd lost their brains, but only our bodies had wasted away, not our minds.

After taking our wallets and putting them into a container, one soldier counted forty-eight bullet holes in the raft. Everybody came by to inspect the damage and wonder about all those holes in the rubber and none in us. I told them, "On the twenty-seventh day one of your pilots strafed us. It was a Sally bomber."

"Oh, no," they said. "Japanese don't do that."

I pointed at the raft. "There are the holes."

They still didn't believe me.

Two days later Phil and I were put aboard a merchant vessel. The detachment commander said, "You will be taken to an island called Kwajalein. But," he added, ominously, "I cannot guarantee your life after you leave the ship."

The trip due west took almost twenty-four hours, and again we were well treated. The captain came to visit more than once. In almost perfect English he explained that he'd been to Seattle often. He talked about how he'd enjoyed his former life as a merchant marine, hauling international goods. He also tried to justify why Japan was at war. The country, he said, was poor, with too many people; since we were all part of the same world system, they were entitled to more land for their citizens.

As we neared Kwajalein, they brought generous portions of rice, soup, and daikon. My appetite had returned, but it backfired. I got sick as a dog and wanted to die. Two of the crew took me on deck to throw up and held me because there was no railing. Vomiting, I looked straight down about thirty or forty feet to the ocean, hoping they'd let me go.

ON KWAJALEIN I was blindfolded again and transported to shore like a sack of wheat. There four soldiers carried Phil and me to the beach, tossed us into the back of a truck, and drove to a building

where they dumped us into separate cells. I skidded on my bottom until my back hit the wall. When I took off my blindfold my brain and my eyes fluttered with the unreality of it all. After nearly two months floating under vast open skies and infinite seas, I found myself locked in a cubicle the size of a dog kennel. The instant claustrophobia made me want to scream, but I was too weak. Instead, I lay down and looked at my body. Just six weeks before I'd been a vigorous athlete who could run a mile in just over four minutes. Now I was fleshless, skeletal. All my life I had kept my emotions tightly in check when it came to my own troubles, but I could no longer help myself.

I broke down and cried.

THE DETENTION BUILDING housed six wooden cells, three to a side. Each was six feet long, six feet high, and thirty inches wide. A ventilation slit on the rear wall was thickly coated with flies. Most tropical buildings stood a couple feet off the ground on stilts to avoid flooding during a monsoon, and the crawl space provided a slight breeze. But with no window, the heat was almost unbearable. Mosquitoes buzzed everywhere. A six-inch-diameter hole cut in the floor and a tin can underneath functioned as my toilet. I looked down and saw the can half full with maggots. Worse, they made me sleep with my head next to the hole and my feet near the door.

The guards shoved food through an eight-inch slot in the cell's solid wood door. Appetizing it was not. I got whatever was leftover from the men's mess—fish heads, boiled daikon—not otherwise fed to the pigs. Sometimes they'd reach into the slop bucket, squeeze together a gob of rice the size of a golf ball, and throw it at me. That usually meant an hour or two spent crawling around in the half-light, on the dirty floor, trying to find every grain while the guards howled with delight. Even then I'd have to spit out sand.

The rations were so horrible that I had constant diarrhea and dripped mucus from my rear end. Flies got into the mucus and laid their eggs. Some nights it was so bad that I had to curl up in the back of the cell with my naked butt hanging over the hole, leaking. I'd

think I had it under control, then five minutes later it would start again, making sleep impossible.

Most people never understand how bad life can be for prisoners of war because no survivor talks frankly and in detail about these horrible experiences from the banquet dais.

I could tell from his groans that Phil suffered similarly two cells away, but the guards did not allow us to talk. Any attempt meant suffering a swift kick or a poke with a sharp stick. They also beat us regularly.

My new life was no new life at all. Better to starve me, or send me out to sea again on the raft. At least dying that way would allow me some dignity.

I FOUND A crude message carved into my cell wall. 9 MARINES MAROONED ON MAKIN ISLAND—AUGUST 18, 1942. Each name was listed. I knew the date and story well.

Two American submarines had approached Makin at midnight, carrying the Marine Carlson Raiders. Second in charge was James Roosevelt. They went secretly ashore in life rafts, crossing a dangerous reef, sank one ship in the harbor, and killed almost every Japanese soldier on the island. The idea wasn't to take Makin but to dent Japan's confidence and boost American morale. In retrospect it might have been a mistake because the Japanese refortified the island ten times over, making it more difficult for the next guys to land there.

During the battle, sixteen marines died. When Carlson left, he said to the native chief, "Here's fifty dollars. Will you bury the marines?"

Evidently, nine *other* marines didn't get back to their beachhead on schedule and make it safely to the submarines, which took off right on time, perhaps believing their comrades were also killed.

Those marines were captured by the Japanese and imprisoned on Kwajalein. At least one of them had lived in the cell I occupied and carved his legend on the wall so those who followed would never forget.

I carved my name underneath theirs, and the date of my arrival.

. . .

SOMETIME DURING THE first day, a Kwajalein native had poked his nose through the hole in my cell door and said in surprisingly good English, "Are you Louis Zamperini, the USC track star?"

"What?" I couldn't believe my ears.

"Are you Lou Zamperini, the runner, the Olympian, from USC?"

"Yeah," I answered, confused. There I was, way out in the middle of nowhere, and people still knew me. I shouldn't have been surprised. In those days, between radio, newspaper, and newsreel coverage, international sports figures were as popular as movie stars.

The man—I never got his name—worked for the Japanese, probably as a laborer. He said he was a Trojan fan and began to tell me about my track records. "I follow all USC sports." He knew every football player. Every score. We discussed the Rose Bowl, even the Olympics. He knew more than I did. Then he said, "My time is up. I am glad to meet you."

"Before you leave," I said, "tell me about the nine marines."

"They were all executed," he said, shrugging. "Decapitated with the samurai sword." He fell silent for a moment, watching for my reaction. Then he spat out the rest. "This is what happens to all who come to Kwajalein."

Later I learned that the marines whose names were listed in my cell had been awaiting transport to a mainland POW camp in October 1942, when the former Kwajalein commander, Captain Yoshio Obara, claimed he was directed by Vice Admiral Koso Abe, commander of all bases in the Marshall Islands, to execute the men. Abe said that he had received orders for this action via a dispatch from Truk Island, originating with the central authorities in Japan—but his claim was never proved. Abe also said that Commander Okada, from Central Command, who was on Kwajalein in 1942, had made the following statement to him: "From now on it will not be necessary to transport prisoners to Japan. They will be disposed of locally."

I felt so rotten at the news of my eventual execution that my first thought was, Well, so what?

•    •    •

THE GUARDS DAILY taunted me and Phil. They jabbed us with sticks, spit on us, tossed hot tea in our faces. Sometimes they made us sing and dance—as if we could—for their amusement. Worst of all, they took great delight in drawing their thumbs across their throats, or slicing their flattened hands across their Adam's apple and making a sound to remind us of our inevitable fate.

I wanted to live and I hoped I'd live, but the kind of faith I'd had on the raft had disappeared. I believed my date with death was set. Each morning I'd wake up and think, Is this the day? Where will they put my bones? What could I do? I just had to wait until they decided.

ON THE SECOND day, guards led me to the interrogation building. I hadn't yet been fed, the better to make me vulnerable. On the way I passed two somber young girls, very out of place in a combat zone. They shuffled and stared at the ground.

I was shoved into a large room to face six dignified-looking Japanese officers, big shots dressed in white uniforms with gold braid and combat medals. They sat at a white table as if they were kings of the earth. A guard told me to sit facing the officers but far enough away that my filthy appearance and smell did not offend them. Biscuits, pastries, and beverages covered the table. Nonchalantly, each man lit a cigarette and blew smoke in my direction. Clearly their tactics were designed to tempt me to answer their questions.

I braced myself, not knowing know what to expect. I could never have predicted the first question: "Lieutenant Zamperini. How many girls do you have on your islands to satisfy your military personnel?"

What? Their icebreaker question was about sex? Was that really what these arrogant pipsqueaks wanted to know? I decided to contain my disgust and play along.

"We don't have them," I said.

"How do the men get satisfied?"

"They use their willpower and wait until they get home."

My questioner chuckled and I'm sure he thought I was either a liar or a fool. Smugly, he continued. "Japan provides girls on every island to keep our men happy."

The two girls I'd seen, obviously conscripted against their will, now made sense. The informalities over, the panel got down to business.

"What model B-24 you fly in?" one asked brusquely. I knew they had more than one of our crashed bombers, so it was no big deal to say, "B-24D." The *Green Hornet* was borrowed; our regular plane was a B-24F model.

They produced a picture of a B-24E. "Where is radar on the plane? Draw a picture." Again, a pointless question; they had the plane. They already knew. What they really wanted came next. "How do you operate the radar?"

"I have no idea," I said. "That's the radioman or engineer's job." I really did know, but it was my way out. They were not happy. I returned to my cell without a snack, drink, or cigarette.

A NEW GUARD asked my name. "Louie Zamperini," I told him.

"Ruie Zamperini-ka."

"No, just Louis Zamperini." The *L* was a tongue-twister and the *ka* a quotation mark.

Another guard said, "Ohio."

I said, "California." I knew *ohio* meant "good morning," but why should I give them the satisfaction?

I STARED OFTEN at the marines' names carved into the wall. I memorized each one in case I had to recite them later for Allied intelligence. It was my small way of keeping hope alive. I considered these men my cell mates. I took a name each day and wondered about that person's life. I asked myself, What did he look like? Where was he from? Did he have a girlfriend, or was he married? Did he have children? How would his family take the news of his death? I contemplated each man's fear or emotions or resolve as the samurai sword

came swiftly down, sending his head rolling. Was he buried on the island or taken out to sea? How soon would I join them?

ONE MORNING I heard a commotion and many voices. Suddenly soldiers lined up in front of my door. Was this it? My last day? Luckily—or unluckily—no. This was a submarine crew in for refueling, supplies, and shore leave. On a sub you never see the enemy; what a treat when they heard two POWs were on the island. Perhaps eighty men lined up as if at a movie theater. Phil and I were the feature. As each sailor passed, he cursed us, spit, threw rocks, jabbed us with sticks, and treated us like caged animals. I thought I was already in the worst shape of my life, but this dehumanization and torment proved me wrong.

THE NEXT DAY I was again taken to the interrogation room. I found everyone chatting and grinning. My face was still caked with blood from the free-for-all. I'm sure the ranking officers considered this a clever, strategic move. After the submarine crew had humiliated us, perhaps our spirits had broken.

The new topic: the number and location of airfields on Oahu. The Japanese unfolded a large map and asked me to mark the locations and the number and type of aircraft at each. They already had the major fields circled, a result of reconnaissance during the attack on Pearl Harbor.

Again, my reward for cooperating would be food and drink. My face and body may have been battered but my mind was sharp. I figured maybe I could put one over on these self-righteous son of a guns.

Part of our strategy in the Pacific was to build phony air bases. We'd already put up three; I'd seen them myself: fake runways, mock-up aircraft with expert paint jobs that looked like real P-51s and B-24s on the outside, built of plywood and sticks instead. At first I evaded the question, pretending I didn't want to tell. They kept at me and I let them harass me. Whatever I said could only hurt them. If they bombed Hawaii again, they wouldn't bomb the real fields.

Finally, I went, "Well, uh . . ." and they thought they had me. With a bit more pushing, I "broke down" and said, "Okay, okay. There's one here"—I showed them on the map—"one here, one there, and one there." Boy, were they happy. They looked at each other like, "Ah, we finally won a victory over this guy."

The victory was mine. I tricked these educated men and earned a biscuit and a little glass of soda in the bargain. More important, I proved to myself that I hadn't lost my mind on the raft.

The panel dismissed me, satisfied. But before I could leave, an officer decided to show me my place. "Well, Mr. Zamperini, big track star, you got much publicity when you were missing in action. I want you to know that when you entered USC in 1936, I was graduating."

I bowed humbly, mocking him.

A WEEK LATER a new guard came on duty. He motioned me to the door and whispered, "You Christian?" I nodded yes, dully, expecting the worst. He smiled and repeated himself. "You Christian. Me Christian!" His name was Kawamura, and he gave me a handful of rice and his ration of sugar candy.

Kawamura's English was poor, but I managed to understand a few words about Canadian missionaries. Also, that he assumed *all* Americans were Christians. But the following morning *another* new guard took his pleasure by jabbing me with a stick until blood ran down my face. When Kawamura's shift began he asked about the blood. Taking a chance, I told him who was responsible. Kawamura made an angry fist. I didn't give it much thought. After all, I was their enemy.

I didn't see either guard for three days, but when Kawamura returned he opened my cell door and pointed to the other guard, about fifty yards away. A bandage covered his head. Kawamura had beaten him. If not for his kindness, I might not have survived my "rescue."

ONE MORNING THE guards took Phil and me to the infirmary porch and told us to lie down. Two doctors came out and injected us

with a smoky fluid. "Tell us when you get dizzy," one said. He scribbled notes, while the other held a stopwatch.

It took about five seconds. The disorientation and nausea were accompanied by the rapid appearance of red, itchy pimples. Had they injected us again I would have passed out. Instead I went back to my cell, where in addition to the usual discomforts my body burned throughout the night.

They repeated the experiment the next day.

Soon Phil and I came down with dengue fever.

Dengue fever is caused by one of four related viruses transmitted by mosquitoes in tropical and subtropical regions. It comes on quickly, with a high fever, severe headaches, joint and muscle pain, nausea, vomiting, and a rash. The illness can last up to ten days, but complete recovery can take two to four weeks. Afterward, you're immune to the specific virus but only partially protected from the other three. Dengue is commonly confused with other infectious illnesses such as influenza, measles, malaria, typhoid, and scarlet fever.

The good news about most dengue is that it rarely causes death; the bad news is that I felt so terrible I wished I was dead.

The first week was intense. I was already mentally, physically, and emotionally shattered. The fever made it worse. And yet, it was in one way a small blessing: disorientation made the time pass more quickly and made the fear of decapitation more tolerable. I just thought, Well, so I'm going to die. Now or later. Accept it. It was as if a guy had come up and said, "I'm going to shoot you in the head," and I'd said, "So, shoot me."

The fever lasted three or four weeks, during which another submarine crew arrived and we had to go through more of the same barbarous treatment. I just didn't seem to notice or care as much this time.

PHIL AND I had been prisoners for nearly forty days, expecting each to be our last, when the interrogation panel summoned me for another session. They wanted to know the number of ships, troops, and planes transported to the Pacific through Hawaii. They probably expected me to finally break down, but I'd had enough. "We have

spent forty days here, and more on a raft," I said. "What could I possibly know? We are obsolete. My information was obsolete the day after I left my home base. Whatever you want to know, you already know. I can't tell you anything else."

No cookies for me that day.

ON THE FORTY-SECOND day the guards gathered outside our cell block and talked in low voices.

An officer burst in and said, "Tomorrow you will"—I held my breath—"be put aboard a ship and go to the island of Truk, and from there to Yokohama as prisoners of war."

My God, I thought, we're going to live through this.

WHAT HAD CHANGED their minds? Maybe they thought it better to save the life of a famous American athlete and Olympian than wantonly destroy me. But why? Did they think showing me mercy would help their cause? It made no sense.

Whatever the rationale, I didn't argue. Who would? As an official prisoner of war, I was under the jurisdiction of international law. I wasn't really sure what it would be like under Japanese authority, but I thought, At least they have to feed us properly and bed us down.

Phil and I left Kwajalein on a vessel that was part of the Japanese fleet and sailed due west for Truk, in the Carolines. We spent about a week in the harbor. Every time I went to the rest room, I looked out the window to count the ships. If I ever escaped, at least I'd have some information about this big Japanese naval base.

(Six months later, at 06:00 hours on February 17, 1944, in Operation Hailstone, the American Allied force attacked the Japanese naval and air force fleet in Truk Lagoon. More than seventy planes and forty ships were destroyed and hundreds of lives lost. The raid helped win the war. Today, Truk Lagoon attracts many divers because of the undersea wrecks and multicolored reefs and marine life growing on them.)

After Truk, on the way to Yokohama, my shipboard hosts couldn't

contain their excitement at seeing the enemy face-to-face. They rifled through my wallet and found an illustration of me in my running suit against a backdrop of the planes bombing Wake Island. It was a patriotic "Stars in Service" ad for the war effort that told about my participation in that raid. In big letters, at the bottom, it read: THEY GIVE THEIR LIVES—YOU LEND YOUR MONEY. BUY SECOND WAR LOAN BONDS. Evidently our Christmas Eve attack had killed many of the crewmen's buddies, as I discovered when five or six sailors burst into the cabin Phil and I shared.

"Who's going to win the war?" they shouted.

"America."

That was all they needed to beat us, still skeletons, to the floor. They also broke my nose, which I had to set myself. Finally an officer came in, stopped the fight, and made everyone leave. He took me topside to an officer's cabin. It was a nice room. For the rest of the trip I slept there on a long, padded bench.

I spent most of my time alone in that cabin. Occasionally an older sailor came in and thumped me in the head. He was a weird and funny guy. He'd say, "Thump you in the head for a biscuit?"

"Hey, go ahead." For a biscuit, he could thump all he wanted. He'd thump me once, give me the biscuit, and leave. He did this every other day. I ate well; he felt better.

WE HAD A submarine scare on the way to Yokohama. Alert bells rang and I was suddenly afraid. I thought, Boy, I've had it now. Our navy is out there and they're going to let these Nips have it—and me, too. After all this time I'll be killed by my own people. But as much as I was frightened, I was thrilled, too. Sirens blared. Sailors screamed and ran for battle stations. This continued for about thirty minutes, but we were never attacked.

WITH NOTHING TO do but sit in someone's cabin all day, waiting for a thump in the head and a biscuit, I decided to poke around. I didn't search in vain; I found a magnum of sake hidden under another

bench. Apparently the owner didn't want anyone to know he had it. The bottle was open, otherwise I would have left it alone. I took one swallow and felt heavenly. I hummed inside. Glowed. I waited a day and thought, Well, they won't miss another swallow.

This went on for two weeks, until we arrived at Yokosuka Naval Base. By then the bottle was nearly empty, and I thought, Ah, the hell with it, and drank the rest.

On September 15, 1943, we docked. Two crewmen blindfolded us again and took us off the ship. The blindfold was loose and through a crack at the bottom I could see a Chevrolet hubcap. I recognized the model. It had a jump seat behind the backseat.

Phil and I had to wait for a ship's officer to take us to our next destination. He arrived mad as a hornet. "Get in there!" he shouted, shoving me into the jump seat. I tried to maneuver, but my legs were too long and gave me trouble. He kept pushing. Finally, he hit me across the face a few times with his flashlight. My nose was a two-time loser.

To this day I believe with all my heart that he was the officer whose room I'd lived in and whose sake I'd finished. He didn't have to wonder who drank it, or that I had paid for my indulgence.

OUR NEW HOME would be a prison camp named Ofuna, in the hills just outside of Yokohama. I felt a strange combination of joy and reassurance at the prospect of seeing Western faces again. For the first time since crashing, Phil and I would no longer feel completely alone.

At the camp I could smell the damp coolness of the coastal valley as we entered the gates and walked into a cinder-strewn central compound. Gray barracks bordered an open common area. Prisoners stood against the walls, huddled together for warmth, their faces long, silent, hungry. Even so, I looked forward to their company. I tried to attract the attention of one or two, but they would not speak. I soon learned that prisoners at Ofuna were not allowed to talk to one another.

That made me angry. I had finally arrived in Japan, dreaming of better treatment, and this was my payoff? Beyond the fourth wall, which

closed off the camp's far end, stood a large hill covered with bamboo and forest. I pictured trying to disappear into its darkness some night.

A guard prodded me into the barracks and my solitary cell. That night, in furtive whispers and at risk of a beating or worse, I learned the terrible truth: Ofuna was *the* secret, high-intensity interrogation camp run by the Japanese Navy, hidden from the populace and all relief agencies. There would be no Red Cross supervision, no improved treatment. No humanity. I wouldn't be registered as an official prisoner of war. Men left the camp to be either executed or relocated. If you died there, no one would know but your brothers in arms.

· The next day, after a hot bath, a guard escorted me into the headquarters building and ushered me to a door. "When you enter the room there will be a man sitting behind the desk," he said. "You bow, stand at attention, and wait for orders." Then he opened the door and shoved me in. The room was lit only by the afternoon sun. The man did not sit at the desk but stood in front of it, his back toward me. He wore civilian clothes. I bowed, as instructed, stood straight, and waited. He turned around and smiled.

"Hello, Louis," said a familiar voice. "It's been a long time since USC."

I felt like I'd taken a sucker punch to the gut.

The man was my former classmate James Sasaki.

# 8

## WE REGRET TO INFORM . . .

I⊤ HURT TO see James Sasaki, not only because we'd been together at USC but because I thought he, of all people, had been around Americans long enough to know that we didn't deserve the hatred and brutality his country had shown us.

"Sit, Louis," Sasaki said, pointing at a chair. He perched on a corner of his desk and tried to explain what he knew I was at that moment desperately trying to explain to myself. "All the time I went to colleges in the United States," he said, "I also spoke to Japanese communities."

"I remember you went to the Torrance Japanese district."

"Also to Carson and Gardena and Lomita," he added. "I lectured to the Japanese, especially the Issei—the first generation in America—to admonish them to maintain their Japanese culture, and to keep faithful to the homeland."

"Why? They were American citizens."

"I was never an American citizen. Japan's a poor country, so I told them, 'Send money home to your poor families in a country that needs your help.' I also showed them how to save lead foil from gum and cigarette wrappers and roll it into a huge ball. Also, copper, brass, and aluminum. When the Japanese freighters came to San Pedro to buy American scrap metal, they could contribute to their country."

I knew what he meant. I'd seen the lead balls at the Breakfast Club

on Riverside Drive in Los Angeles. A close friend was the son of the owner, and I worked at huge private parties on weekends when I was in college. A Japanese gardener and cleanup man lived on the premises. I visited his shack a few times and I saw two 20-pound balls of soft lead—all painstakingly collected after each function—that he'd pressed together by hand. I even picked one up to judge the weight.

At one time I might have considered Sasaki's ideals admirable, but now I had to think of them in terms of the war. I'm sure he never put it to his people that way, because to admit that they were helping a future war effort would have been foolhardy. I'm certain not one Japanese-American he spoke to knew of the conflict to come. I doubt the gardener had any idea the lead he'd collected would one day become bullets fired at Americans. He loved the United States and was glad to be there.

Most Americans never knew about these activities. Had they, particularly after the war began, it would only have increased the hunger for revenge we felt after the Japanese made their unprovoked, surprise attack on Pearl Harbor, wiping us out without warning. That was a dangerous time; with or without reason, many Americans hated any Japanese face—or any Oriental face. That's one reason the government relocated the Japanese to internment camps: absolute necessity. Had they been left among the people, their homes might have been set on fire, and lives lost. I'm not saying that the property of American citizens of Japanese origin being confiscated by the government was right, because they were defenseless. Some were even my close friends, Japanese kids with whom I went to school. Others were patriotic citizens and proved that many times over fighting in Europe as part of the 442nd, the highest-decorated combat group ever. Internment, sadly, was just the best of many imperfect choices made at a time of national shock, fear, and disbelief.

Sasaki chuckled and interrupted my memories. "Oh, how I used to love having breakfast at the student union," he said. "Ham and eggs, bacon, sausage, coffee. I enjoyed American food." So did I, and here he was, making a seventy-pound skeleton drool.

We spoke a bit more about USC, then he asked for a rundown of

my raft experience and spoke with calm confidence of Japan's successful aggression in the Pacific. "We shall see each other from time to time," he added. Despite our earlier friendship we were now on opposite sides not only of the desk but of the war. I expected no personal favors and no special treatment, and wouldn't ask for anything. As far as I was concerned, I could call him friend no longer.

Sasaki dismissed me and I returned to my cell. As soon as the guard on patrol was out of earshot the other prisoners peppered me with questions: Who are you? Where were you based? What outfit? How were you captured? But when we fell silent, a suspicion gnawed at my gut, grew, and wouldn't let up. Not once had Sasaki asked me a military question. I knew that Ofuna was a high-level interrogation camp. If a pilot was shot down Tuesday, he could be at Ofuna Wednesday for an intense grilling. What's more, Sasaki had told me he not only held a civilian rank equivalent to admiral but was the head interrogator for the Japanese prison-camp system; he traveled the country, visiting one or two camps a day. Had he simply not bothered because he knew that after forty-seven days on a raft, forty-three in a Kwajalein dungeon, and nearly a month in transit to Yokohama, any information I had was more than stale, more than obsolete? Probably. It made perfect sense. Whatever I could say would be useless.

What didn't add up, then, was why I'd been brought to Ofuna in the first place.

SET IN THE foothills at the junction of two valleys, Ofuna in September was much like New York in the winter, layered with thin crusts of snow and cold, very cold.

The camp was built of flimsy wood and consisted mainly of three plain, crackerbox structures called One, Two, and Three—*Ichi, Ni,* and *San.* The layout looked like the letter *E.* Each barrack was set apart from the other by twenty yards; all were connected to a main building that housed the officers' headquarters, the latrines, and the kitchen.

Inside, each cell was as wide as the tatami mats on which we slept. My blanket was made of paper; we got two and had to learn

how to fold them—tightly, to get layer after layer—for maximum warmth. The pillow was straw. I slept in my clothes and shoes. All I had was the uniform I'd crashed in, now a sleeveless khaki shirt and torn pants. A Norwegian named Thor Bjorn Christiansen, a crewman on a captured merchant ship, went through his belongings and gave me his extra coat. Without his kindness I'd probably have frozen to death.

Despite the icy temperatures, the guards wouldn't let us stay inside during the day. I spent every hour of sunlight outside, huddling against the elements. Fortunately, we'd worked out a system in which we lined up and walked slowly, wound around like a serpent. The men on the outside moved inside, got warm, and moved out again.

Our cells had small square windows with wooden bars through which anyone could easily escape; but then what? Japan was not like Europe, where most people looked alike. What's more, the guards made it clear: "If you escape, we line up ten men and shoot."

Frank Tinker, a captured pilot who'd gone to the Juilliard School of Music, and I had a plan anyway. We could always hear airplanes, and they didn't sound too far away, maybe two or three miles from Ofuna. I said, "Can you fly a Japanese plane?"

"Louie," he said, "I can fly anything with wings."

I thought we'd sneak to the airport and grab a plane. Of course, we wouldn't know if the fuel tank was full, if we'd end up flying to China or crash in the Sea of Japan. Still, we plotted for several weeks, then decided to abandon our crazy idea.

One guy did escape, though, but within twenty-four hours got caught hiding in the hills. Luckily, everyone knew he was crazy, even the Japanese, so they didn't shoot him or anyone else.

Not everyone was so fortunate. When men left the camp I often watched them exit. If they turned to the left, that usually meant they didn't live. If they turned to the right, that meant they went to another camp. Every time, other men arrived to take their place.

RUNNING THE LENGTH of each barrack was a long, narrow walkway about four feet wide and made of smooth wood that we had to

mop continually. The cells, on either side, were one step up from ground level. My day began at sunrise when the guards rang the morning bell. Sometimes I'd do calisthenics. Then, after going to the head, I'd sit on the step below my cell, my feet sticking into the walkway, and wait for breakfast. Utensils clanging in the kitchen became like music to me. Sometimes I'd smell the food on the wind and salivate. Even today, I can't kick that habit.

Two prisoners, Duva and Mead, worked in the kitchen doing the serving and cleanup. Duva had survived after the Japanese crippled his submarine. Mead flew for the navy and was captured after his plane ran out of fuel during the battle of Midway. Both were strapping fellows and impressive physical specimens—and stayed that way because on kitchen duty they could always sneak an extra mouthful.

Every day, with big wooden ladles, they scooped rice into our tiny bowls. A few guys liked their rice dry, but dry rice never made me feel nourished, especially when I'd find straw in it. Other times it was too moist and had rat droppings in it. When all you get is rice, it's funny how you're always conscious of the way it's prepared. Sometimes we also got a small cup of water with a piece of daikon radish, the Japs' version of soup. If we were lucky, we'd get miso paste.

Lunch was the same. Dinner, too.

ALTHOUGH I WAS starving, sometimes I preferred hunger to eating what the Japanese served. A few of the prisoners—we had Americans, British, Australians, Norwegians, even Italians captured from merchant ships—knew international law required that we get meat rations once every week or so. We mentioned that to the guards, and a few days later a truck backed up to the big cement trough outside the barracks, where we washed ourselves and spit. The truck was packed with fish that had been frozen but had spoiled. Even before the driver dumped it in the trough, the smell overpowered us and the whole mass seemed to move. In fact, it *was* moving, *it* being infested with thousands of maggots.

The guards told us to wash the "fish." Looking at it made me sick, but I hosed it down and tried to get the maggots off and kill the

stench. Then I helped shovel the mess into big soup tureens. We all got the result, hot, the next morning. (They had to serve us hot food or we'd die. Japan was contaminated with human feces, which they used liberally as fertilizer.) The maggots floated lazily on top, as if in their own private swimming pools. I half expected to see them wearing sunglasses and drinking lemonade. Some guys considered the maggots nutritious, guzzled, and threw up. At no more than eighty pounds I was probably the hungriest guy in camp, but I just shook my head no.

A guard barked a command. "Eat!"

"I can't eat it," I said.

"You *eat*," he said, and stuck me with the point of his bayonet, behind my ear, right on the muscle. I bled. He repeated himself. "You eat." I ate.

We'd asked for meat; they'd given us "meat." Two weeks later, we each got a little whale steak, about the size of a fifty-cent piece and as thick, cooked with teriyaki. Now, *that* was tasty.

ONE SPRING DAY, when the ice broke in the little reservoir between the barracks that served as a fire-fighting supply, the guards took turns throwing a little puppy high in the air and watching it splash in the water. When, inevitably, the puppy missed the pool, he showed up in the stew the next day. I passed.

I wasn't the only one who shied away from the rations. One old Norwegian would regularly trade his food for cigarettes. We told him he'd die if he didn't eat. "I think maybe the tobacco is better for me," he joked. He finally died of malnutrition.

Our food should have been better. In fact, it was supposed to be, except that the cook, Hata, had a racket. He stole rations meant for the prisoners and traded them through the fence to civilians. He wrapped the booty in bandanas and had me and others wait with them by the edge of camp until a tiny Japanese farm woman came along. I gave her Hata's package and got a package in return. I'd give that to Hata. Sometimes he got chestnuts to boil with the rice—not that the prisoners ever got any. He also got gifts to share with the officers; in

other words, insurance that let him conduct his illegitimate business so openly.

AFTER BREAKFAST I sat outside with the men on long wooden benches. Since we couldn't speak to one another or hold anything in our hands—so no reading—each day seemed like a month. (When, after many months, we *were* allowed to read, we got basic books about an English girl named Pam, titled *Pam's Own Story, Pam's Little Box*, and *Pam Visits Her Grandmother*.) Any communication we managed was by Morse code. When the guards were far enough away, I'd shield one hand and tap out messages. Everyone did the same after lights-out, when the night patrol had moved to a different barrack.

For anyone caught breaking the rules, the reward was a severe beating, and the various guards—Shimizu, Yamazaki ("Swivel Neck"), Kumagai ("the Canary"), Asoma ("Metal Mouth"), Hirayama, and others (these aren't translations, just nicknames)—took great delight in turning offenders in to the head man, whom we called "Conga Joe," just to get a feather in their cap. Kitamura, the medic ("the Quack"), especially wanted to know who'd broken the rules, and not because he was interested in caring for them after the beating.

AFTER THREE MONTHS, Phil left for an officers' camp in south Honshu, where he was trotted out as a display piece for the Red Cross and other international agencies. It was plush, with no punishment. All anyone did was garden to grow their own food. We had no time for final words, but I was glad for Phil, even though I'd miss him. Unlike Ofuna or Kwajalein, his new home did stick to a few international rules for prisoners of war because it was a show camp for the Red Cross.

IN SPRING 1944 Major Gregory "Pappy" Boyington, the famous flying ace of the Marine Corps "Black Sheep Squadron" and, earlier, volunteer with the Flying Tigers in China, showed up at Ofuna. He'd

crashed in January, during a raid, and been captured by a Japanese submarine. After a brutal interrogation they moved him to Truk, and eventually to Ofuna.

They put Pappy in the small cell next to mine. Of course, I knew who he was, and he had read that I was missing in action. Boyington had shrapnel in his thigh and was almost a cripple. I used to massage his leg every morning to loosen up the tendons so he could walk. Later, the Quack claimed he could find the shrapnel with a magnet and cut it out. I don't know what he used for a painkiller, but he did what he promised.

Though I was twenty-six and Boyington was probably thirty, he and I became pretty close friends. Fortunately, by the time he arrived, the rules had loosened up a bit and we could talk to each other. He was braggadocious and liked to throw the bull a lot. I'd already heard about his problems at home and in the service, but since I was now his number-one outlet for conversation, he began to unload his marriage troubles on me. I tried to be a good listener as he unraveled the story of the incredibly painful divorce process that still tore him apart. "There are times when I don't care if I live or die," he said, "and that's the way I feel when I'm up there shooting down those yellow bastards. Yet the moment we tangle I have this strong desire to win. You, being a runner, probably know what I mean."

"Pappy," I said, "that's the deadly combination that makes you an ace—not caring and hating to lose. Maybe that's why the divorce is so tough: you hate to lose."

Taking it out on the enemy was one way to handle the pain, but it was only temporary. Same as climbing into a bottle. When you sober up, the problems are still staring you in the face.

Pappy was stubborn and wanted things his own way; he caused some trouble in camp and suffered the same mistreatment and starvation as the rest of us. After being caught smoking during a nonsmoking period, he was beaten pretty badly. It took a few bumps on his head, but he finally began in his own bulldog way to conform to the submissive POW lifestyle.

In his book, *Baa Baa Black Sheep*, Boyington wrote that the only

qualification to become a guard or officer at Ofuna was passing "a minus-one-hundred I.Q. test."

My opinion, exactly. They were dummies.

A guard once called three of us to peep through a knothole in the headquarters shack at one of his buddies who was inside, masturbating. That same guard also had intercourse with a duck. A fuller description of their odd sexual experiment is in Boyington's book. It made me sick and I had to turn away. All I'll say is that the duck died.

Another time a guard called me into the kitchen. There stood a nice-looking Japanese girl, maybe twenty-five years old. She worked cleaning pots and pans. The guard told me to stand behind her. Then he moved behind me, reached around and grabbed her, and thrust his hips into me, forcing me back and forth into her. Man, it was embarrassing. The poor girl.

The guards and officers were third-rate guys because Japan needed their good men so badly on the front lines. Those who worked in the camps were mostly moronic farm kids and misfits not fit for combat. Not that they didn't try to simulate the experience. One afternoon they brought in a B-24 pilot on a stretcher, with a crushed chest. After he died that night the guards staged a mock bayonet drill using the corpse as a target.

The Japanese did all they could to break our will and self-respect. They'd taunt us by saying, "Hey, we just invaded San Francisco!" or "Shirley Temple had an abortion and died!" or "Clark Gable got killed over Africa!" Brutal beatings, with fist or club, were the daily rule, not only for infractions of unknown camp regulations but for the merest suspicion that we might be contemplating any disobedience.

WE ALL PERFORMED slave labor, usually in the kitchen and on cleanup patrol. The guards also needed someone to cut their hair and shave their faces—and what better way than forcing someone to do it? When I was a kid, we all got a quarter for a haircut at Tansy's barbershop. I'd stand around and watch the barbers at work and eventually figured I could do it, too. So I started a racket: I would cut neighborhood kids' hair for the quarter their mothers gave them so we could

go to the beach and use the money to ride the roller coaster and get a hamburger. This went on until one boy's mother thought the barber did a "bad job." Determined to improve and keep the business going, I hung out at Tansy's every chance I had.

With all that experience, I thought I should volunteer to be the camp barber. It wasn't out of kindness or to prepare for a postwar career. For each haircut and shave I'd get a rice ball: wet rice baked to a golden brown in the oven.

I never had such an easy job. I just clipped the guards' hair as close to their scalp as possible. As for the shave: I'd never used a straight-edge razor, and it scared the hell out of me, especially when one guard said, "You bring blood and . . ." But I couldn't get out of it, so I practiced on myself first. I still nicked a few guys—without conse-quence—and soon learned how to use the razor.

The guards also asked me to shave their foreheads. I couldn't figure out why. They had no hair there, nor on their chests, but they wanted their foreheads shaved down to the top of the eyebrows. Were these men masochists, or did they just like how the blade felt?

Every guard paid the rice ball, except the Weasel. He needed to show his superiority, and it made me mad. Whenever he came around, I'd say, "You didn't pay me last time."

"Yeah? I pay you later."

So I'd shave him again—I couldn't really refuse—figuring that maybe he'd keep his word. He didn't. Finally, I got wise. The next time I cut his hair and shaved his forehead, I cut his eyebrows down real thin, just like a pencil line. He was relaxed, in another world, and didn't pay attention. When I finished I asked for my rice ball and, as expected, he stiffed me and went back to the honcho shack. Suddenly I heard cussing and screaming, then laughter from the other guards. Next I heard two words I'll never forget: "Marlene Dietrich! Marlene Dietrich!"

I expected a beating, but he *loved* it. The Japanese idolized Ameri-can movie stars, and when his pals approved of his new style, he left me alone.

·          ·          ·

NOW AND THEN Sasaki called me into his office. Interrogation was pointless, but that's never what he seemed to want. He was nostalgic for the old days.

Although I could no longer muster friendship for him, I could sense it in him for me. At first he was self-confident and cocky, bragging that Japan would win the war. When they started losing battles—and he knew that we knew it after they'd captured Pappy Boyington and he told us the truth—Sasaki's attitude changed. He even called Emperor Tojo a son of a bitch and cussed a blue streak. Perhaps he wanted to get on my good side. I don't know. But always, when I'd ask why I, an officer, was still at a camp in which I was clearly out of place, he never answered.

Sometimes I told Sasaki about the men's hopes for better food and less punishment. "Oh, Louie, you *know* him," they'd say. "Tell him what's happening here." Sasaki would say, "Well, we'll see what we can do." Then he'd leave and a couple of days later we'd all be beaten. The next time I'd see him I'd complain about the beatings, and he'd say, "Well, they have to keep rigid discipline in the camps, but we'll see what we can do." That was always his way. Never "I," but "we," meaning it was always "unfortunately" out of his hands. Sasaki never had to take any responsibility for what happened. Or didn't.

BOYINGTON RELAYED THE information he brought back from his frequent interviews with Sasaki to two prisoners. The first was Geoffrey Lempriere, an Aussie lieutenant captured in the jungle near Rabaul, or New Britain Island in Papua New Guinea. A wealthy wool merchant in his private life, Lempriere hustled around the camp in a ragged black coat, acting as official chaplain. The second was my close friend Lieutenant Bill Harris, the six-foot-ten son of marine general Fielding Harris, who ran the marine air corps. They had captured Bill in the Philippines several years earlier, but he'd remained mentally sharp by reading every scrap of paper available and conducting vigorous memory exercises. As a result, all information, including newspapers that we could occasionally steal from the guard shack, we rushed

to Bill. He had a photographic memory, could look at a map and sketch it later with complete symbols for the rest of the group.

BY SPRING I'D gained a bit more weight but was still weak and, as usual, hungry. I constantly thought of ways to pilfer rations, though I was aware and afraid of the terrible consequences; stealing food in wartime was punishable by death.

Sometimes Duva and Mead would walk by my cell after dinner and throw me a rice ball, knowing the serious trouble they'd catch if caught. Mead called the Los Angeles area home, so he knew about me from my USC running days. However, his kindness had little to do with special treatment. Because of my ordeal, I most needed the food. (As did Phil, when he was still at Ofuna. I'd always split my rice ball with him.) Otherwise, everybody was in the same boat. We all pulled together. When you're trying to survive, you cooperate.

Eventually my desperation overcame common sense. I knew I had to take a chance, even with my life. I studied the patrol habits, and one night at about 1 A.M. the camp was asleep except for a single guard, who had all three barracks to cover. The main passageway tying all the buildings together went through the kitchen. I snuck in and quietly stuffed my face with Japanese navy food. I lost track of the time until suddenly I sensed a presence to my left. I turned slowly, and there stood a guard we called Shithead. He was the worst of the bunch, a sneaky pipsqueak always trying to catch us at fault so he could report us and impress his superiors. I knew I was in deep, deep trouble.

He held his rifle at his side, butt on the floor, stepped out of the shadows, and faced me. I waited for him to raise the weapon, but he didn't move. He just stared. It was bizarre. So I inched slowly away, our eyes locked together, figuring he'd take me out any moment, saying I had tried to escape. He certainly looked like he wanted to shoot me, but I kept backing up anyway, my eyes glued on him until he was out of sight.

The next day I waited, nervously, to suffer my fate. No one called me out. I'm certain he had reported my crime—it had to be Shit-

head's greatest trophy—but for some reason the commandant ignored or dismissed it. Why?

WHEN THE WEATHER warmed, the commandant began to take his morning tea under the cherry tree in front of the barracks next to the road. He also read his newspaper there. An old gentleman, he only held a warrant officer's rank. We called him "the Mummy." His world was spare and he seemed detached.

One morning, while I swept the yard around him, I noticed him studying his paper, the *Mainichi Shinbun,* with a furrowed brow and great concern. Occasionally he muttered to himself. I realized I had to get that paper because it might hold valuable information.

I kept sweeping, looking for an opening. I worried less about the commandant catching me than about being spotted by the cook, Hata, or the Quack. Though not in any way responsible for camp discipline, both frequently administered punishments.

The commandant began to doze, and let his paper slip beneath his tea table. I edged closer, reached out, and snagged the paper with my broom, crumpling it as if it were trash. I swept it around the corner and to the latrine. There I undid the wad. I couldn't read the Japanese scrawl, but it didn't matter. I saw a map with arrows showing major troop movements.

I gave it to Bill Harris to decipher.

Harris read the text and said, "How do you spell the name of the island you were on when you came in from the Marshalls?"

"K-W-A-J-A-L-E-I-N," I said. "Why? Have we taken it?"

"Long ago, I think," he said, "because we're apparently launching attacks from there on all the other islands, leading right to Japan."

Kwajalein taken! Where Phil and I had suffered, our forces now played gin rummy. We never had a doubt about winning the war. It just took time for our country, an industrial giant, to get rolling. But with the war split between two enemies and continents, we could understand the slower pace.

Harris returned the newspaper, and I took it outside to the trash pile. Meanwhile, he made a rough sketch from memory depicting the

Allied advances. Later he showed it to the ranking officers. The men in our little espionage group were overjoyed. We imagined imminent victory and speculated about when they might release us.

Our joy was brief.

Harris should have destroyed his map, but he hid it instead. The next day, when we were outside, the Japanese went through everyone's stuff and found it.

The cry went out. "Line up! Inspection."

The Quack called Harris out and started punching him, then grabbed a heavy cherrywood bludgeon and hit him repeatedly, knocking him out. We all wanted to jump in and stop the sadistic medic, but the guards had their rifles ready because they knew it was a serious situation. The Quack kept jumping on Harris even as he lay helpless on the ground. He totally lost control. It broke our hearts to watch and not be able to intervene.

Afterward, the Quack leaned against a bench, ecstatic, breathing hard, like a guy just finished having intercourse with a woman. We thought Harris was dead, and I hated the Japanese then even more than I had hated them on Kwajalein. I felt angry and helpless. Had it been possible I would gladly have torn the Quack to bits with my own hands and shot those who leered from the doorways and giggled behind the kitchen windows.

Meanwhile, the commandant had acted like he couldn't care less. He'd let the beating continue uninterrupted. And Conga Joe walked up and down the line of men left standing at attention—two had fainted—belting anyone who blinked or looked suspicious.

No one could touch Harris. We had to let him lie there until, thankfully, he stirred. Then one of our ranking men got permission to take him back to his cubicle. I helped. We lay him facedown on his tatami mat and ripped away his clothing. When we saw the spare flesh of his back, now reduced to pulp, and his buttocks, all one purple-black bruise, it was hard not to cry. We were sure the Quack had crushed Bill's vertebrae. Maybe still being alive wouldn't be so great after all.

The next morning, rather than give his captors the satisfaction of having eliminated him, Harris, with the pride of an American marine,

walked stiffly to roll call. Afterward he returned to bed, where he stayed for days. Even when he could move again, it was months before he could focus mentally.

The attack was so savage, making me wonder what I would have done in his place—and why I had gotten away with my "crime" in the kitchen.

NOT LONG AFTER Harris's beating, a B-24 pilot shot down in the Pacific joined us at Ofuna. His name was Fred Garrett. I watched as the guards brought him in, sitting in a special wooden chair because he only had one leg. Word quickly spread that he had lost the other on Kwajalein, and that he'd been asking if anyone named Louie Zamperini was at the camp.

I went to see Garrett. He told me that after his plane crashed the Japanese had imprisoned him and his men on Kwajalein. His crew was executed, but Garrett was spared. He didn't know why. In addition, he had an ankle injury, which didn't receive proper treatment and got infected, so they decided to amputate. Garrett was bitter, especially about the operation. I couldn't blame him. For a mere ankle injury they'd cut off his leg above the knee, without using anesthetic or anti-septic—he said—with an ordinary crosscut wood saw. I couldn't imagine the pain Garrett had endured. And I didn't want to.

But why did he want to see me?

"I saw your name carved into the wall in my cell," he explained. "Right under the names of the marines. I knew who you were because you got a lot of publicity when you went missing in action." That was great. He was the second American, after Boyington, to confirm that, and we became close friends.

ONE DAY THE commandant decided to stage a track meet, featuring me. It was weird. My muscles had atrophied; I couldn't run. I entered the high jump instead, and won it. I guess I was so skinny, I didn't have much to lift. After that, I made a point of exercising to get in better shape.

Soon, with great fanfare, they brought in a local runner because what they really wanted was for me to run and lose. I told the grinning officers that the race would be unfair, that the track was hardly adequate for going distances. Most important, I had no desire to run. I shouldn't have said that. They told me in no uncertain terms that if I didn't run, not only I but the whole camp would suffer. My pride was not worth that, so I ran, and surprised myself at how light and comfortable I felt, considering my condition. I let the local runner set the pace and allowed him to stay ahead even as the finish line loomed. Then I stretched out and passed him; I shouldn't have, but I couldn't resist.

Moments later I woke up on the ground. Someone had hit me on the head from behind with a cherrywood club.

They brought up another runner a few weeks later, and I beat him, too. After the race he took me aside and said, "Next week I bring my girlfriend. Let me win, so I can say I beat an Olympian, and I'll give you a rice ball."

No problem. I let him win. Instead of giving me a rice ball, he left with his girlfriend. But two days later he came back and gave me *two* rice balls. I guess I'd helped him win with his girlfriend, too.

THOUGH I HAD thought often of my family and friends, the running and meeting Fred Garrett brought back stronger memories of life before the war and made me wonder again how everyone was back home. I'd been gone almost a year, and according to Garrett, everyone thought I was dead. (I would later discover that because Ofuna was a secret camp, the Japanese had never registered me as a prisoner of war with the Geneva POW Convention.) I felt sorrier for my loved ones than I did for myself.

After the war I would confirm what Garrett had told me, that my disappearance had quickly made the papers. No more than a month after the crash, even as I drifted on the raft, a UPI story began, "A little flag hangs today in the 'memory corner' of a Pacific air base barracks for Lieut. Lou Zamperini and his dream of future miles." Another paper described me as having "turned in [his] Service

wings . . . Zamperini—as far as can be determined—has made the supreme sacrifice."

In June 1943 my mother received a letter from friends that read in part:

> We heard over the radio and read in our paper that Louie was reported missing May 27, 1943. We were all so distressed and do hope that news will come of Louie's whereabouts and that somewhere, somehow, he is all right.

Another letter, this from a stranger, read:

> Dear Mrs. Zamperini,
> I had read of your son being missing, then gone. I am praying and hoping for you that there may be good news yet. My son, Howard, was killed January 23, 1942, off the Atlantic coast . . .

Most touching, at least to me, was learning later that my mother had kept a list in her daily reminder book of who had called after I disappeared. She filled three pages, in her beautiful handwriting, with at least one hundred names.

IN NOVEMBER 1943 the army listed me as tentatively killed in action, but you had to be missing for a year and a month before they'd make it official. In June 1944 my parents received the country's condolences. It read:

IN GRATEFUL MEMORY OF
*First Lieutenant Louis S. Zamperini, A.S. No 0-663341,*
WHO DIED IN THE SERVICE OF HIS COUNTRY AT
*in the Central Pacific Area, May 28, 1944.*
HE STANDS IN THE UNBROKEN LINE OF PATRIOTS
WHO HAVE DARED TO DIE
THAT FREEDOM MIGHT LIVE, AND GROW,
AND INCREASE ITS BLESSINGS.
FREEDOM LIVES, AND THROUGH IT, HE LIVES—
IN A WAY THAT HUMBLES THE UNDERTAKINGS
OF MOST MEN

*Franklin D. Roosevelt,*
*President of the United States of America.*

After an all-too-brief summer, the first fall chill filled the air. Before long it would be colder still, and I didn't relish another winter trying not to freeze standing outside on the cinder-strewn campgrounds.

Each night, just outside the gate, I could hear the local people on their way to a nearby shrine. Every morning a heavy mist covered the paddies and hills, and through it I could hear the voices of children walking to school, singing. Now it seems idyllic; then it irritated the heck out of me. Lempriere translated for me. They sang a marching song, the lyrics a stark and bitter contrast to the innocence of school-books and fresh faces. It would make sense to someone who'd fought in a war, but to the children?

One day I knew the war would be over, but I wondered how long the remains of war would last in me and in them even after the bombs had stopped falling and the guns were silent. What I feared most was that my generation would teach the hatred and resentment I was learning at the hands of the Japanese to our own children and the cycle of disaffection and violence would never stop.

But when I turned my attention back to the camp, to its filth, squalor, and inhumanity, I knew in my heart that the war—this war— was right. If it took my hatred to support it, to win it, and most important, to get me through it alive, so be it.

# 9

## THE BIRD

O<small>N SEPTEMBER 30</small>, 1944, just over a year after my arrival at Ofuna, a dozen prisoners marched through the camp's wooden gate, turned right—toward life—and headed down a narrow country road.

I was one.

At last, they'd transferred me to a recognized POW camp, inspected by the Red Cross, where they might more strongly acknowledge my value as a human being. I'd be free to write letters, and my loved ones at home would soon discover to their great surprise that I still lived. I wanted that more than anything. As badly as I'd been treated, I knew their sorrow must be worse. I missed them so.

After a few hours and a short train ride, I crossed a small bridge and walked through oversize wooden gates into Omori, the Tokyo headquarters for perhaps thirty other POW compounds, and home to more than six hundred prisoners. As Tom Henling Wade, an Omori prisoner I'd soon meet, would later write in his book, *Prisoner of the Japanese,* "Omori meant great forest, but there was no forest now."

Two guards with rifles motioned for the new prisoners to form a line. Wearily, we snapped to attention as best we could, and I stood waiting in a cold, barren quadrangle on a man-made sand-and-gravel spit—not even as long or wide as a football field—dredged from and protruding into the bay halfway between Yokohama and Tokyo.

During my journey I'd been told how lucky I was to be assigned here. After the barbarism of Ofuna, I prayed that was true; I'd heard of other camps with horrid conditions equivalent to Ofuna, like 3-B, under the Yokohama baseball stadium, and the various *Kempeitai* (Japanese secret police) prisons.

The group stood shivering for ten minutes until a flat-faced, frog-headed sergeant with the cruelest eyes I'd ever seen strutted out, more prima donna than martinet, to meet us. About five-feet-seven and in his midtwenties, he wore the usual enlisted man's outfit: the little cap you see in all the movies, khaki green uniform with baggy pants, coat with a belt, boots, sword. He paced slowly in front of the line, pausing to push his face within inches of each prisoner.

Stopping in front of a seaman from the submarine *Grenadier,* he stuck his finger in the man's face and said, "You do not stand at attention. You move!" The sergeant's face contorted and he shook with uncontrolled rage. He unstrapped his sword and was about to strike the seaman across the face but hesitated, replaced the strap, and instead hit him full in the mouth with his fist. The sailor staggered back but remained standing. The sergeant adjusted his sword and resumed pacing.

Soon it was my turn. When I looked into those black and indelibly sadistic eyes I had the eerie feeling that the sergeant knew me. That was impossible, of course, but I couldn't take the intensity of his stare and looked over his shoulder. Whack! He knocked me down.

"Why you no look in my eyes?" he barked. He stared again, and this time I stubbornly met his gaze. Whack! "You no look at me!" Damned if you do, damned if you don't. I immediately hated the little bastard—and feared him.

This was my introduction to Sergeant Matsuhiro Watanabe, disciplinary NCO and, although he had superiors, functional head of Omori. The prisoners called him "the Bird." The practice with guards and camp officials was always to label them with the worst and dirtiest names we could invent. Watanabe was the Bird not because of any physical or personal characteristic but just because he was so rotten that no one could think of a name derogatory enough to match his irrational behavior. Also, if we'd called him an insulting name and he

found out about it—Watanabe could speak broken English—he might punish the whole camp.

Deranged, brutal beyond belief, vicious like someone who tortured animals as a child before turning his evil talents on people, the Bird by his mere existence allowed me to focus all the hatred I'd accumulated and let fester since my capture.

Later, I would learn that even Omori's second-in-command, Lieutenant Kato, was simply a puppet. He'd see the Bird mete out punishment and look away. The Bird's beatings went beyond doing his duty; he seemed to get personal satisfaction from causing pain. We thought he had almost *too* much authority; perhaps he belonged to the *Kempeitai*, the secret police. Tom Wade thought he might be in the Black Dragon Society, a secret, patriotic group. No one knew.

Compared with the Bird, the Ofuna guards were country gentleman.

I SPENT MY first three days in a quarantine shed. I'm being generous; it was more like a carport: a roof and posts without walls, surrounded by an inch of snow and camp debris. I still wore my original, ragged clothes and the Norwegian's coat. I slept on the dirt with nothing to keep me warm but a thin paper blanket. At only ninety pounds, with little meat on my bones to protect me, I nearly froze and I knew I couldn't spend another night that way. But maybe I wouldn't have to. I had an idea. I scoured the area and found an abandoned apple crate, old mats, driftwood—plenty of kindling, if only someone had a match.

Thank goodness for my Boy Scout training.

I took apart the box and made a base, a stick, and tinder. I borrowed leather shoestrings from another guy in the shed. Everyone chuckled while I worked, but pretty soon smoke streamed upward and no one laughed. I used bits of an old tatami mat to feed the embers, then I began to blow, blow, blow. Before long I had a small flame. I put it under the apple-box kindling, and soon we had a fire to warm ourselves. We moved in close, only to have each man immediately pull out a long-stashed cigarette butt and light up. Priorities. Only in wartime.

When word got to the Bird that we had a fire without permission he wanted to know who'd built it. I took responsibility. "Where you get the matches?" he screamed. We weren't supposed to have matches, and we didn't. I explained what I'd done. I thought he'd admire my resourcefulness. Instead, he beat me. Later a guard told me that this was part of my introductory "training."

OMORI WAS MOSTLY sand. The camp, surrounded by a six-foot fence, took up most of the man-made island. On the other side of the fence I could see big holes in the "beach," where the prisoners charged with cleaning the latrines dumped the human excrement. Thousand of flies hovered over this sickening, open sewer. The smell never went away.

Inside the fence, Omori consisted of eight barracks, five on one side of the main walkway and three on the other, plus some administrative buildings like the camp office and infirmary. The bathrooms and kitchen were at the far end.

The barracks were long and narrow, with double-deck sleeping areas on either side of the central aisle. All the old-timers had the bottom bunks; the lowest-ranking men slept on top—my spot. In the woodwork behind my bunk someone showed me a nailed panel. He pulled out the nail and opened a wood slat. "That's where you can hide stuff from the Japs," he explained.

Once squared away, I got a cup of tea made from the leaves already used by the camp officers. It tasted weak and watery. A Royal Scots soldier a few bunks away noticed and walked over carrying a sock and spoon. He introduced himself as Blackie, and he seemed quite cheerful for a POW. He put two teaspoons of sugar from the sock in my tea.

Oh, what a treat that was.

Blackie was one of the Royal Scots who lived in Number Two, my barrack. The Scots were former criminals doing time in England who, when the war broke out, were given the choice of staying in prison or serving the queen in battle. They chose the latter.

Most of the able prisoners, excluding officers and the sick, had to work all day outside the camp, at the local railway yards, factories,

and warehouses. Each location provided great opportunities to steal goods to sneak into the camp: rice, sugar, canned oysters, canned sardines, dried fish, whale meat, dried egg powder, coconut, chocolate, even grain alcohol. The contraband kept the men healthier not only physically but mentally, because the game of pilfering sharpened their minds and sustained their hopes.

The Scots worked at a Mitsubishi warehouse and specialized in smuggling sugar. According to Tom Wade, they averaged ten pounds of sugar a day, or three tons a year. That's why we knew them as the "Sugar Barons."

At first I couldn't figure out how they did it; we were regularly frisked. But rather than hide contraband in their jackets, waistbands, or other obvious places, they'd tie off their pant cuffs and fill the legs. Even more creatively, they'd ordered bigger work boots. The Japanese would say, "American crazy. Big shoes. Japanese wear tight shoes." The reason was so they could fill the shoes with goodies and walk into camp with stolen items under their feet and no one the wiser.

The Scots also requested wraparound leggings like the Japanese had worn in World War I. This appealed to the Nippon ego, and it allowed the Scots to smuggle tobacco into Omori to supplement our meager ration. Again, they were quite inventive; they had to dampen at least every other leaf and stack them. By the time they were through working, the leaves were all soft, so they could wrap them around their legs. Then they'd put on the leggings and pull their pants down to cover the evidence.

Back at the barracks, the Scots would dry the leaves in secret compartments above their bunks until they hardened like wood. As a finishing touch, they'd somehow obtained a piece of steel, bent it at an angle, and used it to shave the dried wads. The result was more tobacco for everyone, free.

Not everyone smuggled contraband successfully. Guards searched prisoners when exiting work and entering camp. Guilty parties received beatings and limped back to their bunks with bruises, missing teeth, black eyes, and broken bones—but rarely broken spirits.

·    ·    ·

TO FURTHER HELP the war effort the Scots drank excessive amounts of tea on the job. Seems strange; even the guards didn't understand. They'd question the Scots and hear, "Never drank tea in my life, but you Japanese have the secret. It's the greatest." In truth, this was an elegantly simple form of sabotage. Every ship they loaded had rice. The Scots would drink tea all day, then take turns peeing on the rice so by the time it reached its destination it had spoiled. The same with oysters; they'd puncture the cans and pee on them. If they found a crate addressed to the German chancellor, they'd take great delight in ruining it as well.

The Japanese also shipped bricks to build fortifications. When the Scots loaded the bricks, the last guy would catch two bricks and bang them together, creating four "bricks" instead of two, then stack them carefully to look whole. By the time anyone found out, it was too late.

MY FIRST DAY out of quarantine I immediately reported to the American officer in charge, naval commander Arthur L. Maher, gunnery chief and most senior crew member to survive when the *Houston* sank in March 1942. Maher had been at Omori since December 1943.

We looked to our leaders and to those who had the gift of fluency in foreign languages as our spokesmen. Besides Maher, Tom Wade, an Englishman of mixed parentage, knew Japanese; Lempriere, who'd been with me at Ofuna, knew a bit of many languages and picked up Japanese quickly. Martindale, an air corps second lieutenant from Arizona, also had a fair knowledge of Japanese. This didn't necessarily ensure better treatment, just better comprehension of what our captors wanted from us each day, and the ability to follow directions when told—often by the Bird, usually screaming—that we must obey "all Japanese orders."

Unfortunately, Maher seemed unhealthy and low-key, not a take-charge type at all. Wade remembers him regretfully telling us he had no access to the camp command—meaning Watanabe, reportedly once a quieter, friendlier fellow—or any international agency—the Red Cross wasn't "recognized" except for carefully selected propaganda purposes. The only advice Maher offered was that we "obey all

Japanese commands, no matter how insane," and pray along with the rest of the prisoners that they would transfer the Bird before he went completely insane and caused a mass killing. Meanwhile, he insisted that no officer was allowed to join the daily work parties. The Royal Scots said we were fools not to because we could steal goods, but we had to listen to Maher.

Our refusal to work did not please the Bird. With our group's arrival, a surplus of unemployed officers sat around the camp all day. Although we scavenged the beach for driftwood, swept the grounds, handled sewage, and worked in the kitchen, he did not think it was enough.

One evening, while we smoked cigarettes and socialized, the Bird burst into the barracks for a surprise inspection. A prisoner by the door screamed, *"Kiotsuke!"* (Attention.) *"Kashira naka!"* (Eyes center.) He wasn't quick enough for the Bird, who lunged at him and kicked him. Everyone else stood at attention. Waiting. Hardly breathing.

The Bird walked down the center aisle and scanned the building. Finally, his eyes found mine. "Look at me!" he screamed. "You come to attention last." I hadn't, and the Bird knew it. He'd entered at the opposite end of the building, and I was beyond his line of sight. Even if I had, the Japanese never punished anyone for such an offense. Yet somehow the Bird always managed to pick on me, as if he held some special grudge. Whenever he came around I did what I would do with anybody who is my superior and has a lease on my life: I was extremely nice, the model prisoner. I also stayed as far to the rear of the pack as possible, yet every day he managed to punish me. Now he'd set me up again.

Usually, he used his fists or a stick. This time he removed his thick web belt, held it like a baseball bat, and cracked me full across the temple with a steel buckle that must have weighed a pound or more. I fell to the ground, bleeding, in horrible pain. He ordered me to stand. I couldn't. The Bird took a few squares of toilet tissue from his pocket, bent down, and gave them to me. "Ahhh," he muttered, like he was sorry. I must have been really out of it because for a second I thought, Maybe the guy isn't all that bad.

I struggled slowly to my feet and dabbed at the blood until it stopped. When I moved my hand away from my head he hit me again, in the same place, and I woke up on the floor. This time he offered no tissue, and my only thought was, God, this guy is scary.

I stood up again, angry. I have Italian blood, and revenge was written all over my face, not because of my physical agony but because I'd been humiliated. The guards at Ofuna punished us hard but impersonally. The Bird focused on me. He knew I could only cry, not act. But I wouldn't cry. Not for him. Not for anyone.

My best revenge was to take secret comfort in knowing that Watanabe had mental problems. Even the other guards called him a sadistic psychopath. Once, the Bird sent for ten officers—including me—who worked in a makeshift leather shop. By the time we put away our tools and walked two hundred yards to his office, five minutes had elapsed—too long for Watanabe. He came after us swinging his belt, the heavy buckle whipping through the cold air. He struck everyone more than once across the face.

Sometimes the friendlier guards whispered to us about Watanabe's life, explaining that when he had first come to Omori he hadn't fussed much, just observed and did his job. Tom Wade knew more. As he wrote in his book:

> Watanabe was the spoilt son of a wealthy family. As he'd told us, he had a beautiful home with a swimming pool in the hills behind Kobe, unlimited money, an adoring mother and he had led a dissolute student's life. Watanabe went to school at Waseda University in Tokyo, then worked for *Domei,* the Japanese news agency. When called up by the army, he had immediately taken the examination for a commission. When he failed he resented it deeply, as his brother and brother-in-law were officers. So the army made him a corporal (later a sergeant), spared him service overseas and settled him at the age of twenty-seven, in a safe berth at Tokyo Headquarters Camp.
>
> Although the wrong rank, Watanabe was a typical member of the "Young Officers" clique, believers in *Kodo,* the Imperial Way—

an extreme, patriotic association that dominated Army and then national policy. [Watanabe] was proud, arrogant, and nationalistic, while sheltering an inferiority complex over his failure to become an officer.

In other words, the Bird hated officers because he couldn't be one, and given a camp full of high-ranking men he acted like a jealous god, abusing his power. If we defied him or hesitated, he'd beat us. A favorite punishment—even more than the belt—was making our own enlisted men beat us. We'd line up while each noncom was forced to walk down the line striking an officer with his fist. After each punch, the Bird shouted, "Next!" It became a maniacal chant: "Next-next-next . . ." When our men hit easy he'd club *them* on the head. We'd whisper, "Look, hit us once. Hard." Then we'd go down and Watanabe was satisfied. So were we, preferring to be hit by our own men than by anyone Japanese.

AS AT KWAJALEIN, one Omori guard was Christian, and he quietly performed many acts of kindness for which he could have been severely punished. His name was Kano. Sometimes he would slip us his tobacco rations, and if a man was ill, he brought him candy for the much needed sugar. Kano also risked his life to help anyone unfortunate enough to be tossed into "the barn," a room with holes in the wall, cold and miserable at night, where men caught stealing were forced to remain for days wearing only their undershorts. Kano would wait until the other guards were asleep and cover the prisoner with a blanket, then arrive an hour before sunrise to reclaim it.

AFTER MY BELT lashing, the Bird shouted for everyone to go outside. We lined up on the compound, and he paraded stiffly before us, as always.

"You are all officers," he said, carefully pronouncing each word. "You should work. You should be example for all camp. Work. Now you volunteer."

No one spoke up. We were determined not to do any work for the Japanese.

The Bird stepped in front of the first man. "You. Volunteer!"

"According to international law," he began, but he didn't get far. Watanabe hit him with his kendo stick, a heavy cudgel the size of a child's baseball bat. The next man had the courage to say the same. He, too, felt the kendo stick. Another simply gestured hopelessly. The man beside me found himself on the ground after a kendo strike to the throat. Then it was my turn.

"You!" the Bird shrieked. "You da?"

Well, I'm not a fool. The Japanese knew international law as well as I did, but clearly they ignored it. "Sure," I said, in my most soothing voice. "What kind of work? I'd love to work. But only in camp, not outside. I'd be glad to help to improve conditions *here* any way I can."

The Bird stopped, unsure of how to react, thinking slowly, the rage draining from his face. His eyes studied mine, then darted along the row of officers, to see if anyone had moved.

"Yes, of course. *Awari*—dismissed."

We saluted and dashed for the barracks before he changed his mind. The Bird strutted to his office, smirking. The next day he turned one of the smaller buildings into a workshop where we could make goods for the camp. The officers often spent all day inside, shoulder to shoulder, stitching scraps of leather together for later use. We must have looked too happy, though. Eventually the Bird decided we were simply lazy. His punishment was as foul an atrocity as I'd ever witnessed, as did Tom Wade, who confirms this story in his book.

David James, a British businessman and interpreter, had lived in Japan for many years, but the government had imprisoned him on the irrelevant charge that he held a reserve military status as a captain. Apparently, James had even known the Bird's family in Kobe, before Pearl Harbor; but rather than this winning him any consideration, Watanabe singled him out. For being at ease while the rest of us stood at attention, the Bird beat Captain James and forced him to stand in front of his office for several days and nights in early winter, saluting the tree planted in front of the door—not an easy task for a starving,

*sixty-three-year-old* POW. After a few days, Dr. James collapsed, nearly insane, and spent weeks in bed recovering.

ONE EVENING I walked past the door of the little cubicle the senior American officers occupied, and they hailed me.

"Zamp," one said. "The Norwegians managed to get their hands on another newspaper today. But if any of us are seen going over to their barracks, the Bird might get suspicious. He knows the Norwegians like you, though. Maybe you can do it."

I knew the penalty for getting caught with contraband, remembering the episode with Bill Harris at Ofuna quite clearly. The Japanese did not want the prisoners to know how the war progressed, assuming our minds would turn immediately to espionage and to plotting against them. Of course, they were right, though every time they caught us with a measly scrap of paper we protested our innocence loudly.

"Of course I'll get it," I said. This began my regular job as runner between barracks, relaying important information or stolen papers to senior officers who secretly employed prisoners like David James to translate, or did it themselves. The Japanese papers, by this time—the winter of 1944/45—overstated their victories, but at least they contained accurate maps.

One story I read, in an English version of a Japanese newspaper, was so funny and unbelievable that for many years I never told anyone because people might think I was nuts, like someone who says he's seen a flying saucer. (If you see one, keep your mouth shut!) Apparently, a Zero and a B-29 bomber were engaged at thirty thousand feet when the Zero ran out of bullets. According to the report, the Japanese pilot opened his lunch bag, grabbed a rice ball, cracked his canopy, and threw it at the B-29—and knocked it down! A picture of the smiling Zero pilot was plastered across the front page. I thought, Gee, are the Japanese people really that stupid? Would anyone, even in need of a major morale boost, believe that?

What I *did* believe I'd seen with my own eyes.

One afternoon the air-raid sirens wailed. "I don't think this is any more than a practice run," said a soldier with whom I was discussing

the state of the war. "We don't have a base near enough to launch an attack." Still, we both backed away from the windows, just in case.

Suddenly we heard a big gun fire. We dashed back to the windows and looked outside, where in flagrant violation of the Geneva Convention and the rules of war there was an antiaircraft battery that the Japs had just uncovered on a small sandy spit not more than a hundred yards from our compound. (No one could take it out without hurting the prisoners.) In camp the guards roamed, rifles ready, shouting *"Bi-ni ju-ku!"* I knew I had to get away from the window or be shot, but I could not resist finding out what had caused the commotion. By sliding on my back along the floor I could see the sky straight up through the narrow windows. There, floating through a high-altitude haze, leaving vapor trails from each end of its huge wingspan, was the largest aircraft I had ever seen, flying at thirty thousand feet like some sort of white angel. I knew it was a messenger from home, a harbinger of imminent revenge. It took my breath away.

The word spread, and when the day's work parties returned we found out from a pilot who'd recently arrived at Omori that it was "the latest thing out," a B-29. (*Bi-ni ju-ku*, in Japanese.) Then I remembered seeing those words scrawled as graffiti on a slaughterhouse wall when my group went to pick up some horse guts for dinner.

The plane flew over casually, around the Tokyo industrial complex, in a big lazy circle, taking pictures. No Zeroes chased it, but a few days later the Japanese papers reported that Zeroes took off to attack the bomber. The exact headline read: THEY FLED IN CONSTERNATION.

ON A BRIGHT, crisp November morning the Bird burst into barracks Number Two and without resorting to the usual subterfuge called my name. I thought surely I'd been chosen for some awful detail or, worse, another beating.

Instead, he paced in front of me, hand on his chin and said, "You run, eh?"

"*Hai* (yes), Watanabe-san," I said, wondering what he had in mind.

"Olympics, eh?"

"*Hai.*"

"Your mama and papa worried maybe you dead?"

"*Hai.*"

Tom Wade had set up a post-office operation at Omori that was responsible for many letters from home reaching their destinations, but when I tried to write—I was desperate to contact my family, to let them know I was still alive—the Bird forbade it. I never understood why.

"Maybe you make a—ah, *nan deska?*" He cupped his hands in front of his mouth, as if he were talking into a microphone.

"A broadcast?" I asked. I was instantly on guard. I knew about the *bunka,* the special "culture camp" in Tokyo that housed those who made pro-Japanese (or anti-Allied) propaganda broadcasts from Radio Tokyo. No one in his right mind wanted to participate. Not only was it morally wrong, but soldiers too weak to resist would pay for their treason, however rationalized, with a court-martial after the war. On the other hand, I wanted my family to know I was alive.

"Yes, broadcast," the Bird said. "You broadcast. Okay? *Na?*"

I shook my head from side to side. "I have to think about it," I told him. I wanted to say that international law would not permit me to do more than give a basic greeting for identification purposes, but I had no doubt he'd punish me for my boldness. However, the Bird accepted my reluctance with amazing good humor, and I sensed then that he must have been acting on strict instructions not to hurt me, rather than his own twisted desires.

I WENT IMMEDIATELY to the senior camp officers and asked their opinion on the question of broadcasting. To my surprise I discovered that they had given other prisoners the same opportunity to send home their names, status, and a simple message. No one would object if I only did the same. They had just one request: perhaps I could find someone in authority to whom to complain about the Bird. As a rule, you never spoke up about the treatment at camp. When the Red Cross came to Omori, the other prisoners had cautioned me, "Don't say a word about the beatings because when they leave, there's no protection and you'll get a double dose." But the Bird was different. I had to take the chance.

•   •   •

I TOLD THE Bird I'd make the broadcast. A couple of days later two men from Radio Tokyo, both in their fifties, gave me a pad and pencils and said, "Write what you want to say." While I wrote, other prisoners urged me, "Mention my name!"

The men from Radio Tokyo read my speech and said, "Oh, very good, very good." Like Sasaki, they didn't wear uniforms. Of course, they probably didn't really work for the station either, but were propagandists like Goebbels was for Hitler.

On November 18, 1944, I rode with them to Radio Tokyo. We arrived early, and with time to kill they gave me a grand tour. The place was beautiful. "This is a new building," they explained. "We have an American-style cafeteria; we will have lunch." The food amazed me, but after the camp rations, I'd have been happy with a peanut-butter-and-jelly sandwich. They also showed me hotel-style rooms with beautiful beds and white sheets. At Omori I slept on a plank where each night the bedbugs swarmed out of the cracks and over my body, and I'd wake up covered with bites.

I knew they wanted to seduce me with the promise of a better life to become a radio propagandist. I suspected they also wanted credit with our government for having rescued me and kept me alive. They could say, "Hey, we had your boy," as if they'd saved me. I suppose the Japanese figured that one day soon they might need all the goodwill they could get.

Eventually, I was ushered into a studio and placed in front of a microphone. The program was *Japanese Postman*. My nerves kicked in for a moment, but I didn't mind. For the first time in a long time my anxiety had nothing to do with starvation or deprivation or a beating. The announcer introduced me as "Louis Philby Zamperini"—my middle name is Silvie, so it was an innocent mistake—and cued me. I clutched my prepared text, took a deep breath, and read:

*Hello Mother and Father, brothers and friends, this is your Louis talking. Through the courtesy of the authorities here I am broadcasting a special message to you. This will be the first time in one and one half*

*years that you will have heard my voice. I am sure it sounds the same to you as it did when I left home. I am unwounded and in good health and can hardly wait until the day we are together again. Not having heard from you since my most abrupt departure, I have been somewhat worried about the condition of my family. As far as health is concerned. I hope this message finds all of you in the best of health and doing well. I am now interned in the Tokyo prisoners' camp and am being treated as well as can be expected, under wartime conditions. The Jap authorities are kind to me and I have no kick coming. Please write as often as you can and, when doing so, send snapshots of everyone. In my lonesome hours nothing would be more appreciated than to look at pictures of the family. If you are forgetting, Pete, I would be very pleased if you would keep my gun in good condition for we might do some good hunting when I return home. Mother, Sylvia and Virginia, I hope you will keep up your wonderful talents in the kitchen. I often visualize those wonderful pies you used to bake. Did Miss Florence take a visit to San Diego? I hope they are sending her home. Give my best regards to Gordon, Harvey, Eldon, and Henry, and wish them the best of health. I send my fondest love to Sylvia, Virginia, and Pete and hope they are enjoying their work at the present. I miss them very much. Since I have been in Japan, I have run into several of my old acquaintances. You will probably remember a few of them. Paul Maurin is here and enjoying good health. Lawrence Stoddard, Sammy Manier, and Peter Hyriskanich are the same. You must remember William Payton of Bakersfield. We have been living together for the past two months. He is looking fine. I know that you have taken care of my personal belongings and savings. Long ago, you have no doubt received the rest of my belongings, the phonograph and records, from the Army. Say hello to all my hometown friends. And before closing, I wish you all a merry Christmas and a happy New Year. Your loving son, Louie, First Lieutenant Louis S. Zamperini, Tokyo Camp.*

I'd added the part about my gun so that if my family heard the broadcast, they would know it was authentic. I also mentioned Pete Hyriskanich's name so his folks would know he was still alive.

Before returning to Omori I brought up the prisoners' complaints about the Bird. I thought, Whoever these guys really are,

they have authority to take me out of prison, so maybe they can help us. I explained that I'd never talked about this to the Red Cross for fear of a beating. They said, "Oh, well, we'll see what we can do about it."

"We" again. I should have known better.

ONLY DAYS AFTER my broadcast, the United States government sent my parents a telegram reading: "Following enemy propaganda broadcast from Japan has been intercepted"—with the text of my statement. They refused to confirm it had been my voice; that would have to wait. But at least the telegram made official what my parents had already been told by their friends who'd heard the program and recognized my voice. Of course, not that long ago the army had also advised my parents that I was also officially dead. It was nice to be sure.

My parents would later tell me that they'd never lost hope, but ironically, as part of their effort to support the war, *the day after my broadcast* they had been interviewed at their house by producer Cecil B. DeMille for a coast-to-coast live broadcast on CBS Radio. Hollywood had from the beginning signed on to support the war any way it could, and this was part of the Sixth War Loan Drive—a bond drive. Here are a few selections from the script sent to my parents:

DEMILLE: Good evening, ladies and gentlemen. This is Cecil B. DeMille and I'm speaking to you tonight from a modest American home where a gold star hangs in the window. This is the home of Mr. and Mrs. Anthony Zamperini and their children. They are a typical American family. In this home live the things our soldiers are fighting for.

One member will not return to this family because he treasured the simple and sacred rights of this home—more than his life. There are many mothers who wear gold stars in their hearts, mothers who have paid a price perhaps as high as that given by their fighting sons themselves. One of those mothers—I want you to meet—the hearthstone of this home—Mrs. Anthony Zamperini. Mrs. Zamperini, when did you learn that your son, Louis, was lost?

MRS. Z: Last Sunday. But Louis had been listed as missing in action since May of 1943. He was just twenty-five, Mr. DeMille.

DEMILLE: Your son was one of the first to enlist, wasn't he?

MRS. Z: Yes, Mr. DeMille. He sent in his enlistment early in 1941, before Pearl Harbor. He had been to Berlin as a member of the Olympic Games team and he saw what was coming before we did.

And later . . .

MRS. Z: Louis did win many medals for his sports activities, Mr. DeMille.

DEMILLE: I know he did, but I'm sure that of all his medals you are proudest of his Oak Leaf Cluster and the Air Medal he won for gallantry in battle.

MRS. Z: That's right. He won the Air Medal for giving first aid to five other wounded boys while their damaged bomber was returning from a raid.

And finally, after my sister Sylvia told how our dad came from Italy but owed much to America . . .

DEMILLE: That is a thrilling tribute to America, Miss Zamperini. Everyone in America is a European—or the descendant of a European. We become Americans when we leave behind us all the ancient prejudices and manners of the Old World and when we accept new ones from the way of life in the New World. Here, individuals of all nations are melted into one race of man. . . . Your brother has given his life so that America will remain free. We won't ever forget that. We are on the front and have a job to do. . . . Thank you for letting us come into your home this evening to speak to you. The people of the United States have seen the gold star in your window. You and your family are America.

My family, especially my mother, would never give up hope that I'd come home. After the war I found out she'd even written General Hale—the same one who hadn't reported accurately about the Nauru raid—asking him to search for me. His reply was, "It's better you give him up like we have." A tart letter from a callous person, as far as I'm concerned. It made her furious. He'd tried to dim her hope, but when my brother found out he helped restore her faith. "I still believe my son's alive," she wrote to the general. Then, when I made my radio broadcast she said, "I know there was a lot of static. But there are things he said that make me sure it was Louie."

TWO WEEKS AFTER my visit to Radio Tokyo, three men came to Omori and asked me to make another broadcast.

"You have a beautiful radio voice," they said, with obsequious and encouraging smiles. "You did such a good job that we want to let you do it again." Well, I thought, why not? I've got more to say to my parents.

To brave the icy weather they gave me a new, heavy, U.S. Army overcoat they'd confiscated after some battle. I wore it to the station, savoring each moment of warmth because I knew from their blatant, graceless patronizing to be very wary.

At the station we ate in the cafeteria again, and then they said, "By the way, we want you to meet three nice fellows." They introduced me to one American and two Australians.

All three shook my hand, but not one met my eyes. They stared at the floor instead. I got the message: "Hey, I'm sorry I got into this mess. They tortured me. I'm ashamed. Don't you do it."

I understood but still couldn't condone their actions. I'd suffered, too—daily; from their look I wasn't sure these guys had had it rough in some time. Yes, prison camp was rotten, but the Japanese had just found the right guys to give in.

Before I could speak up my chaperones hustled me to a nearby office. Seeing paper and pencils on the desk, I asked, "Do you want me to write another broadcast?" Even if they didn't, I knew I could speak off the cuff.

"No," said one, handing me a typewritten sheet of paper. "We already have something written for you. Make broadcast with this."

They stood silently while I read.

After a few sentences I knew it stunk.

The speech was casual and in what the Japanese supposed was an offhanded American vernacular, but it still had the unmistakable smell of propaganda; if I read it, it would be the beginning of a career I'd regret. The third time would be even stronger, and I'd get stuck like those guys I'd met in the hall. Once you join the Mafia, you can't get out. (After the war I heard that the American serviceman I'd met at Radio Tokyo was thrown overboard on his way home; men who knew he'd made propaganda broadcasts lay in wait for him.) Plus, I was familiar with the Tokyo Rose broadcasts and their aim of demoralizing the enemy. The Japanese imagined themselves samurai warriors, aggressive fighting men dedicated to the death. They figured Americans were weak, so they always picked on guys on the front lines: "Do you know where your girlfriend is today? Is she in the arms of somebody else? Is she faithful to you?" If you could make a man go into battle worried and not concentrating, he'd get killed. The Japanese considered the poor soldiers on the front lines akin to morons, easily influenced.

"Sorry," I said, shaking my head. "I can't read this."

"But you must read it."

"Nah. Besides, it doesn't sound like me. No one in America will believe it's me."

I shouldn't have said that because they just offered to change the words.

"No, sorry. I just can't do it."

"You are a great athlete," one man said, taking the tone he might take with a child. "Do you want to eat in the cafeteria and have a nice clean room?"

I gave them an emphatic no.

They spoke in Japanese and walked into another room to confer further. I looked at the desk and saw four or five copies of the speech just lying there. I stuck my hand in my overcoat pocket and stood close to the desk. Then I slipped my hand through the slit all overcoats

have in the pocket so that you can put your hand into your pants pocket without opening the coat—and snatched a copy of the speech. I quickly folded it with one hand and prayed they wouldn't miss it, because then I'd really be in trouble.

The men returned and asked me again to cooperate.

"No. I positively can't do it."

That seemed to make up their minds. "Because you will not read this, I think you go to punishment camp." Those are the exact words he used: *I think,* meaning a moment of hesitation in case I wanted to change my decision.

I didn't. I'd taken an oath as an officer. What's more, my immediate thought was, Great. This will get me away from the Bird. I couldn't stand to be around that guy.

But then, they knew that.

By the way, here's what they wrote, exactly as typed.

*Well, believe it or not . . . I guess I'm one of the those "Lucky guys", or maybe, I dunno, maybe I'm really unlucky . . . Anyway . . . here's me, Louis Zamperini, age, 27, hometown Los Angeles California, good ole United States of America speaking. What I mean by lucky is that I'm still alive and healthy . . . Yes and it's a funny thing . . . I've heard and also saw with my own eyes that I'm washed-up that is I was reported to have died in combat . . . Yes, one of those who died gallantry fighting for the cause . . . I think the official report went something like this . . . 'First Lieutenant Louis S. Zamperini, holder of the national inter-scholastic mile record, is, listed as dead by the War Department . . . the former University of Southern California miler was reported missing in action in the South Pacific in May 1943' . . . Well, what do you know? . . . Boy . . . that's rich . . . Here I am just as alive as I could be . . . but hell I'm supposed to be dead . . . Yeah and this reminds me of another fellow who's in the same boat as me or at least he was . . . Anyway he told me that he was officially reported as "killed in action" but in reality he was a prisoner-of-war . . . After several months he received a letter from his wife in which she told him that she had married again since she thought he was dead . . . Of course, she was astonished to hear that he was safe and held in an interment camp . . . she*

*however, consolated him by saying that she was willing to divorce again and marry him once again when he gets home . . . Boy, I really feel sorry for a fellow like that and the blame lies with the official who allow such unreliable reports . . . After all the least they can do is to let the folks back home know just where their boys are . . . Anyway that's not my worry but I hope the folks back home are properly notified of the fact that I am still alive and intend to stay alive . . . It's certainly a sad world when a fellow can't even be allowed to live, I mean when a fellow is killed off by a so-called official report . . . How about that? . . .*

Yes, how about that? I don't think it sounds like me at all.

BACK AT OMORI, I hid the pilfered speech in the wall and later gave it to the War Crimes Commission.

Of course, the Bird and his guards were mad. I guess I'd made him look bad. They beat me for a week.

Around Christmas, Bill Harris arrived from Ofuna, with some other prisoners I knew. Now my friends were all in one place: Harris, the Scots, Lempriere, Lieutenant Green, who flew for New Zealand, and others. Suddenly, I wanted to stay instead of be transferred to the punishment camp.

For the holiday, the Bird distributed Red Cross packages from America. Actually, he allotted three packages for every five prisoners. Typical. I was hungry, as always, but I gave my part to Harris. He was still haggard and sick and in the infirmary with a temperature of nearly 105. "You're a fool," he said, when I handed it over. "Your life depends on that box." Ever since his pummeling at Ofuna, Harris had been slightly off. He didn't know that he needed the nourishment more than I did. I also convinced the Royal Scots to donate some sugar, and Harris pulled through.

After the war Harris returned to Camp Lejeune and planned to get married and leave the service. Then he wrote me and said he'd decided to re-up. The marines sent him to Korea. During a battle he was surrounded, captured, and later executed. It was war, we knew it could happen, but no one deserves that. The poor guy.

．　　　．　　　．

AS 1944 TURNED into 1945, the Germans were close to defeat in Europe and the Japanese knew their end was near. The more desperate they became the more they relied on propaganda to motivate their troops and citizens, and to paint a better picture of themselves for the world.

At one point a film crew came to the camp and asked the huskiest guys to step forward. About fifty did. Not me, of course; skin and bones was not what they were after. They told the group to go to the beach and whoever did would get all the food they could eat. But first they had to put on American marine uniforms and take rifles with no bullets.

On the beach the film crew explained that they wanted to make a little movie. After the group went through some sort of exercise, everyone stood around wondering what would happen next. The Japanese pointed out tables set with fruit and rice balls and other foods, about a hundred yards away. They said, "Okay, we're through shooting here. Like we promised you, you can have all you can eat. See those tables? There's your food. The first one there gets more food."

You'd have thought a starter's pistol went off. The men were so hungry they literally raced to the food tables—and what footage that made! "American marines" running desperately, carrying rifles, losing ground, throwing down their rifles, running. Later, the Japanese spliced in ten little Japanese soldiers with rifles and bayonets so it looked like they were chasing the marines along the beach, forcing a coward's retreat. And not a sign of the food anywhere in the movie, of course.

IN FEBRUARY 1945 sirens wailed again and the camp came alive. I ran out of my barracks and looked up to see the beginning of a raid, probably from a carrier ship. There were planes all over the sky: navy Hell Cats and Zeroes. Three F-4U fighters streaked over the camp and dived in on the Japanese navy airstrip about two miles south. Above, I could see Zeroes exploding, popping like little firecrackers.

Suddenly, a navy Hellcat flashed by, chasing a Zero. He was so close I could have hit him with a brick. The Zero finally veered over Tokyo, where he knew he had protection, and the navy pilot turned right and went out over the ocean. That was my first real taste of the victory to come. The Bird and the camp guards had all run outside to watch, and I could hear them saying, *"Nippon skokey!"* In other words, the Japanese air force is no good. *"Dah may!"*

Then I saw a B-29 in flames. The crew bailed out, but two Zeroes strafed the survivors all the way down to the water. That was a sickening sight, and I thought I could hear a cold moan of frustration and vengeance rise up from the prisoners.

I turned to Bill Harris. "It's going to be a pleasure to watch them squirm when the pressure really mounts," I said. "I think it won't be long before our planes come over by the hundreds and turn Tokyo to rubble."

Not a week later we heard sirens again, saw vapor trails, and smoke rising from the city as our bombs found their targets.

Had we cheered as we watched, the sullen guards would surely have shot us on the spot, but we satisfied ourselves with whispers and nudges and bets on when we'd finally head home. We knew from stolen scraps of newspaper that MacArthur had returned to the Philippines, headed for Manila. The German lines in Western Europe had all but crumbled in the face of irresistible Allied forces.

DESPITE OUR VICTORIES, the reality of my transfer was only a matter of time. But even as I wondered when I'd be forced to leave Omori, the entire camp got a big surprise: *the Bird had been transferred.* Perhaps his new assignment was another move by the Japanese command to appease prisoners who might shortly be free, by ridding them of the scourge of Matsuhiro Watanabe. I'm certain I wasn't the only one who'd complained.

*Overjoyed* does not begin to describe my state of mind, but my celebration was cut short on March, 1, 1945, when my own transfer came in. My destination: Camp 4-B in Naoetsu, 250 miles northwest of

Tokyo, on the other side of the country. A few other prisoners, like Tom Wade, moved with me. The rest came to say good-bye.

NINETEEN SQUARE MILES of Tokyo had burned in the recent fire-bombing raid, and our train to Naoetsu went right through the devastation. I'd seen the area before the destruction, home to huge power lines, electrical transformers, and generators, factories, private houses. Now all I could see was charcoal for miles as thousands of buildings were reduced to ash. Only one silhouette stuck up repeatedly through the waste: lathes, the machines used to make airplane and ship parts. What a sight, these charred metal monsters framed against an overcast Tokyo sky.

Then we slid into a tunnel and a cold, depressing blackness.

Twelve hours later the train arrived in Naoetsu, a city about forty miles outside of Nagano, where the 1998 Winter Olympics were held. Snow blanketed the ground in huge ten- to twelve-foot drifts, reaching to the rooftops. How the hell would we walk through this stuff? People actually tunneled *down* to get into their homes. The guards herded us through gloomy streets. In the distance I could see the dirty smokestacks of a factory perched on a hillside overlooking the Sea of Japan and the prison camp.

We shuffled into Camp 4-B's main courtyard, and the gate closed behind the last man. A guard shouted for everyone to stand at attention and wait for inspection. And wait we did, in the bone-numbing, frigid wasteland: five minutes, ten, fifteen, twenty, thirty. I could hardly move my half-frozen hands and feet. If this was "punishment camp," then the penance had already begun—and I expected it would soon get worse.

Finally, the door of a rusty, corrugated tin shack by the main gate opened. The camp commandant stepped out onto the icy parade ground, moved briskly into the light, and surveyed his new arrivals.

I felt my knees buckle and my heart collapse.

The Bird.

I steadied myself on the man next to me in line, but inside I gave up

all hope. I thought, Oh, what they've done to me! This is futile. There's no escape. It was the lowest ebb. The cruelest joke. The kiss of death. I realized I'd never get away from the Bird.

Watanabe marched down the line and found me. His black eyes bored into mine. It was impossible to look at him, and impossible to look away. His face twisted into a sick, sardonic smile. He didn't seem surprised at all to see me.

In his book, Tom Wade put perfectly exactly how I also felt at that moment: "If someone had given me a pistol then, I would have just blown my brains out."

# 10

## "IF GOAT DIE, YOU DIE!"

EVEN TAKING INTO account the barbarity of my captors, I couldn't imagine they were so devious that they'd planned all along to get even with me by transferring the Bird from Omori—to raise my spirits—and then to crush them again by moving me to his new command.

I was only one man, yet it seemed so.

They knew I hated the Bird's guts. I'd ruined their propaganda plans, and when they'd threatened me with punishment camp, I'd acted almost pleased. I would have worked in a coal or salt mine to be away from Watanabe. How many nights had I already dreamed about strangling him? So what better comeuppance than to make my greatest fear come true? It was a hateful, brilliant plan.

And what about the Bird himself? Was it all his idea, or had he been banished to Naoetsu because of my failure to play along with Radio Tokyo, and then cleverly used as a pawn in my continued torture? He may have run Camp 4-B, but I'm sure there were other places he'd rather be.

Whatever the sorry truth, I'll always believe our intertwined fate was more than mere coincidence.

·    ·    ·

NAOETSU ROSE ON the west bank of the Aba River, about two kilometers from the Sea of Japan. Camp 4-B was maybe fifty meters square, at the confluence of two rivers, with fences but no barbed wire and a complement of five or six guards to oversee anywhere from fifty to three hundred men.

In each prison camp my first thought always turned to escape. As at Ofuna and Omori, I repressed these fantasies. The threat leveled at Ofuna to shoot innocent prisoners if others tried to run had since become a national edict. I couldn't see sacrificing someone else's life for my own freedom. Instead, I hung in as best I could, hoping the war would end soon and we'd all be free.

The raid over Tokyo was more than inspiring, and it gave our souls the power to endure through any hardships to come.

In the Tokyo area alone, 250,000 civilians were armed, knowing the Allies might invade any day. Word had spread that if our forces landed on Japanese soil, all prisoners of war would be executed. Why, when we were already locked up? Because the authorities considered us their number one threat; we could organize overnight and attack *from within*. In fact, we'd already discussed that possibility in camp, but we believed that if our troops invaded, our *only* recourse was to scatter. Every man for himself. Like on Okinawa and other Pacific islands, we knew that the Japanese would fight to the last person. How could we, starving men with no weapons, fight back? All we could do was leave at night and run for the hills.

IF THE JAPANESE didn't kill us first, the dwindling food supply might. Or a miserable winter. Or both. The winter before my arrival, eighty-one Australian soldiers (out of three hundred prisoners) died from pneumonia, starvation, forced labor, and brutality. While I was there, one third of my camp buddies didn't make it.

Forced labor was our only occupation; officers, too. Every day, gangs marched to the nearby steel mill, train yard, and port. Although we all had shoes, most of us walked the two miles to work barefoot in the March snow and ice, our feet wrapped in rags, because the Bird

had a rule: whoever had dirty shoes got beaten and had to lick them clean.

Watanabe required all men with temperatures of 103 or less to work; those with 104 and above could stay behind. You worked or you died, and sometimes you'd die anyway. I never knew when a soldier would go; even men who didn't seem ill at all would come back from work detail, fall asleep, and never wake up. I'd kick a guy's foot, saying, "Come on, let's go eat," and he wouldn't move. Then we'd have to haul the poor guy to the village crematorium on a toboggan, and his remains would end up in a little wooden box stacked on piles of other little wooden boxes, in a small storage room on the first floor of the main prison building, waiting for the rats to gnaw through the thin wood and scatter the ashes on the cold cement floor.

IN APRIL 1945 the Bird demanded that all the POW officers line up on the parade ground. He stood with his hands behind his back, gazing up at the sky, indifferent to our restlessness. Finally, he sauntered up to our senior officer, Commander Fitzgerald, of the submarine *Grenadier,* and said, "Roosevelt-san, he is dead. Dead!"

We managed to show the proper grief and surprise at the Bird's announcement and did not bother to tell him that we'd learned the news six hours earlier from the workmen at the steel mill. Let him enjoy his moment.

AS THE WEATHER warmed the Bird dispatched an older civilian guard to accompany some officers to a garden about six miles from the camp, where we planted potato vines in the sandy soil, knowing we'd never get to taste the harvest. Every day we took turns pulling a heavy, dung-laden cart to and from the site, and on the way home we'd scoop up forgotten or discarded daikons from the roadside.

One night the Bird searched everyone at the gate and found the food scraps. He exploded. The next day he sent us with a detachment of enlisted men to unload coal from ships anchored at the end of

Naoetsu's breakwater. The job was not only dirty but dangerous. Naoetsu didn't have a proper harbor; when swells came in, the ships rose and fell on the break. We'd approach on heavy barges and have to jump onto rope netting to climb aboard the ship. One guy missed and was crushed like a grape between the surging barge and cold steel hull.

It took two or three days to unload a ship. A huge net lowered us into the hold, where we breathed black dust and filled the net with raw coke. A *kempii*, or member of the military police, always stood watch and drove us like slaves. "Work faster! Work faster!" I've always been a fast worker, and the other prisoners didn't like it. They'd say, "Zamperini, slow down. Slow down!" Gradually I did.

Next we'd take the barges upriver and unload the coal into wicker baskets, then carry those on our backs up a hill to waiting train cars. The baskets often weighed a hundred pounds, and we'd have to walk over a short wooden plank, barely big enough for one person, to dump them onto the half car. One day a guard coming off the car shoved me aside and I dropped about five feet to the ground with all that weight on my back, and tore the ligaments in my knee and ankle. After that I couldn't work. Unfortunately, the rule in a Japanese prison camp is, if you work, you get a full dinner. If you don't, you get half. That made even the most reluctant workers do the job.

Nutrition, of course, was a joke and starvation common. The Japanese had ninety-one camps on the home islands alone, not to mention in Malaysia, Singapore, and all over the Far East. Food for the civilian population was scarce, which meant it was almost nonexistent for prisoners. Prisoners died of hunger; the Japanese didn't care.

Even farm animals ate better than we did. Every day, three times a day, we were served an awful red grain—Korean millet, I think— along with dried ferns and seaweed. The grain tasted bitter and foul. Often it contained pebbles and bits of wire that chipped my teeth and left my mouth bleeding and raw. The seaweed was pulled straight from the ocean and boiled, turning the water into a goop the consistency of snot. Our meals were perfectly suited to typical prison camp gallows humor. Guys would say, "Well, call me when the chow's ready. I wonder what's on Tojo's menu tonight."

This time I didn't hesitate to steal food from the Japanese at every opportunity. Using an old trick learned from the Royal Scots at Omori, I sharpened one end of a short bamboo stick to form a natural funnel that, once stuck into any rough mesh bag of grain, siphoned out the contents.

Every night we had to change into pajamas provided by the camp. The pants had a waist string to hold them up, and strings to pull the cuffs closed to keep in the heat. A fly in front let you take a leak. They kept all the grain at Naoetsu in a small room near the heads; I could see the straw bags through knotholes in the walls. I'd say I had to pee, take my bamboo funnel, which was about two feet long, and standing outside the grain room, put one end in my fly. Then I'd lean against an open knothole and work the sharp end into a rice sack. Soon I could feel rice running down my leg. I'd let it fill calf-high, then shift to the other side.

We lived in a locked building, three stories high, with only one door, bracketed by two guards. I'd come back from the head, find Commander Fitzgerald on the second floor, stand on a blanket, and untie my ankle strings. Fitzgerald stashed the contraband in socks and fake wall panels. The Bird had allowed us a little stove with which to make tea; we used it to cook rice whenever the guards stood outside, and stashed it whenever they came in for regular walk-throughs.

Because my injury kept me from working, I was on half rations and stuck in camp. One afternoon I peeked through a mesh door into a room and saw a Singer sewing machine just like the one my mother had. As a kid I'd patched my pants, and I got an idea about how to get back on full rations. "I'll make your clothes like Hollywood," I told a senior guard. "Like Clark Gable."

I spent half a day cleaning the machine, oiling it, adjusting it. Then I altered the guard's coat. When the others saw it they flipped. Even the Bird. He wanted me to style his clothes, too. I said, "Okay, if I get back on full ration." He agreed, and I tailored everyone's clothes until I ran out of work, and the Bird cut my rations again.

Next, I went to Corporal Kono, the Bird's assistant. A rotten stinker, Kono idolized Watanabe and always tried to imitate him by

using the kendo stick to beat us at every opportunity and bolster his own doubtful courage. "I want to get back on full rations," I said. "You got work for me?"

Kono spoke to the Bird, and they made me handmaiden to a skinny, sickly little goat. The Bird himself offered me the job, hoping to humiliate me.

"Care for goat," the Bird said. "Care good."

Whatever. I just wanted food.

Unfortunately, that night someone let the goat into the grain shack and closed the door. The next morning I heard, "Zamperini!"

The Bird shoved me into the kitchen and pointed at the young goat, which lay on the brick hearth, heaving for breath, its body bloated from gobbling barley all night.

"I told you take care of goat!" the Bird screamed. "If goat die, you die!"

I NURSED THE goat while word of the Bird's ultimatum spread through camp. When the goat died a week later, I prayed the Bird had been joking; I'd never seen him kill anyone, but I still I couldn't be sure that the threat had been idle. Several senior officers who had seen the Bird come close to killing advised me to attempt an escape before the Bird found out.

I didn't take their advice. Instead, I went straight to the Bird and told him the truth. He rushed at me, enraged, and I thought I'd made the wrong decision. Watanabe could easily have killed me. He beat me, then dragged me outside and ordered me to stand at one end of the compound while holding a four-by-four-by-six-foot hardwood timber at arm's length over my head—and keep it there. Then he said, "Wait," and sat on a low roof nearby, chatting with the other guards, watching.

The first three minutes I could hardly take the pain. Every muscle burned and begged to collapse. Then all one hundred pounds of me went numb. I froze in that position and time stood still until, seething with anger and frustration, the Bird hopped off the roof and punched me in the stomach with all his might. The beam dropped on my head and knocked me flat on my face, and out.

When I awoke, Tom Wade told me he'd timed my punishment. I'd held the wood aloft for thirty-seven minutes.

ABOUT A WEEK later I asked the Bird for another job. "Okay," he said. "You are in charge and take care of pigs." I swear, the pigs were so skinny you could see through them. He said, "We're getting food for the pigs. You clean out the pen."

I said, "You got any tools?"

"No tools. You clean out by hand."

Oh, God, what a mess.

They fed the pigs rice polishings, which are high in vitamin B. I knew this and ate along with the pigs. It helped protect me against beriberi, which had infected the camp.

ANOTHER TIME THE Bird suddenly filled a tub with water and told me to prepare to die, he would drown me in it. I don't know what kind of response he expected, but when he didn't get fear or begging he abruptly changed his mind. "I drown you tomorrow," he said, before stomping off.

THE LATRINES AT Camp 4-B had cement floors and a trough into which we peed. The toilets had wooden seats like an outhouse, and the refuse went into big steel tubs underneath. When the tubs were full, prisoners on *benjos* duty scooped out the excrement with big wooden dippers and put it in barrels, on a cart, to be used in our garden six miles away.

When a heavy rain fell for days we couldn't empty the steel tubs and the muck overflowed into the urinal trench and then all over the cement floor. This was disgusting stuff on its own; the nonstop diarrhea from one ever-present disease or another made it worse.

The Bird, being the Bird, called a surprise inspection. Men in the head with the runs rushed back to the barracks as fast as possible, put their boots in the rack by the door—we weren't allowed to

wear shoes inside—and stood at attention by their beds. The Bird came in with two guards and, knowing that men had just come back from the latrine, checked their boots. Three had crap on the soles. The Bird bawled out the offenders and said, "You lick bottom of boots or die." He meant it. Sometimes he made us do push-ups over the latrine troughs until we collapsed facedown on the ground. I watched this from the upper deck where I was in my bed with a 104-degree fever.

Had it been me, I'd have chosen to die. I've always been germphobic. I couldn't have done what he asked, but those men did. I don't know how.

AT NIGHT HUGE rats would run over those of us sleeping up high. If you made any attempt to knock them away, they were certain to attack with a vengeance—and no one wanted to be bitten by these filthy, aggressive creatures.

On the other hand, we had to do something. One night I prepared myself with a wooden paddle fashioned from a piece of driftwood. I lay it across my chest and was about to doze off one night when I felt a large rat stand on my blanket, between my knees. I slowly clutched the paddle and gave it all I had. I didn't dare miss.

I heard a sickening thud from the impact and then the loud rattling of metal as the rat landed on our hanging kitchen utensils. The entire barracks burst out with laughter.

Then someone turned on the barrack's lights and said, "Is he dead?"

An Australian soldier said, "Nah, nah, the blighter is limping back to his hole." Everyone cracked up again.

Laughter was just the medicine we needed.

The next day I was in the paddle business.

WHEN TWO ENLISTED men stole a piece of dried fish from the coal ship, someone snitched. (Desperate for food or better treatment, some men informed. We sympathized; we all suffered. But we

couldn't condone ratting.) Back at camp, the Bird indulged in his favorite form of punishment: having the enlisted men beat the officers.

Occasionally he was more creative. When the Bird and Kono got a book on American boxing they lined up everyone in the yard and assigned us numbers. They'd call your number and you'd step forward. They'd consult their book, then they'd hit you. The Japanese usually hit with the inside of a closed hand; they didn't know about knuckle punching. Still, Watanabe expected us to go down. If not, his obnoxious little assistant made sure we fell with his kendo stick. Nobody could take more than two blows, and then you went out like a light.

And yet, through it all, we hated the punishments less than being treated like nonentities, as if we were less than human. I could take the pain and the blood. That didn't bother me. But to have fewer rights and less respect than an animal? That really stripped me of my dignity.

SUMMER FINALLY ARRIVED, bringing with it oppressive heat and legions of vermin. They dripped from the rafters and ceiling and crept through the floorboards of the old bunkhouse at night, leaving our bodies covered with welts. The sand fleas were so thick that the earth itself seemed to be crawling, undulating like waves. I tried to sleep outside but gave up, exhausted and, frankly, indifferent. Bugs were the least of our torments.

Only our hope for a speedy end to the war kept us going. We knew Germany had surrendered, and I'd heard that B-29s had finally firebombed Tokyo almost beyond recognition. To continue fighting was clearly pointless, yet the Japanese wouldn't give in. Their willingness to prolong the war seemed senseless, but they insisted Japan would win because whatever God they believed in was on their side.

This faith was deeply rooted in their history. In the year 1273, Kublai Khan had landed on the shores of Japan with a large fleet of ships and a horde of Mongol warriors. The situation was hopeless as the invaders overpowered the populace. As a last resort, the Japanese

prayed to their god and suddenly a typhoon blew in and destroyed the entire Mongol fleet.

In 1281 Kublai Khan tried again, with double the number of ships. Another typhoon destroyed the fleet a second time. Again, the Japanese believed that God had intervened. They named the great typhoon "the divine wind," or *kamikaze*.

To cap it all, the Bird had started to act erratic. He'd disappear for days at a time, leaving Kono in charge. Then he'd return, find some minor offense involving the arrangement of clothing or eating utensils, and drag the victim around the yard by his feet, while other guards rifled through our belongings. He was completely unpredictable. I knew we couldn't take much more of him.

By August, freedom was clearly so near that we could taste it. I'd hear planes overhead coming and going. One night a group of us were in the latrine, trying to pick insects off our bodies, when we heard pounding in the distance. Just before dawn, a lone B-29 circled the nearby steel mill and dropped what was probably a leftover, discretionary bomb just off target. The tremendous explosion nearly emptied the village. Later, the Bird confirmed the bombing of Niigata, just to the north, when he called the American officers into the yard for punishment because American planes had done the damage.

The bombers made us brave, and some men hatched a plot to kill the Bird and Kono as soon as the war was over. Rather than wait for the slow machinery of military justice, I joined the conspirators. Somehow we managed to bring a big rock, weighing maybe one hundred pounds, up to the second floor and stow it by a window overlooking the river just beyond the fence that pushed up against our barrack. I stole some rope from the grain shack. The plan was to grab the Bird, tie him to the rock, and throw him and it out the window into the muddy water.

AS THE ALLIED invasion loomed, we heard scuttlebutt—as expected—that all prisoners of war would be moved to the interior mountains where we could be easily killed when the first foreign forces landed. Then, one morning, Ogawa-san, the kindly old civilian guard who had supervised our trips to the garden, struck me brutally.

He'd never before expressed anger or even impatience with any of us. I couldn't understand his behavior; I thought maybe the emperor had called for a last-ditch stand against the prisoners, but that didn't make much sense.

That afternoon Kono ordered all prisoners to line up in the yard. I shuffled into place, weary, expecting the worst.

"The war is over," he said simply. "No work today. War is over."

No one moved. No one cheered. I'd heard these rumors before and been disappointed too many times to take the news seriously. But Kono repeated himself, and told us to paint *POW* in large letters on the roof of the headquarters and barracks, and to clean ourselves by swimming in the river.

Finally, I began to believe.

THAT DAY WAS peaceful unlike any other. A plane lazily circled the barracks and rocked its wings to acknowledge the letters we'd painted for our flyboys to see. While some of us swam, a navy torpedo bomber flew over, the red lights on both sides of the plane blinking Morse code. A couple of radiomen in the water translated: "The war is over." Before leaving, the pilot dropped a red ribbon; tied to one end was a candy bar with a bite taken out of it and a pack of cigarettes with two missing. The candy and cigarettes had to be divided among three hundred men. We did it by cutting the candy into little slivers; for the smokes, we formed circles, lit the cigarettes, took one puff, and passed them around.

A few hours later the plane returned and dropped what looked like a body; it was actually a pair of navy pants stuffed with goodies. Not all the contents were delightful. We found cartons of cigarettes and candy but also a magazine with a front-page picture of the atomic bomb exploding. The ranking officer grabbed it, and we all looked over his shoulder, thinking, What the heck? Atomic bomb? Never heard of it. The picture had been taken in New Mexico. For a moment we froze, shocked at the power of our side's weapon. (Later we'd learn that both Germany and Japan had atomic programs and we were just lucky to get ours out of the gate first.)

The magazine shed light on a story we'd all heard maybe two weeks earlier when the guard whose coat I'd first tailored took me aside and said, "A terrible thing happened in a city called Hiroshima." I'd never heard of Hiroshima. He said, "Epidemic of cholera broke out, so Hiroshima is off limits. No one can come in or come out. No one can call on the phone."

I thought, Gee, that's terrible. Here's a whole city quarantined with an epidemic. The war's not bad enough, and these people are dying from cholera?

Now we all knew what had really happened.

I think the camp was silent for half an hour, contemplating the unavoidable horror, and what the world might be like if we used these bombs again.

We also found a message inside that supplies would soon be dropped by parachute.

The first delivery was a big bag of shoes. I got a pair and some socks. Unfortunately, the package crashed through the barracks roof, killing one man and injuring two others. That stuff came down hard, and I realized the drop had to be made *outside* the compound. I organized a crew and, using lime, wrote DROP HERE with a big arrow pointing at a rice paddy.

On September 2, 1945, the day Japan officially surrendered, most of our supplies were delivered. I was duty officer. A B-29 brought the goods. First it made a pass at about one thousand feet, searching for a drop target. Though we had POW on the roof and DROP HERE near the paddy, the letters probably looked quite small from the air. On the next pass, the plane was at maybe eight hundred feet. Their forward bomb bay opened and disgorged a parcel, which landed in the paddy. Even though I'd discussed safety, the men rushed out of the buildings. I frantically waved them back. I tried to keep everyone inside because even with parachutes, the platforms made a dent a foot deep. The bomber circled again, came in for another drop, and, once I'd cleared the area, released its load. One eager Japanese farmer darted out anyway and got flattened.

The B-29 made a final pass at about five hundred feet, rocking its wings. I stood in the open, waving my shirt, and when I looked up I

saw the pilot's face as he banked. He saw me, too. I remember think-
ing how I'd love to meet that guy and his crew. Maybe he said the same
to himself, wondering about me, where I came from, how I got there.

Lots of crazy stories come out of a war, and this is one. A couple of
years later a friend of the pilot, Byron W. Kinney, heard me inter-
viewed on Ted Malone's radio show on ABC. She recognized my tale
because Kinney had told her his story of dropping supplies in northern
Japan, at a camp near Naoetsu. He'd remembered the soldier below,
waving his shirt, and the look that passed between them. She called Kin-
ney, who wrote to Malone and got my address. When I got his letter we
exchanged information that proved that I was the guy on the ground.

Here's part of my letter to him:

> Your letter is very interesting especially since every word of it
> is true . . .
>
> We had a total of seven hundred men in the camp at the time,
> including two-hundred-seventy-five Australians. Most of the Wake
> Is. boys were sent in the last five months. Your description of the
> camp was right including the drawing and the bridge. I heard your
> plane when you passed over the first time. You were quite high.
> During your first drop I was organizing a group to pick up the
> stuff when a bunch of enlisted men broke loose and ran for the
> food. I had to get them back for fear of a second drop. You gave us
> a real thrill when you buzzed the camp. It was more appreciated
> than the food, especially for the Air Corps men. We were a filthy
> looking lot, but the happiest men in the world. . . . For the first
> time we felt like real Americans again. It made us feel that our
> sufferings were all worth it . . .
>
> A few Navy TBF's came in off battleships or carriers a few days
> before you fellows did. They could only drop enough stuff for a
> taste. . . . Your ship was the first to drop enough food to feed the
> entire camp and give the fellows more smokes than they could
> handle . . .
>
> I'm very glad you contacted me for since the day you dropped
> the food I have always wanted to know who took such wonderful
> care of us.

When Kinney came to Los Angeles in 1948, on vacation, he dropped by to see me. Unfortunately, I was out of town. Thirty-seven years later, on November 1, 1985, we finally met.

THE MORE FOOD our troops delivered, the faster we gained weight. Some men overdid it. Instead of mixing concentrated pea soup with water, they ate it straight, without even heating. Diarrhea was their reward. I knew from training—and experience—that you can't change your diet overnight, but any food helped and by the time I left Camp 4-B, I weighed about 110 pounds.

Freedom felt unusual, but strangest of all was the role reversal with our former captors. The guards were now our prisoners, not that we treated them as such. The minute we had food, they bowed and scraped subserviently and confessed to us all their problems. We fed them liberally, gave them rations for their families, cartons of good American cigarettes, candy bars. The anger and desire for revenge I'd had on the final day had already almost faded. It's funny how one minute I wanted to kill someone, and then, when I saw how pathetic they really were—like dogs with their tails between their legs—I wanted to help them.

The only guard missing from this pretty new picture was the Bird.

Watanabe had left the camp two days before hostilities ceased, on one of his usual trips. He had not returned. When we checked his quarters, all his belongings were gone. I asked the guards, but they didn't have any information on his earlier destinations or current whereabouts. Had he learned of our plot, or was he simply afraid of our pent-up anger? Had he gone to Tokyo, or Korea, or been captured in town? One fact was certain: with the war over, no one expected him to come back voluntarily. It seemed that instead of our disposing of Watanabe as planned, all that went out the barracks window was our scheme itself.

Kono remained, and we'd had plans for him as well, but when he came to the officers quarters weeping and begging for mercy, we could only regard him with contempt, not malice.

.  .  .

ON SEPTEMBER 5, 1945, a special train pulled into the Naoetsu station and we bundled our rags and possessions and marched through the wooden gates of Camp 4-B for the last time. Looking back as I climbed the road leading to the village and the station, I could see Ogawa-san, the old farmer; Homma-san, the cook, who, like Hata at Ofuna, had sold much of our ration through the back fence; and Corporal Kono, now an insignificance, staring dully at our departure.

When they waved, I waved back—to Ogawa-san—and then I walked around a bend and the camp disappeared from view. My thoughts were no longer of all the suffering, only of having made it, and of my new life ahead. At last, I had a chance to make the promises, plans, and dreams to which I'd so furiously clung for so long come true.

# 11

## THE LONG ROAD HOME

THE TRAIN RIDE east through the mountains to Yokohama took about eight hours. My mind stayed in neutral most of the trip, but my stomach tingled apprehensively with the unfamiliar sensation of being totally free. Unlike some, who grumbled about years of miserable treatment or complained that we should have been liberated from Camp 4-B sooner, I'd made up my mind to stay focused on the future, not the past. I was happy that more than two years of hell were over; I knew the time had come to think of going home. When I saw the Stars and Stripes over Yokohama, that would signal the beginning of the rest of my life.

Other men echoed my feelings. "I'm going to marry a rich girl and let her take care of me the rest of my life!" one G.I. exclaimed.

"Oh, sure," we said. "Just like that."

"Yeah. Just like that," he said, undaunted. "I'll spend my time where the rich people circulate. Law of averages: one of them will be single, and I'll be there at the right psychological moment. Spend all your time on the docks and you'll marry a fisherman's daughter. Join an exclusive country club and wind up with an heiress."

"Maybe," I said. "Sounds pretty sentimental to me."

He shrugged, and then I heard a trace of the bitterness we all felt in what he said next. "I just don't want any more problems. Let the world treat *me* nicely for a change."

. . .

A SOLDIER GOT on the train at the stop before Yokohama to tell us what would happen next. My ears perked up when he explained that in a building near the station the Red Cross would give us Coke, coffee, and donuts. "You can have all you want," he said with a knowing smile. "The nurses and Red Cross girls are ready to serve you."

Naturally, everyone wanted into that building immediately. The minute we stopped moving, manic, salivating soldiers poured out of the train cars and headed for the sweets and the sweeties. As I waded into the crowd, I heard a voice hollering over the din, "Who's got a great story? Who's got a great story?" My POW buddy Frank Tinker grabbed my shirt, pointed at me, and said, "Hey, this guy's got an *incredible* story!"

I didn't want to talk to anyone; I just wanted the goodies. But the guy who yelled stopped me as I tried to get by and said, "What's your name? What's your name?"

"Hey!" I said. "They told me that when I got off the train I could go into that building and get all the Coke, all the coffee, and all the donuts I wanted.

"You will," he said, "but your friend said you had a good story. What's your name?"

"Lou Zamperini," I snapped. "Okay? I've got to get—"

"Wait a minute, wait a minute," he said. Somehow I'd stopped *him* cold. "Lou Zamperini? Impossible. He's dead."

That stopped *me* cold. "I know who I am," I replied, "and I'm not dead. I'm Lou Zamperini."

"I'll need some verification, okay? I can't print a story without proof."

I didn't want to verify anything, or be anyone's story. I wanted a Coke and a donut. But I tried to be as graceful as possible under the circumstances. "Maybe after I get some food, all right?"

He shook his head, unwilling to let me go. "How can you prove you're Zamperini?"

"The Japanese took everything I had but my wallet."

"Yeah?" he said.

"But they emptied that, except for eight dollars in American money hidden in a secret compartment, and my USC Life Pass." Only athletes who lettered three years in a row got the sterling silver pass, engraved with their name. I was number 265. Reluctantly I dug out my wallet and handed him the pass.

"I can't believe it," he said, after a moment, "but that's good enough for me." He introduced himself then. "I'm Robert Trumbull of the *New York Times*."

"Like I said, I'm Lou Zamperini, and I want something to eat and drink."

Trumbull told one of his buddies, "Go get something for Louie." So I waited, half-furious, trying to think of what to say as Trumbull peppered me with questions and pulled out every detail I could remember, including some I didn't want to. The more I spoke, the more his face settled into a mask of almost permanent astonishment.

His friend never came back with the food.

When Trumbull finished I walked into the Red Cross building, famished. I couldn't get at the food right away because I had to stand in a line so some guy with an air blower could cover me with white sulfa drug powder. (Years later we learned the stuff was toxic. The manufacturer had dumped some in the ocean between Catalina and Palos Verdes, and the cleanup costs went into the billions. Ruined the fishing, too.)

By the time I got deloused or whatever, all the food was gone. I was so desperate for a taste of anything American that I scoured the floor searching for crumbs.

The next day, while waiting at the Yokohama airfield for a plane to Okinawa, I saw a table by the quartermaster's window stacked with extra rations. I grabbed all I could hold. To have enough food was wonderful; to have more than I needed was pure joy.

"Hey, hey, Lieutenant, take it easy," a sergeant said, obviously familiar with this type of behavior. "Don't worry about food. You'll get all you want where you're going."

"That's what they told me when I got here," I said. "I'm taking no chances." I shoved the booty into my shirt until it bulged like a Christmas stocking, remembering at that moment how I'd shoved my

mother's cookies into my shirt when I was seven years old, after she'd told me not to take any from the cookie jar. (She caught me, and I got scolded.) But when you've been hungry for two years, you trust no one. The sergeant was right, though. When I landed in Okinawa that night the Red Cross had two portable wagons set up at the airport, with the same coffee, Coke, donuts, and volunteer girls. I saw fluffy pastries, jelly donuts, and brown dunkers. I scooped up one of each and enjoyed the hell out of them all.

OKINAWA, WHERE WE fought one of our last great battles in Pacific, was only 350 miles from Japan. We'd sent 168,000 troops ashore to assault 100,000 defenders who had spent a year digging sixty miles of caves, tunnels, and underground positions. The cost of victory was dear. We lost thirty-two ships and took over 10,000 casualties. Fourteen hundred kamikaze planes (*kamikaze* means "divine wind" in Japanese, named after the typhoon that destroyed the invading Mongol fleet in 1281) sank twenty-six ships, and claimed 3,000 American lives. The battle lasted fifty-one days, from April 1 to June 21, 1945.

Now Okinawa served as a staging area for returning troops, POWs, and occupation forces headed for Japan. At the temporary shelter they ushered us into big tents with cots and told us to bunk down for the night. The next morning, bright and early, I lined up for more medical treatment. The routine of being reabsorbed into a free society felt weird, but like a patient who has to see the doctor, I submitted. I got three different shots in the arm, then an orderly told me to go into a room at the end of the building. I had noticed, while standing in line, that the door to the room was always closed; a sign on it read: LAST SHOT. When my turn came I opened the door and stepped hesitantly inside to find a colonel sitting at desk covered with shot glasses full of whisky. I broke out in a wide grin. "Welcome home, soldier," the colonel said. I drank my shot without hesitation. It went down nice and warm.

I lined up for a breakfast meal ticket at the mess hall, but an orderly, scanning a list of names on a clipboard, turned me away. "Sorry," she said. "This food is only for prisoners of war."

"But I'm a prisoner."

"You're not registered as a POW."

I couldn't believe my ears. That was the first I'd heard of it, offi-cially. "Maybe so, but I'm still a prisoner. I've been one for more than two years. Ask anyone."

"Sorry. Your name's not on the list."

Unbelievable. They thought I was just trying to get a free meal, and the pity was that a good look at me proved that I desperately needed one. It's like if you don't have an appointment with a doctor, you say, "But, Doctor, look at me, I'm dying."

"Well, yes, you are. Come on in."

I tried again: "I'm skinny. I'm hungry. I'm a prisoner of war."

She wouldn't budge. "Sorry. No I.D. You're not listed."

Rather than argue, I went to the Red Cross tent and put two and two together on the way. At Ofuna, the secret interrogation camp, the Japanese hadn't registered me as a POW—and apparently had neglected to correct that after transferring me to Omori. Even so, I thought that after my broadcast proved to the army that I was alive— certainly I was well known enough that if anyone with any clout had heard, it would make the news—*someone* would have added me to the POW list. Obviously not. It was assumed that I was already on it. That brought up another problem: without the proper I.D. I wouldn't get new clothes either.

Fortunately, the Red Cross girl was very nice. "Help yourself," she said, pointing at the snack food. I grabbed a couple of Snickers. "Why aren't you with the others?" she asked as I wolfed them down.

"I'm a prisoner of war but I'm not registered, and they wouldn't let me in the dining room with the rest of the guys."

As I told her my story a lieutenant walked in. "Here's a man who can help you," she said. So I told *him* my story. "I'm the general's adju-tant," he said. He took me to see his boss, who also wanted to hear my story. By now it was lunchtime, and I'd told my story so many times that the general invited me to eat with him while we talked.

Afterward he asked, "Are you in a hurry to get home?"

"Not really," I confessed. "I'd like to stay if I could. I'd like to fatten up. I don't want my mother to see me like this."

The general got on the phone and called Dr. Eli Lippman. He was in charge of medical services on Okinawa and ran a hospital in part of the underground fortifications the former tenants had dug. Lippman took me in tow and made sure I got my food and clothes.

That night, as I lay sleeping, a typhoon struck. I was safe enough inside the tent, but I had to use the head because I still had a touch of dysentery. Fortunately, someone had tied a rope to the tent pole and strung it to a post by the outhouse. I grabbed ahold and followed the rope, made it through the wind and rain, and sat down. But just as my bowel emptied I felt a big explosion as the storm lifted the outhouse into the air and blew it over the side of the hill. I was only able to make it back up through the mud and muck by hugging the ground.

The next day no one could believe the devastation: ships turned over, planes upside down on top of other planes. We could hardly find a place to eat, and when we did, the roof leaked rainwater onto our dishes.

After the weather cleared, Dr. Lippman said, "Well, Louie, I found out that your outfit's here, the Eleventh Bomb Group." He drove me to their headquarters, and man, was I glad to see them! I guess the feeling was mutual because they decided to throw a party for me.

We had only one problem: a short supply of liquor. Dr. Lippman said, "Don't worry about the drinks." He mixed five gallons of his alcohol reserve with distilled water and cola syrup and made "bourbon." The party was fun, and emotional in a military sort of way, because everybody had thought I was dead. Later the nurses wanted to throw another celebration for me. I even took a jeep ride with a beautiful nurse. I was a good boy, though. In fact, not too long ago I got a letter from her, asking if I remembered that night. Beautiful!

My buddies drove me all over the island and showed me the different military installations. At one a guy said, "You're from 'SC? Bobby Peoples is here." Peoples was the school's champion javelin thrower and a football player. When I saw him he said, "Hey, guess what? Dutch Wilcox is here." Wilcox was an official at USC. "Let's go find him. He'll be thrilled to see you."

I said, "You go in first and say, 'Hey, I just met a guy who's run a four-oh-six mile and he wants to go to USC.'" It was Dutch's job to recruit guys like that.

Peoples went in and then I heard Wilcox say, "Send him in!"

Dutch was leaning back in a chair when I stepped in, and the minute he saw my face he fell backward. Nothing like a man you thought was in heaven walking in to say hi. Then Tyrone Power, the actor, came in and we all had lunch.

I also ran into Major Pearce, from my old squadron, who showed me my own obituary, cut out of the *Minneapolis Star Journal*. It felt great to be remembered so well, even if they'd exaggerated.

I STUCK AROUND Okinawa, gaining weight, watching the POWs fly in and out. The general called and said the occupation troops had also arrived from the States and were eager to get to Japan, but would I talk to them first? He explained that the men were so mad about Japan's behavior in the war that he was afraid they'd destroy property and abuse the women. He wanted me to keep them from overreacting by letting them know that not all Japanese were bad. "If you can help minimize their anger . . . ," he said.

"I can not only minimize, I can tell the truth," I assured him. Soon I stood on a stage in a huge canyon before the largest audience I'd ever seen. "We had Japanese soldiers, guards, who were kind to us, helped us, and saved lives," I told the men. "One saved my life at Kwajalein."

About halfway through my stay, USC tried to get me to come home to speak during halftime at a football game. I was still skinny and, frankly, having a good time with all the attention. Dr. Lippman asked, "Do you want to go home?"

"Not really," I said. That's not to say that I didn't want to see my family. I wondered if my mom still had the wings I'd sent her before I went overseas. What about my dad's million-dollar smile—had it faded a bit? Were my kid sisters, Virginia and Sylvia, still shy? And Pete? He'd gone into the navy. I assumed he was unhurt; wouldn't he be surprised to learn that when I got back in shape I wanted to run again?

"That's no problem," Dr. Lippman said. "I'll say you're medically unfit to travel."

That was good for me, but I learned later how shocked my mother

was when she read in the paper that I was "unfit." I felt bad. I was as fit as I could be, considering. I just enjoyed partying with the nurses, drinking Dr. Lippman's homemade bourbon, and I hadn't thought how my pursuit of long-denied pleasures might affect anyone else.

On the other hand, I had also started to catch up with the world I'd left behind, and step by step I began to regain the confidence and self-esteem I'd lost under the enemy's relentless effort to destroy my dignity. Actually, I didn't lose it; I just couldn't display it. I could have been the strongest and meanest guy in the world, someone who would strike back at a moment's notice, but when you're controlled twenty-four hours a day by an authority who will beat or kill you if you step out of line, you have to be submissive. In prison camp we all acted normal in private; only when the Japanese were around did we "act" like cowards. I don't know if that's a good word to use, but you either played along or paid the price. A smart guy plays along as little as possible, just enough to survive. I never saw anyone summarily shot in front of me, but there were ninety-one camps in Japan and its occupied lands, and just because I didn't witness that kind of horror didn't mean that the Japanese hadn't slaughtered many men. Besides, I'd never forget the names on my cell wall in Kwajalein.

TO HELP POWS readjust, the army passed out a small red pamphlet published by the Army Air Forces Headquarters, at the command of General Hap Arnold, for "distribution to AAF returnees." Titled *Coming Home,* it had simple graphics and straightforward, friendly language. Here's how it began:

> Good? Bad? Mixed up? Or can't you tell?
> That's O.K., though. It's exactly the way thousands of men
> have felt who have come back ahead of you. Some of them wanted
> to talk it over. But some of them didn't even want to think about
> their feelings. If that's the way you feel right now, it's perfectly all
> right; don't turn another page. We suggest that you stick this away
> in your flight bag or some other place where you can get at it later.
> It may come in handy.

The story followed a typical soldier, John Brown, through his homecoming, through the fear, the strange feelings of having changed, of being treated differently, and gave tips on how to go along and get along. The advice pretty much came down to this:

No matter how much help John Brown got, though, in the final analysis it was up to him. The real, permanent solution, he found, *lies with the individual man himself*. But it sure is a big help to understand what is going on inside and why.

I read my copy right away and determined that all things considered, I was doing okay. I packed away the pamphlet in the unlikely event I'd need to refer to it again.

I SPENT AS much time as I could on Okinawa but eventually had to continue my journey home. Guam was the next scheduled stop, only I got put on the wrong plane and ended up headed for Manila, capital of the Philippines. At first I didn't want to fly at all; the plane was a B-24 with a plywood deck and forty former POWs inside. But it was the only way home, so I climbed aboard. Midflight the pilot got a call that Manila was socked in with rain and to land instead on a little fighter strip between two mountains at Laoag, in northern Luzon. We came in from the beach side, taxied up between the peaks, and parked overnight.

The next day they turned the plane around and we sped down the runway, heading toward the water. Suddenly, I realized we had a problem. The plane should have been airborne but wasn't. With the wind against us, the runway was too short for a big craft, so heavily loaded. I rushed to the bomb-bay window and looked out. There was the water, right in front of us, and a mound of dirt; I guess they'd bulldozed sand into a small dike to keep the ocean from flooding the runway. I thought, Oh no, after all I've gone through, *now* I'm dead? Then the B-24 hit that bump at the end of the runway, bounced into the air, and settled down so low that whitecaps came through the ill-

fitting bomb-bay doors and soaked us. Fortunately the plane never dipped below that level.

Not long ago, after my story was on national TV, I got a phone call. A voice said, "You're Louis Zamperini?"

"Yeah," I said.

"How did you get from Okinawa to Manila?" he asked.

"Well," I replied, "in a B-24, but we didn't actually go to Manila first." Then I told him this story.

I asked him why he wanted to know, and he said, "I was the pilot. I almost crapped in my pants. I knew we'd had it. That plane just barely, barely stayed above water."

Nice to know that all these years later we were both still among the living.

MANILA, UNFORTUNATELY, WAS more of the same situation I'd encountered on Okinawa—and worse. I'd gotten a bottle of rare and valuable whisky as a present on Okinawa, but someone stole it from my tent in Manila, and yet again I couldn't get food or clothing. So I did what I'd done before: head to the Red Cross tent and tell my story. The girl there set me up with Joe Laitin, a big wheel with Reuters in the Pacific. (Clearly, the Red Cross gals in the Pacific had the system wired and knew how to work it.)

"I've got a big problem," I told Joe. "I'm damn hungry, and I can't get a meal ticket." When I told him my story he got so uptight that he immediately took me to headquarters, talked to a colonel, and got me squared away. For a war correspondent he had lots of pull. He even had me on his NBC radio show.

When the Japanese vacated Manila, they left a hundred thousand dead bodies and an impoverished, bomb-ravaged shell of a city. The place was entirely unappealing. Boring. At least on Okinawa, after the POWs left, I was the only former prisoner there; I was singled out, taken care of, unique. In Manila I was nobody. I just walked around, in rain that never let up, and the world was caked with mud and misery.

I wanted out quickly, but I had to wait for a flight. Joe Laitin tried to help by getting me an application, but the functionary at headquarters said, "Are you kidding? There are eighty-one colonels ahead of him, trying to get a flight home."

Joe took the application anyway, and I filled it out, waited a couple days, didn't get a call. Joe and I went to headquarters. He found a stack of applications on a desk and went through them until he found mine—on the bottom. He put it on top and told the desk officer, "He goes on the next plane." The officer didn't argue. Reuters could ruin you, if they wanted to. (Later Joe spent years as a journalist in Hollywood and worked as a deputy press secretary under President Lyndon Johnson.)

I got off easy. Normally it took a bottle of whisky or a box of cigars—the next most precious commodity—to move up the list. The ATC—Air Transport Command—had a racket going. Their job was to haul goods for the rank and file, plus airplane parts. They also took liquor and cigars all over, charged a bundle, and got away with it because money is meaningless to a soldier in combat, stationed on some far-out atoll. A hundred dollars for a bottle of liquor? Sure! Twenty-five dollars for a cigar? Okay! The ATC got that stuff free from guys like me, who wanted to get on a plane without waiting.

The ATC also hauled commodities for the upper brass. I ran into several officers who were alcoholics. Some people believe that if the Pacific generals hadn't gotten so much liquor, the war would have been over two years sooner.

I FLEW OUT of Manila for Hawaii on a brand new C-54 Skymaster transport, the military version of the DC-4 that McDonnell Douglas put into commercial service in 1946.

The crew knew about me and invited me to fly up in the cockpit. That's when I learned that Robert Trumbull's story about me had broken on the front page of the *New York Times* and had been syndicated, running in newspapers from the *Honolulu Advertiser* and the *Detroit Free Press*, to the *Catholic Digest* and my hometown *Torrance Herald*. Later my story made *Time* and *Newsweek* and countless other publications.

Although I'd enjoyed the spotlight when I ran, now I couldn't have cared less about being in the *New York Times*. Trumbull did a good job, but in Yokohama he had taken from me what was most precious: Coke and donuts. I know it sounds crazy, but to a POW those priorities make perfect sense.

I told the crew some stories until we landed on a small island to refuel. When we got out to stretch our legs, the pilot said, "How do you like this island?"

"Well, there's not much here," I said.

"Not now," he said. "This is where you spent forty-three days. This is Kwajalein."

"Where are all the trees?" I asked.

"Leveled by naval gunfire. There's only one tree left." He took me to see it, and that was that.

HAWAII WAS UTOPIA. First I got a long-overdue promotion to captain. Then friends introduced me to the legendary waterman Duke Kahanamoku, who welcomed me into the Outrigger Canoe Club and even took me out himself. Hawaii was wide open and jubilant because the war was over. When the civilians saw us in uniform, they all wanted to buy us a drink. The place was awash in booze and girls and activity. Ignoring the future *and* the past, I drank and danced and gorged myself, and forgot to thank anyone, including God, for my being alive. Best of all, I did this while being made to "stay" in the hospital because I still had a touch of some tropical bug that didn't really need any special treatment. Again, I felt no hurry to get home.

Fred Garrett, the POW whose leg had been amputated on Kwajalein, was at the same hospital. We bummed around together and got physically fit by wrestling on Waikiki Beach. People thought I was nuts, wrestling a one-legged guy, but Fred was big and strong and wanted to show he had no handicap.

Of course, I got busted for having too good a time. I was a bit of a celebrity, the "hero" returning home and all, and someone in General Arnold's office found out I was goofing off, boozing and partying every night. Beset by queries from my family, friends, and reporters,

Arnold sent a red-letter order: "Get your ass back here with every available dispatch," meaning: come home, even if you have to row.

I left immediately, wondering what I'd done wrong other than try to make up for a few years of hell.

ON OCTOBER 2, 1945, I flew straight to San Francisco and went to Letterman Hospital, where I got another physical, found out I still had a touch of something tropical, and agreed to spend a week under loose observation. In the meantime Fred Garrett and I shared a room and tried to see as much as possible of the city.

Because of Robert Trumbull's story of my return from the "listed dead," I was constantly hounded by a gaggle of reporters. I quickly understood the pressures that had forced General Arnold to put a halt to my island holiday, as well as that once again the army could make public relations hay from my reputation and adventures. The limelight was bright. Phone lines were jammed with interview requests and calls from well-wishers. Organizations wanted me as an after-dinner speaker. What a pain. Of course, I quickly decided it was better to love the attention than to hate it. I'd been here before, and it felt good being back.

To control the situation, I met the press in the hospital lobby. The reporters were generally nice, and the interviews weren't too extensive, though it could get overbearing. If an interview is ten or fifteen minutes, that's fine, but if they want to hear your whole story, well, hey, you got a month? I told them to read the Trumbull piece.

A banquet held in my honor by the San Francisco Press Club was a taste of life to come and a nostalgic reminder of my glory days as a runner. In fact, this time around was better because an awestruck respect was part of the package, coupled with an eagerness to help me forget my ordeals. Just as training hard for a race had paid off, I soon found it tough to deny that I'd "earned" whatever attention now came my way. Sitting there on the dais, I experienced a gratifying, exciting warmth, a flush, part adulation, part liquor. Fred filled our glasses the moment we emptied them, my eyes turned redder, and I grew expan-

sive. When finally called on to speak, I not only touched on the past but made promises about the future.

"Before I crashed at sea," I said, "I told you there were still many miles left in these legs. That hasn't changed. I'll be running again. In fact, I hope to qualify not just for the next Olympics in 1948, but for the next three!"

A brash promise, not to mention a direct contradiction of what I'd said on Joe Laitin's radio show from Manila. Thinking about my injury from being pushed off a plank with one hundred pounds of coal on my back, I'd said, "I'm through with competitive racing, thanks to the Japanese."

Leave it to Fred, though, to neatly express our great joy at being on native soil again. Rising unsteadily to his foot, hands on the table for support, he grinned amicably and said, "Boy, it's sure nice to be home and see a bunch of fat people again."

His comment also made me look at myself, now nearly 160 pounds—of spongy, limp flesh, not toned muscle.

A COUPLE OF days later I answered the phone for what seemed like the hundredth time. A dry voice drawled in my ear: "I *told* them you were too ornery to die."

I was silent for what seemed like forever, then, "Pete! Where are you?"

"Just forty miles away, Toots. Be there soon."

"You on a pass?"

"Nope. Went AWOL. See you soon as I can hitch a ride."

As Pete later explained, a navy friend ran into his quarters and said, "Pete, look at this. Your brother's home!" Pete wanted to see me so much that he just left San Diego without permission and flew to Frisco on a navy plane. I was very touched that he took such a huge risk—and relieved that he also got away with it.

Within the hour we were hugging each other unashamedly. "I knew you were all right," he said, over and over. "Everyone thought I was crazy. I told Mom, 'If Louie can get his feet on solid ground, he's

okay. Just give him a toothbrush and a scout knife, and he can take care of himself."

I beamed and let him carry on.

"You know what we were going to do, Dad and I, if you didn't show up?" he continued. "We were going to save up enough money to buy a boat and go from island to island and until we found you. I just knew you were alive somewhere out there!"

I forget what I said. I was so overcome that I couldn't manage much.

Pete held me at arm's length and said, "Let me get a look at you." He took all of me in. "Hey, boy, you been living on cream puffs?" he joked, only he wasn't joking.

"I know, I have to go on a diet. Give me a chance. All I did was dream about eating for two years." Then I took a good look at Pete, and my grin slipped a little. Hair that had been as thick as mine was now sparse and thin, more gray than brown. Weariness lined his face; his body seemed gaunt and weighed down. "What's happened to you, old man?"

"Boy, you got no respect for your elders," he said, punching me lightly on the arm and changing the subject. I later learned that his transformation had lots to do with his worrying about my fate. That was Pete. He was my mentor, my advisor, my coach, my guardian. We were so close.

The day after Pete arrived, we were in midconversation in the hospital visiting room when the news media blew in, grabbed him, and mistaking his slim figure for a man who'd starved for two years, tried to interview him as Lou Zamperini, prisoner of war. We talked fast and straightened out their mistake.

Pete stayed for five days in a nearby motel. We talked about Dad and Mom, my sisters, track and field, his navy work in San Diego. The subject of my incarceration or what had appeared in the paper rarely came up, not because I didn't want to talk about it but because we both felt the family was most important. Family first.

Finally, General Arnold, whom I never met, sent a special B-25 to San Francisco to fly Pete and me to Long Beach, and together we went home.

. . .

THOUGH IT WAS a very different moment, when my family met me as I stepped off the plane I couldn't help think of the time I'd come home from the Olympics, I immediately ran up and hugged my mother. She had never lost faith that her boy was alive, and now she was beside herself. I guess most mothers are the same way, though many sons and husbands never came back. I hugged my dad and sisters, too. Everyone cried with joy, and I knew that my brother was the inspiration behind my parents' determination to never give up hope. Even Chief Strohe of the Torrance Police was there, his police-car siren wailing in the background. But on the ride home there was more awkward silence than exuberant chat. I told no exciting stories of talented teammates, fine food, or stealing a Nazi flag. My only accomplishment had been staying alive.

We turned onto Gramercy Street and stopped in front of 2028, the white frame house I remembered so well. When I wasn't having nightmares about strangling the Bird, I had dreamed often about relaxing on the living room sofa while my mother's heels clicked on the blue-and-white checkered kitchen linoleum, and of watching as she prepared dinner.

Suddenly, I tensed up and shivered; none of it seemed real. I wanted to go in but I was afraid. What if the reality didn't match up with my dreams? Would the house be the way I'd left it? Pretty much, I discovered, except for the fireplace. "An earthquake shook it to pieces," my mother explained. But the bed in my room was freshly made, waiting for me.

Soon the phone rang and rang, and the house filled with friends, city officials, and photographers. Every time I turned around a flashbulb blinded me. Voices rose and fell like ocean chop. My body grew numb and my mind disoriented.

*What's the matter, Louie? You're home. There's Mom, crying—stop crying, I'm here, it's okay, that death certificate you got is not worth the paper it's printed on, don't worry . . . why don't I feel anything?*

I heard a voice in my ear: "Look in the kitchen, Louie."

Another voice: "How about a picture, Louie?"

I sleepwalked through it all, dimly aware of the expectant grins on the faces that constantly surrounded me. In the kitchen I saw a dinner of gnocchi and ravioli, steak, risotto, sosole, and biscotti cooking on the old green-and-white Roper stove—all of which I'd described time after time to Phil and Mac on the raft. I also recalled painful memories of so many meals taken at the huge white table Dad had made with his bare hands, my head bent over my plate in sullen silence. Now fancy bottles of every description covered the table. Liquor—that was fine.

My mother picked up one bottle and showed it to me. "The man across the street brought this one the day you were declared missing," she said. "He said he didn't drink but he'd have a drink with you, from this bottle, when you came home."

Many bottles, all expressions of faith that I was alive, were labeled with the name of the donor. "Even after the death certificate arrived," my mother cried, "the bottles kept coming."

I looked away and on another kitchen counter saw cookies baked by my sister Sylvia, in the form of letters that spelled WELCOME HOME LOUIE.

In the living room, more pictures and flashbulbs and voices. Finally, I broke away and wandered aimlessly through the house and out the back door to the garage. To my surprise, I found my 1939 Plymouth convertible inside. At least my parents hadn't sold it. As I ran my hand over the smooth wax job and patted the hood, my reserve gave way and the dam burst. I rushed back inside, crying. Soon, everyone was in everyone else's arms.

At dinner I was too nervous to eat everything my mother had prepared, but I devoured the risotto to the last grain. Afterward we had coffee, and I noticed everyone looking at one another with expressions that seemed to ask, "Now?" My mother nodded, and everyone trooped out of the living room and returned moments later with armfuls of brightly wrapped packages. These were presents, tagged CHRISTMAS 1943, CHRISTMAS 1944, JANUARY 26, 1945 (my birthday), and notes that read: "Thinking of you on your birthday, wherever you are," and the like. Here was the full proof that my family had never given up hope, had never stopped believing I was alive, and it struck deeply, not only reaffirming their love but revealing to me—despite

all our previous differences—just where I'd come by the indomitable spirit that had kept me going on the raft and in prison camp. And to think that this was the family I'd often ignored, the mother I'd once, years ago, accused of loving Pete more than me. I was ashamed and overcome.

My family and friends didn't try to get me to talk about POW camp or my war experiences except to say, with obvious satisfaction at the positive outcome, that monthly checks from my life insurance had arrived at the house for almost a year and been deposited in the bank, where they lay untouched—another symbol of their faith in my return.

I didn't want to talk about the war either. When someone comes home from prison you don't immediately say, "How was it in the big house?" You take him out to dinner and talk about other things—how it feels to be back, going hunting and fishing, running again, what kind of job he wants to get. Otherwise it's like reminding someone they had cancer. Besides, I'd told it all to Trumbull, my parents had read it, and every paper in the country had copied it.

My parents also did interviews. One paper quoted my father as saying, "Those Japs couldn't break him. My boy's pretty tough, you know." My mother tearfully offered another perspective: "From now on, September ninth is going to be Mother's Day to me because that's the day I learned for sure my boy was coming home to stay."

Both hit the nail on the head and summed up my feelings exactly. Well, almost. What I told the papers about being home again completed the sentiment: "It's just like Christmas, only better."

# 12

## THE HOLLOW HERO

I STAYED WITH my parents for a few days, living in my old room, before being ordered to Birmingham Hospital in Van Nuys for a month of observation. There they fed me pills to finally kill the intestinal parasites and any other bugs I'd brought back from the war. The regimen often made me sick all night, but at least the doctors warned me in advance, saying, "You'll be fine in the morning."

I had to stay in the hospital the first week, but then I could put on my uniform and go out if I came back at a decent hour. Wherever I went, publicity followed. Whatever I did after the war was news. Today, if Tom Cruise drove down the street in plain sight, people would yell and wave. I'm no Tom Cruise, but that's about how famous I was after the war. The exposure cost me my privacy, but after what I'd been through, I didn't mind the glory. The other guys in my ward couldn't resist kidding me relentlessly: "Hey, we saw you in the paper with a cute chick, Zamp. An actress. You've gone Hollywood, Zamp."

The coverage and attention kept building as everyone tried to get into the act. In early November the Los Angeles chapter of the Military Order of the Purple Heart honored me, along with Lieutenant Will Rogers, Jr., and Commander Edward Dockweiler. I was happy to be there, as my parents had received my Purple Heart for "wounds resulting in my death" in May 1944.

(A few years later, Will invited me to be on his radio show to talk about the Bill of Rights. His other guest was a B-movie actor named Ronald Reagan. At the time a couple of big oilmen wanted to groom me for the state legislature. I declined. When Reagan found out, I remember him saying, "It's interesting that you're going into politics. I was *born* for politics." His remarks made me scratch my head; he was just an actor.)

Newspapers dug out my old track records, gave them new importance, and speculated about my competitive future. Sports editors— even those who had openly expressed disappointment with me before the war—again filled their columns with my exploits. Radio commentators and luncheon groups extended invitations to appear. I made a broadcast with my old coach, Dean Cromwell. I officiated at track meets. I even handed out gold cups to horse-race winners at the Santa Anita racetrack.

In 1944 Torrance had renamed its army airstrip Zamperini Memorial Field, but when I came back alive they changed it to just plain Zamperini Field. A couple of Academy Award actresses and generals from Washington came down for the big luncheon and ceremony.

In February 1945 a track meet in New York had begun featuring the annual Zamperini Memorial Mile. They changed the name on that one, too.

I also joined the Sea Squatters Club, whose ranks were open only to "United Nations airmen forced down at sea who used a rubber life raft, no raft, or stayed with their plane and survived."

Jack and Harry Warner—they ran the movie studio—told the *Los Angeles Times*, "When Louis gets home, we're throwing an all-studio party for him." They held it at the John Ford ranch. I danced with Maureen O'Hara and other lovely young actresses.

Many Warner stars belonged to the Lakeside Golf Club near the studio, and that soon became my hangout. I didn't play golf; I just walked around the course with the celebrities, and they seemed to like it. One day I stood at the bar with Dennis Morgan, Jack Carson, Forrest Tucker, and Bob Hope when a guy ran out of the dressing room and said, "Captain Zamperini, Oliver Hardy wants to see you. Come with me."

I found Hardy, one of my heroes, in the shower. He walked out stark naked and hugged me. Then he started crying. "Louis," he said with a sniff, "I prayed for you every day you were missing." Hardy was Catholic; I'd been Catholic Athlete of the Year the year after DiMaggio got the award. Later Hardy told Lakeside's manager, "Whenever Zamperini comes in, all the food, liquor—whatever he wants—is on my tab. Unlimited." I'm not sure why, but I never took advantage of his generosity.

Nightclubs around town also threw open their doors to me. Of *that* I took advantage, in part because I didn't know how long it would go on. Postwar celebrations were everywhere, and my old college friend Harry Read and I could be found almost any night of the week at the Florentine Gardens in Hollywood, at the world-famous Earl Carroll Theater and Nightclub on Sunset, or in any of the area bars. (Carroll's place opened in 1938 and included technical innovations like a sixty-foot-wide double revolving turntable on the eighty-foot main stage, three swings that lowered from the auditorium ceiling, an elevator, a revolving staircase, and a rain machine. Out front was a twenty-foot-high painting in neon of Beryl Wallace, one of Carroll's "most beautiful girls in the world," and Sunset Boulevard's Wall of Fame, preserving, in cement, the personal inscriptions to Earl Carroll of more than 150 of Hollywood's most glamorous stars.)

Sometimes Phil joined us and we did the town. The war was over and we kept the nostalgia to a minimum—though occasionally we shared a private look full of amazement and gratitude that even though we'd lost two crews, and gone through hell, we'd still survived.

Once, Fred Garrett and his wife joined Harry and me at Earl Carroll's. Fred had been fitted with a prosthetic leg. Recalling how he'd anticipated yet dreaded his homecoming, I looked first at Mrs. Garrett's face, then searched Fred's. I knew Fred hated the Japanese so much that he would never let rice touch his lips again, and depression followed him like a lost dog. Of course, I had both my legs, so although I hated the Japanese, too, I couldn't honestly compare our treatment in the war. All I knew was that hate was as deadly as any poison and did no one any good. You had to control and eliminate it, if you could.

Fred, who went on to work for years in the control tower at Los Angeles International Airport, intercepted my glance, grinned from ear to ear, and lifted his glass high. "Welcome home, Zampo," he said, and I knew he meant it.

ME? I FOUND my own way of "controlling" the hate that had revealed itself as recurring nightmares about the Bird. I'd had the same angry dreams in prison camp, but there I also had to deal with the horrible reality of his presence, meaning that awake or asleep I couldn't get away from Watanabe.

Even after my release, when I was caught up in the excitement of going home, the dreams didn't stop. I kept hoping they'd pass, but when they didn't, my solution was alcohol. I thought if I got drunk enough, I'd sleep like a baby.

A common dream usually began with the Bird's eyes glittering in a gray emptiness and his clipped voice shouting, "Look at me! Why you no look at me? Look at me!" As he raised his arm I tossed and twisted, helpless to avoid the heavy belt buckle swinging in slow motion at my face. But the metal always struck again and again while the Bird rhythmically screamed, "Next! Next! Next!" with each blow. When I couldn't take it another second, I sprang at him, grabbed his thick neck, and crushed it until I knew he was dead.

Sometimes I found myself bobbing on the raft, only this time a grinning Jap pilot in the Sally bomber blew me full of bullet holes on his strafing run, causing unimaginable agony.

Other times I got caught stealing in prison camp and suffered beatings so horrible that when I woke up my body hurt and my hatred rose in my throat like a bad meal.

To dull the pain and memories, I roamed from bar to bar accepting drinks on the house or from bighearted strangers. I told my stories and wallowed in the term "war hero" until I actually believed it myself.

"It's a miracle you're still alive," people generous enough to buy my drinks would say.

"Miracle?" I scoffed. "There's no such thing as miracles. I was in

better physical condition because I've always believed in good food and plenty of exercise! That's what pulled me through. Nothing else."

That certainly sounded wonderful, but no matter how fogged my brain, the irony of my extolling clean living as my fingers curled around my fourth or fifth damp tumbler of brown liquor did not escape me. I must have been a ludicrous sight, but no one seemed to notice or care, except to say, "Have a good time, kid. You've earned it."

I LEFT BIRMINGHAM Hospital but didn't go back to Torrance because it was too far from the action. Instead I moved in temporarily with a friend, the man who owned the Florentine Gardens. His place was huge and decked out like a palace. Another perk: he was in the girl business, by which I mean beauty contests. Miss South Dakota and Miss Chicago also lived in two of the six bedrooms. Surrounded by such dreamboats, I felt like a little kid in a candy shop; but as the only man allowed to stay there, I believed I had to behave myself.

Naturally, I was tempted. A young actress guest who'd won a part in the new *Cisco Kid* movie caught my eye. My host said, "Louis, she's got two weeks before they start shooting, and she's never been on a horse. It's up to you to teach her how to ride. She doesn't have to ride too well, just ride."

I happily gave her lessons. A few days later, as I sat in the living room reading, she groaned and purred at the same time, and said, "My whole body is stiff, Louie. Would you give me a massage?" Before I could object she took off most of her clothes and lay facedown on the living room couch. I obliged her with my best massage—but that was it. When our host came home early and walked in on us, he nodded approvingly at my virtue. I knew I'd acted appropriately. Oh, well.

ON THE SURFACE I looked like I was having the time of my life, but the laughs were more and more a cover-up for the conflicts and tensions I'd brought home from the Pacific. After being confined to a raft, then a makeshift dungeon, and finally a series of prison camps, I was less and less able to sit still or tolerate a quiet moment. The sec-

ond I awoke I called Harry to figure out what we'd do next. I became a social drinker who drank too much but not enough to become a "stupid" drunk or admit I had a problem.

Too often I embarrassed myself. Sitting at the bar in the Sunset House one night, lost in an alcohol reverie, I was startled by a sudden shout. Before I could stop myself I leaped off the stool and snapped to attention, shaking. Everyone stared. Mortified at my instinctive reaction, I covered my face. What I'd imagine to be a prison guard ordering me to snap to was only another customer boisterously punctuating a wild story.

Sometimes it only took a car-exhaust backfire to remind me of being caught in bombing raids like on Funafuti, where the explosions were so close that it's lucky my eardrums didn't burst. Or in Omori, where I had watched four hundred planes drop sixteen tons of bombs apiece on Tokyo.

"Have another drink," the bartender urged. "On the house."

"Yeah . . . yeah, thanks," I mumbled. It took three to finally calm me.

At home I stayed up later and later, dreading sleep, yet drinking more and more while still believing I could numb myself enough to pass out and stay out. Even when I did, the dreams still came and their grip on me tightened.

I also liked to fight at the drop of a hat and got into scrapes at the slightest provocation. Some guy would say, "Yeah, you prisoners of war. That was a good way to get *out* of the war, sitting back and getting free meals." I'd pummel jerks like him to the floor. I was on edge all the time.

The remedy? Drink to dull *those* impulses.

I should have reread my *Coming Home* pamphlet, which described my symptoms exactly. Memories of war kept running around my head. I couldn't concentrate. I tossed all night. And yet I had so much nervous energy I couldn't slow down. The section on fear was especially relevant—in my case fear of what to do with my life, of personal failure, of not being able to run again, of the media sobering up long enough to realize that despite my running trophies, war medals, and headlines, I was just a guy who'd done nothing more heroic than live.

·     ·     ·

IN FEBRUARY 1946 Madison Square Garden invited me to be the starter for the renamed Zamperini Mile. Actually, they insisted; seven of the world's greatest runners would compete. Unfortunately, I was afraid I wouldn't get to New York on time because the planes leaving the Burbank airport were full. (LAX then wasn't even an international airport.) TWA had a waiting list, but the chances I'd make the cut didn't look good. I needed some leverage, so I called Paul Zimmerman, the *Los Angeles Times* sports editor, to ask him to phone the TWA public relations man and give him a breakdown on my sports and war experience and say I *had* to get to New York, and could they do me a favor.

Zimmerman was on vacation.

When you're desperate you get crazy. I found a phone booth near the TWA desk. I called the airline, told them *I* was Paul Zimmerman, and asked for the PR department. When the publicist, whose office was right across from where I stood, picked up, I said, "Lou Zamperini, you've heard of him, right? Forty-seven days on a raft, Olympian, all that."

The PR guy said, "Oh, yeah, yeah."

I said, "Well, he's flying to New York, going back to start the Zamperini Mile, and I wanted to talk to him before he left. When he comes in, have him call me."

Meanwhile, I could see the PR guy writing down every word I said. Ten minutes later I walked to the counter, told the gal my name. "Oh, just a minute!" she said, and called the PR guy, who came out and told me that Zimmerman had called and left a message.

"Okay, I'll call him," I said quickly, "but it's essential that I be in New York by tomorrow night, for the Zamperini Mile."

The counter agent shook her head. "Sorry, the flight's full."

"Hold on just a minute," the PR guy said, and hurried down a hallway. Three minutes later he came back and said, "Mr. Hughes wants to see you."

He meant Howard Hughes. I admired the guy for his flying ability but didn't know much about him then except that he owned TWA.

His office was quite plain, and he was very nice. "I read about your episode in the Pacific," he said, and we chatted about flying in the war. Then he added, "I understand you have to be in New York."

"Yeah," I said, "but from what the girl says the flight is full."

"I'm on that flight," he said. "You can have my seat and I'll go later, or I'll fly my own plane." His exact words.

TWA used four-engine Constellations. The trip would take all day, with a fuel stop in St. Louis. I got to sit with Frank Sinatra and two of his bodyguards. I didn't know much about Sinatra either, except that in Omori Duva had told me, "He's the top singer in America. The bobby-soxers are rolling in the aisles."

In those days the flight attendants checked in each passenger by name after takeoff. When ours got to Sinatra, he gave her a look and said, "Russ Colombo."

The woman knew who Sinatra was, but she had to maintain protocol and wasn't about to give in. "Sir," she said patiently, "I want your real name."

"Russ Colombo." Real snotty. I thought it unbelievable for a grown man to treat the hostess like that, trying to get her to say, "Oh, that's okay. I know who you are." I felt like punching him in the nose, and I might have, but she went to the captain instead. He sauntered up and told Sinatra, "Fella, one more disturbance and you're off the plane in St. Louis."

Sinatra turned red and told the attendant, "Frank Sinatra." She wrote it down and didn't give him a second look.

Frank's buddies were nice guys and talked to me during the flight. I wore my uniform, and without really knowing much about me they wanted to hear my war stories. "You survived *two* plane crashes during the war?"

"Yeah," I said. "Every time I get in a plane something seems to happen."

I was just kidding, of course, but they got all excited: "Hey, Frank. Frank!"

Frank turned to me and said, "I tried to get in the service but I had a punctured eardrum."

"So did I," I said. When I was a kid someone shoved me off a

twenty-foot platform at the Redondo Beach saltwater pool, and I hit the water sideways. My ear swelled up for a month or two. I had to wear an earplug forever. If the army noticed at my physical, they didn't care, and I wasn't about to remind them.

Sinatra thought I was being clever at his expense and just clammed up.

After we left St. Louis, I had my own run-in with the flight attendant. I don't know why, but the number-three motor on the Constellation sometimes leaked oil and caught fire. I looked out the window and spotted oil trailing.

I said, "Uh-oh."

Sinatra said, "What's wrong?"

"She's got an oil leak. And this is a Constellation."

"What the hell does that mean?" he said.

"Well, the Constellation has had problems with the number-three motor." They called the attendant, and she bawled me out for getting the passengers aroused. I didn't care. "Young lady," I said, "you better call the captain right now."

"Sir, you're disturbing the passengers."

I said, "You better get the captain, or I'll get him." This time he came to see me. When I pointed out the problem, he ran like mad back to the cockpit, turned the ship around, and flew back to St. Louis. TWA put us in a hotel for the night. The next day I took another flight. Sinatra and his group took a train.

THE ARMY AIR Corps gave all returning prisoners of war two weeks of free R&R. I had no complaint about the nightlife and good times in Hollywood, but I thought a change in scenery might shake off my nightmares. We could select from a list of four approved resorts. One was Hawaii, but I'd just returned from Hawaii. Another was Miami Beach. I'd never been there. They also said I could take a guest. A family member would curtail my activities, and I had no steady girl, so I asked the ideal companion: my fun-loving buddy Harry Read.

We checked in at the beautiful Embassy Hotel in Miami and in the room found a long list of optional activities for soldiers on the loose. For instance, every day Ron Rico Rum held a party. You went to their

headquarters—beautiful layout and bar—and let them mix you one fancy iced or frothy drink after another, sometimes with an umbrella in it. Or we could go deep-sea fishing. Take tours. Visit the zoo. Attend air force parties and dances.

"What do you want to do first?" I asked Harry.

"Let's check out some of the private clubs," he said with a wink.

"Perfect," I said, and ripped up the list. Rest and relaxation? No, we'd knock ourselves out.

The air hostess on our flight had mentioned the McFadden-Deauville Club, owned by Bernarr McFadden. He was a big fitness buff, my era's Charles Atlas, who'd gotten rich after starting *Physical Culture* magazine and would go on to found *True Story* and *True Romance. Time* and *Newsweek* wrote about him, and at the sight of a press camera he would strip to his underwear to show off his muscles. He sometimes gave interviews standing on his head.

We had to climb the wall to sneak in. Luckily, we found the flight attendant in the lounge and the three of us sat at a table, surveying the room as if we had every right to be there. I had my eye on a flashy girl sitting at the end of the bar. When our hostess friend left to meet a date, Harry said, "Look at the dolls."

"They look friendly," I said, leaning back expansively. "You know, this is the life. Single, no responsibilities, free to pick and choose. Can you see being here with a wife?" Harry didn't have to answer. "I once said I'd be a bachelor for the rest of my life," I continued. "That goes double now. Variety, that's . . ."

My sentiment suddenly hung in the air as my head turned and my voice trailed off. Harry followed my gaze.

"Did you see her, Harry?" I whispered.

"Which one?"

"The tall one with the long, golden hair and the face of an angel. She was here, now she's gone."

"Can't say I did." He shrugged, scanning the room for other prospects. But I could only think about the girl who had just glided through, head high, looking straight ahead. I consoled myself by deciding that she wasn't the type to hang around a bar while a crew of eager beavers like us ogled her.

Harry tried to revive the carefree-bachelor conversation, but I'd lost interest.

THE NEXT DAY we dressed for the beach and climbed the McFadden-Deauville wall again. Harry spotted two unaccompanied girls lying facedown on towels in the sand and spread our blankets as close to them as possible. I ignored our neighbors but Harry couldn't resist. Soon I heard him telling the story of *my* athletic career, and I heard one of the girls say that although she was only eleven at the time she remembered seeing the newsreel of me winning the NCAA mile race. "How could I forget a runner sitting on a table with four large bandages on his leg?" she said.

I sat up to join the conversation and to my total shock found myself staring at the beautiful girl I'd seen the day before.

She smiled when our eyes met, and I all but froze. I could talk to anyone, but I'd never been that good at making the usual inane conversation meant to captivate and entrance women—especially with one who captivated and entranced me. But I meant to try. We said hello and introduced ourselves; her name was Cynthia Applewhite. When I stumbled and slipped, trying to keep breaking the ice, she took over.

"Where you from?"

Before I answered, this is what went through my head: I like skinny girls, and she's skinny. She's beautiful, looks intelligent. Nice personality. The kind of girl I always pictured meeting one day. My type, definitely.

Here's what came out of my mouth. "Uh, Torrance . . . but staying in Hollywood."

"I lived in Los Angeles once," Cynthia said brightly, "right near Cathay Circle." She went on about her life there as a young girl, and about living in St. Louis, New York, and finally Florida. Cynthia was nineteen, a debutante (also voted a Sweetheart of the Deauville), and the only daughter of a well-to-do family. She'd been educated at exclusive girls' schools and even attended the American Academy of Dramatic Arts in New York. In other words, our life experiences

couldn't have been more different, but I found telling her about myself much easier than I could have hoped for. I wanted to keep talking, just to be near her, and asked her out for that evening.

"Sorry. Taken."

"Tomorrow?"

"Taken."

Cynthia's popularity slowed me down for a moment, but when she saw my disappointment she told me her afternoons were free. We arranged to go deep-sea fishing.

"And by the way, Captain Zamperini," she added, "you don't have to sneak in here anymore. Just tell the desk that you're guests of my family and use our cabana."

CYNTHIA GOT SICK on the fishing boat and caught only a green face as the army launch rolled in the heavy sea. To make good, I asked if she'd see me the next afternoon and she said yes. Unfortunately, we ended up at the Ron Rico Rum place and I drank more than I should have. I apologized and we made another date to go to the movies.

Pretty soon I fell madly in love. I told her so on the beach as the sunset's dying glow warmed the water with oranges and pinks, and a pale moon hung in the sky—just like in a movie. I put my arm around her and kissed her a few times, and then, even though emotion has always been tough for me and mushy moments were never my style, I said it.

"I love you, Cynthia."

I'd never told any other girl I loved her, and the words that had been moments ago stuck in my mouth felt weird and wonderful once freed. I tried not to make it sound as if I were pleading with her to say it back, or as if I didn't know what my declaration would mean to a person as naturally sincere as she. I'd known Cynthia only a week, but I knew she was the gal.

Believe it or not, I forget exactly what she said in return, but the meaning was the same—and clear. That night she called her two other boyfriends and canceled their dates, leaving her free to be with me in the evenings. For the next few days we walked on the beach, went to

movies we never actually saw, and allowed ourselves to be over-whelmed by the realization that we were in love.

Harry returned to Los Angeles, leaving Cynthia and me a last night alone. As we sat on the beach under a summer moon, I said, as casually as possible, "You know, Cynthia, one of these days we're going to get married." She hesitated, and suddenly I felt lost, like another over-heated flyboy who had mistaken some friendly moments for forever. "Ah . . . maybe it wasn't such a good idea," I mumbled.

"Oh, no!" she said. "I think it's a fine idea. But when?"

"When?" I felt a stab of fear, and for a moment I thought of backing away while I still had the chance, but when I looked at her I knew I'd never want to change my mind. "Soon," I said. "As soon as we can."

"Dad and Mother are going to take this awfully hard, Louie," she said. "You know, the proper things, the family name . . ."

"I guess they'll try to talk you out of it," I said.

"Maybe," she said evenly. "But they won't. I have a mind of my own, Louie. Besides, you're what I've always wanted. The other boys I know are like children."

I knew she meant every word, and I prayed that she'd never dis-cover that I had feet of clay.

THE NEXT DAY Cynthia brought her mother to meet me at the Embassy Hotel. We sat on the front porch, under the awning, while Mrs. Applewhite more or less conducted a cross-examination. After-ward Cynthia saw me off at the airport. I had six weeks of speaking engagements around the country, and then I'd be back in Los Angeles. We made plans for her to visit me after I got settled.

In the interim, in one of many letters, Cynthia told me her mother *had* tried to talk her out of marriage. "You're marrying below your-self," Mrs. Applewhite had said. As part of a family whose name had been honored for generations in Carolina history, her mom was quite society-conscious. I was Italian; she'd made it clear they don't have Italians in American high society. Italians were pushcart peddlers or cheap-restaurant owners. Why, I could even be part of some Mafia family. Apparently many stormy fights followed, along with threats of

Cynthia's being sent away to school in the Northeast, like some of her friends. Her parents were understandably protective, since hordes of soldiers roamed Miami's beaches and streets and didn't exactly have marriage in mind but would say so if it helped them. Nothing new there. Yet with us it was different.

Back home I moved in temporarily with Harry Read and his mother and resumed my life. After the war nobody really expected much from my running career. They figured I'd had a rough time and it was all over—until I opened my big mouth and told them different. So now I got up every morning at five-thirty and worked out in the arroyo nearby. My body tested out okay as I ran up and down the little canyon, again and again, and managed to clock a 4:18 mile in heavy tennis shoes, which meant I could probably run a 4:13 in competition. I'd have to press harder to get into world-class shape, so I doubled up my workouts.

At night, instead of carousing as usual with Harry, I sent him off alone. Sometimes he'd try to set me up, but I wasn't interested.

One morning, out of the blue, Harry's mother said, "Louie, how come every day I see the same car parked in front of my house, with the same guy in the car?"

Good question. Later I found out that Cynthia's father wanted to catch me misbehaving and discourage the relationship, so he'd hired a private eye to see if I went out with other girls. (When I told Cynthia about the stakeout, she laughed too hard to be mad. "Well, I wouldn't put it past my father to have *me* watched," she said.)

When Cynthia and I couldn't stand being apart any longer, she told her parents that she planned to visit me in Los Angeles. Naturally they forbade it and refused to give her the money. Only when Cynthia threatened to get a job and earn her fare did the Applewhites finally understand their daughter's determination.

"Are you sure this is what you want?" her mother asked. "You know we only want you to be happy. I'll buy your plane ticket and you stay out there for a week and find out about his family. You know, there could be insanity or something."

Mr. Applewhite wasn't that easy to convince. In fact, he reacted furiously to the plan, but it was too late. I'd met Cynthia in March

1946. In May she came west to visit and I met her at the airport. News of our engagement had already hit the papers. We'd set the date for August, but the *Los Angeles Times* ran a picture of her getting off the plane and another of us on a running track, with the caption, "Will they jump the gun?"

Why would they even care? They just did. Everywhere Cynthia and I drove in my convertible, people would stop and stare. While we waited at the stop sign at the intersection of Wilshire and Western Boulevards, the busiest in town at the time, people at all four corners waved and shouted, "Have a great marriage!"

Cynthia's trip wasn't all flashbulbs and fun, though. When she saw my family's little house—a shack to her—and met my dad with his Italian accent, I could tell she had misgivings. Doubts. Questions. I tried to ignore it, but I couldn't stop stewing. I got mad and said, "Maybe we better call the whole thing off." Neither of us wanted that, so we talked it through and realized that our life together was pretty well clinched.

We decided not to put off the wedding any longer. I had accumulated about $10,000 in back pay and been allowed to keep almost $1,600 in life insurance payments, so we had no immediate financial worries. We got blood tests and a marriage license, sidestepped a few other technicalities, and on May 25, 1946, we were married in the Episcopal church Cynthia had attended as a child.

After the reception, at a friend's house, we went to the Chatham Hotel. Everyone thought we were across the street at the world-famous Ambassador. I brought a magnum of champagne I'd borrowed from the party.

"I want to call my mother first," Cynthia said as I popped the cork. Her parents had a fit at the news, and she stayed on the phone for over an hour, crying. I sat there, disgusted, saying, "Call her back in the morning," to no avail. Instead, I drank all the champagne myself. I didn't pass out, but I went to bed drunk. Heck of a marriage night.

BEFORE THE WEDDING Victor McLaglen, the actor, and Jim Jeffries, the prizefighter, gave me some advice. They said that the sure-

fire way to know whether or not my wife really loved me was to honeymoon in the wilderness for a couple weeks, alone. "You'll really get to know each other," McLaglen said. "If she loves you afterward, she always will."

I gave Cynthia a choice of going to Hawaii or to a friend's cabin forty miles past Red Bluff, near the Eel River. Cynthia said she knew enough about the ocean, so with a short stop in Reno to get supplies, we headed straight into the hills.

We swam, caught fish, rode horses. Cynthia got to be a crack shot hitting cans with the .22. When she almost stepped on a rattlesnake, she whipped out the pistol and plugged it in the head. We loved every minute, and Cynthia would have been happy to rough it for a year, but I had grown restless and missed my life in the city. I wanted to keep running and stay in the action. Also, the nightmares continued. Evidently, marriage would not be the cure-all. Cynthia had heard about many of my POW experiences from Harry Read, though never in great detail. I'd never told her about the nightmares, and during our courtship she asked me about my ordeal from time to time but never pressed, figuring I'd talk about it if I wanted to. I didn't, really.

DUE TO A severe housing shortage we had no place to live, so we stayed with Harry and his mother, which was far from ideal. The situation only made me more irritable, and I occasionally took it out on Cynthia. To make matters worse, we'd heard that Cynthia's father, who had been in the hospital with bronchial asthma when we got married, had suffered a severe relapse when he heard the news of our union. Only my mother-in-law spoke to us, and she left no doubt about their feelings when she told us that our wedding day had been the worst Sunday of their lives and that they had simply closed the doors when the inevitable reporters came nosing around for a quote.

Finally, through a friend, we found a cheap apartment—more just a room—in Edgemont Manor, by Vermont Avenue and Hollywood Boulevard. It was not the best place to commence the responsibilities of marriage. I found it too depressing and went out as much as possi-

ble, seeing friends, drinking, partying. I had officially separated from the army Air Corps that August, but the great and would-be great in Hollywood still invited me to their homes and postwar celebrations. I went, glad for the liquor and the company, yet frustrated by knowing I could never repay their hospitality. Little by little I slipped back into my old negative personality patterns.

Cynthia went to the parties, but she didn't drink and drew the line at going from bar to bar. In some ways she fit perfectly into my lifestyle. We went to USC football games. She met my college buddies. We got along fine and were very much in love. But mostly she didn't agree with my friends' idea of a good time. As a result, she got fed up and withdrew more and more into herself. Soon the evening came when she told me I could go out by myself—if I had to.

Cynthia was better off staying home or going to a movie with her friends. One night, I had a couple of beers with some Olympic buddies at a restaurant called Nickodell's. I left to see a pal but felt more woozy than two beers' worth. I don't remember leaving his place later, but apparently I was so drunk that I drove aimlessly through the Hollywood Hills not knowing where I was headed. Hours later I parked the car, got out, took a leak against a tree, and walked to what I thought was my apartment nearby. It wasn't. Finally, at four in the morning, after walking for miles in circles and wearing down the heels of my new shoes, I stumbled onto the right street. The next morning I reported my car stolen. Two days later the police found it miles away.

I thought someone had spiked my beer and I never went back to Nickodell's, but the truth was that I had begun to experience alcoholic blackouts and couldn't remember what I'd done for hours at a time. For example, I remember sitting at a bar with a friend and a young couple one evening when the lights suddenly went out and the next I knew someone was helping me into a car.

"What's the matter?" I asked nervously. "What happened?"

"You learned a little lesson," my friend told me. "Someone walked by with a lady friend and you patted her in the wrong place. The guy she was with didn't like the idea and patted you once—in the right place."

My fighting also got worse. At a Newport Beach bar with buddies I got shoved accidentally by a guy who weighed about fifty pounds more than I did. I didn't care. My blood boiled for revenge. I got him out on the sand and danced around him until he was winded. Then I attacked, punching him until he went down, then pushing his face in the sand for good measure. Suddenly I was like the kid who had beat the bakery-truck driver to a pulp and left him by the roadside, not knowing whether he was dead or alive.

Realizing that I needed help, Cynthia put aside her fears and anger and tried to calm me and to help me restore some measure of self-respect. But all that helped, though only temporarily, was another dose of recognition, like when Torrance held a ceremony dedicating Zamperini Field. Sitting there with my wife and family, listening to the mayor and some military bigwigs give me the most generous compliments imaginable, I wondered what they'd do if they knew the truth about my high life and my low life and all the demons in between.

DURING A SMALL dinner party on Harry's yacht I seriously lost control. Cynthia agreed to cook the steaks on a tiny, slow butane stove, and we joshed her mercilessly as she struggled. When dinner was served I made one more joking, disparaging comment. That did it. Cynthia told us off, left the boat, and went to the car. I followed. "Get back on board," I ordered. "You're spoiling the party."

"I will not," she said. "Either take me to your parents' place or give me money for a bus ticket home." She got in the car. I did, too, furious, and repeated my demand. She ignored me. Without realizing it, I grabbed her and . . . let's just say she was coughing and choking when I let go of her. In shock, I ran back to the boat and the bottle. Cynthia went to my parents' house.

That night, as I lay alone in bed, the nightmares returned with unusual ferocity. Just as my fingers clutched the Bird's windpipe and crushed it, I woke with a start and sat up in bed shouting. Had Cynthia been there she'd have calmed me, but she wasn't. Sweat poured off my body, and I remembered what had happened earlier in the car. I

froze. I couldn't get even with the Bird or avenge my life in Japan, so I got even with everybody else. What if by mistake I reached out for Cynthia's neck in the middle of a bad dream? I couldn't go back to sleep. I sat up, staring out the window at the streetlights and then the dawn, then went running, pushing myself during my workout as if I were trying to get away from everything that had happened to me.

CYNTHIA AND I made up, and I decided that a rededication to racing would help me get better. I bought some new running shoes and worked out at Los Angeles City College. Cynthia came and timed me.

I did it for the self-esteem. I wanted to win again, to fill the gaping hole in my life. And yet, though I approached my workouts with the best positive attitude I could muster, I resented them. *Why* must I run? Why did people insist I try again? Weren't my previous achievements enough? Maybe if I hadn't bragged to the clubs and organizations that had paid good money to hear the Great Zamperini speak that I'd be back for the next three Olympics, I'd have acted differently. In truth, no one had forced me to run but me; I still believed that my only true identity lay with the sport.

One morning I warmed up with some short sprints, then jogged over to Cynthia. She told me I had a "pretty stride" in my new shoes. I snapped, "Cut the remarks and just time me."

Her face wrinkled up and she began to cry, but my heart remained cold. I'd given her money, a place to live, good times, and soon I'd be a famous runner again. What more could she want? After all, the past few months hadn't been easy for me either, with the dreams and the drinking and the blackouts. Plus, I'd quit booze to starting training. Couldn't she see I was trying?

"Set the watch like I told you and call out the times whenever I pass you. And speak up. You have to holler so I can hear you."

I dropped into starting position, thinking, Well, here goes nothing. I looked down the long straightaway. Time to prove I could to it. I gazed at Cynthia, and when she yelled "Go!" I sprang forward. For a moment my mind was empty, at peace, as my body automatically remembered what to do. I took the first turn and settled in for the

long haul. I'd trained for six weeks in heavy tennis shoes, running and hiking in Griffith Park, and taken whirlpool treatments and had my legs massaged. The preparation seemed to be working. My shoes seemed light, and I felt clean in the brisk fall air. Pretty stride, indeed. I stretched out, reaching for the extra inch that meant a better time. But when I passed Cynthia after the first lap, I heard her yell out, "Sixty-eight!"

Sixty-eight? Obviously she'd read the watch wrong. I'd always finished the first quarter faster than that. I pushed harder on the second lap, imagining the stopwatch relentlessly ticking. Then a sudden tug at my chest and a tightening in the back of my legs told me I'd overdone it. I eased up a bit and let my momentum carry me, but my focus had shattered. I thought suddenly of the guard at Naoetsu who knocked me off the plank with a hundred pounds of coal on my back.

"Two-seventeen!" Cynthia called out.

A second slower than my first lap. She must be wrong. I panicked. What if I couldn't run anymore? What if whatever I had was no longer there? I forgot about pacing and stride and just started sprinting like I had in college when the chips were down.

Immediately a sharp pain tore through my calf and ankle. Too bad, I thought, and pushed ahead. Maybe it just needs a good stretching. Either way, I'll find out. I ignored the pain and ran another lap, then went all out in the final quarter. I didn't even hear Cynthia mark the time. I just knew that no matter how bad the pain, I had to keep going.

I should have known better. My leg tightened and throbbed, and I closed my eyes against the agony. As I rounded the final turn I knew my quest was hopeless. I had no kick, no spring, nothing.

I crossed the finish line and collapsed on the grass. Cynthia rushed to my side. "Your time was four twenty-eight," she said, upbeat. "Pretty good." I could see in her eyes that she knew better.

I rolled over and sat up. A bad ankle, a sprained knee, a ripped muscle that never healed. All I could do now was give up my dream. Running had been my whole life, and now it was gone. Chalk up another victory for the Japanese. I dropped my head on my folded arms. "It's all right, honey," I said. "Just help me over to the car."

I left the stadium as a runner for the last time, leaning on the shoul-

der of a 110-pound woman, with no cheers ringing from the stands
and only a few curious children watching.

HUMILIATION FOLLOWED MY panic. Because I'd bragged so often in
speeches, radio broadcasts, and newspaper articles that my new run-
ning career had just begun, I had too much to retract or ignore.
Would my fast-moving friends, always ready for a laugh at someone
else's expense, consider me a big joke? Or, even worse, would they
smother me with compassionate inquiries and reassuring platitudes? I
didn't really want to find out, and I avoided the parties and functions
at which I'd have to admit failure.

When my depression finally dissolved, a fearsome rage replaced it.
The nightmares, the headaches, a well-planned career stolen from
me. What more could the Japanese have done? "God," I said aloud,
staring out the window of my apartment one afternoon when Cynthia
was away, "what more will you let them do to me? What more will
*you* do to me?"

I waited for an answer, but none came. Why should it? This was the
first time God had crossed my mind in over a year, and again only in
my moment of absolute hopelessness. I'd done the same on the raft
and in the prison camps when I'd promised God my life should he let
me survive. Had I kept my promise? No. And this time, instead of
promises, I had only anger and complaints and blame. But I didn't
blame myself; I blamed God. Maybe he was listening, maybe not, but
even if, as I sometimes suspected, God watched over me, I couldn't
blame him for cutting me loose this time.

My solution was to wallow and brood and resent and drink. Yet out
of all the self-pity came a strange new resolve. I had achieved many
goals, and now only one remained: to make as much money as I possi-
bly could and use some of it to return to Japan and find the Bird and
give him the deadly payback he deserved.

# 13

## A SECOND CHANCE

M Y BANK ACCOUNT was still pretty flush, a good starting point to prove the old adage that it takes money to make money. In fact, visions of glory filled me, and I became downright optimistic. Because of the postwar boom, everyone talked about making money, of "working the angles" in "fast deals." I wanted in on the lucre. I had to make up for lost time, avoid the mundane, find the action. Why should I have to crawl through the years on a regular paycheck like my father? I was restless. I wanted to make it big, and quickly.

War surplus was an obvious choice. I bid on thirty Quonset huts and immediately sold them to the movie studios, who wanted as many as they could get for storage. When supplies ran out I switched to wartime iceboxes in need of small repairs and made a profit. With a friend, I went into a business called the Ready Phone, a crystal-based ancestor to today's mobile. Again, I made money.

"See how easy it is when you have the cash and know the right people?" I bragged to Cynthia. "Pretty soon you'll have a bigger house than the one you grew up in." I wanted to prove to her parents that their daughter had made the right decision.

"I don't need a big house, Louie," she said. "But we should buy a small one and get out of this apartment."

"Wait a while," I said. "This is working capital. Soon we'll be living off the interest."

Cynthia was skeptical but indulgent. I knew she liked the flexible working hours my entrepreneurial career afforded. My "office" was at home, and there's nothing a young couple in love likes to do better than spend time together.

As my cash flow increased so did my appetite for more. I got excited when two USC buddies, both business majors, said they had a corner on some D8 Caterpillars in the Philippines. Seven thousand dollars would hold them for shipment; if I invested, I'd double my money in six weeks. They showed me signed affidavits to verify the deal. Cynthia came to a business meeting and afterward had reservations, but I overrode her objections. "You heard them," I said. "You saw the proof. We can't miss. I want in on this."

Our representative was a Japanese gentleman from Hawaii. "No problem," he said, a few hours before leaving to close the deal, my cashier's check for $7,000 in his pocket. "Everything's under control."

CONFIDENT OF A rosy financial future, I threw myself into plans for an adventure cruise to Acapulco with Harry Read on his new diesel-powered, two-masted schooner, the *Flyaway*. We advertised for a crew and, after a shakedown run, took off in early February.

We made our destination and on the return got as far as Cabo San Lucas, at the tip of Baja, heading for the Tres Marias Islands, about eighty miles off the coast—one island was a big prison for Mexico's worst criminals—before we got caught in a Tabasco, or a white squall, so violent that it sheared the three-quarter-inch rudder pin and shredded our sails. To regain control we had to open up the lazaret to get to the rudder and try to shove an eye bolt into the hole while the *Flyaway* took on water. Our crew was too green to do much, so I took charge of hauling down the sail while Harry handled the pin. We rode out the storm but flooded the boat inches above the floor, shorting every onboard electric device: the icebox, the radio, the pump, even the engine.

Worse, we'd been blown nearly a hundred miles off course into

the doldrums. Familiar territory to me. The sea was like glass. Hot. No wind, nothing. Fortunately we had food. Before the storm we'd anchored at an island and two natives had rowed out to meet us. We gave them apples and oranges for their kids, and before we left they returned with buckets of lobsters and coconuts. For a few days, while I busied myself sewing the sails and we tried to figure out what to do next, everyone feasted on langoustines by the potload, and drank vodka and coconut-milk concoctions with a squeeze of lime. When one of the crew asked me if, after drifting on a raft for forty-seven days, being lost at sea again scared me, I said, "Nope. Between the lobster and the liquor, I could do this for forty-seven years."

After a week we got a little wind and made for land. I could smell the dirt and trees even before we sailed into the lagoon at a little village called Puerto Vallarta. I'd never heard of it. The only access then was by air or sea. The inhabitants gathered on the shore and told us, "We haven't seen a boat from America for twelve years." The mayor received us with a gracious welcome.

I got a message to Cynthia that I was all right, and she told me my disappearance had made the front page of the *Los Angeles Times*. ZAMPERINI, L.A. WAR HERO, MISSING ON BOAT AT SEA. When I finally got home, Cynthia had more news: some bad, some good.

The bad news: our Hawaii representative on the Caterpillar deal had spent my money on himself and his family. I'd lost every cent of my investment. I hired an attorney and sued and eventually the man had to pay me back a little every month, which was fine, but that left me without a lump sum to reinvest elsewhere.

The good news: Cynthia was pregnant.

I WAS OVERJOYED and dismayed. How could I bring a baby into the world—especially now? I'd lost money. We lived in a dingy apartment. Every few days our neighbors down the hall would argue loudly, and every Sunday night a radio upstairs blared until all hours. Fuses blew out regularly and more often in the winter from the electric heaters that supplemented the gas radiators.

I didn't hide my fears or concerns from Cynthia, though I probably

should have. She'd toss and turn at night, worrying about my worries in addition to her own. At times she'd let her mind drift back to the easy life she'd given up with servants and loving, protective parents. Then suddenly she'd shrug off her regrets and melancholy and hug me. Yet I could still feel fear in her embrace, all of which left me guilty and bitterly ashamed. I did my best to reassure her and told her often that I wanted to give her comforts and a life she'd never dreamed of, but somehow we both knew that deeds rarely followed my words.

Desperate, I turned again to prayer, though secretly, because how could I pray openly when I had for some time done my best to convince Cynthia she shouldn't go to church and live by someone else's philosophies and rules? I'd managed to keep her away from worship for two years, and I knew she wasn't happy about it. Now there I was, pacing night after night, always asking God why he had again forsaken me. "After all I've been through, surely I'm entitled to *some* compensation. You performed miracles for me before, so help me now." What kind of help did I require? "Return my money and help me double it so I can support my family decently."

I usually felt better in the morning.

RATHER THAN HELP myself and look for a job, I waited for God to take care of me. After all, I'd always been Lucky Louie. I grew certain that my mistake had been in not praying sooner. Meanwhile, I continued to put my faith in fast-turnover, get-rich-quick schemes. I had high hopes when a friend asked me to help organize a motion-picture company in Egypt, but that fell through. A member of the opposition party in a shaky Caribbean government wanted my help with a revolution. He already had several B-24s and needed only pilots, navigators, and bombardiers. The pay was one thousand dollars in advance and another thousand on completion. While I thought it over, the revolution failed. Next, I got involved in a scheme to launch the first passenger-boat service to Tahiti, but while waiting to make my fortune, the yacht got repossessed.

Then a surefire deal came along. The uncertain manner in which

licenses to hunt and fish in Mexico were obtained had always inconve-
nienced American sportsmen. Through a series of introductions I met
a wealthy and influential businessman from Mexico City who had con-
nections to Enrico Romay, Mexico's secretary of the navy. Together,
they agreed to grant me the exclusive right to sell the licenses in
America. Even Cynthia believed our prospects were good and that
we'd make lots of money, but when my partner drove to Mexico to
get the necessary signatures to seal the deal, he died in a head-on col-
lision with a Mack truck. Poof. No more deal.

Broke and angry, I left town for a couple of days. While I was
away, a friend who worked at a little record company called Capitol
phoned to tell me to immediately buy all the Capitol stock I could.
The next day it went sky-high. The day after that I found out about his
call—and his good fortune. He'd bought at noon and sold at six times
the original price only hours later.

The truth, so obvious to others, finally began to dawn on me. No
matter how hard I prayed, I could no longer avoid failure. Lucky
Louie had disappeared, and God wasn't listening. I'd have to struggle
on my own to stay alive.

ON JANUARY 7, 1949, our daughter Cynthia Battle Zamperini,
immediately nicknamed Cissy, was born. We were very happy, but
my mother-in-law, who had come for a visit, marred the occasion by
saying, "Louie, this is no place to raise a baby. There's no yard, the sun
only shines in the window for ten minutes a day. Promise me you'll
move." Mrs. Applewhite, who had rented a dreary little room across
the street, cried often at our pathetic surroundings.

She meant well, but I wanted to explode.

"I'm doing the best I can," I said stonily. "I've just had hard luck." I
tried to explain, but the more I did the more upset she became. Any
minute I expected her to pack up Cynthia and the baby and steal them
back to Miami. As it turned out she was the only one to leave, but
afterward Cynthia grew morose. I couldn't blame her. Forced to stay
home with the baby, she complained of feeling like a mole living
underground. One day I walked in from a business meeting to find

bottles of cologne, hand cream, and powder smashed on the floor.
Pictures hung sideways, some broken.

"What happened?"

Cynthia burst into tears. "I just got fed up. That's all. I've had it!"

Again, I couldn't blame her. Or myself. "I'm trying."

"Louie, you just have to find a job. We can't go on worrying like
this week after week."

"I go to one place and they ask if I'm qualified to be an oil engi-
neer," I said. "What can I say but the truth: no. Another place asks for
a degree in a subject I don't have."

She almost spat at me: "You don't need a degree . . . to dig ditches.
I know you don't want to work for someone else, but you may just
have to. Temporarily."

I ignored her pleading and good sense, mumbled evasively, and
changed the subject. But inside I seethed. Couldn't anyone understand
*my* turmoil? *My* problems? *My* disappointments? How could I give her
all she deserved on a weekly paycheck?

THE GROWING STRESS at home made my nightmares worse, and
with that my drinking. I lost my temper often and fought even more
than usual. The anger that later filled me with the greatest remorse
was the rage I felt when Cissy cried. I loved her so very much and
got up every night to feed and change her, but with my nerves so on
edge, every whimper cut into me like a knife, and made me feel like
I was failing not only myself but her. One afternoon, with Cynthia
out shopping, I stayed home to watch the baby, hoping she'd sleep
and I could get my work done. The apartment was peaceful for a
few moments, but then she opened her eyes and cried, louder and
louder.

"Stop it! Stop it!" I yelled from across the room. Cissy only cried
harder. Not thinking and out of my mind with frustration, I picked
her up and shook her when I should have hugged her. "Stop! Stop!"

Then dimly, as if from far away, I heard a voice say, "Louie!"

Cynthia was home. I turned around to see her in the doorway, her

face drained of all color, terror in her eyes. She dropped her packages and snatched the baby. "You might have killed her!" she screamed.

"Oh, my God," I whispered, as I slowly returned to sanity.

It never happened again, but sometimes I'd wake up in the dark, soaked from another nightmare, to find Cynthia weeping in bed. "I don't know, Louie," she'd say when I'd ask what was wrong—as if I didn't know. "I love you and you love me and we have a beautiful baby, but even if we had all the money in the world to go with this I think something would still be missing. I don't know what it is, but I know something's missing."

What could I say to that? Then her mood would vanish and we'd spend part of each day arguing about finances—and worse. One day, out of the blue, she said, "If this keeps up, Louie, I may have to leave you. You *have* to come to your senses. I can't do anything to please you. You act as if you hate me."

"I don't hate you," I barked. "I just don't like you reminding me that you think I'm a failure." I also wanted to say that I loved her and was more frightened of her following through with her threat than I'd ever been of daily beatings by the Bird, but I couldn't find the courage.

ONE AFTERNOON, WHILE leafing through our desk calendar, I discovered a mysterious notation penciled in by Cynthia: "Take inventory." I didn't know what it meant, and that worried me. Inventory of what? Clothes? Possessions? Our marriage? I reviewed our fights—there were so many—looking for the one incident that might have caused her to take such a step. Then I got it. Last Christmas Eve, before Cissy had been born . . .

As we'd dressed for a party Cynthia said she wanted to stop at a church on the way, and she wouldn't let up no matter how much I argued against it. When we got into the car, she insisted again.

"Be quiet," I said. "We'll be late for the party."

"I will not," she snapped. "There's a church on the next block. I haven't been for two years because you didn't want me to go. Now I don't care. I'm going in for a few minutes, like it or not."

I glared at her, then slammed on the brakes in front of the church and said, "Okay. Fine. But if you're not back in five minutes, I'm going to the party without you."

I watched Cynthia, pregnant, struggle up the steps, then looked at my watch. My head pounded as each second passed. I couldn't explain my hatred of religion, of God, to her. She wouldn't understand. She'd say I was foolish. I just wanted to get to the party, have a few drinks, forget her whims and my misery. Why was she suddenly all fired up about church in the first place? What was the big deal?

The car door opened and Cynthia got back in. She didn't look at me, but she was calmer. "I just said a quick prayer for us, Louie. That's all." Then she stared out the window while I drove, convinced because of my own failures with prayer that Cynthia had also wasted her time.

BY THE END of 1948 I finally ran out of money. To pay my bills I borrowed a thousand dollars from a friend and offered my car as collateral. I said I'd pay him back by a certain date or he could take the car. Meanwhile, Cynthia went to Miami with Cissy to see her parents, and as I dreaded, she returned determined to get a divorce. Our situation, she insisted, was hopeless. I didn't have a steady income. I'd been "taken" by different people. I drank. I was angry. Unstable. She loved me, but that was no longer enough.

I didn't want a divorce, but I was caught in a self-pity trap. All I could say was, "Well, you're entitled, the way I'm doing, but I can't do anything about my situation." I was too proud and too ashamed to ask for help—even from my family. Inside I knew that she was absolutely right.

I'd failed her. I'd failed my family. I'd failed myself.

ALTHOUGH CYNTHIA HAD said we were through, she didn't rush to leave, and we went on much as before. In September 1949 a new neighbor moved into the apartment building. A nice young man, serene and friendly, he immediately revealed a strong attachment to religion. While I worked on my latest deal, he spent time talking with

Cynthia. His visits didn't deter her from divorce, but they seemed to soothe her nonetheless. One night he invited us to go with him to hear an evangelist who'd set up a huge tent on the corner of Washington and Hill Streets in downtown Los Angeles. I knew I was a rotten failure and a sinner, but when this guy started talking about church and God, I felt like he was pointing his finger at me. I didn't want to have to listen.

"It's not for us," I said curtly. He did not press the point. When he left, Cynthia did. "I'd really like to go," she told me. "I've heard about this evangelist, and I'm curious."

"No," I said. "Absolutely not." I knew that Cynthia, who had been reared in a devoutly Protestant household, was sincerely concerned about our spiritual welfare; despite my own antipathy toward religion and my stubbornness about her attending church, I respected this in her. Yet to go to a tent revival with people moaning and wailing and shouting . . . nonsense.

I been around holy rollers before. When I was a kid they'd come to town but weren't allowed inside the Torrance city limits. Sometimes my friends and I would sneak out to the site at night, lie on the ground, and peek under the tent to watch these crazies make a spectacle of themselves—foaming at the mouth, groveling in the sawdust, screaming in a frenzy. Some of them even got on their backs and raised their hands and feet up to the Lord. That's why they called them holy rollers.

We'd go back and tell the priest, and he'd warn us off. "They're demon-possessed. Keep away."

A few days later our neighbor asked us to accompany him again, and this time Cynthia decided to go on her own. We were getting a divorce anyway, so what was the difference? I went to a party instead.

Later that night, swaying from too much booze, I came home to find Cynthia beaming. She seemed different. She actually smiled and acted calm, and frankly it felt eerie and vaguely disturbing.

"What's going on?" I asked.

"I went to hear the Reverend Billy Graham," she said.

"And?" I said, bored but tensing for a fight.

"And it was *wonderful*. Not at all the way you'd imagine it."

"How do you know how I'd imagine it?" I slurred, sensing danger.

"Oh, Louie. You know how I always say there's something missing in our lives? Now I know what it is. For the first time I have peace in my heart."

"Great," I sighed, dismissing her. "That's great. I'm tired. Let's go to bed."

"No, Louie. Listen to me. *I've accepted Christ as my Savior.*"

I didn't know if I should cry, laugh, or yell. Cynthia was smarter than this. Only old ladies and kids fell for this nonsense. I said nothing.

Cynthia just smiled. I went to bed.

THE NEXT MORNING nothing had changed, except that Cynthia was all over me to go to a meeting. I wouldn't bend. "You know how I feel about it," I snapped. "Leave me alone. I don't understand it and I don't like it."

"You don't understand it because you don't understand yourself," she replied evenly.

Cynthia and our new Christian neighbor began to work on me, and all I could do was to stay as far away from them as possible. I figured they'd get the message that I wasn't buying it and would give up. Eventually they eased off, maybe because Billy Graham was supposed to fold his tent and leave town by week's end. But Saturday night Cynthia told me that Dr. Graham would be in town for another three weeks by popular demand, and she tried to persuade me again.

"Billy Graham doesn't preach *all* the time," she said. "He talks about many things, like how many scientific facts can be found in the Bible."

"Science?" I asked. I should have known better. Cynthia knew science fascinated me. Once she'd piqued my curiosity, she didn't let up.

That evening Cynthia asked me again to take her to the meeting. What could I do? Reluctantly I relented.

THE SIGN OUTSIDE the tent read: GREAT LOS ANGELES CRUSADE—6,000 FREE SEATS. I studied the picture of Dr. Graham by the entrance.

Holding an open Bible in one hand, he seemed like a serious young man. Otherwise, he was hardly my picture of an evangelist, and my impression was confirmed inside when, after some hymns, a man introduced Dr. Graham and he walked purposefully onstage.

Tall, handsome, clean-cut, athletic, he had clear blue eyes and seemed even younger in person than in his photograph. He stood erect, shoulders squared.

Cynthia stared at the stage, captivated and radiant. I settled back in my chair prepared to close my ears at a second's notice. I may have come out of curiosity, but I was determined to resist being influenced in any way.

I expected Dr. Graham to start right in with the fire and brimstone, but to my surprise he spoke only about one person: Jesus Christ. And he did it with boldness and conviction. If nothing else, I had to admire his spirit. He didn't scream nonsense, like the holy rollers I'd seen, but read strictly from the Scriptures. Fine, so he was a decent guy, but I still wasn't buying. Plus, I had trouble following along and got restless.

"Where's all the stuff about science?" I asked my wife.

"Be patient," she said. "Just listen."

The more I listened, the more I became convinced that Cynthia had tricked me into coming; this was no casual lecture, and it was least of all about science.

"There is not a just man upon earth, that doeth good, and sinneth not," Dr. Graham said. "For all have sinned, and come short of the glory of God."

No, this was not about science at all. This was a sermon on sin— and it might have been directed at me. I knew I wasn't perfect, but I hated being reminded. The Bible was meant to give comfort, not make a person uneasy. Was Dr. Graham trying to say that good deeds didn't get you to heaven? Well, the heck with him and his big tent. I'd performed many kind acts. I was generous and gave to the poor even when I couldn't afford to. I loved my family and was a faithful husband. I'd get to heaven my own way.

Then Dr. Graham said, "Not by works of righteousness which we have done, but according to His mercy He saved us," and I sat straight up in my seat. How had he known what was in my mind? Then he

said, "For God so loved the world that He gave His only begotten Son that whosoever believeth in Him should not perish but have everlasting life."

My anger vanished and fear replaced it. I grabbed Cynthia's arm forcefully and said, "We're going. Now. Don't *ever* take me to a place like this again." I almost ran out of the tent, dragging her behind me.

That night I couldn't sleep; the nightmares came, worse than ever, driving me crazy, ruining my life. The Bird's face and Satan's face were indistinguishable as the heavy belt lashed at my head again and again. In the morning I brooded and ignored Cynthia's almost constant urging to return to the tent that night. But she wouldn't give up. After arguing for hours, I agreed to go back, "under one condition: When that fellow says 'every head bowed and every eye closed,' we're getting out of there." I figured I could handle it as long as I had that escape clause.

AGAIN WE LISTENED to hymns, then Dr. Graham spoke about the emptiness of material wealth and its inability to buy salvation, which itself was a gift from God. "For what shall it profit a man if he shall gain the whole world and lose his own soul?"

Sure, I'd been involved in get-rich-quick deals, but what was so wrong about making money legitimately? Think of all the good I could do with the money. I squirmed in my seat while Dr. Graham quoted more Scripture:

"That if thou shalt confess with thy mouth the Lord Jesus, and shalt believe in thine heart that God hath raised him from the dead, thou shalt be saved."

That really got me mad, but then I thought about the war. On that life raft, bobbing up and down in the ocean, hungry, thirsty, desperate, all I did was pray. Even if I'd been an atheist instead of a half-lapsed Catholic, I'd have prayed. That's just the way it is. When there's no further hope, men always look up. The thousands of prayers I'd said, and the thousands more in prison camp for two and a half years, came back to me in a flood. During the war I'd probably prayed more than Dr. Graham and his family had in their entire

lives—"Lord, bring me back safely from the war and I'll seek you and serve you"—and yet when I'd come home alive, I completely dismissed my promises because no one could remind me of them except myself. Now I felt tremendous guilt.

"When you receive Jesus as your Savior," Dr. Graham continued, "you are regenerated by the spirit of God. Your life is transformed. You are a new person in Jesus Christ. Remember, Jesus doesn't want part of your life, He wants all of your life. He wants you to repent of your sins and then completely and totally surrender your life to Him and follow Him."

Surrender? Tall order. Not for me. All I wanted to surrender to was the overwhelming desire to escape the tent forever. I couldn't stand the self-recrimination. I had to get out. I needed a drink.

I was about to get up when Dr. Graham read a verse that stunned me to the core:

"And this is the record, that God hath given to us eternal life, and this life is in His Son. He that hath the Son hath life, and he that hath not the Son of God hath not life."

A great weight pressed on my chest, my throat tightened, I gasped for air. As a kid I had always believed that Christ was the Son of God, especially around Christmastime, but I knew I did not have the Son of God in my life. Not really. Not by a long shot.

"What kind of life are you living?" Dr. Graham asked. "Are you satisfied with your life? The Bible says for all that sin, they can serve the glory of God." Just then, my whole rotten sinful life passed before my eyes and I began to get an inkling of what I feared I had to do.

Only I didn't want to do it. Why? Men prefer darkness to light. How could I give up the parties and the liquor and living for the moment and the fun?

Dr. Graham answered that question, too. "Many people reject Christ because they feel they can't live a Christian life. Well, *nobody* can live a Christian life—without help." I thought when you accepted Christ you had to be perfect, but he said, "Christ has promised to help you. He said, 'I will uphold you with the right hand of my righteousness. If you have problems in life, cast all your cares on me, for I care for you.'"

Boy, I thought, this is pretty good. I don't have to be perfect. The Lord will help me. And yet, when Dr. Graham gave the invitation to any and all to come forward and accept Jesus as Savior, I could not budge. I would not budge. I felt suddenly like the angry young boy I'd once been, full of resentment at being forced to run the 660 for my junior high class, yet crouched at the starting line, butterflies in my stomach, waiting for the gun to go off. *"On your mark . . ."*

"Don't you want to go forward?" Cynthia said softly. I refused to look at her. I could feel the sweat on my forehead and neck, and my heart beating fast. Again, the anger came and I wanted to lash out. *"Get set . . ."*

"Let's go," I told Cynthia. I grabbed her hand and pulled her up. "I've had enough." I walked down the row, squeezing between people's knees and the chairs, dragging my downcast wife behind me. Finally, I got to the aisle. I stepped onto the sawdust path and knew it was my crossroads of decision. I fought against it, perhaps harder than I'd ever fought, but in the end I made my decision, turned right, toward Billy Graham, released Cynthia's hand . . .

*"Go."*

I WALKED FORWARD and realized that my decision *was* like running a race. On the track I always felt 100 percent different after the gun went off than I did before. Only while running did all my worries and doubts disappear and leave me simply committed, my only thought how am I going to win? I had to use strategy, call on my training and my body to perform. Boxed in, pushed out, whatever the pace, but I'm in the race.

This was a different race but a race nonetheless. A race for life. My life.

A young American Indian fellow met me by the stage, and I followed him to a prayer room behind the curtain. I wasn't alone; other men and women in transition were on their knees or talking quietly to their counselors. I knew then that I would not turn back. I'd struggled to come this far, and I would commit myself to whatever happened next.

I dropped to my knees and for the first time in my life truly hum-

bled myself before the Lord. I asked Him to forgive me for not having kept the promises I'd made during the war, and for my sinful life. I made no excuses. I did not rationalize, I did not blame. He had said, "Whosoever shall call upon the name of the Lord shall be saved," so I took Him at His word, begged for His pardon, and asked Jesus to come into my life.

I waited. And then, true to His promise, He came into my heart and my life. The moment was more than remarkable; it was the most *realistic* experience I'd ever had. I'm not sure what I expected; perhaps my life or my sins or a great white light would flash before my eyes; perhaps I'd feel a shock like being hit by a bolt of lightning. Instead, I felt no tremendous sensation, just a weightlessness and an enveloping calm that let me know that Christ had come into my heart.

WHEN I FINALLY opened my eyes and looked up, my counselor said, "Do you know you're saved?"

"I know it," I said.

"How do you know it?"

"You said that 'whosoever shall call on the name of the Lord shall be saved.' I called upon his name, and I'm saved."

"Do you really believe it?" he asked.

"I don't have to believe it," I said. "I know it."

He held up a pencil and said, "Now that you're a Christian, that's you. If you try to stand alone, you're going to fall. The Lord says, 'Cast all your cares upon me'—in other words, lean your entire weight on me—'and I will uphold you with the right hand of my righteousness.' Always remember, that pencil is you, and once you get away from the Lord, you're going to fall."

I prayed for another fifteen or twenty minutes, and the counselor walked me back out front. "I'll be praying for you," he said.

"Thank you so much," I said.

I found Cynthia waiting in the audience, and she threw her arms around me. I looked at her and knew in my heart, as if it had always been so, that I was through drinking, through smoking, through with everything. My lifelong desire for revenge had disappeared, including

my need to get even with the Japanese and the Bird. I didn't know what the future held—would I be rich, poor, whatever?—but that didn't matter. "I'm through with my past life," I told Cynthia. "I'm through."

She smiled, lit with the light of the miracle she knew had occurred.

THE BIBLE SPEAKS of the Word of God as a seed. Sometimes it's planted by the wayside, and nothing grows there. Sometimes it's sown among the thorns and represents the person who makes the decision and then goes back to his old life of bars and chasing women or whatever. A third seed is sown among the rocks. There's sand and dirt between the rocks, and when it rains you'll see a stalk of green coming up. But on the first day with sunshine it wilts because there is no room for roots.

The fourth seed is planted on fertile soil, and finally it takes hold and has a chance to grow and live. That's what happened to me.

I had a lot of liquor at home. My father-in-law was an importer, and once he'd accepted my marriage to Cynthia he'd given me a three-hundred-year-old bottle of cognac. A collector's item. Also Clicquot champagne. Pommery wine. I poured it all down the drain—except the cognac, which I returned. (I still had my senses!) I threw my cigarettes in the trash. Cynthia and I talked and prayed. When she saw me emptying the bottles into the sink, she was on cloud nine. She knew I'd undergone a real conversion.

"Now I'm not going to get a divorce," she said.

THE NEXT MORNING I woke up and realized I hadn't had a nightmare about the Bird. And to this day I've never had another. It was as if a doctor had cut out that hating part of my brain. I remember the facts, but the violent emotions are gone. I never even had to resolve to "work on it." Before, as much as the hate poisoned me, I think it gave me a kind of satisfaction. I believed hating was *the same* as getting even, but those I hated didn't even know my feelings. All I did was destroy myself with my hate.

After breakfast I told Cynthia I had to be alone. I took my army Bible, a New Testament that all servicemen had by order of President Roosevelt, and walked half a mile to Barnsdale Park. I'd tried to read it before but threw it aside, not understanding. I sat under a tree, said a prayer, opened up the Bible to John 1:1, and started reading: *In the beginning was the Word, and the Word was with God, and the Word was God* . . .

For the first time in my life the beautiful story made clear sense. I began to cry, overwhelmed by the emotion. For many years the Bible had been a mystery to me, but now it was an open book. This was the clincher: how could I suddenly understand the Bible when I never could before? How often had I picked it up and put it down because I couldn't make heads or tails of what it was all about? But with the Holy Spirit as my interpreter, the meanings were obvious.

I sat on that bench all morning and thanked God for my life from the day I was born, for all that I'd been and been through, all that I'd lost, all the times I'd tried to change and failed, all the times I'd prayed to survive and had. Otherwise I'd never have known Christ. All things work together for the good. The Lord had seen to it that I'd made it through every life-threatening situation and lost in every business venture because that's what brought me to the tent. Now I knew that God's hand had always been upon me and had prepared me for this moment.

VERY FEW PEOPLE really understand the difficulties of accepting Christianity. The picture painted by the well-meaning is that after a conversion God gives the new believer a steady diet of happiness and all is immediately well. Nothing of the sort is true. On the contrary, like every other sincere person who is striving to believe in spite of having so long lived another way with a mind conditioned to cynicism, I had to go through a period of despondency, doubt, and painful self-examination. Often I'd sit in the apartment for hours, without speaking to anyone. This was my trial period, during which I descended from the elation and satisfaction into the valley of despair. And unlike the war, when I had faced obstacles and overcome them, this time I

did not have the same self-confidence. Then I'd taken survival-training courses, knew I was in great physical shape. Now I was simply a baby. That's why they call it being reborn.

The Christian life is not easy. You'll always get a guy who stands up and says, "Ever since I became a Christian, my life's been a bowl of cherries."

I've always turned to that guy and said, "You know what you need? You need Christ. Christian life isn't about a bowl of cherries. It's a struggle, and that struggle keeps you dependent on Him."

Cynthia stood faithfully by waiting for me to rebound, and as my new humility took hold, I went to the Veterans Employment Service downtown and applied for honest work. No more "deals" for me; I'd dig ditches if necessary.

I didn't know it, but that wasn't God's plan. My experience best fitted me for a different job.

FIVE NIGHTS AFTER my conversion I went back to see Billy Graham and met him and Cliff Barrows, the choir director, platform emcee, and radio-TV program director who started with Dr. Graham that year in Los Angeles. I told them my story and confirmed, "Yes, I'm converted." I could tell by the way they looked me over that they had some scheme in mind—and I could guess it pretty well—but I said, "No man will ever get me on the platform preaching like Billy. I'm just going to be a regular Christian."

The next week Barrows bought me a train ticket to Modesto and convinced me to give a testimony. I couldn't very well say no. "What do I say?" I asked.

"Just tell them your war story and how God put you through this and that, and what happened to you at the tent."

He sent me to his dad's church, but the church had burned down, so they erected a tent. My first testimony was in a tent, under Cliff Barrows's father.

The very week I found Christ, two other well-known men did the same. Jim Vaus, the wiretapper for mobster Mickey Cohen, and Stu-

art Hamblen, the singing cowboy and owner of the famous racehorse El Lobo. They joined me in spreading the Word.

When publishing baron William Randolph Hearst, who owned the Los Angeles *Herald Examiner* and many other papers, heard of these high-profile conversions, he was so impressed that he called *Examiner* editor Joe Pine and said, "Blow up Billy Graham," meaning do a story and give him front-page publicity.

Until then evangelism hadn't been news, more of a dirty word. That coverage made Dr. Graham famous overnight.

Later I spoke to a big crowd of *Examiner* carrier boys and their families at the Biltmore Hotel. Joe Pine was there. He said, "We've got Jewish people here. We've got this and that. But Louis, when you get up and talk, be sure and give them the gospel." Joe Pine was, evidently, a Christian. He also said, "You have many friends on the paper"— originally the sportswriters—"and we knew you were having a problem. When Hearst called me and said to blow up Billy Graham, it was the best news I could have received."

"Boy, am I glad Mr. Hearst talked to you," I said.

"Who do you think talked to Mr. Hearst?" he countered, meaning God.

When the *Examiner* splashed Billy Graham, the *Los Angeles Times* did, too. Then it hit *Life* magazine and went worldwide, and I got invited to speak everywhere, expenses paid. I could also collect an offering. I made a few bucks here and there, but getting around was difficult, since I had defaulted on my loan and lost my car. Then, at a meeting, I met a guy who had a little hamburger joint in Glendale. He said, "I'm getting a new car, Louis. I'll sell you my DeSoto coupe for a hundred and fifty bucks." A bargain. It had good tires and ran like a top. Now I had a way to get to more meetings and soon I found myself back in the spotlight like in the old days—only altogether different. Some friends later accused me of accepting Christ for the new publicity it brought, but they were dead wrong. It was thrilling to know I was on the right side for a change. Had I cravenly sought publicity, I certainly wouldn't have thought or planned to kneel and cry in the sawdust in a dingy tent to find it.

.    .    .

I FORGAVE THE Japanese, I quit drinking, I quit smoking. My only struggle was when I went to parties with my friends. Most of them didn't think my new religion would last.

I was at a Hollywood get-together at the house of some guy who invented backache pills. My friends stood around drinking with their usual enthusiasm, and they kept urging me to join them. I said, "No way," but they had trouble accepting my new resolve. I understood. When you've known someone so well for so long and suddenly he turns his life around, you're tempted to look for a practical, understandable answer first. No one considers the spiritual answer off the bat. I didn't expect my transformation to go down easy, but as the Bible says, a smooth sea never made a good sailor. I believe that to this day.

Later I sat on the floor with the actress Jeanne Crain and some of her eminent show-business friends and witnessed to them—meaning I told about my conversion and answered their questions. They all listened because Billy Graham had made the headlines. Some gave me their cards and asked me to call and tell them more about my experiences privately. Then I went into the backyard, where my old cronies implied I was "chicken" if I didn't drink. I left then, feeling rather low.

Later that night one of my buddies called and said that the guys pushing me to drink was just "a trick" to see "if that religion of yours was real or just a gag. I know they were pretty rude, but when you left, several of the same guys said, 'Man, I wish I had the guts to do what he did.' "

I knew that along with their natural curiosity they had doubts about what had happened to me—was it real? would it last?—and his news gave me new strength and vigor. I decided then that while I'd continue telling my story to whoever would listen. Rather than preach I'd just plant the seed, live an impeccable life so people could see the difference in me, and let God grant the increase.

It was all in His hands now—as it had always been.

# 14

## FORGIVENESS

AFTER MY FIRST talk in Modesto, offers to share my story poured in. I knew my journey from delinquent to Olympian, from POW to drinking, from nightmares to conversion—my testimony—was an attention getter—"And then what happened?"—so I accepted the invitations as evidence of God's plan and an opportunity to test my new faith by following it.

I drove to most engagements, sometimes took the train or flew. Now and then Cynthia and Cissy came with me. When invited to speak, all expenses were paid and an honorarium provided. God knew my needs and took care accordingly. I also faithfully gave 10 percent back to the church.

ONE NIGHT, AFTER speaking in a little church in Burbank, I saw my old friend Harry Read standing in the back, behind the last pew.

"I thought I'd drop by and see what all the fuss is about," he said.

His visit was a great surprise, and not just because my old college buddy was in a church, of all places. Harry had entered a boat race eight months earlier and had moved to Hawaii. I didn't know he was in town.

"I'll drive you home," he said.

On the ride to Hollywood he recalled the months he'd spent in the islands. "I tried to charter my boat but couldn't do it, so I had lots of time on my hands. I filled it with the easy life: parties, beautiful gals, drinking—you know the routine."

I did. But Harry sounded more puzzled than happy.

"You know, Louie, despite the good times and beautiful scenery, I got bored. I wasn't . . . happy. Something's wrong, but I just can't figure it out."

I could have spoken then, but I let him ask a few questions about my new life instead and hoped he'd get the message on his own. Besides, I couldn't tell from his expression whether what I'd said in church had impressed him or revolted him, or if he'd even heard me.

A week later Harry attended another meeting—not mine—and when the preacher extended an invitation to accept Christ, Harry stepped forward. Later he told me, "I just wasn't sure, Louie. Knowing you the way I do, I just couldn't believe it. But I've watched you and that convinced me."

Harry threw himself into his new life. He moved to Oceanside, where he had an equipment-rental business, and sometimes we'd get together. He married a beautiful model and asked me to teach them running so they could stay in shape. Years later Harry got kidney cancer. When he had only a week or two to live, I drove to see him and we prayed together.

THE GREAT COMMANDMENT is that we preach the gospel to every creature, but neither God nor the Bible says anything about forcing it down people's throats. If you go to the door and get rejected, you're supposed to kick the dust off your shoes and move on, not try to kick down the door. Back when the Jesus freaks roamed Hollywood Boulevard accosting passersby, I thought their pressure tactics gave Christianity a bad name. I believe what the Bible says: many are called, few are chosen. That's one of today's big problems: we've got too many die-hard fundamentalists the world over. You can see the hate in their eyes when someone doesn't agree with everything they say. A dangerous few go to terrible lengths, even violence, to spread their

beliefs. I've met many people who rejected Christ, yet it's always some guy trying to *spread* the Word who gets mad and madder because he believes he *has* to score a conversion, like it's a game he has to win.

In the beginning I struggled with my own eagerness to spread the Word and sometimes tried too hard. But after a few frustrating and occasionally embarrassing encounters, I finally accepted the truth: the Bible says you can't convert anybody. All you can do is plant the seed and water it, and God will grant the increase according to His will.

IN MID-1950 I attended a huge annual Christian conference at Winona Lake, Indiana. Every night I stood on the dirt-floor auditorium and listened enthusiastically to the messages of missionaries and evangelists from around the world.

Only when Bob Pierce, who established World Vision and had just returned from the Orient, spoke did I have reservations. Bob had become a war correspondent and had a radio program that dealt with the problems of Japan and other Asian countries.

"Why," he asked, in his forceful way, "are no missionary teams going to Japan? You've scheduled many teams for Europe"—I was part of one, ready to leave within twenty-four hours—"yet only one team for the Orient! We need more."

Pierce was very upset, and I couldn't stop feeling that he was speaking directly to me. Whether or not he was, it made sense; if anybody ended up in Japan, I'd be the one. Not that anyone had asked—and if anyone did, I already knew I definitely *didn't* want to go.

A few years earlier I'd made that much clear to *Time* magazine when I'd said, "I'd rather be dead than return to that country." I couldn't stand Japan. The war memories—like the times we had to fertilize the potato and carrot crops with our own human dung, and then eat the result—just made thinking about a return trip worse.

In Japan poverty was still a way of life. I wanted to do missionary work where my surroundings were more Americanized, more democratic. I had friends all over Europe and knew I'd have a good time there. Had I not become a Christian, I might have eventually gone back to Japan just to find the Bird, if he was alive, and make him pay

for what he'd done to me, but since I'd forgiven everyone, the coun-
try no longer held my interest. At least that's what I told myself.

When Pierce finished I snuck out before anyone could talk to me.
Yet walking back to my hotel room, I could not escape the conviction
that until I had actually faced the Japanese again and seen the reflection
of my supposedly new self in their eyes, I would never know for sure
whether or not I had dispelled the past. So I got the idea that perhaps
I should come face-to-face with some of my former captors, now
interned at Tokyo's Sugamo Prison, and forgive them. Only then
would I be complete.

In the lobby I met some buddies who wanted to have a prayer
meeting. When it was my turn, I said, "Lord, I feel this terrible con-
viction that I have to go back to Japan, but I'm not sure. It's burning in
my heart." Then I came up with a clever way to shift the responsibility
for the decision elsewhere: "Being a new Christian, Lord, I'll need a
good swift kick in the pants to understand your will." In other words,
show me an unmistakable sign—and quickly—or I'll leave with my
team for Europe, as planned.

On the way to my room I walked by a conference room just emp-
tying. A young minister, a complete stranger, stopped me. "My name
is Eric Folsom," he said. "I'm an evangelist from Tucson. I heard you
speak. Perhaps you'd tell your story at my church?"

"Certainly," I replied, handing him my card. "Write me when you
get back and let me know when it's convenient and we'll work it out."

"By the way," he said, "Did you hear that challenge on Japan?"

"I did. But I've got to get to my room and—"

"It thrilled me to hear Bob Pierce's message."

"Me as well," I said. "Anyway, I've got to get to bed . . ."

Folsom put his hand on my arm. "Just a minute, Louie."

"What's the matter?"

"As we've been talking, God has burdened my heart to give you five
hundred dollars to start you on your way back to Japan."

I didn't know whether to hug him or hit him, but the truth was
inescapable: I had asked God to give me a sign, and He had obliged
me. Folsom explained that he didn't actually have the money, but he

promised to send it to me in California the moment he got home. (I found out later that he went back to Arizona and sold his car!)

Less than a hour later, a singing group of about six people knocked on my hotel-room door and said, "We heard that challenge on Japan, and you're the logical person to go back there. We want to give you our tithe money."

Another sign.

Before turning in for the night, I wrote a letter to Cynthia and Cissy:

> My little lonesome ones,
>     Your daddy is thoroughly befuddled. So many things are happening back here that I am in a constant nervous state. I have been praying for the Lord's guidance on these missionary trips, and doors seem to be opening in all directions. Tonight I got a very distinct lead. The Lord is really here.
>     Cynthia, the Lord has kept me here for my own good and yours. Our main interest is the Lord's will first and I believe that getting a house is part of the Lord's will. Pray hard and long and often about Japan, the juvenile program, that television show, and our house.
>     The only plane I can take stops in Los Angeles for ten minutes at 11:30 Sunday night, then takes off for Frisco. I'll try to call you from Lockheed Terminal during our stop. I'll try like mad to get home by Tuesday night. I guess I missed my dental appointment, so make two for me any morning.
>     I sure do miss your cold little feet.
>     Yours in His service,
>     Love, Louie

In Los Angeles, Youth for Christ International's vice president said he'd help me make the money I needed to fully finance my trip to Japan, and he booked me on a speaking tour up and down the West Coast. I also became the director of their juvenile-delinquency program. In Washington State I met a team of young evangelists bound

for the Orient, and we agreed to travel together for two months. They also raised money for me.

My non-Christian friends said, "Well, I sure wouldn't do it. It takes a lot of guts." The Christians understood. At least this time no one thought it was a publicity stunt.

I flew on a Northwest Airlines clipper prop plane to Hawaii, where we stayed overnight, and then to Wake. I'd bombed Wake and knew its every nook and cranny but had never actually set foot on the island. During the trip I had severe second thoughts about going and spent most of my time resenting my decision to return. I just couldn't accept the reality of what was happening. But my confusion didn't matter. The trip was God's will, and I knew it. God doesn't say we have to be happy in His will, He just says that we should be *obedient* to His will and joy will follow.

For the moment, I had to take that—and all else—on faith.

I STEPPED OFF the plane at Tokyo's drab airport on a cool, gray October day in 1950, and was immediately reminded of hundreds of similar days when I'd been imprisoned, not knowing how much longer I'd have to endure to survive. Again I asked myself, What am I doing here? Again, I knew the answer. I just didn't like it.

I cleared customs and met my missionary hosts and interpreter. A team from *Life* magazine's Tokyo bureau stopped me in the terminal. They'd learned that I wanted to visit Sugamo Prison, where many of the men who'd guarded and mistreated me—along with the other war criminals—were held. They wanted to get inside for a story but had been denied. After hearing their report I didn't know if I could get in, either, but I promised to talk with the chaplain at the army's General Headquarters on their behalf, and mine, and keep them posted.

Driving into Tokyo, I could immediately see that the city had changed. Where I remembered charred building skeletons and pitiful, hungry people, a bustling metropolis now grew, with wide boulevards and residents seemingly full of energy and enthusiasm. I saw open-fronted stores filled with huge daikons, hanging meats, and jars of colored candy. Vendors pushed carts through the streets. Little shops sold

paper and tea. New factories stood next to the firebombed ruins of the old, and swarms of small houses covered areas the B-29s had once left in cinders. The city appeared infused with hope instead of hate. I wanted to feel that way, too, and remained inwardly watchful for any trace of bitterness and enmity, especially when I thought of those who had beaten me with their fists and worse.

My schedule was full. Various Christian organizations had arranged meetings and public testimonials. Military chaplains asked me to visit their installations. Universities and civic groups arranged lectures. Newspapers donated reams of print to my arrival and appearances.

All I had to do was manage my money well. After buying my plane ticket I had only a few dollars left, which, when supplemented with some donations collected during our layover in Honolulu, totaled about fifty dollars. Fortunately, fifty dollars then was like five hundred dollars today. I could get a steak dinner for twenty-five or thirty cents, and usually we were fed in Japanese homes or at communal meals with church groups. Because the army had neglected to collect my official I.D. card when I separated from the service in 1946, I could even go to the PX, where food was cheap. Sleeping accommodations were another matter. We slept where we slept, often on pads at cheap hotels. However, between the hospitality and the anticipation of my public appearances—I had no idea I'd be so well received—I slowly began to enjoy my stay.

FROM MY MANY postwar appearances I had long ago established my standard talk. I had learned to condense the story to thirty minutes because most people don't want to listen for longer than that. Even though I'd recently made a decision for Christ, I didn't change the content of my lecture much or load it up with the Word of God. I believed then, and still do, in going very light on Scripture, saving that for the end, and letting listeners take from my total experience what they need and what works for them.

The only difference was that I'd never told my story to a Japanese audience before, and I wondered how they'd react. Could they handle the harsh detail and my memories of hate and anger? I decided to do

what I did when I spoke to the occupation troops on Okinawa: just tell the truth—about Kano, the good guard; about the Bird; about my life being spared on Kwajalein and how I'd never been able to figure out why.

Whenever I finished a talk, my group passed out tracts and pamphlets, and we were struck by the eagerness with which people accepted them. In America much of our material was tossed on the auditorium floor, left for the janitor. The Japanese discarded little.

One afternoon I was about to leave my hotel for a speech at Waseda, one of Tokyo's biggest universities, when the school president called and said he had to cancel my appearance. "I'm sorry," he explained, "but there's a little trouble on campus."

"Little trouble" was an understatement. The Communist movement was strong in postwar Japan, and over a thousand students and an equal number of policemen were at that very moment engaged in a bloody battle that lasted six hours. One hundred forty-three people were arrested, and thirty-four students and eleven policemen were injured, some critically.

I spoke at four factories instead, and three days later we decided to try Waseda again. The university president made it clear that I'd come at my own risk. "I'll announce the event," he said, "but I can't guarantee anyone will attend."

The stage at Waseda was about five feet off the floor. I was preparing for the assembly when students began to arrive. Many wore bandages; they were the radicals. That frightened me, yet again I didn't pull any punches talking about the Bird and the torture. Everyone listened politely, and when I finished the interpreter gave the invitation to become a Christian. Suddenly a sea of students surged forward, many of them wearing bandages. It occurred to me that they might not be rushing the stage to accept Jesus. I admit that even after two years in prison camp I still found it difficult to look in a Japanese face and know whether the owner is happy or mad or about to kill me.

I turned to the interpreter and said, "Hey, what do they want?"

He asked one guy with a bandaged head, turned back to me, and said, "They want to become Christians."

Our usual harvest was fifty or sixty. That night nearly three hundred renounced all other gods and ideologies, even communism. Beautiful!

TOKYO HAD BUILT a huge new civic auditorium, which held about sixteen thousand people. The night I appeared, eighteen thousand jammed inside and another five thousand waited outside in a heavy downpour. To reach everyone, I did a double program. Again I told the story, and again people came forward to accept Christ.

Afterward, a shriveled old Japanese lady approached me, bowed, and got right to the point. "I'm a Christian," she said, plainly, "and the reason your life was spared on Kwajalein was because my son was an officer in authority there."

"What?" I couldn't believe my ears.

"My son's words saved your life," she repeated matter-of-factly.

I had so many questions, but I asked only this: "Is he still alive?" I knew that when the Allies bombarded the island, the enemy had been wiped out.

"Oh, yes," she said. "He manages a department store in Tokyo." She gave me the name, and I went directly there.

THOUGH I WROTE it down, I've lost the piece of paper and today I don't remember the name of the man who saved me on Kwajalein, though I have his picture. It's the sorriest, silliest thing. Nonetheless, we met and talked through an interpreter for nearly an hour, and I got the whole story.

"When you crashed at sea," he explained, "you made headlines in America. We knew who you were because of the Olympics and USC. Everybody did."

Americans today might not understand, but the Japanese then knew more about American movie stars and American athletes than we did. An American athlete could walk down Hollywood Boulevard and never be bothered. In Tokyo he'd be recognized.

"When you were picked up at Wotje, we were beside ourselves," he continued. "The officers on Kwajalein wanted to interrogate you. One had even gone to USC."

"I know. We met."

"After they decided you were of no more use to them, an execution date was set. All prisoners on Kwajalein were beheaded."

"I know that, too."

"But I went before the panel and made a suggestion. I said, 'I have a better idea. Louie-san Zamperini is a famous American runner and an Olympian. Because of that and the publicity when he disappeared, it would better serve Japan's purpose to send him to Tokyo as a prisoner of war, to make broadcasts. The panel agreed and contacted Vice Admiral Abe, who had given the original order that no prisoners leave Kwajalein alive—and he gave his consent."

And so my life was saved. So simple. My destiny had been determined on Kwajalein.

I thanked him profusely and told him that the mystery of why I'd been spared had bugged me for years. "Now I know the truth, and I'm very grateful."

We posed for pictures and shook hands all around.

MY TEAM AND I extended our travels outside Tokyo, to the other islands—and to Hiroshima. Sections of the city were still highly radioactive, but on the outskirts of town, houses had been already been repaired.

I was met by Mayor Oye, a devout Christian who had lived in a concentration camp during the war for his preaching. He didn't seem in the least bitter, particularly about his imprisonment. "I have no reason to complain," he chuckled. "I had the largest congregation I'd ever had—and they couldn't leave!"

As a gift, he presented me with a rifle hit by the atomic bomb while in the hands of a soldier. It had melted and curled, and I couldn't believe he had given me this symbol of horror and defeat. Talk about forgiveness. I was touched.

I talked to burn victims in the rebuilt hospital, going from bed to

bed with my interpreter. One guy showed me his back, burnt from the blast, and said, "I feel honored that this happened to me, to save millions of lives."

Honored? Save lives? Was he crazy? No. Though thousands were lost in the atomic-bomb blasts, students of the war know the statement makes sense. Still believing in the "divine wind" of old, the Japanese would have waited for a miracle and never surrendered, forcing us to storm their shores. The fierce, prolonged battle for Okinawa had been an example. In Ofuna, James Sasaki had told me that if the Allies ever invaded Japan, 10 percent of the 75 million population would die—plus untold numbers of the invading forces, most of whom weren't real soldiers but part of the Youth Corps: teenagers taken out of college, trained for the final assault, likely destined to die. After the war, when some people condemned the A-bomb, a former Youth Corps kid wrote to the newspaper saying, "Hey, I was one of those guys who got six weeks of training on how to handle a gun and a bayonet. I knew I was going to die. Without the bomb we might have lost half a million men in the invasion (code-named "Downfall"), and the Japanese ten times that."

I ALMOST RAN out of money on the way back to Tokyo, but during lunch at a hotel outside Hiroshima, a navy ensign who'd heard my talk introduced himself. Before leaving Hiroshima I'd discovered I wasn't allowed to ship home the rifle I'd received. The ensign said, "I'll tell you what I'll do. You come out to the ship with me, talk to some of the guys, and I'll not only give you two hundred and fifty bucks so you can stay in Japan, I'll take your rifle home and give it to you when you return." He was as good as his word, and I extended my stay.

The money allowed me to go into the Japanese countryside. After living at Ofuna and Naoetsu, I felt more at home there than in the cities. The men and women who now struggled along dirt roads carrying their loads of dried fish and bean paste seemed like old friends. On an overcast, cold and miserable day we stopped an old man pulling a loaded two-wheeled cart through a barley field. He listened to us long enough to know we were talking about God, then he

looked up and pointed at the sky and said, "I worship the Sun Goddess." Just then the clouds parted and the sun shone through, warming us all. He smiled and said, "Is there anything better?" What could I do but smile back? When I handed him a Christian booklet, he bowed and thanked me, then trudged on his way, enjoying the sunshine.

IN TOKYO I received word through a missionary couple that a former Japanese navy recruit who had heard me speak had approached them with a question: "I was one of those who beat Zamperini on the ship to Yokohama and broke his nose," he'd confessed. "Do you think he has truly forgiven me?"

He was assured I had but urged to ask me in a note. I replied in a way that left no doubt about my pardon, but as I scribbled I thought, Writing is easy. Would it be as easy to say it in person?"

The time had come to find out.

LIFE MAGAZINE HAD kept in touch with me every few days, asking if I had made any progress toward being allowed to visit Sugamo Prison. I hadn't and said I'd try again. But first I wanted to visit the camps where I'd been confined. Call it training, a prerace warm-up.

At Ofuna I walked the long narrow road, now slippery with rain, to discover that the camp was still there. Scavengers had stolen the wood fence, probably for lumber or fuel, and two barracks had been replaced by planted fields. A third barrack housed squatters, one of whom slept in the arbor where the Mummy had read his paper. The cemetery, where we'd said good-bye to so many of our buddies, had been burned over.

Today Ofuna is a resort. Then it was just a painful memory.

Omori was much the same story, except that as I drove across the bridge to the man-made island, I was more afraid than sad. Would I remember the thrill of watching B-29s streak toward Tokyo, bomb bays pregnant with destruction? Or would I see the Bird's leering frog face and feel the sting of his buckle hitting my head?

The island was a shambles. The fences had vanished, but the deep

holes once filled with human excrement remained. I tracked through the weeds and looked in the window of a collapsing barrack to find the same two planks where I'd slept. Three tramps now called it home, and poverty-stricken Japanese families huddled in the cubbyholes for warmth, picking at the sand fleas that still swarmed unchecked.

I saw the room where we were allowed an occasional bath while an inquisitive audience of girl cooks giggled and pointed at our physical merits or shortcomings.

I stood in the barn with the holes in the wall where I saw another POW shiver for days, surrounded by ankle-deep snow, for stealing rice. I remembered Kano, the kindly guard, who'd risked his life to bring him blankets in the night.

I wandered through the courtyard, memories coming hard and fast: me, a virtual skeleton forced to run, stealing newspapers, beatings, depression, death, and the Bird—watching, never missing anything, grinning as he unburdened his rage on yet another prisoner. My chest tightened at how real it all seemed. Soon I would see my guards face-to-face. My forgiveness was so authentic and total that I looked forward to seeing each of them. I longed to look into their eyes and say not only "I forgive you," but to tell them of the greatest event of forgiveness the world has ever known when Christ on the Cross, and at the peak of his agony, could say of his executioners, "Forgive them father, for they know not what they do."

I took one more look as I left and to my surprise was overcome with a wave of . . . nostalgia? I had lived here. It had been my *home*. I missed my former buddies. Hell, I even missed the guards.

And the Bird? For so long I had wanted to kill him. Now only a mental picture of Watanabe as a lost soul remained. Maybe if the military would let me into Sugamo, I could find the Bird and talk to him. I had already helped myself; maybe I could even help him.

I crossed the bridge to the mainland and turned my back to the past. All that remained was the most difficult part, the test: Sugamo.

ENTRY TO SUGAMO was highly regulated. It was almost impossible to get a pass, since none but the captives' immediate families and those

who had specific and worthy business were allowed inside the wooden walls.

I called the GHQ chaplain again, and he told me my only hope was to appeal directly to General MacArthur at SAC headquarters. "That's kind of ridiculous, isn't it?" I said.

"Maybe," he responded, "but *he*'s the one who asked for ten thousand Bibles and twenty-five hundred missionaries. Give him a ring."

When the fellow I reached in MacArthur's office gave me a little runaround, I played my best and only card: "I'm calling because my former guards are there," I explained, "and because MacArthur asked for twenty-five hundred missionaries and ten million Bibles." I let that sink in for a moment. "I know I'm only one, but I'm *here* and I'd like to get in." MacArthur was apparently in the same room, and the guy put his hand over the mouthpiece and talked to him. I waited and waited. Finally he came back on the line and said, "Okay. Tomorrow at ten A.M. you can visit Sugamo Prison."

ON A COLD, dreary morning I stood under the archway with the red letters SUGAMO across the top. Before I walked through the gate, my imagination ran wild. Who would be there? Sasaki? Shithead? The Weasel? Kono? The Bird?

The colonel in charge of Sugamo welcomed me cordially. "Your guards are here and the overseers of your prison camps are here," he said, and assured me that he'd be pleased to have me speak to *every* prisoner, if possible. He said to talk openly and not hold back. He also told me a bit about the camp, which housed 850 prisoners, every single war criminal in one place. He said this was the only way to control them, and they had to be close to Tokyo because of the war-crime trials.

"The inmates vote for their own officers, and those elected run their affairs as a model village," he explained. "Food is their own kind and there is plenty. We don't practice physical coercion or punishment. All the prisoners are missing is their freedom and self-respect. But many are getting those back, too, month by month."

A bell rang out, signaling the meeting. I stood on a platform and watched the men quietly file in. I wondered if those who knew me

recognized my face, now older and fuller, but I couldn't see their faces well enough in the stage-light glare.

I gave my usual talk but never with more conviction. When I came to the part about how I'd been treated in Japanese prison camps, I again thought to temper the details and emotions so as not to appear too angry, but I didn't because otherwise my forgiveness would lack true meaning.

Afterward, I invited the men to become Christians and asked for a show of hands. Sixty percent raised them high. "This will in no way shorten your sentence," I explained. "I am not a part of the army and not part of SAC headquarters. It will not help you that way in the least." Then I asked for hands again. Some who had been tempted or misunderstood withdrew, but many others in search of a new life persisted.

The colonel said, "Those of you who were Louie's guards and heads of his prison camps, he'd like to speak with you. You may come forward if you wish.

Without hesitation they did. The moment had finally arrived. I waited onstage, watching men walk down the aisle and faces emerge from the mists of memory. I recognized each vividly: Sasaki, Admiral Yokura, Conga Joe, Shithead, Weasel, Hata the cook, Kano, and others.

But not the Bird.

Without even thinking I jumped off the stage, ran to the group, and threw my arm around the first guard. He pulled back at my friendliness; I don't think he understood my intention. My sign of affection was unfamiliar in Japanese culture. It was probably also the last reaction he expected from me.

The colonel ushered us into a small room. There I continued to press the issue of salvation, and a few made a decision for Christ, but others didn't understand or rejected my invitation, particularly the Quack, the medic from Ofuna who had so badly beaten Bill Harris. He remained a committed Buddhist.

During my talk I had praised guards like Kano, who had treated us kindly, like human beings. And yet here he was in the room, a prisoner. I couldn't understand why. When I asked, he explained that despite letters written by former POWs attesting to his kindness, he

had been confused with the sadistic Kono and sentenced to several years. I told him I would try to help.

I also spoke to James Sasaki, who that day decided to become a Christian. "I don't understand how you can come back here and forgive us," he said. "Your Christianity must be real, but I don't understand it."

"It is real," I said, "and if you continue in your faith, you will one day understand."

I had many questions for Sasaki. Why, I asked, had I spent fourteen months at Ofuna, a high-profile interrogation camp, when I wasn't high-profile? "You were being prepared. We decided to hide you away for a year and a month until your government officially declared you dead," he explained.

"Why did you have to wait?"

"The element of surprise."

"Surprise at what?"

"Your voice making broadcasts."

"Is that why, when I stole food at Ofuna—a crime punishable by death—and the Weasel—a guard who would turn on you if he saw you spitting on the ground—caught me, you never did anything and I was spared?"

"Yes. I kept it quiet. But we made your life as miserable as possible—also at Omori—so that when you were offered a better life at Radio Tokyo, you would accept it."

"That was Watanabe's job?"

"Yes."

"But I didn't cooperate."

"I know. And you were sent to Camp 4-B."

Camp 4-B. The freezing hellhole. In my mind I heard the sound of granulated snow crunching beneath the Bird's boots as he faced me with a wicked grin the day I arrived. I remember my knees buckling at the thought of never being free of him.

"What *about* Watanabe?" I prodded. "Is he here? Is he alive?" According to testimony from surviving POWs, the Bird had been listed by General MacArthur as a class-A war criminal, the twenty-

third most-wanted. I had expected to see him in the audience, or at least discover that he had been tried and executed.

"Missing. There is still a reward, twenty-five thousand dollars, but we believe he committed hari-kiri," Sasaki simply said.

I didn't want to believe that. Despite his cruelty and bluster I thought Watanabe was too chicken to commit hara-kiri. After the war Frank Tinker and I even came up with a possible scenario: Watanabe always wanted to be an officer. Perhaps he had left Naoetsu two days early, escaped to Korea, and become an officer in the North Korean Army, and gotten killed there.

So much for wishful thinking.

I had come to Japan with forgiveness in my heart. I just wanted to look the Bird in the eyes, put my arm around him, and say "I forgive you." Yet, even in apparent death, as he had in life, the Bird still managed to confound me.

I LEFT THE prison having promised Kano, James Sasaki, and Admiral Yokura that I'd try to help their cases for early release. Yokura had told me, "Louie, I do not understand your democracy. I have done nothing wrong, and yet I am sentenced to twenty-five years in prison."

To the best of my knowledge, that was true. During the war-crimes trials our government had hired a lawyer to defend the Japanese. He didn't want to do the job until he saw some defendants being "railroaded" by judges in a hurry to sentence prisoners left and right. He stayed in the country and still had access to the files, which he let me see. Admiral Yokura's file indicated he was a kind, personable guy. I'd met him at Ofuna and again at Omori. When I read the transcripts of his trial, it shocked me. The evidence showed him innocent of every accusation. On the next-to-the-last page it said, "Innocent"— and yet the final page read, "Sentence: 10 years." It didn't make sense.

I wrote a deposition to General MacArthur indicating I had read Yokura's case history and, "by your own courts he was found absolutely innocent of any crime. Yet, on the last page he's sentenced to ten years. That evidently is an error. Please read the last two pages

and come to some conclusion." The attorney had my note delivered to SAC headquarters, and eventually Yokura was let out of prison.

I also wrote that Kano was not Kono. Kono was the Bird's syco-phantic right-hand man; he was a bastard. Kano was a nice guy. He took chances with his own life by helping us. Kano was also freed.

Sasaki was my only failure. Shortly after my liberation I had com-pleted an affidavit on his behalf and thought the matter done. After seeing him at Sugamo I wrote to MacArthur—and then his successor, General Matthew Ridgway—that Sasaki (and Yokura) "were not war criminals in any sense of the term, not only to my personal knowl-edge but also to the knowledge of many of the other personnel who were imprisoned with me and subsequently in the Ofuna Prisoner of War Center. Since my return I have met some of the former prisoners of war and all have experienced the same shock and surprise that I did when learning that these men are now serving prison terms." But I couldn't get to first base with SAC for Sasaki, and neither could the attorney. And no one would tell us why. "Handsome Harry" had to wait until 1952's general amnesty to go free.

THIS TIME WHEN I landed in Los Angeles there was no welcoming committee, no speeches, no fanfare. I simply went home to my wife and child. Happily. I may have been doing the Lord's work—and more successfully than I had imagined—but I had missed them terri-bly. I also knew that I had finally come full circle. Except for continu-ing to tell my story and spreading the Word, a great part of my life was over: the delinquency, the running, the war, the imprisonment, the drinking, the nightmares, the greediness and desperation, the unhappiness. I was completely satisfied with my test of forgiveness and more than ready to move on.

# 15

## NOT EVERY OLD SOLDIER FADES AWAY

I F THE LOVE of family and friends and a newfound peace of mind alone could sustain me, what a wonderful world it would be. However, I also needed a job, preferably one that would not only support my family but allow me to serve the Lord as I had promised on the raft.

A Christian college in Hawaii inquired about my taking a teaching position. Another, on the East Coast, offered me work as a coach. But I was too busy speaking all over the country to take advantage of the many opportunities that came my way. Once I gave twelve talks in a day. It was almost as if I were campaigning for office.

In 1951 I toured from the Northwest to Florida. Miami was supposed to be my last stop, but I got booked from there through the West Indies. In Nassau they didn't have a place big enough for the thousands who came, so we used a huge vacant lot. In Jamaica I circled the island, speaking often. I also went to Cuba—this was before Castro took power—and appeared for two nights at a church in Havana. The first talk was "Devil at My Heels," my war story. The second was "Communism versus Christianity in Japan," based on my experience at Waseda University. Both were advertised in the newspaper. The second night a bearded young man and his friends, all dressed in khaki but with no official designation, sat in the back of a church and listened. Afterward Pastor Rodriguez walked Cynthia and me to his

house, where we were guests. On the way, one of the bearded young men who'd been in the back of the church called to Rodriguez from across the street. I watched while they talked; the conversation seemed heated. When the pastor came back, he grinned sheepishly. "What was that all about?" I asked.

"That's a young revolutionary named Fidel Castro," he explained. "He didn't like your comments about communism."

Fulgencio Batista still ran the country, but young activists could cause problems, like setting churches on fire. That concerned me. "Is this going to get you in trouble?" I asked.

"No," Pastor Rodriguez said with a smile. "Don't worry about it."

Seven years later Castro took over, and communism was his religion. But I'll always remember that when he heard the gospel, he heard it from me.

ONE OF MY favorite activities was visiting prisons and camps for delinquent and/or troubled young people. Each time I felt as if I gave my younger self the support and advice that would have once benefited me. I had a wonderful rapport with kids and prisoners, especially when I told my tale of incarceration in Japan. They were amazed to hear about the conditions; by comparison, their prison stays were soft, and I'd hear comments like, "Hey, after listening to your story, I can do my five years standing on my head."

As a result I was put in charge of Lifeline Christian camps, which ran several sites on the West Coast from Seattle to San Diego. I bounced from location to location, talking to kids only eight to twelve years old. Then I was asked to speak to a State Youth Authority detention home in Whittier, where kids sixteen to twenty were in for major crimes, including homicide. I'd start my talk by admitting I was a problem kid, too, with some of the same difficulties they had now.

The response inspired me to open my own camp for troubled kids. I called it the Victory Boys Camp and hired two other Olympians as counselors. At first I had an actual location on the Angeles Crest Highway, in the Southern California mountains near Lake Arrowhead, but it cost too much to maintain. I ended up restructuring the program so

that I could take about thirty-five kids a week into the Sierras for a real wilderness experience that included fishing, camping, rappeling over cliffs, skiing, mountaineering—whatever seemed adventurous. Dave McCoy of Mammoth Mountain Ski Area provided skis and lift tickets for free. Others donated food and lodging to help defray the cost.

The experience always offered big surprises for the kids. At first they'd sit in the bus on the way up, talking only to one other. I had to get them on my side, so after a few hours we'd stop in volcanic country and someone would ask, "What are we gonna do here?"

"We're going to go to a dry waterfall called Fossil Falls," I'd say. "You hike in about a mile." There I'd throw a rope over the top and rappel down—three big jumps to the bottom. I'd come back up and say, "Every one of you guys is going to do that before the week is out."

"Oh, no, not me!"

"No way!"

"Forget it."

But back in the bus they would no longer talk sullenly among themselves. They yakked and asked me all kinds of questions. Now I had them, and I didn't let go for a week. I did it because I believe everybody in the world should try to help somebody else. Let's say half the people in the world are successful. If they help the other half, hey, you've got no problem.

In my experience, juvenile delinquents never accomplish much of anything. They quit high school, get in trouble, wind up in Youth Authority. So my approach emphasized various interests and accomplishments, and when the kids were successful, boy, they were thrilled to death. I saw what happened to my life because of sports, and I thought, Well, if it could happen to me, it could happen to anybody. I think of my camps as the first Outward Bound–type program, back in 1953.

We also provided counseling. That's the important part. I'd get the kids up to the cabins, sit them around a fire, and get them to talk about their lives. At some point I'd offer the Scriptures, but I applied no pressure. The rest was up to the boys. Most listened, a few didn't; either way they usually got it together.

Now I'll speak to a group and inevitably some older guy with gray

temples will come up and say, "I was in your camp when I was four-
teen, and you really straightened me out." That's a thrill.

SOMETIMES THE PEOPLE interested in Christianity surprised
even me.

Mickey Cohen, the Los Angeles mobster, loved athletes. Jim Vaus,
his former wiretapper, who'd come to the Lord at the same time I had
and now just did electronic security consulting, said Cohen wanted to
meet me. I guess Jim had laid the groundwork, because we had a nice
conversation about sports, the war, and my conversion. Cohen
wanted to know all the details. Afterward, he kept calling and Cynthia
and I even met him for lunch at the Brown Derby, on Wilshire. Then
he wanted to introduce me to his new girlfriend; I met them at his
haberdasher. He was a former boxer, a thug, so I wondered what kind
of a girl he'd be attracted to. She was a big, buxom blonde, sweet and
friendly but kind of naïve. I guess that after he'd met Cynthia he
wanted me to know he had a nice girlfriend, too. I also figured out
pretty quickly that he just wanted to be around people associated with
culture. He wanted to move easily in other parts of society.

One night Cohen called me very late and asked me to come to his
home. I drove up, alone. Floodlights went on automatically as I pulled
into the driveway. A henchman opened the door. Inside, I saw a half-
eaten turkey in the dining room, and a ham, like he'd had a party. Jim
Vaus was there. Mickey offered me food, then took me on a tour of
his closet, which seemed more like a room-length hallway. On one
side he had about a hundred suits, plus overcoats and shoes. He said,
"Anything that'll fit you, you can have." Vaus, a fat guy, took a beauti-
ful overcoat. Nothing fit me, which was just as well, since I wouldn't
have taken his clothes anyway.

Then Cohen showed me his escape chute. If there was a raid on his
place or if some other gang guys tried to get him, he'd go down this
chute. The door would lock behind him automatically, and he'd end
up in the basement.

After we chatted for a while, I said, "I've got to go. I've got a meet-
ing tomorrow at noon." I dismissed myself and went home.

Two weeks later I was at the Coliseum for a football game and I saw former USC All-American John Ferraro, then police commissioner who later became a Los Angeles councilman. He yelled, "Hey, Zamperini! What were you doing at Mickey Cohen's house Saturday night?" Evidently they'd had a stakeout.

All I could say was, "You know what I was doing there!" I was there to tell Mickey about Christ.

IN 1954 I got one of the greatest surprises of my life when someone in sportscaster Elmer Peterson's office said he'd like to interview me. I'd done the show a few times and thought nothing of it.

A man picked me up at my home and took me to the studio. We went to Peterson's door and it was locked. My driver said, "Well, we'll have to wait until Mr. Peterson gets here, I guess." We stood around outside, in the shadow of the huge soundproof doors of the El Capitan Theater, and after a while I got fidgety, so I said, "Are you sure you have the right time?"

"Oh, yeah, he should be here any minute."

All of a sudden the big doors slid open. A bright light shone in my face, blinding me, and I backed away. Then, I heard a voice saying, "Louie Zamperini!" two or three times. The driver walked me toward the light, and when my eyes adjusted I stood there in stunned silence. There was TV host Ralph Edwards, calling to me. When I crashed during the war I handled that pretty well, and though I'd been beaten almost daily in prison camp, I still took that in stride. But now I was so astonished that I couldn't move.

"Louie Zamperini," Edwards said again, *"This is your life!"*

The driver shoved me forward, and I walked onto the set of *This Is Your Life.* I sat on the couch, stunned and shaking my head. The show was at its peak. I'd watched it so often, and listened to my friends tell me over and over that with my story I should be on it, that I figured I knew every angle and if they ever chose me, they'd never be able to fool me as they just had.

Then voices came from behind the curtain and I was asked if I recognized them: One was my old Olympic team buddy Jesse Owens.

Another was my coach Dean Cromwell. And my pilot, Russell Phillips. And my family. They gave me a beautiful gold wristwatch, a Bell and Howell movie camera, a thousand dollars in cash, and a 1954 Mercury station wagon. I used the money to help my Victory Boys Camp program.

IN 1955, DUTTON asked me to write a book about my life. I did, and it was published the following year. I called it *Devil at My Heels*. But as time passed and I remembered more of my experience and— most important—discovered crucial details and answers to enigmas about my incarceration, and about what had determined my fate during the war, I began to think of my book as telling hardly any story at all, especially after finding my long-lost World War II diary. I hoped one day to get the chance to redo my book, expand it, and add another chapter to the history of The Greatest Generation.

Still, just after publication I got a call from Universal Pictures, telling me that Tony Curtis wanted to play me and had asked them to buy the book. I was about to sell my house and I needed some cash to purchase a new one in the hills, so I agreed. Universal drew up a contract, but when I read it I said it wasn't good enough.

"That's a standard Hollywood contract," they said. "It's all we can give you."

I knew they could give me whatever I wanted, and they probably thought I wanted more money. I didn't. "I need money to buy a new house," I explained, "but that's not the problem. Money is not as important as a guarantee not to minimize my conversion or its influence on my life. I have to have some protection for my faith." I told him that they'd made a picture called *Battle Hymn* in which Rock Hudson played Colonel Dean Hess. A World War II flying ace, the real Hess came home and joined the ministry; then they drafted him back into the Korean War and nobody knew he was a minister. I knew Hess, and he had told me, "If they ever make a movie of your life, get a separate contract to protect your faith. I have to live with my movie for the rest of my life, and believe me, it's not pleasant. Don't let them do it to you."

I didn't want much, just a moment to show Christ as in Isaiah 9:6, as both God and Savior. The producer wrote a couple drafts of the contract, but Cynthia and I turned them both down until he came up with something we liked. Then I made the deal and a script was commissioned. Tony Curtis went to Europe to make *Spartacus,* then to South America for another film. When he got back the script was ready, but I didn't like it and neither did Universal, so they put it on the back burner.

IN THE YEARS that followed my return from Japan my faith was strong and my life was full, and included occasional stories in newspaper and magazines remembering and honoring me. I've always been superactive, never bored, looking for new challenges, confronting those that found me.

Yet the daily dramas were of a different sort, more like everyone else's: kids, school, vacations, jobs. We had a wonderful son, Luke, and Cynthia and I helped him and Cissy grow up happy, inquisitive, and bright. We lived a Christian life, and I continued telling my story, as usual. But my appearances, while well attended, no longer brought in enough money to support us. Fortunately, the Lord provided many other opportunities to earn a living. I went into commercial real estate. I worked as a youth director at a church. I was chaplain for a corporation and ran a program for retired people at the First Presbyterian Church of Hollywood.

Cynthia bloomed, too, and never lost her independent spirit. She was a painter first, and at her one-person show she sold everything. Then she became a writer, penning three well-reviewed novels. She also traveled around the world. To pay for it she did whatever she had to, like drive a delivery truck until she had the money she needed. Then she'd come back, pick up another job, then take another trip. To tell you the truth, I used to worry about her traveling alone, and once when she came home I asked, "What's the worst thing that happened?

"I was on a tour and this guy, when he walked by me, patted me on the left cheek."

I said, "As a good Christian you should have turned the other cheek."

"Well, I did throw a stone at him," she said.

"That's also scriptural," I said.

EVEN THOUGH I no longer ran, I made it my priority to stay in shape. Today I'm still in great condition. I fly planes, ski double-diamond runs, trail-bike, and climb, though I gave up skateboarding a few years ago, just to be on the safe side.

To this day, people ask me how, after all I've been through, I managed to do it. It's a valid question. I say I eat right and exercise—both are necessary and true—but really, it's all about attitude. The war, the raft, prison camp, drinking—they took ten years off my life. I simply made up my mind to get those ten years back.

For instance, in 1957 Olympic ski jumper Keith Wageman and I climbed 14,000-foot Gannett Glacier, the largest ice field in the North American continent, in the Wind River area of Wyoming, and almost got killed in the process.

We figured it would take all day long to climb, but a storm delayed us until noon, so we had to hurry, and go without much of our safety gear. Between the rope, the crampons, and the ice ax, we had to decide which we'd use the most. We picked the ice ax. Our clothes were khakis and army boots.

Unfortunately we got caught in an electrical storm and nearly froze, but when we got to the top after eight hours, the clouds lifted, and we could see the glory of the ice field and the Grand Tetons seventy miles away. It seemed like heaven. The beauty of the vistas far outweighed the struggle and the cold. There was only one problem: the sun was setting. We'd have to scramble down quickly by boot-skiing and glissading. Keith and I made it in thirty minutes, and shot footage on the way. At the bottom we found the mule and the gear we'd left behind, but by then it was dark and, worse, overcast. We struck a match, tied a rope to each other and to the mule, then tried to find our way back to Cynthia. We fell into streams and slipped on rocks—it was pretty terrible—until we saw a big blaze in the distance. Cynthia had started a bonfire, and when she saw us she came running up with tears in her eyes. Later she told me she'd thought we were dead.

Two days later we climbed the glacier again, this time taking our skis. The return trip took only minutes. At the bottom, the ranger said he'd "never heard of anyone skiing Gannett before. You two are most likely the first to do so."

LATER I PUT those same survival techniques to good use one summer at Squaw Valley, where for two weeks I'd been given free food and lodging plus use of the facilities for the Victory Boys Camp program.

Large sheets of ice still covered the north slopes, and one morning I taught the kids how to use an ice ax both for climbing and as a survival weapon when slipping and sliding on the floes. In the middle of the class I heard a man's voice call frantically for help. I saw him up the mountain, outlined against the sky, waving his arms and shouting. "My girlfriend's fallen over the cliff!" Turning the kids over to an assistant, I grabbed the ice ax, and headed for the summit.

Panicked, the young man explained the situation as we made our way to where his girlfriend had fallen. I could see her on a rock outcropping. "Don't move!" I shouted. "Take a deep breath, relax. I'm coming to get you." I also told her to protect her head from the rocks that might come her way during my descent.

I had only the ax; what I really needed was my climbing rope. Nonetheless, I clambered down to the rock, gripped her arm, and lowered her onto a narrow ledge. From there I led her along the ledge to safety. She was one grateful girl. Meanwhile, my assistant had moved the class across the mountain so they could watch. Seeing the girl saved had a profound impact on the kids. And that, of course, is what I've always been and always hope to be about.

I COULD GO on and tell you about other adventures, personal triumphs, difficult situations, inspirational moments, emotional struggles, and best of all the everlasting rewards of helping others. After all, this story stops when I was about forty years old. I'm eighty-six now. But that's another book. Let's just say that I took my place as, I hope, a respected member of the community. I stayed active as a former

Olympian and serviceman. I cherished my family. That's the way life is and is supposed to be. I've probably had enough excitement for one man. Smooth seas aren't so bad. However, one day, in early 1997 . . .

THE PHONE RANG at my house in the Hollywood Hills, and Cynthia answered. Draggan Mihailovich, an Emmy Award–winning senior producer with the Olympic Features Unit of CBS Sports, was on the line—and for some reason he wanted to speak with me.

But I'll let Draggan tell it:

I'd followed the Olympics and read David Wallechinsky's books, which had anecdotes about these great Olympic heroes, but I'd never heard of Louie. By sheer chance—it was the luckiest thing in the world—talk about divine intervention or whatnot—I was working on a story and I just happened to go to the news library because I wanted to research the Army's great football team of 1945 for a piece about their fiftieth anniversary. I wanted to check out the *New York Times* from then on microfilm, and find out if maybe on the day Army played Navy, did MacArthur land somewhere, or whatever.

So I'm flipping through the pages, and out of the corner of my eye I see the word *Olympic* and wonder what it was, since 1945 wasn't an Olympic year and they hadn't even held an Olympics since 1936. And on the front page of the *New York Times,* on September 10, I read, ZAMPERINI, OLYMPIC MILER, SAFE AFTER EPIC ORDEAL. I wondered, who is this guy? I started to read the story and realized the reporter had talked to Louie just days after he'd been released. My production assistant was with me, and we were blown away. But we also thought, None of these guys can be alive, so how do you even tell this story?

To be honest—and I hate to admit it—I sat on it for about six months because the prospect of Louie being alive and being able to tell the story anyway was just so out there. Finally, I thought maybe I'll just give it a shot. I'll make sure he's dead; I'll at least sleep better knowing I gave it my best shot.

I found an address for Louie in Hollywood from 1979, then made a call. Cynthia answered the phone. I'd just had an experience where I called a widow and found out her husband was dead and she took it really badly, so I was already apprehensive. But I introduced myself and said, "Can I speak to Mr. Louis Zamperini?"

She said, "Oh, well . . ."

And I thought, Oh gosh. Not again.

". . . he's not home right now."

I said, "Are you kidding? *The* Louie Zamperini, war hero, prisoner of war, Olympic runner?"

"That's him. He's down at the church. He'd love to talk to you."

And that's how it started. I called back, spoke to Louie, told him I'd be in California in a couple of weeks and would he mind sitting down and telling me his story.

My story? For nearly fifty years I'd lived my life the way God wanted me to. I'd been active in the church and sports and raising my family. I'd also been honored to run with the Olympic Torch before the Los Angeles Games in 1984 and the Atlanta Games in 1996, and occasionally the newspapers did a nostalgia piece about me.

I'd even unearthed new facts about my war story, among them, why I could never help get James Sasaki out of prison.

A couple of years earlier, at the Zamperini Field air fair, a young policeman came up to me while I greeted pilots. He said, "Oh, Mr. Zamperini, I have your book. Could you autograph it for me?"

When I opened it I saw it was already autographed "to Ernie Ashton," a guy I went to high school with, who later became a policeman. The young man said Ernie had died and he'd come by the book and read it. I signed it again, and then he said, "Oh, by the way, Ernie wrote something on another page." I flipped through the book, and on the page where I mentioned Sasaki, this is what he'd written at the bottom: "Jimmy Sasaki had a powerful radio transmitter in a field off Torrance Boulevard near a Southern California Edison substation, which was in constant radio contact with the Japanese government. He left the USA by boat before a raid by the FBI and CIA."

Sasaki had been a spy.

No wonder he had bragged so often at Ofuna about his fondness for Long Beach and San Pedro. He'd go there, then to his transmitter, and broadcast a report about ship movement in the harbor.

When Draggan called, I saw an opportunity to complete the record. We met, he took some notes, realized he'd found more than he expected. He put together a little outline and proposed a segment about me to air during the Winter Olympics. CBS loved it and allotted ten minutes.

As part of his research—Draggan loves research—he flew to Japan and started digging. He went to Wotje and filmed. He went to Naoetsu, now renamed Joetsu, and discovered that in October 1995 the site of Camp 4-B had been turned into a Peace Park, with a memorial dedicated to the Allied prisoners of war who died there. Kids who were in school when I was a prisoner had grown up, made some money, pooled their resources, pitched in to buy the land, and created the park. They didn't want their kids or their kids' kids to forget what had happened.

He also wanted me to go to Japan and carry the Olympic Torch again, this time for a kilometer at the 1998 Winter Games in nearby Nagano. I suggested I do it right alongside the old prison camp, but as it didn't exist, I ran through town just a few miles away, and later he filmed me visiting the Peace Park memorial.

I'm a die-hard pack rat, and as the piece took shape Draggan and I spent days going through so much of the stuff I've kept all my life: letters, documents, magazines, newspapers, films, pictures, scraps of this and that, and finally, my World War II diary. He didn't mind. "Everything has to be authentic," he said. "We have to confirm everything."

For instance, when I told Draggan about the Bird and the time I had to hold up the wooden beam, he asked, "Who else saw that?" Most of the guys were dead, but Draggan got ahold of Tom Wade in England, and Wade gave him *his* book, *Prisoner of the Japanese,* in which he just happened to write that very story.

I also told Draggan, "My whole life is serving God. If you want this to be authentic, you have to have my conversion in there."

"There's no story without that," he said immediately. "We're basing this all on a theme of forgiveness."

I was greatly relieved. "Besides my conversion," I said, "I want you to show a picture of Billy Graham to confirm it. When people hear the name Billy Graham they think of one thing: the gospel."

He said, "You got it," and he took care of everything.

Based on the material I'd archived, and the proof of events from his research, CBS gave Draggan five more minutes of airtime. Then another five. Lucky me. After all I'd been through, I thought it couldn't get better than that.

I WAS WRONG.

While I was answering mail in my office at the church, the phone rang. Draggan was on the line from Tokyo, where he'd gone to verify more of my story and to shoot footage. "Are you sitting down?" he asked.

"Yes."

"Well, hold on to your chair."

I grabbed the edge of my seat. "Okay. What's up?"

"We found the Bird," Draggan said. "And he's alive."

When I could finally speak, all I said was, "What!?"

"Yeah, we found him. He's retired and wealthy from selling life insurance. We're going to try and get an interview."

"Really?"

"Would you like to see him?"

"Absolutely."

AFTER WE HUNG up I flashed back to the final week at Camp 4-B. The Bird had left two days before we knew the war was over, and no one had seen him since. Even his mother, when questioned, said the family hadn't heard from him. Eventually she built a shrine to her son and we assumed Watanabe was simply dead.

Draggan had somehow tracked him down, called the Bird's home, spoken to his wife, and asked for an interview. She said he was sick. A couple of days later he tried again, and this time she said, "He's on a trip."

Draggan and his crew, including veteran CBS reporter Bob Simon, who fronted the story, decided to hide and watch the house. They discovered that Watanabe took long walks, so they set up a camera across the street and hid another in someone's hat, just in case. When the Bird came out, they approached him and, speaking through a translator, asked if he was Watanabe.

"Yes, I'm Matsuhiro Watanabe," he said. After the usual formalities he agreed to speak.

"When you were in charge of Omori do you remember Tom Henling Wade?" Simon asked.

"No, I don't remember. So many prisoners."

I don't know why he didn't. Wade spoke Japanese and was always interpreting for us. "No, I don't remember Wado," he said.

"Do you remember Louis Zamperini?"

"Ah, Zamperini-ka. Orympi-ka. I remember him well. Good prisoner."

"Would you like to see him?"

To my surprise the Bird said yes.

They also solved the mystery of Watanabe's whereabouts after the war. He said he'd hidden in a mountain cabin way back in the hills of Nagano, which was wilderness before it became a big ski area. He stayed for seven or eight years, until the general amnesty. I don't understand how he could have survived that long without a job or at least supplies. The story just increased my suspicion that his parents *had* known where he was. Where had he gotten the mountain cabin? They had money; they probably owned it. Besides, what kind of man would let his parents think he was dead for seven years?

In the middle of the interview/confrontation, Watanabe's son and grandson came out of the house and discovered what was going on. They listened in and heard Bob Simon say, "Well, if [Zamperini] was such a good prisoner, why did you beat the hell out of him?"

Watanabe spoke very little English, but he understood. "He said that?"

"Zamperini and the other prisoners remember you in particular as being the most brutal of all the guards," Simon asked. "How do you explain that?"

"Beating and kicking in Caucasian society are considered cruel, cruel behavior," the Bird explained. "However, there were some occasions in the prison camp in which beating and kicking were unavoidable. I wasn't given military orders, but because of my own personal feelings . . . I treated the prisoners strictly as enemies of Japan. Zamperini was well known to me. If he says he was beaten by Watanabe, then such a thing probably occurred at the camp, if you consider my personal feelings at the time."

"When you were at Omori, according to Tom Henling Wade," Simon continued, and he brought up the belt buckle, the brutality, the testimony of Wade and Frank Tinker.

The Bird denied none of it.

Watanabe's family, however, was astonished. They didn't know the Bird had been a prison guard during the war and were horrified by what they heard and by the old man fighting to find the words. The son and grandson were probably pretty nice people. You can imagine their shock.

"No more!" they shouted. Watanabe's son said, "You can't see my father anymore. Leave and do not come back."

I can't blame them for that. Any son, no matter whether his father is right or wrong, is going to back his father. The Bird probably wishes he'd never been interviewed, too, because it exposed his past to the family: that he was a guard accused of being the worst of all guards; that there was a reward for his capture and General MacArthur had searched for him; that he was a class-A war criminal, number twenty-three of the top forty wanted men, which means execution. This was heavy stuff.

Draggan stopped filming but asked Watanabe if he still wanted to meet with me. Again he said yes.

DRAGGAN TRIED AGAIN to arrange a get-together, but the son adamantly refused. "Mr. Zamperini will expect my father to bow and scrape and ask forgiveness."

When I heard, I said, "No. I'm not going to ask him to ask for forgiveness. I've already forgiven him."

Draggan called back, but Watanabe's son wouldn't talk to him. Draggan told me, "We want you two together, but the only way we could get him again is to hide a block from the house and grab him if he walks by."

"No, I can't do that," I said. "That's not me. I'm not sneaky."

Draggan agreed. "You're right. It wouldn't look good for you, and it wouldn't look good in the story."

Of course, I've thought about what I might have said or done had I just happened to be outside the house when the Bird went for his walk. What if I just said, "Mr. Watanabe? I'm Louis Zamperini." I don't think there would be any fuss; we'd just stand there and chat. I'd suggest we have lunch. I'd ask about his family, children, grandchildren, wife. What they're doing. That's all. If he brings up the war, I'd say it's unfortunate that we even had a war. Otherwise, I wouldn't speak of it or accuse him of crimes. The one who forgives never brings up the past to that person's face. When you forgive, it's like it never happened. True forgiveness is complete and total.

WHEN DRAGGAN FOUND the Bird, CBS gave him forty minutes of airtime and virtually a blank check. Draggan went all out. He even dropped a raft into the ocean from a helicopter and did a telephoto shot that pulled away until the raft looked just like another whitecap on the water.

He also decided to keep the story a secret until the broadcast, which, when CBS realized what an award-winning job Draggan had done, they rescheduled to air on the final day, before the closing ceremony.

THE LAST PIECE of film Draggan needed was of me running with the Olympic torch. First I met the mayor of Joetsu, who had made my run possible, and with the Peace Park people, who said they would continue to try and get me together with the Bird.

The mayor asked, "Did anything good come out of your two and a half years as a prisoner of war?"

"Yes," I said. "It prepared me for fifty-three years of married life."

He roared with laughter. I could have gone into detail about being reborn, but he wouldn't have understood. The Bible says all things work together for good, for those who love the Lord. If it hadn't been for the Bird, I never would have been converted. My life would have never changed. But my torments about him drove me to destruction, and when my whole world completely crumbled around me, it was like on the life raft—there was nowhere else to turn. Like I've said, everybody looks up.

The next morning, at about eight o'clock, the mayor said, "Welcome to Joetsu, under different circumstances," and lit my torch from his. I wore a beautiful red, white, and blue running suit, with long pants and long-sleeved jacket. It was cold.

As I ran with that symbol of international sportsmanship and cooperation held high, I kept thinking about Camp 4-B and the war, and the contrast between my life then and now. Then I was beaten almost daily and all around me people died. Now I ran with thousands of people lining the road, most of them the kids or grandkids of the war generation, cheering and screaming. Then I hated Japan and wanted revenge. Now I thought about the Bird getting away scot-free and felt no bitterness at all. I forgave and, even better, understood what forgiveness had done for me. Forgiving myself and others was the story of my life.

People called me Lucky Louie, and I knew it was true.

The love and graciousness I experienced on that trip to Japan was unbelievable. Being treated like a king had always blown my mind, but this felt different from before. I had, after all this time, learned to live with my "fame" and get comfortable with recognition. That's what had made me a runner in the first place: I wanted to be acknowledged for something besides getting into trouble. My fans made me; I've always known that. My classmates cheering for me when I didn't even think they knew my name, when I didn't think I had the energy to go all the way, spurred me on as I came down that first of many final stretches and finished the race.

I'd always finished the race.

The Olympic spirit is like the wind. We don't see it coming or going, but we do hear its voice and feel the power of its presence, and

we enjoy the results of its passing. Then, it becomes a memory, and echoes of our Days of Glory.

In Nagano I didn't set any records.

For once, I didn't need to.

AFTER WHAT I'VE lived through it's easy to understand that it's almost impossible to get the better of me. Yet on April 10, 2001, when my flight from Hawaii to Manila landed for a routine refueling stop on Kwajalein chills went up my spine and it was tough to control my emotions.

Even though I'd forgiven the Japanese long before, any mention of Kwajalein was still like hearing the name of someone who had killed my entire family. The thought of going back to that hellhole, even after fifty-eight years, was almost unbearable. It didn't matter that the island was no longer the Kwajalein I remembered, the place where, to put it as plainly as possible, I'd been treated like a sewer rat and spent the most miserable days of my life.

By the way, Kwajalein today is not on *any* regular tourist itinerary. Set a few degrees north of the Equator and about fifteen hundred miles east of Guam, the island is a seven-square-mile U.S. military installation, home to a "Star Wars" intercept launch site that's part of our antimissile defense program. Huge antenna dishes track the skies, and the entire area is highly restricted. None but the handful of security-cleared passengers who already lived and worked on the island would be allowed off the plane.

Except for me. And as much as I had hated the place, I'd come of my own accord.

A few months earlier, a woman who attends my church told me that her sister worked on Kwajalein. When she came to Los Angeles to visit, she discovered that I'd been imprisoned there and saw a video of my life story that aired on CBS's *48 Hours*. The sister left me a Kwajalein magazine and her phone number. I called, and she told me that she'd shown the tape on the island and everyone was very excited. The colonel in charge invited me to return to speak at a Vet-

erans Day ceremony. I didn't want to, but Cynthia told me I should go, and she'd come, too. As usual, she made sense.

We'd planned to go in November 2000. Unfortunately, Cynthia began to lose her battle with cancer. I canceled the trip, and a few months later she died. Everybody who loved her—and there were many—came to the service in her honor. It was a beautiful day, with beautiful words about Cynthia offered both in private and from the podium. I miss her terribly, but I have faith I'll see her again someday.

Now ground workers rolled a huge staircase up to the jet door, and over the intercom the pilot said, "Mr. Zamperini will be the last one to leave the ship."

Cissy—she'd come with me in Cynthia's place—smiled and said, "Daddy. They're going to have a greeting for you."

I stepped out of the plane and stood at the top of the steps. The day was perfect. Balmy trade winds ruffled the American flag. I could see homes and buildings in the distance. Someone took my bags. A pipes-and-drum band marched on the field. The commanding officer and his assistant stood at attention, as if I were royalty. Suddenly I felt sheepish. Real sheepish. I folded my hands in front of me and thought, I'm eighty-four. I long ago forgave the Japanese for what they did to me, not only on Kwajalein but during the war. It's just that I never wanted to come back to this place, and now I'm here. Is it too late for me? Can I really shake off the past and see Kwajalein in a different light?

Ignoring the handrail—and my age—I came down snappy. I knew I had to try.

I walked briskly onto the tarmac. The colonel in command saluted and shook my hand, then escorted me and Cissy to a room and presented us with a book on Kwajalein.

"This is our gift to you," he said.

I thanked him and reached into my bag and brought out a bottle of French champagne. They'd had a little contest among the four hundred passengers on our flight over: "We've been flying at a certain air speed, head winds have been this much—how long have we been aloft?" Easy. I wrote down two hours and twenty-eight minutes. Half

an hour later they announced, "The French champagne has been won by the person sitting in seat 41-E."

I wasn't paying attention, but Cissy said, "Daddy, you won the champagne!"

The flight attendant brought me a bottle wrapped in a white cloth napkin. I'd put it in my bag and had forgotten about it until now.

"Here," I said to the colonel. "I won this on the flight over. My gift to you."

THEY LEFT US alone for a couple of hours, to relax. My room had cherry furniture with a high-gloss shine. A huge TV. Better than the Hilton. I lay on the very comfortable bed and kept thinking about the Kwajalein cell I'd once occupied. Now I was on cloud nine. It was my finest hour. The only thing missing was Cynthia.

Whatever Preston, the protocol chief, scheduled for us, I drank it all in. Would you like to play golf? Great! Can you get up at five-thirty? Sure! We had a ball. A lot happened. They found an old map of the island from before it had been bombed, pieced it together from sections, and ran it through a huge laminator. Preston asked if I could pick out my old prison quarters. I remembered coming off the boat, blindfolded, riding in a truck, driving to the right. I pointed to where I thought I'd lived for forty-three days, and Preston took me to the spot. Nothing was the same, of course. It was a well-paved street. Trees, houses, families.

Nothing was the same for me, either. I was greeted, honored, loved, fed.

Most of the workers live on Kwajalein, but a lot of people work on Roi-Namur, another island in the atoll, only a half-hour flight away. There all the old Japanese bunkers still stand, with the grass neatly mowed around them. It takes two hours to tour. We saw one building that hadn't been hit by shells and had iron prison bars on the windows. Today the natives swear they once saw a tall, slender woman with blond hair and a work suit standing behind the bars just around the time Amelia Earhart disappeared. The old-timers today say they've

never heard of Amelia Earhart but that there *was* a woman there who matched her description.

If the pleasure of my arrival was a big surprise, the difficulty saying good-bye was another. It was hard to leave those people. They were so gracious and wonderful. They couldn't do enough for us. Every night a different family threw a dinner for us. We'd have a glass of wine and a toast, and great food. The guests were always fascinating.

Kwajalein was nothing short of a utopia. Everybody rides a bicycle. Nobody's in a hurry. When I got back to Los Angeles I kept thinking, Would I like to go back? As soon as we hit the freeway and fought rush-hour traffic back to the house, I knew the answer.

Three days later I got a call from Preston. "The people here just love you and your daughter." He told me that just before we left he'd gone to the colonel and said, "I've been doing this for fourteen years. All the people who came here, I couldn't wait until they left. But as far as I'm concerned, Louie and Cissy can stay forever."

I NEVER THOUGHT I'd return, but the next day I heard from a man based at Hickam Field on Oahu. "This is Tim Miles," he said. "I'm in charge of military I.D. We have a staff of anthropologists here. We went to Makin, dug up the remains of fifteen marines there, and did a DNA test on them. Now we want to go to Kwajalein."

"I just came back from Kwajalein four days ago," I said.

"What!?"

It seemed Miles had a report from a Kwajalein native who'd said, "Yeah, nine marines were here. They were executed. I saw one of them killed and buried."

"How did you know they were marines?" he'd been asked.

"Because they were all white," the native replied.

Miles wanted to look for the remains of the men whose names were carved into my cell wall.

I also got a not especially congenial call from Washington. "How do you know the nine marines were on that island?"

I said, "I'll quote you what I wrote in my original report."

"Were the names written in pencil, or were they inscribed?"

I said, "They were inscribed by a sharp object."

"What happened to them?"

I told them what the native had told me in 1943: "They were all decapitated, samurai-style," by two guards.

"Did you get the names?" he asked.

I said, "I looked at them every day and pretty well memorized them. But after that, I never had to use the names again, so now I can't remember whether they were first names or last names. Seems to me they were last names, but I've never had any reason to think of them. After that, all I did was explain why the marines were there. But here's an idea. You've got a list of twenty-four missing marines. You dug up the fifteen on Makin Island, so just subtract their names and you've got it."

"Yeah, but there were a couple of other guys missing, too. Two guys on a raft; a plane from another island strafed them at Makin. One died from bullet wounds, the other hit the water and the sharks got him. So we still don't know."

Based on the native's affidavit, Tim Miles thought he had a pretty good idea where to find the marines. He wanted to take a team down to dig and wanted me there when they did it.

In early 2002 I accompanied a *National Geographic* team to Kwajalein for a dig. I stayed a week but had to leave before they discovered anything more than an array of munitions, military artifacts, and bones of the Japanese and Marshallese. No marines.

As of now, they haven't found any American remains. If they ever do, part of me would like to be on hand, but a bigger part of me wouldn't. I've lived through a lot, but the thought of staring into a mass grave that could have easily been *my* final resting place is something I believe I can just live without.

I NEVER MET General MacArthur, but with all due respect, I have never agreed when he said, "Old soldiers never die, they just fade away." Fade away? You should make your life count right up to the last minute. All I want to tell young people is that you're not going to be

anything in life unless you learn to commit to a goal. You have to reach deep within yourself to see if you are willing to make the sacrifices. Your dreams won't always come true, but you'll never know if you don't try. Either way, you will always discover so much of value along the way because you'll always run into problems—or as I call them, challenges. The first great challenge of my life was when, as a kid, I made the transition from a dissipated teenager to a dedicated athlete. Another was staying alive for forty-seven days after my plane crashed, then surviving prison camp. The best way to meet any challenge is to be prepared for it. All athletes want to win, but in a raft, in a war, you must win. Luckily, and wisely, I was prepared—and I did win.

I've gone through my life drawing from my experiences both positive and negative to try and influence others for the good. I never thought of myself as a hero, more a grateful survivor, and so the verse "To whom much has been given, much is expected" is the nucleus from which I deal with people. God has been so good to me. I didn't know at first that I had anything to give, but when I see my influence and how appreciative people sometimes are, what can I do? There are no words more gratifying to hear than "The help you gave me is working out."

GOD HAS GIVEN me so much. He expects much out of me.

# ACKNOWLEDGMENTS

## Louis Zamperini

Whatever I have accomplished I owe to the sacrifices of my mother and father; to the support of my sisters, Virginia and Sylvia; and especially to the love of my brother, Pete, who convinced me to run and saved my life. He is my mentor and my inspiration.

I also owe so much to my wife, Cynthia. We were partners in a fifty-five-year adventure called marriage. She knew me before and after I changed my life and stuck with me through it all. Thanks to her love, influence, and persistence we accomplished more than I dreamed possible.

I'm also grateful to my children, Cissy and Luke; my grandson, Clayton; his mother, Lisa; and my son-in-law, Mick. Their love and support mean the world to me.

Thanks to the student body and teachers of Torrance High School who cheered me on at the beginning of my athletic career, as well as to the entire city of Torrance, and the local police who chased me up and down every street in town.

I'm grateful to Draggan Mihailovich, who accidentally rediscovered me and most certainly resurrected me. I'm also indebted to John

Naber, who makes it possible for me to continually enjoy the echoes of my Olympic days of glory.

Writer David Rensin captured my voice, plain and simple, and brought my story to life. Because of him I revealed truths that needed to be told. Finding someone you can work with day-in and day-out is the most precious thing.

This book is my tribute to the memory of our faithful B-24 crew who did not return alive. It is also in recognition of the many thousands of young people in school and camp programs across the nation to whom I've spoken, worked with, or counseled directly these past fifty years.

My enduring appreciation also to Dave McCoy, president of the Mammoth Mountain Ski Area. For the same fifty years he has graciously provided ski equipment and access to the mountain to myself and the many kids I've brought to the slopes in search of a good time and a better life.

Thanks to the Reverend Dr. Billy Graham for his message that caused me to turn my life around.

I would also like to thank my agent, Jennifer Gates; as well as my editor, Mauro DiPreta; his indispensable number one, Joelle Yudin; and the entire staff of William Morrow for letting themselves be inspired and making this book a reality. They were highly professional, always supportive, and relentlessly enthusiastic.

Of course, there are so many others, living and gone, who in ways large and small contributed to this story and to my life. Had I the space I would mention every name, but I'll take comfort in knowing that you and your families know who you are. Thank you all.

**David Rensin**

As always, my love and gratitude to Suzie Peterson and our son, Emmett Rensin. Their wisdom, support, patience, and joy in life and family make everything I do possible. Yes, Emmett, this story is absolutely true.

Thanks also to my agent, Brian DeFiore, for being open to my instincts, and to Lisa Kusel for validating them again and again. Bernie

Brillstein and Bill Zehme were always in my corner, as were many others who heard this story along the way, picked their jaws off the floor, and said they couldn't wait to read it. As always, I'm grateful to Cynthia Price for her fine transcriptions, editorial eye, moral support, and grace under pressure.

I'd also like to acknowledge Cynthia Zamperini, who regrettably passed away in February 2001. We met twenty years ago when she agreed to act as an intermediary between myself and a magazine profile subject I was pursuing—and stayed in touch thereafter. One night in 1999, she called—"accidentally," she said—and told me to watch Louie's story on *48 Hours*. I did, and the next day I called her, excited, and said that Louie should write a book. She agreed. One thing led to another . . . and now I'm writing this coda to an incredible experience that has immeasurably enhanced my life. I wish Cynthia were here in person to enjoy the results, but I know she's watching.

Finally, I have only the greatest respect and affection for Louie, who has lived a miraculous life, set an indelible example, planted the seeds of his wisdom far and wide, and who has taught me more than I ever hoped to learn.